Target III: In Sequence

Photographic sequences from The Target Collection of American Photography

The Museum of Fine Arts, Houston

Edited and with an introduction by Anne Wilkes Tucker
Essay by Leroy Searle

Contents

Cover: Esther Parada, *Past Recovery,* 1979

Designed by Art Works, Houston
Typeset by Perfection Typographers, Inc.
Printed by Wetmore & Company

© 1982 The Museum of Fine Arts, Houston
Library of Congress Catalog Card Number: 82-60725
ISBN 89090-008-6

Acknowledgments

Initially, I would like to extend gratitude and appreciation to Floyd Hall, chief executive officer, Target Stores, and William A. Andres, chairman, Dayton Hudson Corporation. The beneficence of Target Stores to The Museum of Fine Arts, Houston has been more than financial; their support and cooperation have been a model of corporate patronage of the arts. I would further like to acknowledge Bruce G. Allbright, president, Target Stores; Peter Hutchinson, vice-president, Environmental Development Department, Dayton Hudson Corporation; Richard Contee, president, Dayton Hudson Foundation; George Hite, vice-president of consumer and community responsibilities, Target Stores; Barbara Thatcher, grants coordinator, Target Stores; Bill Gerton, vice-president and regional manager, Target Stores; and Charles Meyer, Houston district manager, Target Stores.

I would also like to extend my gratitude to Joan and Stanford Alexander, whose ongoing support and gracious assistance have been sustaining.

From its conception through completion, this exhibition has required of the Museum's staff inventive solutions to complicated, not-previously-encountered problems and endless hours of exacting labor. My deepest appreciation for their talent, and for their humor, goes to the department heads and to their staffs: Margaret Skidmore, director of development; Edward B. Mayo, registrar; Jack Eby, designer; Eric Binas, preparator; Linda Shearouse, librarian; Lainie Fink, publicist; George Eliopul, chief of security; Hilary Mears, controller; and Ron Jarvis, bookstore manager.

Special thanks also to Debbie Satten, Wynne Phelan, and Suzanne Bloom for matting and conservation; to Margaret Moore, Anne Bushman, Elaine Mills, Maggie Olvey, and Kelly Conner for research and catalogue preparation; to Anne Feltus for editing; to Jack Eby and Rafael R. Longoria for exhibition design; to Arthur White and Art Works for publications designs; to Ralph McKay for coordinating the film series; and to David B. Warren for morale.

For assistance with the biography and bibliography sections of the catalogue, I would like to thank the photographers and their galleries, various publishers, and other museums, especially the staff at the International Museum of Photography at the George Eastman House.

Thanks are also due to Leroy Searle for his encouragement and support as well as for his insightful essay and to Jonas Mekas for creating a parallel film series and catalogue entitled *On the Relationship Between Cinema and (Still) Photography.*

Finally, I would like to thank Nathan Lyons, who initiated my interest in sequential photography and whose provocative questions have greatly shaped this exhibition, and William C. Agee for, and with, whom I was privileged to work on all three Target exhibitions. His counsel was invaluable and will be missed.

Anne Wilkes Tucker
Curator of Photography

Preface

Target III: In Sequence has sequential significance for several important reasons.

First, it brings together 41 photographic works — consisting of two or more photographs considered to be one indivisible work or one photograph in which a series of negatives is printed in sequence. In doing so, the exhibition addresses a facet of the photographic art which has been and continues to be a concern among artists of the 19th and 20th century — those problems which cannot be solved by a single photograph in a traditional rectangular frame.

Equally important, *Target III* represents the third in a sequence of grants from Target Stores, a division of the Dayton Hudson Corporation, which has enabled The Museum of Fine Arts, Houston to acquire and exhibit what has grown to become one of the finest photographic collections in this country.

The first in this sequence of grants came in 1976, enabling the Museum to purchase 70 works representing almost every major photographer of this century, to place the collection on public view, and to publish a scholarly, permanent record of these works.

A second grant in 1978 resulted in *Target II.* Unlike the first collection, which demonstrated the diversity of styles and aesthetic concerns in 20th-century photography, *Target II* focused in depth on the work of five photographers — Baron Adolf de Meyer, Paul Strand, Clarence White, Alfred Stieglitz, and Edward Weston — whose work shaped the course of modern photography.

This generosity continued in 1979, when Target Stores awarded still another grant to purchase and exhibit the sequential photographs found in this exhibition. Thus, through a series of grants, Target Stores has enabled The Museum of Fine Arts, Houston to build a comprehensive photographic collection which not only represents the most significant trends in 20th-century photography but extends our knowledge and appreciation of some of these trends.

It has been a privilege to work with the staff of Target Stores and to participate in this exemplary relationship between business and the arts. To them, I extend my warmest appreciation and gratitude. I also wish to express special thanks to Joan Alexander, a trustee of The Museum of Fine Arts, Houston, without whose initial efforts and continued support The Target Collection would have remained a dream. In addition, I wish to thank William C. Agee, former director of The Museum of Fine Arts, Houston, whose vision and commitment to the photographic art were responsible for the original concept of a Target Stores photography collection. Finally, I extend my thanks and congratulations to Anne Tucker, curator of photography, whose scholarship, connoisseurship, devotion, and determination have made this sequence of exhibitions and their accompanying catalogues a reality.

David B. Warren
Acting Director

Introduction

The works exhibited here are drawn from the portion of the Museum's permanent collection known as *The Target Collection of American Photography.* The purpose of *The Target Collection* is to acquire compelling American photographic art for the Museum. The purpose of the exhibition and catalogue *Target III: In Sequence* is to examine some aspects of sequential photography. A sequence is two or more photographs considered one indivisible work or one photograph in which a series of negatives is printed sequentially.

No history of sequential photography has been written, and it is popular to believe that sequences re-emerged in the 1970s after almost a century in eclipse. Photographic sequences, however, have a rich and continuous history dating from the invention of photography. Contemporary photographers, like their predecessors, have turned to the sequence format as a natural extension of the concerns to depict elapsed time, present vast or many-sided locations, objects, and events, trace evolving relationships, or create visual narratives.

The works in this exhibition have been grouped under five headings which suggest the theme or technique employed in forming the sequence: Time, Panorama, Narrative, Montage, and Transformation. These categories are subjective, and they can limit as much as clarify the audience's perception of individual works. They may also be at variance with the artist's intent. The headings merely indicate the range and scope sought in creating this portion of *The Target Collection.*

The first photographic sequences were panoramic views of major cities. Antoine Claudet's views of London published in the Jan. 7, 1843, *Illustrated London News* and the Langeheim brothers' panorama of Niagara Falls in July 1845 were two of the most publicized early panoramas. By the time Eadweard Muybridge made *Panorama of San Francisco from California Street Hill* in 1877, sequencing photographs was an accepted and popular, though still technically difficult, solution to recording long vistas.

Other panoramas in this exhibition are by Todd Webb, Edward Ruscha, and Laurie Brown. Webb's eight prints of *6th Avenue between 43 & 44 St. New York City* directly inform how that block looked in April 1948. Webb's intentions are those classically assigned to the panorama, to record in richly complex detail the specific appearance of a place. Ruscha's *Every Building on the Sunset Strip,* 1966, is more of a pseudodocument, but it also has precedent in a book published in 1906. Ruscha shows both sides of Sunset Boulevard, one view printed above the other. *Panorama of the Hudson* showed both sides of the Hudson River from New York to Albany "as seen from the deck of the Hudson River dayline steamers." Laurie Brown's *Tracking: Chryse Crater Passage,* 1978, appears at first glance to be a traditional panorama. Brown has repeated the land seen in the right edge of photograph #1 in the left edge of photograph #2. The right edge of #2 is repeated in the left edge of #3, and so forth. The landscape is presented so that the track marks seem continuous, even endless.

Joan Lyons and William Eggleston are as committed to making documents as Muybridge and Webb, but their subjects are more personal and their format less traditional. Lyons applied the panoramic idea in making six photo-offset lithographs of her daughter's prom dress. "The pieces," wrote Lyons, "are pressed to the page like last year's corsage to be taken out and looked at from time to time, a memory trace, representation of ritual."[1] William Eggleston made seven photographs of his yard one morning just before he and his family left their house after living there for ten years. The edges of Eggleston's photographs do not abut as in a traditional panoramic landscape, but a sense of place is eloquently communicated. Crepe myrtle, bay laurel, sycamore, rhododendron and magnolia trees — all typical of Southern gardens — have grown in untrimmed profusion, entwined by morning glory vines. For Eggleston, it was the "culmination of how I felt about my front yard."[2]

The category Time, or more accurately movement in time, is twice as large as any of the others in the exhibition. It also begins with works by Eadweard Muybridge, who is represented here by the five studies from *Animal Locomotion* which photograph movement of the hand. The parallel but initially independent experiments of Muybridge, Etienne Jules Marey, and Thomas Eakins are the most frequently cited historical examples of sequential photography. David Bourdon acknowledged Muybridge as having "the most enduring and far-reaching influence."[3] No one since Muybridge has approached his encyclopedic production or had his showman's knack for promoting his work.

Muybridge, as Hollis Frampton suggests, "having once consciously fastened upon *time* as his grand subject, quickly emptied his images as nearly as he could of everything else. His animals, athletes, and subverted painter's models are nameless and mostly naked, performing their banalities, purged of drama, if not of occasional horseplay, before a uniform grid of Cartesian coordinates, a kind of universal 'frame of reference.'"[4] Hollis Frampton and

Marion Faller satirize Muybridge's work in *Scallop Squash Revolving (var. "Patty Pan")*, 1975, from the series "Sixteen Studies from *Vegetable Locomotion*." Athena Tacha extends Muybridge's observations of the hand in *Gestures I: A Study of Finger Positions*, 1973.

Thomas Eakins shared Muybridge's respect (if not his obsession) for systematic inquiry. In his *Naked Series,* from which we have included his study of *Laura,* ca. 1883, Eakins asked his models to assume a series of seven standard poses. What interested Eakins was how each model's center of gravity varied with each pose. If he traced the body's outline, then drew a red line through it, the axis line would curve forward or backward, depending on the body weight, posture, and pose of the model.

Recalling Muybridge and Eakins, Barbara Blondeau, Alice Wells, Eve Sonneman, and Wynn Bullock convey the human figure in motion, but except for Blondeau, they have not stripped the figure from its environment. Sonneman has introduced other variables besides time in viewing the subject, using both color and black-and-white film and both 35 and 50mm lenses. The subject of each photograph is essentially the same, but the appearance of the subject is altered significantly from one photograph to the next. The "truth" of any single moment is called into question in the context of the other three.

Sol LeWitt's works are clearly rooted in the aesthetics of Eakins and Muybridge, particularly their use of the camera as a tool to record information. LeWitt's work is investigatory. Arithmetic and geometric progressions are played out in logical sequence. In his *Brick Wall* series, LeWitt tracks sunlight across a relatively small section of a wall. The increments of change are very slight. The brickwork becomes a grid against which the changing shadows are measured.

Both Tacha and Lew Thomas have emphasized LeWitt's influence on their work. Tacha also perceives the rows of hands in her piece as friezes, "very rhythmical and mysterious, like hieratic dances."[5] For Thomas, in *Time Equals 36 Exposures,* 1971, "the presentation of the idea, Time,

was completely identified with the practice of photography It [the finished work] was not dependent on hidden messages for its depth of meaning. It was physical and opaque, its object being nothing more than the systematic exploration of the photographic process and its corresponding structure."[6]

Harry Callahan's *Cattails Against the Sky,* 1948, is significant to this exhibition for many reasons, not the least of which is elegant beauty. It is also one of the earliest 20th-century works in the collection, made in 1948, the same year as Webb's photograph of Sixth Avenue. It is interesting to note that Webb and Callahan are close friends and that both were members of the Detroit Photo Guild in 1941 when Ansel Adams lectured there and showed his five-print wave sequence made a year earlier. Callahan attributes the making of his first sequence, *Highland Park, Michigan Triptych,* 1941, to seeing Adams' *Surf Sequence.*

Harry Callahan is also significant to this exhibition and to the history of sequential photography because of his role as teacher and director of the photography program at Chicago's Institute of Design (ID) and later at Rhode Island School of Design (RISD). A significant number of the photographers now working with sequenced imagery graduated from RISD or the ID or studied with an ID graduate. Examples in this exhibition are Ray K. Metzker, John Wood, Bart Parker, and Barbara Blondeau.

The third grouping in *Target III* is Narrative. The range in this group is quite broad, from the quick humor of the unfortunate maiden in the stereographs to the more pathos-laden, snapshot-inspired family chronicle of William DeLappa's *Violet and Al.* Of the six narrative pieces, four are fictional stories involving actors and sets.

The fictional narratives have precedents both fabulous and religious: in Henry Peach Robinson's series based on the story of *Little Red Riding Hood* (c. 1860), Julia Margaret Cameron's illustrations for Alfred Lord Tennyson's *The Idylls of the King* (1870), John Edwin Mayall's 1840 daguerreotypes illustrating *The Lord's Prayer,* and F. Holland Day's *The Seven Last Words of Christ,* 1898, to name a few of the most famous examples. Nevertheless, telling fictional stories with photographs has been fiercely contested by those who insist that photographs may serve only as a faithful witness. In the visual arts, permission to use actors, sets, and costumes passed from painting to movies.

Fictional narratives seem to be a preferred format for describing emotionally provocative subjects such as death (Duane Michals) and marital tension (William DeLappa and Robert Heinecken).

Violet and Al are a fictitious married couple whose relationship progresses over a period extending roughly from the Korean War through 1963. DeLappa worked with models and props in a small town in Ohio to construct the signposts that mark the passing times: fashions, hair style, home furnishings, car design. In addition, he manipulated his prints — rephotographing from faded Polaroid snapshots, blanching out details, awkwardly cropping — in such a way that they bear the hallmarks of amateur snapshots, indifferently preserved.

Richard Avedon says that his pictures are fictions, but his portraits, despite his warning not to believe them, retain the quality of authentic record. In his fashion work, Avedon is the auteur (author and director), but in the portraits he works in collaboration with the subject, in this case the photographer's ill and aging father. These portraits of *Jacob Israel Avedon, father of the photographer,* 1969-1973, more than any others in Avedon's career, maintain the individuality of the subject without slackening the photographer's scientific method of working, a la Eakins, in flat light and against a simple background.

Of the non-fiction narratives, the most traditional is Sidney Grossman's magazine essay on Whitey Bimstein, a boxing "cut man" photographed in action at a fight in 1951. The first photo-essay in a magazine was Paul Nadar's photo-interview with the French scientist Marie Eugene Chevreul on the occasion of Chevreul's 100th birthday, Aug. 31, 1886. The magazine photo-story reached a climax in the work for *Life* magazine by Grossman's contemporary W. Eugene Smith. Gross-

man's piece more nearly resembles the work of Nadar than Smith, as it succinctly records a specific event in the subject's life, rather than recording several events over an extended period of time. Succinct photo-essays like those by Grossman and Nadar have a clear, visual logic and did not require or receive a lengthy accompanying text.

The combination of image and language is more frequent in sequential photography than in other photographic formats. In the Narrative group, Heinecken's *Socio-Duo-Habliment Studies #1, #2* and *#3*, 1981, and T. W. Ingersoll's *The Housemaid's Hard Luck*, 1898, incorporate both language and humor.

Eight of the ten works in the fourth category, Montage, also incorporate language with words in the image (Nathan Lyons, Al Souza, Paul Berger), on a text panel (Douglas Huebler), or in a title which is essential to our understanding of the work (Minor White, Bart Parker, Marcia Resnick, Robert Cumming). "Montage" is used here not in the traditional visual arts sense, to make a composite, but rather in the literary, musical, or filmic sense where separate pictures maintain their identity but also gain from association. Many of the pieces in Montage are at once serial (from the root, to join) and sequential (from the root, to follow), where specific juxtapositions create meanings not apparent from seeing the photographs individually. These pieces are more like poetry than prose.

It is notable that this category contains works by two artists, Minor White and Nathan Lyons, who have explored the sequential format since the beginning of their artistic careers. As teachers, writers, and curators, they have also been most attentive to photographers whose work "departs from the traditional concern for basic photographic order."[7] White's first sequence evolved in the late 1940s after he lived in New York and met Alfred Stieglitz. Stieglitz's concept of equivalence became central to White's art. "Stieglitz had postulated that the photograph can be an equivalent — a metaphor for an internal state — and White extended this concept, applying it to a mode of personal photography and teaching in which photography was conceived of as a spiritual discipline both for the photographer and the active viewer."[8] White's sequences frequently existed in several versions. According to Peter C. Bunnell, the version of *Intimations of Disaster* in this collection "was sequenced in 1952 and exhibited only once, at the San Francisco Museum of Art, December 4-21, 1952. It was a version of five panels with 18 photographers. It was laid out in what Minor called a 'free-form arrangement.'"[9] The Museum's piece matches this description except it has one more photograph than Bunnell noted. The "free-form arrangement" is a complex design in which photographs are matched according to internal elements and rhythms, not displayed in a straight line. A single photograph may be even or higher or lower than its neighbors.

The images in Nathan Lyons' *Verbal Landscape* relate to one another verbally as well as visually. The words in three of the first four images rhyme: dream machine, changing scene, green. "I'm the one," says George Washington in image #9; "relax, there is only god," replies grafitti in #10. Lyons is a cultural historian. His pictures both highlight and contrast secular objects of devotion. The public issues embodied in these scribbled and printed messages ("welcome to video land," "a woman was raped . . .," "here's to cowboys") will date the pictures as surely as the cars and clothes in Todd Webb's panorama.

For Al Souza, Robert Cumming, and Marcia Resnick, the objects they photograph have no intrinsic meaning. They are interested only in what they can invent in the juxtapositions of their photographs, what new meanings they can assign to what they see. These pictures are a different kind of photo-fiction. In *landscape-loftscape*, 1976, Resnick re-creates a landscape in her loft to make a "loftscape." From a distance, the differences in the two pictures are not evident. The re-creation on the right appears to be a second view of the real cloud seen in the photographs on the left. Because they are both photographs, the viewer's inclination is to assume that both are

true. The fiction is revealed only with scrutiny. In Cumming's *Walking Shoes Turned Momentarily in Profile (Denise in Heels)*, 1975, the alteration is not in the object photographed (Denise's heels) but in our perception of it from one picture to the next.

Pictures in the final group, called Transformations, are similar to montages in the juxtaposition of seemingly diverse images, but the separate images do not maintain their visual identity in separate frames. For instance, in *Identifying with Mona Lisa*, 1977, MANUAL (Ed Hill and Suzanne Bloom) reincarnates Mona Lisa as Stephanie Kaldis. In *Spruce Street Boogie,* 1966-1967, Ray K. Metzker visually transforms Spruce Street in Philadelphia according to the syncopated sound that he associates with Spruce Street. Wrought iron railings become the bars on which the beat is played. The notes are pedestrians and passing cars.

Esther Parada transforms the photograph of her great aunt's and uncle's anniversary into a composite family scrapbook with images of family members from earlier and later points in their lives imposed upon their images at the banquet. "My sister's face at age two," wrote Parada, "is juxtaposed with her own image thirty years later and with that of a great aunt whom we never met, although family legend has it that they were cast in the same mold. Similarly, I see other members of that family gathering through the filter of my own cumulative experience."[10] Parada titled the resulting 100-frame composite piece *Past Recovery.*

There are, of course, many artists and works not included that one would expect to see in an historical exhibition of sequential photography. Some artists were already represented by a major sequential work in the Museum's holdings other than *The Target Collection*, for example, John Baldessari's *A Different Kind of Order (The Thelonius Monk Story)*, 1972-1973; Jan Groover's untitled work (white houses), 1977; and Thomas Barrow's *Homage to J.C.,* 1973. Since *The Target Collection* contains American work exclusively, there are no works exhibited here by Hamish Fulton, Bernd and Hilda Becher, and other major European and Canadian artists. Other artists are not included because a compelling work was not currently on the market or was not available at a price within this collection's budget.

The photographs in *Target III: In Sequence* are frequently different from popular conceptions of photography. Their makers questioned the traditional expectation of what a photograph looks like and how those expectations affect its meaning to the viewer. In particular, the photographers questioned the sanctity of the single negative: why is one negative — printed and exhibited as a single print — more legitimately photographic than a sequence of photographs? Does the single-frame "decisive moment" print always offer a more significant experience to the viewer?

It is the intent of this exhibition and catalogue to move these questions more centrally into contemporary discussions of the "nature of photography."

Anne Wilkes Tucker

NOTES

[1] Joan Lyons' letter to Anne Bushman, Sept. 2, 1981.

[2] William Eggleston telephone interview with Anne Tucker, May 7, 1980.

[3] "Sequenced Photographs," *(photo) (photo)2 ... (photo)n*, University of Maryland Art Gallery, Baltimore, 1975, p. 7.

[4] "Eadweard Muybridge: Fragments of a Tesseract," *Artforum* (March 1973), p. 51.

[5] Letter from Athena Tacha to Anne Tucker, May 25, 1981.

[6] *Structural(ism) and Photography,* NFS Press, San Francisco, 1978, p. 9.

[7] Nathan Lyons, "Introduction," *The Persistence of Vision,* George Eastman House, Rochester, N.Y., and Horizon Press, New York, 1967.

[8] Lee D. Witkin and Barbara London, *The Photograph Collector's Guide,* New York Graphic Society, Boston, 1979, p. 272.

[9] Letter from Peter C. Bunnell to Anne Tucker, May 24, 1982.

[10] *The Portrait Extended,* Museum of Contemporary Art, Chicago, 1980, p. 22.

"Images in Context: Photographic Sequences"

by Leroy Searle

Part of our natural fascination with photographs is what Herman Melville called, in another context, the "shock of recognition."[1] While Melville was referring to the capacity of art to bridge time and space in showing us that genius is everywhere the same, the particular shock of recognition that photographs convey to us is the sometimes uncanny sense that we already know what we see in them, as if time and space coalesced in the familiar shape of the photographic rectangle.

The drama of photography is uncanny, however, because it proves us wrong consistently: photographs of the most familiar subjects disclose to us less what we see than what we could not have seen, despite familiarity. We can recover subtle differences that evade the hurried glance or can find ourselves recognizing similarities that overturn our comforting notions of ourselves. To "recognize" is thus not merely to correctly identify a subject photographed, but, as the word suggests, to re-cognize, to re-think.

These photographs from The Target Collection of American Photography offer an occasion for rethinking. These images span a considerable portion of the history of photography, while in subject matter and stylistic preference, they cover a prodigious range.

They belong together, however, as a record of a remarkable experiment in artistic and cultural history, an experiment by no means concluded. It is, in brief, an experiment in the making of art as the making of meaning, and these photographs, all of which participate in the experiment by different strategies, illustrate an essential principle for interpreting photographs. It is this: no matter how beautiful, striking, or picturesque, the single photograph is not the critical unit of photographic achievement.

Rather, photographs endure and reinforce their claims to our attention because they transform the context in which we see them, and, by their means, we learn to see the world anew. This exhibition acknowledges a contextual imperative to record and preserve what photographers have long understood: it is in extended, sustained bodies of work, where single images refer to others and alter their visual and cognitive weight and significance, that the spirit or genius of the photographic medium is to be found.

This assertion cannot be taken for granted, since the visual presence of the individual photograph is what we respond to most immediately. The principle of the photographic sequence, on the other hand, is a reflective discovery that photographers make in the practice of their art, just as viewers discover it in the contemplation of a body of photographic work.

Indeed, there is some tension between the photographic image as immediately present and the attenuated

recognition that photographic sequences embody a vital generative idea without which photographs would be relatively trivial. As this exhibition demonstrates, this tension is nothing new, since it arises whenever photographs are juxtaposed and relations among images are observed.

The photographic sequence may be produced or displayed in many ways, with different modes of order (e.g., a linear series, an array, a grid, collage, assemblage), but the sequence, as an idea, is not identical to any particular mode of presentation since it depends on the recognition that photographs create and re-create contexts within which meaning is produced. One might say that the only truly single, isolated photograph was the first photograph. Thereafter, photographic images have proliferated to create a new image environment that evolves according to present possibilities and preferences.

While all innovations in picture making have a similar effect, the critical difference with photography lies in its functional character as an optico-physical process. By effecting point-to-point transformations of three-dimensional space to the two-dimensional surface of the picture plane, the photograph considerably narrows the distance between the picture conceived as artifact and the picture conceived as record — just as it raises fundamental questions about the way we apprehend and assimilate visual information generally. We are notoriously inclined to take our eyes for granted: we do not ordinarily think about the way we see, subordinating this question to a practical purpose, where sight is essential but purely instrumental to other ends. Thus, we may just register a single image without much mental attention, but what do we do with multiple images, carefully ordered to give us the prototypical "message" — namely, "This is a MESSAGE; pay attention"?

Part of the tension in photographic sequences arises from our own cultural and historical presuppositions about what images are and what they are for. We may think we know what to do with a photograph in a newspaper or magazine: read the caption — i.e., treat it as a supplement or "illustration" of a verbal text. Encountered on its own terms as an integral artifact, the photograph may delight us or confuse us without giving us very much specific guidance about what, particularly, we should be attentive to.

On this account, photography has always been a troublesome medium, a radical mode of picture making with a natural inclination to upset tradition (and traditionalists). If we attempt to assimilate it within conventional art history, it tends to disrupt our conventional understanding and transform that history into something vaguely unfamiliar. If we think of single photographs as "art objects," for example, we mentally restrict the context for viewing and tacitly assimilate the photograph within a set of formal picture conventions shaped primarily by the traditions of painting. But photographs are not paintings, nor are they meant as imitations of paintings.[2] Neither are they simply "pictures," literal depictions of other things, despite their intimate ties with the visible world. Surely, they are not just sumptuous artifacts which we call "art" because we don't know what else to call them, or quite what to do with them except hang them on the wall.

If we are searching for a generic term, the photograph is first of all an artifact, as something made, and secondly, a document, as something to be understood. In this respect, it occupies an intermediate position between the historical graphic arts of painting and print making and the arts of language. To say this helps very little, since the mental territory so described is immodestly vast — yet photography seems to have occupied it all and put down roots across the whole terrain from the painter's studio to the press room, without seeming very much at home in any of the places it has occupied.

I do not mean to suggest that we need yet another sterile exercise in definition, for we know well enough what photographs are to pick them out of the crowd of other artifacts and documents. And despite some uneasiness, which we will address shortly, it now seems clear that the most interesting and promising context in which to consider photography as itself, and not just the supple-

ment to something else, is the context of "art." This is not because of formal resemblances between photographs and other works of art, but because of the cultural function of art in any medium.

Here, the essential question is value. If we say that the concept of "art" persists, murky though it is, as a way to attribute or claim value for some human productions and activities, then we should be able to say why "art" of any kind matters and why photography in particular should be of special interest to us.

While it is not altogether surprising, aestheticians seem to have more trouble with photography than does the viewing public, since the actual record of photographic practice wreaks havoc with traditional aesthetic categories such as "beauty" or "taste," or "judgment." For too long, the genteel jury has inclined to the opinion that there must be something wrong or deficient about photographs because they cannot be tidied up to be at home in the aesthetician's parlor; but today, it seems peculiarly obvious that the aesthetician's parlor is a drearily impoverished place (despite the fact that there are now a few photographs hanging discretely on the walls).

In fact, the problem is more fundamental, for since the work of Immanuel Kant, the notion of the "aesthetic" has been grounded on the assumption that we can (and should, in the interest of philosophical order) segregate the Good and the True from the Beautiful.[3] While such a strategy permits greater analytical clarity, it does so at the cost of making the Beautiful insipid or inexplicable, having no other apparent function than to give us pleasure. If pleasure suffices, we should be able to say why; and if it does not, we should be able to provide some basis for value in art.

While these imperatives demand extensive argument, here the primary concern is to indicate a basis and a direction for inquiry. In fact, where speculation on art begins is with concrete experiences: works of art affect us not merely by pleasing us, but by altering profoundly the very way we think, feel, see, and ultimately act.

If so, then it is redundant to say that a work of art is beautiful, when the content of that judgment is the affect, the experience, of encountering the work. What we judge to be "beautiful" is the difference the work makes to us. This difference is not reducible to any particular set of formal or conventional features of the work that will yield to ordinary description. "Aesthetic" speculation, however, has little more to offer than descriptive terms that shift the focus to formal conventions at the expense of the experiences they attempt to describe. What gets lost is the only thing that counts; and it gets lost because it is not a "thing," but a condition of mind, body, and spirit, brought about by encountering things we call "art."

It is clear that the early years of photography were subject to the circular currents of formal aesthetic speculation, and the context in which photography first emerged shaped early thinking about photographs by default. While painters had been struggling for at least two hundred years with the technical demands of visual syntax, in order to achieve a higher degree of verisimilitude between the painting and external referents, photography settled this in an unexpectedly decisive, but still unsatisfying way.

This dissatisfaction is implicit in the remark of the poet and painter William Blake that his works were "Visions" addressed to our intellectual powers.[4] That is, one can strive for as much "likeness" or "verisimilitude" or "realism" in depiction as one wishes, and still miss altogether the point of what an artist addresses to our intellectual powers. Again, to cite Blake, we may be merely seeing "with" and not "through" the eye when we take the pictures we behold to be only references to things outside the picture.

These preliminary considerations suggest one major reason for trouble when earlier artists and thinkers took on photography. This new medium, as "mechanical," "automatic," and fiercely accurate, was an object of suspicion, scorn, fear, and derision, because it seemed to threaten the domain of "Vision" in Blake's sense, and in solving a troublesome formal problem, flushed out the functional

dilemma that lies behind it. The main purpose of art is not to represent or reproduce the world, not, in the old word, to effect mimesis or imitation, but to effect specific (and subtle) changes in the minds and spirits of people.

What was revolutionary about photography was that it quickly showed how little the formal issue of mimesis really matters: the effect of the photographic image can be just as profound, just as visionary, and just as demanding as the effect of the most elaborate allegorical painting in the sublime style. If this is so, it shows as well how little the conventions of allegory and the commonplaces of artistic style matter in producing desired artistic effects: almost anything we want to do can be done in more ways than one.

From another point of view, photography was radical (and disruptive) because it was so readily acknowledged as the representational medium without peer: being "automatic" and "mechanical," it "could not lie," and, in an excess of philosophical incaution, many leapt (as many still do) to the conclusion that the camera must therefore tell the "truth." The confusion unleashed on both fronts, the world of art and the world of fact (also a confusion we have yet to resolve), testifies to the danger of separating the two: without imagination and vision, we could not construct that austere notion, Truth, and without immediate contact with actuality, Art would have no more vitality than lace curtains without even a window to hang them on.

On this basis, art history over the past two centuries loses some of the tidiness attributed to it in the claim of Clement Greenberg (among others) that the essential project of this period is the growth of "modernism," as the search for the ultimate specific ground of particular artistic media.[5] Instead, this differential concentration, self-reflexively exploring the powers and potential of different media, is but the localized manifestation of a more fundamental but diffuse perplexity over the meaning and importance of artistic "form." In this perplexity, photography appears at the center of confusion. The photograph, almost at a single stroke, turned the problem inside out: "form,"

superficially regarded as the physical properties of the artifact, is almost trivially resolved in the conjoint action of optical devices, light rays, and photosensitive materials within the familiar pictorial rectangle. Instead, the perplexity is the function of the image, and the complex generative relations by which meaning is made in images, and value is attributed to the result.

For the public, these matters hold little interest, compared to the direct fascination of this new picture-making means. The relative ease of making photographs effected at least a liberation from the labor of the painter's studio and led, within only a few years, to a pictorial vernacular, a collective repository of pictures not directly connected with "fine art," but much more directly connected with a public hunger for pictures that we have just begun to analyze.[6]

As Rod Slemmons has suggested, it is seriously misleading to present the history of photography exclusively by way of the history of art, since the public response to photographs was both too rapid and too wide-ranging to confine the medium in conventional aesthetic boundaries. And while Slemmons makes the extremely important point that "art" photography has had its moments of efflorescence against the background of documentary work, he suggests that an "art history" of photography would involve much closer attention to the "moral, social, and philosophical" aspects of the world view that produced (and is reciprocally produced by) photography.[7]

Thus, the early and rapid spread of photography, and its steady rise in popularity and preference as the picture-making medium, par excellence, could also be seen as the leading edge of a profound transformation of the concept of art, not as the production of aesthetic marvels, but as a form of intervention in the collective life of a culture. Accordingly, the focus of artistic activity is not just the production of artifacts, but the manipulation and disposition of materials that can be assigned a meaning in the mental and spiritual economy of a culture.

In this connection, the importance of the photographic sequence cannot be overestimated. Not only con-

ventionally trained painters but the rankest amateur discovers quite quickly that it is not easy to make a satisfying photograph, but photographs that are satisfying are so in a somewhat uncanny way, since they alter our perception of the familiar without altering the familiar itself. More importantly, the alteration is generative: it does not merely produce one picture, it generates a basis for other pictures and other visions of a common world.

We discover that it is not enough merely to look at or "appreciate" photographs, we have to read them, and interpret the contexts they evoke and create. While in earlier times, viewers might have taken for granted that an allegorical painting, for example, had to be read and interpreted, in the age of photography we are apt to find ourselves unprepared for a similar task, not merely because we have forgotten how to read allegories nor because photographs are not allegorical. It is more because we appear to have forgotten that works of visual art require us to think, not merely to look.

Before this task, conventional aesthetic thought is self-defeating, since it presumes that the work of art, belonging to the domain of the beautiful, requires only a judgment of taste, informed by principles; but this presumption has nothing to work on because it rules out as irrelevant the very content of the judgment in question. All that remains is formalism, in the guise of painstakingly tedious descriptions that promise to get to the question of value, but never arrive at it for having leapt too quickly over the problem of interpreting the work of art.

Interpreting photographs, however, opens the equivalent of Pandora's Box, for the directness of the relation between the photograph and the familiar world makes anything in the world potentially significant to our interpretations. Thus the familiarity of the photographic image complicates the problem because we are likely to think the photograph is transparent or that what it "means" is simply given. To invoke a homely comparison, this is not unlike the confusion we set in the minds of children when we tell them that cows "give" milk. On the contrary,

they produce it, but you have to take every drop. And before you can even start, you have to persuade the cow to stand still.

For the interpreter, this is the problem of context: how do we set cognitive boundaries that are both plausible and representative and also appraise the importance of the aspects to which we will attend, and the questions we will pose? If we set out to get meaning, we will have to work for it, and this includes, among other things, deciding what kinds of interpretive investigations are pertinent and appropriate.

In this light, the inevitability of the photographic sequence — from simple strategic manifestations, such as juxtapositions of multiple views, to more subtle examples, as in the intricate assemblages of Ray Metzker, Paul Berger, or Barbara Blondeau, or the somewhat eerie sequences by Minor White and Nathan Lyons — is just the imperative to shape internally the interpretive context of photographic work.[8]

Elsewhere, I have argued that we should treat photography as a form of discourse or visual language, requiring, among other things, a substantial revision of what we take a "language" to be.[9] Here, I propose to extend these arguments to some of the forms visual discourse can take in photographic sequences.

I. Art and Discourse

In the medieval school curriculum, introductory studies were incorporated into the "trivium," the first three among the seven liberal arts: logic, grammar, rhetoric. (The advanced studies or "quadrivium" included arithmetic, geometry, astronomy, and music.) Part of the appeal of this antique scheme is the assumption that where people start (indeed, where they constitute themselves as people) is in discourse — which, in its turn, leads one out of oneself into the cosmos.

While this is no recommendation that we should return to the medieval curriculum, there is much to be said for observing this order of study as an order of questions, with a specific basis and a trajectory. The notion that there is a continuity in discourse, leading from ourselves to the world is surely not out of place in contemporary understanding, where we can speak without much hesitation of the "language" of DNA. And once we have agreed that the notion of language need not be restricted to verbal language, but can include such diverse things as fundamental biological processes, symbolic logic, and computer programs, we should not find it too strange to think of photography as a language.

Since the introduction of the noble idea of the "liberal arts," however, we have proceeded in an exciting but costly course of development, wherein our great intellectual advances have come in developing more discriminating languages and specialized discourses, at the cost of fierce alienations. It is as if we have been forced to choose between a kind of vacuous self-absorption and an insensible, sometimes inhuman, oblivion that leaves us gazing at the cosmos or at our own navels, in neglect of the cultural medium in which both of these activities, and everything human in between, is sustained.

In suggesting that photography is a language, then, more is at issue than the invocation of a familiar critical topos or commonplace. [10] At root, our most familiar notions of "art" are merely symptoms of alienation because they do not take into account the function of art as the value concerned or axiological discourse of a culture. Indeed, we may say that a "culture" is itself a composite discourse, observing principles of order and arrangement (logic or syntax), conventions of communicating meaning (grammar), and strategies for implementing arguments, making pleas, statements, and so forth (rhetoric).

I would propose, then, a provisional concept, "cultural discourse," as one way to describe what "art" does: it orders, communicates, and implements the mental materials of culture, with the general intent of permitting us to discover who we are, where we are, and, finally, what we value.

In this context the particular appeal of photography comprises just those features that have made it aesthetically troublesome: it will not stand still in the barnyard of the Beautiful, nor will it recline quietly in the academic groves of arts and humanities departments. Perhaps promiscuously, it will go anywhere in the regions of discourse — arts, sciences, humanities, technology — without, for all its divagations, losing its own character.

The work in this exhibition participates in "modernism," at least in the sense that it self-consciously explores the character and peculiarities of the photographic medium itself. Yet given the simplicity of the medium's principles, and the vast range of possible application, concentration on photography as making, not just talking, pictures situates this work in the middle of art as cultural discourse. By conceiving their work in larger units, these photographers open an extraordinary field for investigation (and intervention) that is imaginatively rich precisely because it is so ordinary — and so often overlooked.

At first view, the principle of the photographic sequence seems almost trivially simple: it is just connection or juxtaposition. Yet it is, for images, a powerful syntactical/grammatical innovation (or, we might say, a recuperation of a principle fallen into disuse) that does not predict at the outset what will follow from particular connections or juxtapositions, but proceeds, generatively, in a fugue-like interaction that has as its "voices" the world as we find it, the culture as we abide in it, past images, and projective possibilities.

To return to the interpretive problem, the syntactical principle of sequences works by using the selected components of a sequence as contextual markers, where internal relations among parts balance the pressures of external references.

The relative delicacy of this balance (as in any artistic medium) depends on the tact of a viewer: no artist could work if he or she assumed the audience to be ignorant, with

open eyes and empty heads. Instead, it presumes an attitude of patient attention, to follow subtle but significant turnings of visual intelligence.

I would suggest, then, that these works will yield their meaning, not, as with the cow, by tying her to a stake or locking her in a stanchion, but by actively construing the visual arguments, propositions, and subtly modulated expressions that maintain the contextual balance between a world (in William Carlos Williams' words) "subject to [our] incursions"[11] and the states of our own imaginations and desires.

In the remaining pages of this essay, I will offer an all-too-general (but I hope not perplexing) Guide for the Perplexed that suggests some of the ways in which these examples of photographic sequences can be interpreted and related to each other.

II. Visual Rhetoric

If we begin by thinking of each piece in this exhibition as a complex visual proposition or predication, what is immediately clear are the remarkable differences among types. There are profound differences, for example, in strategies of presentation, in the way themes are articulated, in mood and tone, and in presuppositions about what viewers will know, recognize, or find of interest.

In the midst of these many differences, however, there is an overriding similarity. None of this work presumes that "art" exists solely in a particular kind of material or subject matter. On the contrary, it presumes that art belongs to the ordinary, not diminished as "merely" ordinary, but disclosed as the actual center of our interests and affairs. As such, the ordinary is the true topic of all art.

It is often remarked that photography is a profoundly democratic medium, if only because the technical means for practicing it are so readily available. More to the point is the pressure to engage the world as it is and as we presently imagine it.

One can sense this pressure merely by holding a camera in one's hands. In Garry Winogrand's well-known remark that he photographs just to "see what something will look like photographed"[12] there is a fundamental imaginative principle: in the practical mode, we almost never see the world, and all vision (in Blake's sense) waits upon revision, reflection, and re-creation. Literally, to see is to imagine, and to imagine is to image.

In the photographic sequence, this principle receives rich exploration. In William De Lappa's *Portraits of Violet and Al*, for example, we encounter what looks like the most ordinary of all photographic groupings: part of a family album. Closer attention, however, shows that De Lappa has gone to the extreme in creating this first impression — deliberately smudging or dog-earring prints, messing up the focus, missing Kodak's handbook clues for "good" pictures — in a set of photographs that are, in fact, carefully staged, with the use of models and deliberately anachronistic sets.

It is a natural question to ask, then, what is special or valuable about this? In one context, the answer is, nothing. The fact that most of us have similar albums of our own (similarly dog-earred, smudged, and blurred) puts us all on par with these photographs. Yet few of us have ever stopped to consider what it is we are doing when we compile such albums. De Lappa's sequence, for all its apparent simplicity and ordinariness, starts where the rest of us stop: it is a sustained and deliberate reflection on what such snapshot albums do. They tell a visual story, where the interest is not in the well-made plot, but in the periodic marking of change by recording our self-conscious rituals — like Christmas, taking leave, being together (alone), and being alone (together).

Since none of us know "Violet" and "Al" (they "exist" no more than Hamlet "exists"), it is up to us to reconstruct this "story," based on what we do know — i.e., Christmas, taking leave, being together (alone), or alone (together). It is essential that we know the artificiality in the making of this sequence, precisely because it then forces us to reflect

on what we all — rich or poor, elegant or shabby — experience and record because it does, in fact, matter to us. Still, it may be that such highly self-conscious explorations of the commonplace leave us cold. One might say, so much the worse for us, but photographic sequences leave us ample room to find out where our warmer interests (or exposed nerves) lie.

In Richard Avedon's powerful portraits of his father, for instance, sequence is constituted as a series of individual images, connected to each other by their common subject, Jacob Israel Avedon. Yet the effect of the connection is to evoke a still more common theme — indeed, a constellation of themes — that cannot be purified of manifold identifications which may trouble us deeply: these are portraits not of just anyone, but of the photographer's father. Yet they are at once less and more than that, because they are portraits of dying. So direct, even aggressive, is the address to this fact, and so uncompromising the acceptance of it as a fact, that interpreting it may evoke two nearly simultaneous (and, I would argue, finally identical) questions: why were these photographs made, and why do we react so strongly to them? It might suffice to quote John Donne: "Do not ask for whom the bell tolls; it tolls for thee." But the rhetorical figure or turn in this work does not depend on our coming up with a single definitive answer. It pivots, instead, on the intimate facility of the questions and on their immediate and ultimate concern to us. To make such photographs is to face the reality of impending death, without disguise and we react to these photographs because they show death to us as one of the facts of our common life to which we cannot be indifferent.

While this powerful example is in some ways one of the simplest in the exhibition, it is representative of the general effect of sequences: starting from highly resolved particulars — be they portraits such as these, or four similar hallways as in the piece by Steve Kahn, or the fragmented views of a woman displayed as a single continuous strip in Barbara Blondeau's *Karen Series* — a connecting theme or motif is identified and a more general set of cultural circumstances is evoked.

The interpretive problem, then, is shaped by the connection between an ordering strategy and the determination of a theme — which in some cases may be very abstract. In the examples we have considered, the ordering principle is, in general, succession. We have examples of visual narrative where the succession of particular views identifies a theme by their association with some aspect of cultural experience. The narrative effect can, of course, be strengthened considerably by focusing on the succession of events — as in Duane Michals' sequence, where the theme is particularly somber, if not macabre, or in the Ingersoll stereo views, *The Housemaid's Hard Luck,* where the theme is comic and ironic.

It especially should be noted that when photographic sequences are ordered serially to produce a narrative, we respond to the inherent ambiguity of the individual images by actually reconstructing a story that could be told in words — just as when we read a verbal narrative, we must partially visualize it in order to succeed in mapping the narrated events (which are always highly selective) to the natural order of chronological time.

In a complementary class of strategies, however, the principle of order is not serial (and consequently does not directly involve the succession of time), but instead produces meaning by substitutions. In the terms of classical rhetoric, we could say that serial order tends to rely on the figure of metonymy (the replacement of one thing by another associated with it), but strategies of substitution tend to rely more heavily upon synecdoche (representing a whole by one of its parts). In such sequences, the range of possibilities increases dramatically, since the viewer is left to infer the whole constituted by the entire sequence.

In Douglas Huebler's *Variable Piece,* for example, the avowed task of photographing everyone alive can only be undertaken by way of synecdoche. In the example here, the representation of "One person who would leave no stone unturned," with the thematic focus on the Holocaust, the whole constituted by these representative parts is pre-

supposed as perhaps the most horrifying cultural event of our epoch. Thus, we cannot presume that the somewhat enigmatic aphorism/caption refers to the man in the third photograph. The point is, rather, that some such person is precisely required to represent the whole of this tragedy.

In other examples where synecdoche and substitution govern the construction of the sequence, the effects resemble montage, where extremely complex wholes are outlined by interweaving diverse elements and themes to create intricate visual metaphors. In Minor White's *Intimations of Disaster,* for example, one scarcely needs the title to apprehend the tone of the piece, but it is frustrating, even a little maddening, since it remains all intimations. What seems to me at issue in this remarkable work is the continuity of watchfulness and apprehension — both in the diverse subjects photographed and in the activity of the photographer. The complexity of the piece, however, lies in its precise manner of development: from each exposure to its successor, there is at least one graphic element to carry the eye forward, with periodic indications of the end, indications such as the arrows, typically pointing to the right, but in one case, also pointing at us, and in another, replaced by a street or alley similarly oriented toward us. Yet when we arrive at the last panel, we are presented with two striking details: the absence of people in the last exposure and the figure standing in the illuminated doorway to the left of the panel, not unlike the departing courtier in Velasquez's *The Maids.*

Like that painting, however, this piece positions its maker (and viewer) in radical foreground, out of view because, like the survivors in the Book of Job, they "only alone have escaped to tell the tale." But like all inherently self-reflexive tales, it has no unconditional denouement, no determinate last act, since it serves precisely to alert the survivor/viewer, not merely to watch out, but to see that we are not mere viewers, but actors who likewise do not know the end.

Similarly, in Nathan Lyons' sequence, we find a remarkable and subtle documentation of what events may intimate ("Riding First Class on the Titanic"?) but without the oppressive aura of gloom that one senses in White's sequence. In its place is a weaving of materials, more abstract, more ironic, and more accessible, that shapes the context of the sequence within a larger historical setting. In this case, the use of messages (in grafitti, billboards, windows) conjoins in an expansive visual metaphor that encapsulates our cultural-historical moment as one of ironic change. Apocalyptic slogans coincide with phrases from children's games, and the folly of our contradictory desires (religion or the state, Jesus or George Washington — or cowboys) is wittily captured in moments of recognition that our notions of a "dream machine" in "video land" do indeed reflect a changing (and often destructively violent) scene. Yet one can scarcely suppress the ironic humor in the last image of the sequence: "Dinosaur sat down." The incongruity of the phrase (like a page in a Beatrix Potter book) with what it records — a moment in the coming extinction of a saurian giant — can lighten the imagination by the implicit comparison between the weary dinosaurs and ourselves. But like all good metaphors, it preserves its opposite in the same figure: we cannot presume immortality, neither according to Jesus nor the Cowboys, since all we know is change.

In selecting these examples as illustrative of what photographic sequences do, I may have inadvertently suggested that they make us soberly depressed. Yet these examples show only the strategic poles of choice and, even in their sobriety, reflect perhaps the most important effect of the photographic sequence. That is to put us into contact with facts, not always pleasant, but of great concern. As Thoreau claimed in *Walden,* "Shams and delusions are esteemed for soundest truths, while reality is fabulous." He continued:

> If you stand right fronting and face to face to a fact, you will see the sun glimmer on both its surfaces, as if it were a cimeter, and feel its sweet edge dividing you through the heart and marrow, and so you will happily conclude your mortal career. Be it life or death, we crave only reality. [13]

If it appears to us that one side of a fact is worry, then the other side of it is care, a gentler and more restorative emotion in which we can, indeed, discover how fabulous reality is. In these sequences, what emerges from the willingness to stand "right fronting and face to face" with facts is that imagination, vision, is not something set apart from fact but the essentially human mode of engaging it. Thus, in this exhibition, as in the larger historical body of work from which it has been drawn, the photographic sequence provides an endlessly variable way to address facts and thereby to discover what we really do care about. It may be to understand the measurement of time through motion, as in Muybridge's meticulous studies, or, as in Esther Parada's *Past Recovery*, to reconstitute a past that is part recovery by articulating its parts. So, too, it may be to see ironic humor as Hollis Frampton and Marion Faller do in *Vegetable Locomotion* or, in a different mode, to capture the poignancy of what is still because it is past, as in Joan Lyons' exquisite photo-lithographs, *Prom Dress*.

In all of these moods and modes, the photographic sequence emerges as an answer to a formal and functional challenge that we have only begun to appreciate. Among these works, there are many that may remind us powerfully of painting, just as others may remind us of poems and stories, not, I submit, because they set out to imitate these other art forms, but because they represent photography at a moment of emerging sophistication that can revive our sense of imaginative vision without alienating us from the ordinary. Thus, in Ray Metzker's remarkable *Spruce Street Boogie*, a compelling visual composition emerges from simple but profound attention to the commonplace sights and events of an ordinary street. Paul Berger's *Economics*, from a longer work, *Seattle Subtext*, draws material from "video land," from the past and the present, into a stunning document that deliberately takes on the look of a *Time* magazine page to do what *Time* could not do. It shows us the rich variegation of a world full of messages we have scarcely known how to read because, without the photograph, they perish.

These sequences, like all good art, are demanding: they can wear you out with their subtle intricacies. But also like all good art, they can refresh the weary with an ultimately simple and saving message: here, we have lived and cared.

NOTES

[1]Herman Melville, "Hawthorne and His Mosses" (1850), quoted from *The Portable Melville.* Edited by Jay Leyda. New York: Viking Press, 1952, pp. 414-15.

[2]Many of the "knottier issues" that Janet Malcolm seeks to unravel in *Diana and Nikon* (Boston: David R. Godine, 1981) seem to stem directly from this presumption. While there is no serious question that painting and photography, both pursued in the same cultural milieu, reciprocally affect each other, the attempt to establish priority or primacy can only obscure the question of how any picture-making activity affects and is affected by the culture in which it is practiced.

[3]For a fuller discussion of this issue, see my "The Imaginary Eye and the Place of Vision," *Exposure,* vol. 18, no. 1 (1980), pp. 42-59. (N.B. In the essay cited, page 57 should immediately follow page 47.)

[4]William Blake, Descriptive Catalogue, "A Vision of The Last Judgment," in David V. Erdman, ed., *The Poetry and Prose of William Blake* (Garden City, N.Y.: Doubleday, 1965), pp. 544-55. Blake's phrase, "We are led to Believe a Lie / When we see not Thro the Eye," is from "Auguries of Innocence," p. 484.

[5]See especially Clement Greenberg, "Modernist Painting," in Gregory Battcock, ed., *The New Art,* New York, 1966. For a contrary view, see Allan Sekula, "Dismantling Modernism, Reinventing Documentary (Notes on the Politics of Representation)," in *Photography: Current Perspectives,* Rochester, N.Y.: Light Impressions, 1978, pp. 231-55.

[6]For insightful introductions to this emerging field of study, see Richard Rudisill, *Mirror Image,* Albuquerque, N.M.: University of New Mexico Press, 1971; Alan Thomas, *Time in a Frame: Photography and the Nineteenth-Century Mind,* New York: Schocken Books, 1977; and *Points of View: The Stereograph in America, A Cultural History.* Edited by Edward W. Earle, Rochester, N.Y.: Visual Studies Workshop Press, 1979.

[7]Rodney S. Slemmons, "Notes Toward an Art History of Photography," *Insight* (Journal of the Henry Gallery Association, Seattle, Washington) (Fall 1981).

[8]For other treatments of the photographic sequence, see especially the following: David Bourdon, "Sequenced Photographs," in *(Photo) (Photo)² . . . (Photo)ⁿ*, Baltimore: University of Maryland Art Gallery, 1975; Hollis Frampton, "Eadweard Muybridge: Fragments of a Tesseract," *Artforum,* vol. 2, no. 7 (1973), pp. 43-52; Nathan Lyons, transcribed comments on sequences in *Camera Austria* (1980), pp. 75-80; Andreas Muller-Pohle, "Series-Cycle-Sequence-Tableau," *European Photography,* vol. 1, no. 1 (1980), pp. 5-7; and Charles Desmarais, "Foreword," *The Portrait Extended.* Chicago: Museum of Contemporary Art, 1980, pp. 4-45.

[9]Cf., "Poems, Pictures and Conceptions of 'Language,'" *Afterimage,* no. 3 (1975), pp. 33-39; and "Language Theory and Photographic Praxis," *Afterimage,* no. 7 (1979), pp. 26-34. See also Robert C. Morgan, "The Pleasure in Photographs/The Components of Language," *Kansas Quarterly,* vol. 2, no. 4 (1979), pp. 105-22.

[10]See, however, the complaint of Peter Wollheim, "Photography Is Not a Language," *Vanguard* (September 1981), pp. 30-35.

[11]William Carlos Williams, *Paterson,* New York: New Directions, 1963, Book III.

[12]Quoted here from Janet Malcolm, *Diana and Nikon,* p. 37.

[13]Henry David Thoreau, *Walden,* edited by J. Lydon Shanley, (Princeton: Princeton University Press, 1971), p. 98.

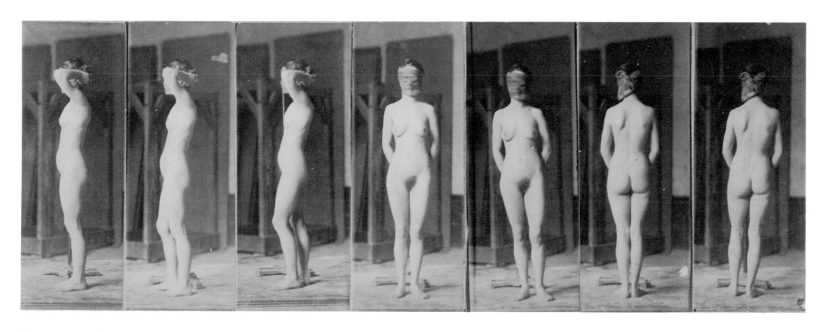

Thomas Copperthwaite Eakins
Laura, ca. 1883, from the *Naked Series*

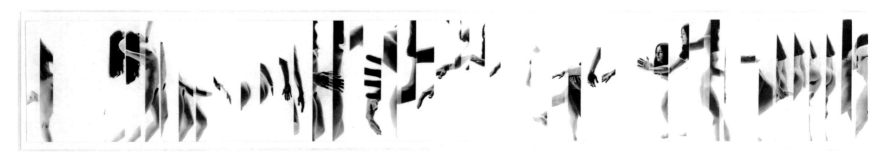

Barbara Blondeau
Karen Series, 1972

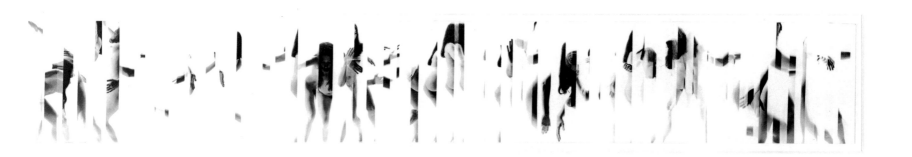

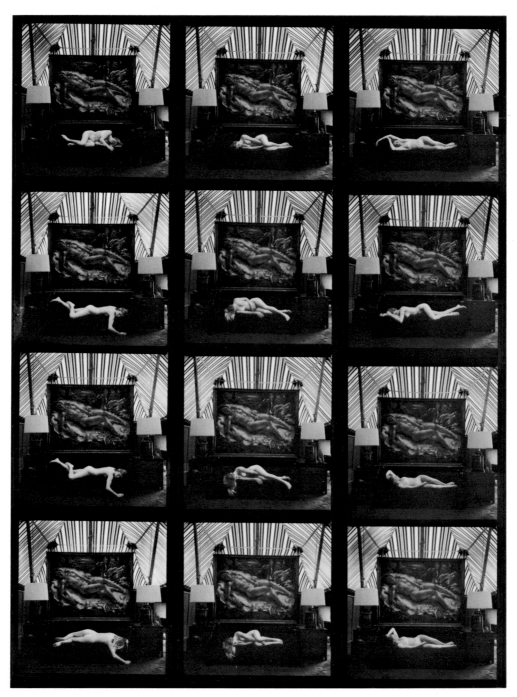

Wynn Bullock
Sleeping Girl, 1968

24

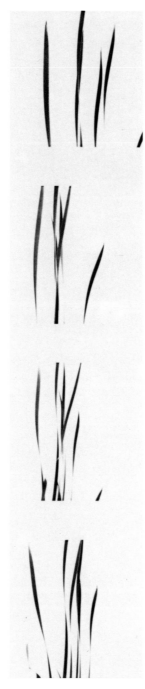

Harry Callahan
Cattails Against the Sky, 1948

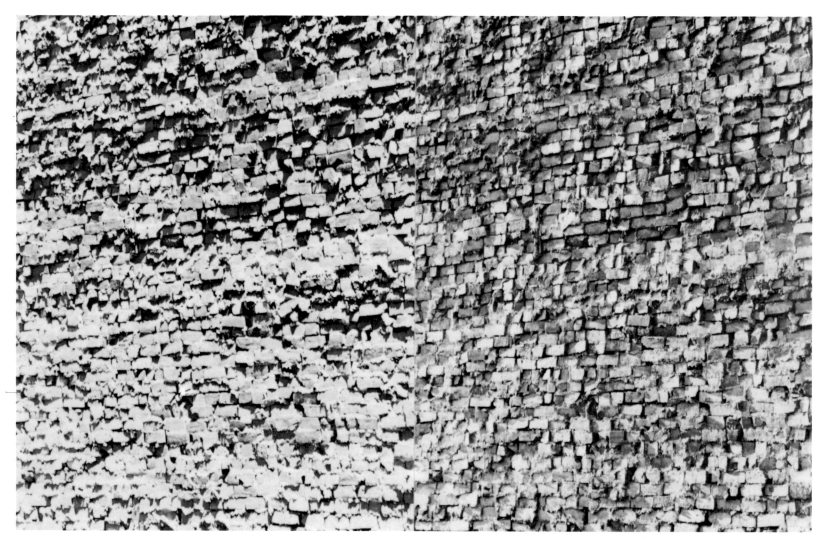

Sol LeWitt
Brick Wall B #4, 1977, from the book *Brick Wall*

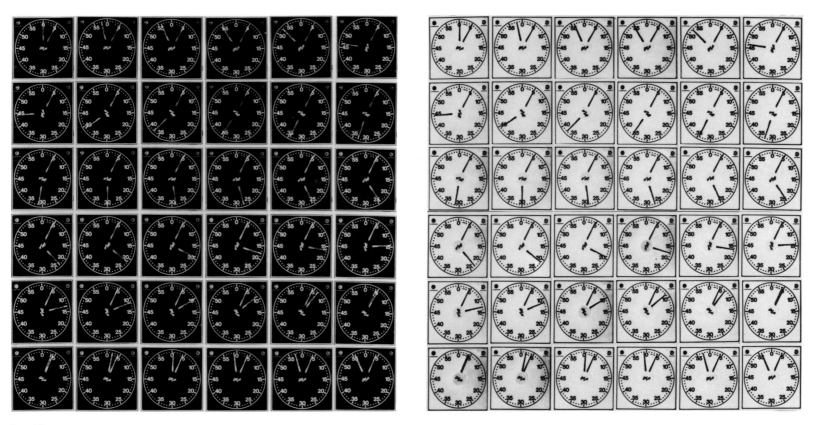

Lew Thomas
Time Equals 36 Exposures, 1971

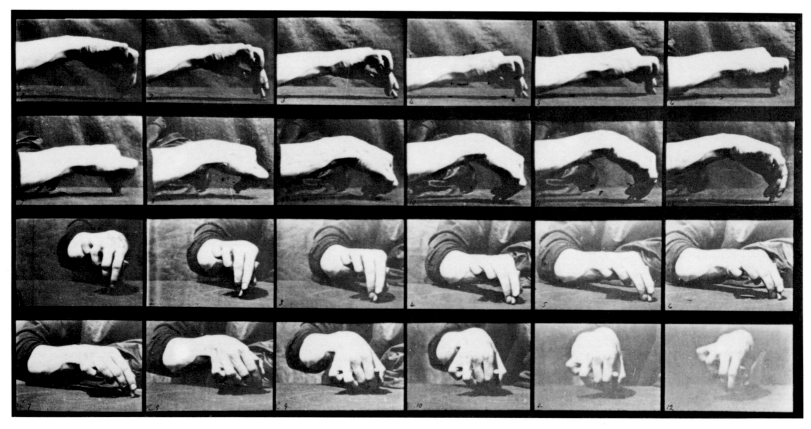

Eadweard Muybridge
Drawing a Circle, 1887, from the *Movement of the Hand* series, Plate 532, in the *Animal Locomotion* project

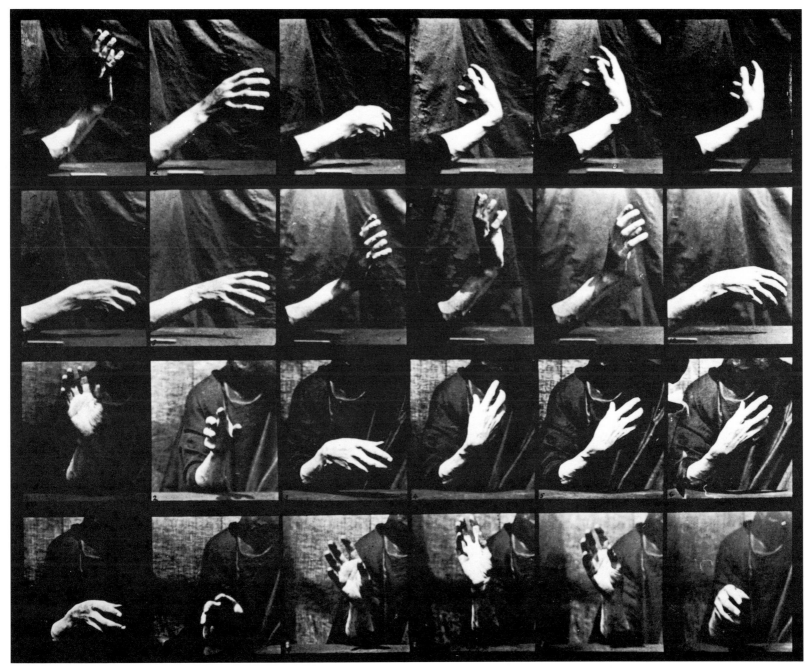

Eadweard Muybridge
Beating Time, 1887, from the *Movement of the Hand* series, Plate 535, in the *Animal Locomotion* project

29

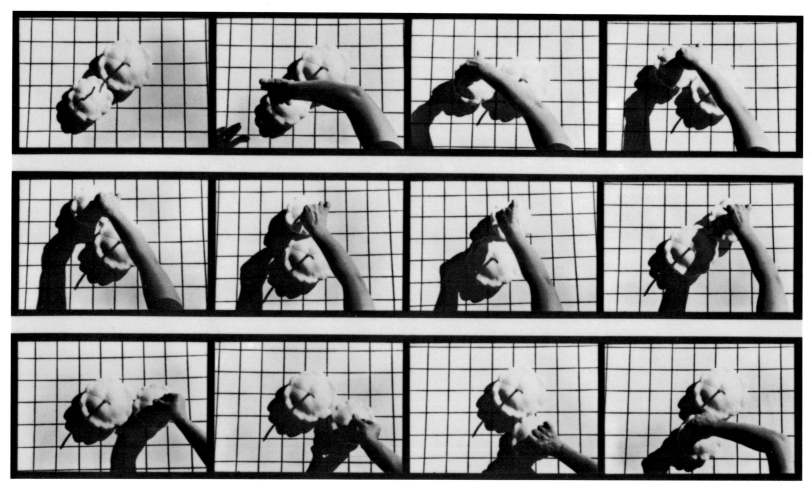

Hollis Frampton and Marion Faller
Scallop Squash Revolving (var. Patty Pan), 1975, from the series "Sixteen Studies from *Vegetable Locomotion*"

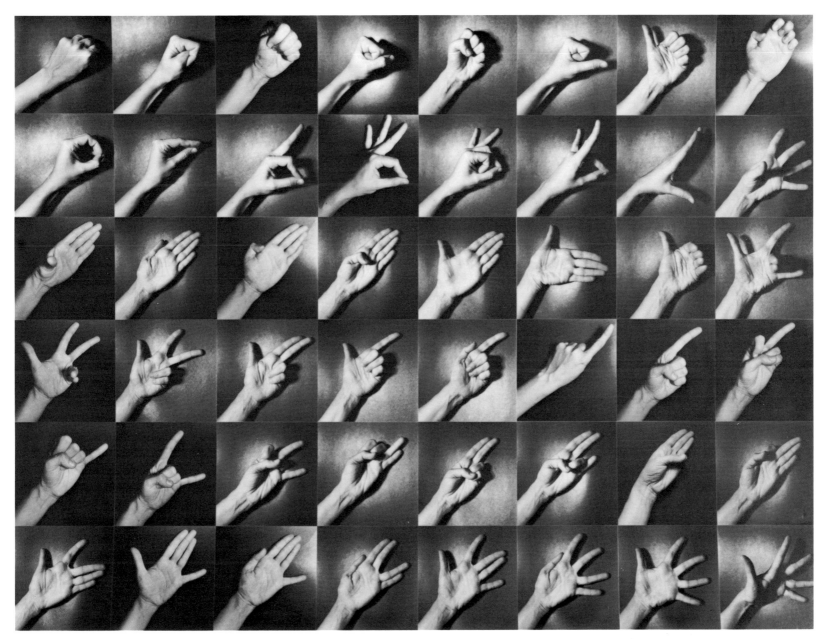

Athena Tacha
Gestures I: A Study of Finger Positions, 1973

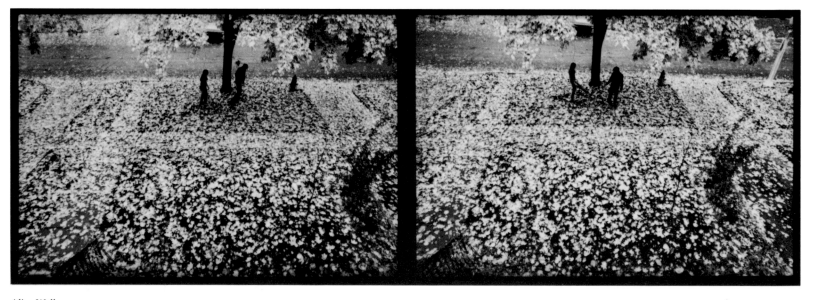

Alice Wells
Sue & Sam, Vick Park B, 1968, from *The Glass Menagerie* series

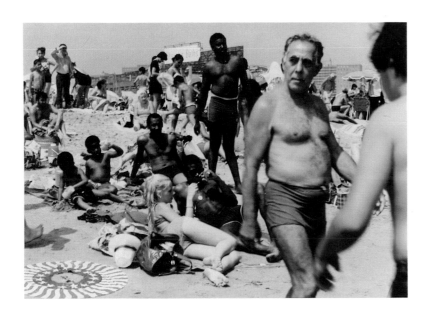
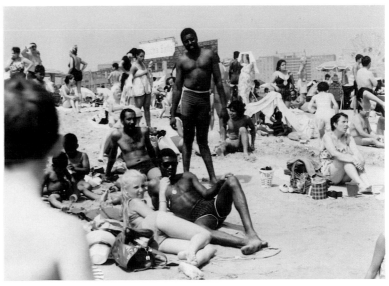
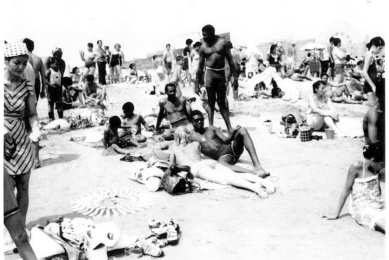
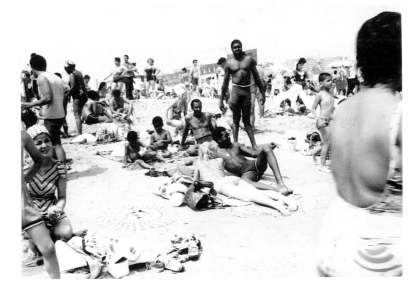

Eve Sonneman
Coney Island, 1974

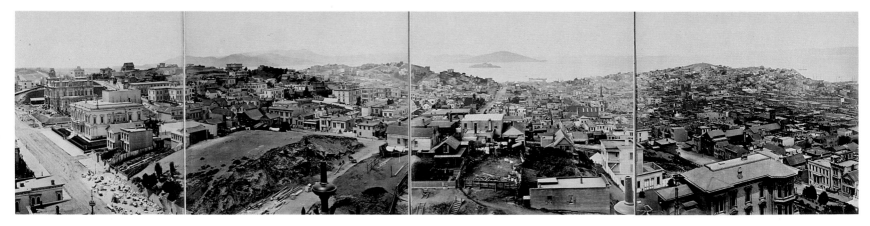

Eadweard Muybridge
Panorama of San Francisco from California Street Hill, 1877

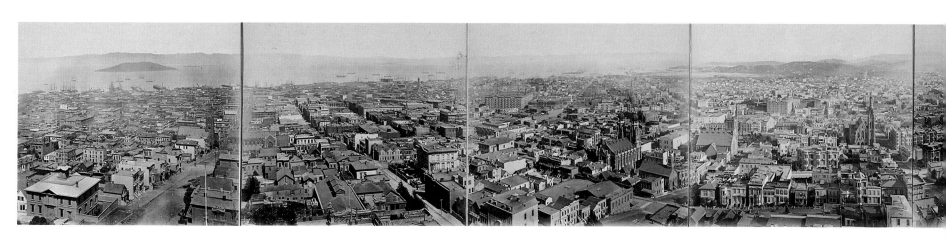

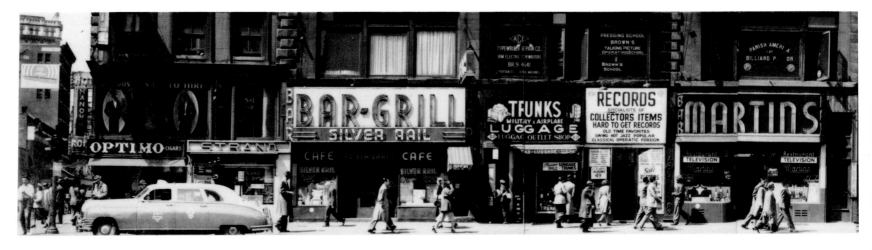

Todd Webb
6th Avenue between 43 and 44 St., New York City, April 1948

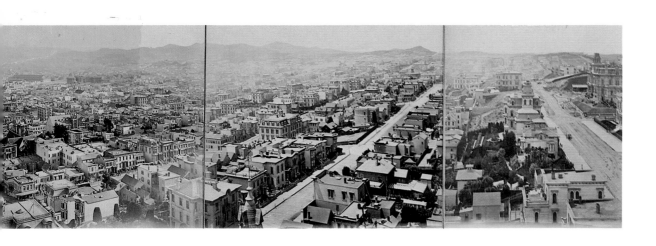

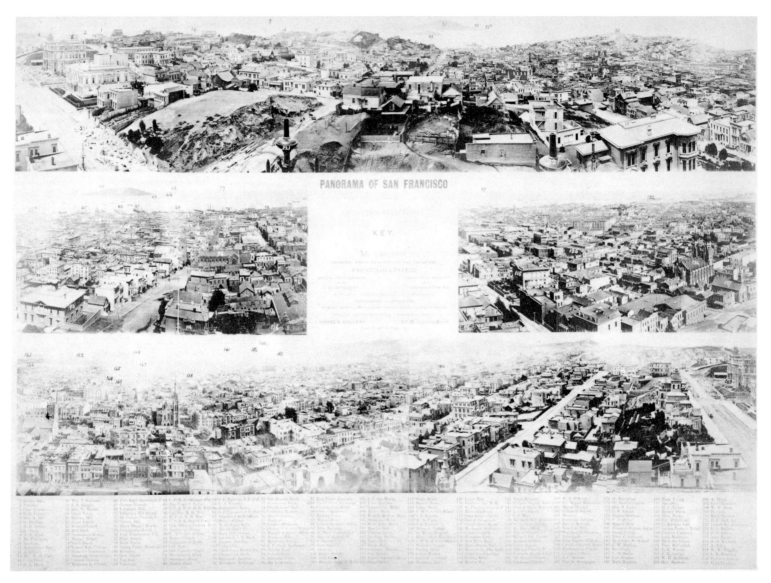

Eadweard Muybridge
Photo-key index for *Panorama of San Francisco from California Street Hill*, 1877

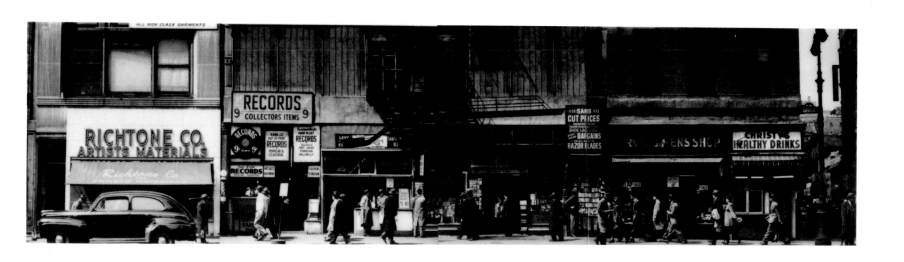

Edward Ruscha
Every Building on the Sunset Strip, 1966 [*detail*]

8250　　　　　8260　　　8262　　　　　　8264　　　　　8272　　　　8278　　8280

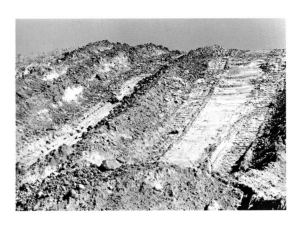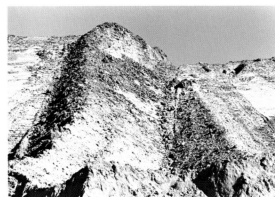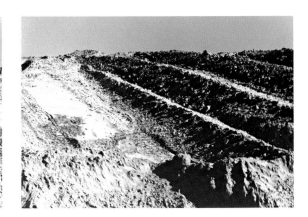

Laurie Brown
Tracking: Chryse Crater Passage, 1978

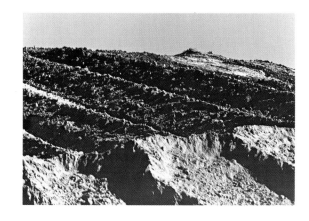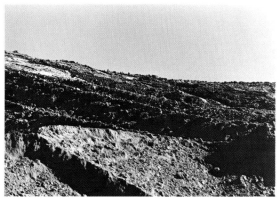

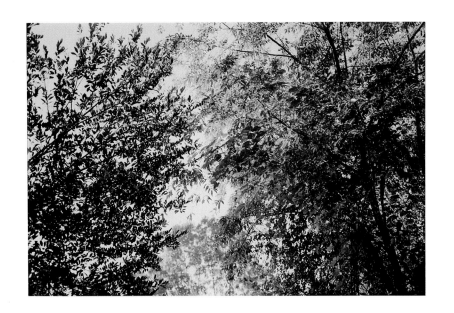
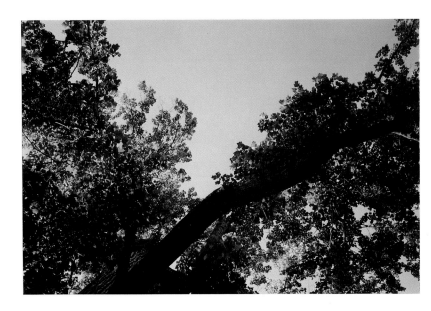
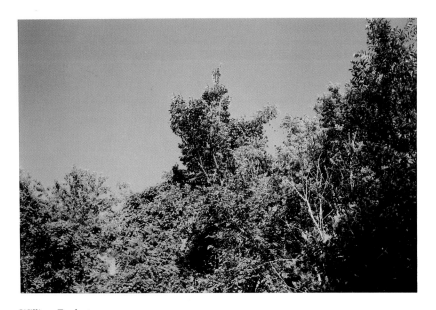

William Eggleston
Seven, 1978

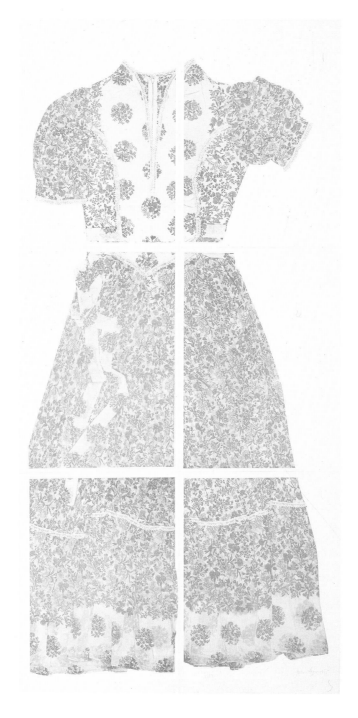

Joan Lyons
Prom Dress Portfolio, 1975

No. 81. "HELPING"; OR THE HOUSEMAID'S HARD LUCK

Dead leaves, bits of grass and dead bugs are apt to float in the water near the shore, that's why Mary has orders to fill the jugs out near the end of the landing. She is a pretty girl, and she knows it, and like all daughters — and many, many sons — of Eve, she cannot pass a mirror without looking into it. The shadow of the boat makes the water near it a perfect mirror, and Mary smiles at her own sweet picture, while she dips a jug into the crystal flood.

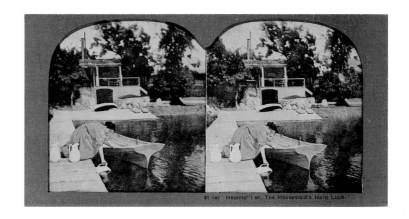

No. 82. "HELP!"; OR THE HOUSEMAID'S HARD LUCK

Water is a treacherous element. It yields to every light pressure, and when Mary leaned on the boat to get a better view of herself, the boat slid out from under her and moved away the faster, the more she tried to push herself back into equipoise. She had to let go of the jug to use both hands to keep from falling into the lake, and now she is holding on for dear life, crying for help.

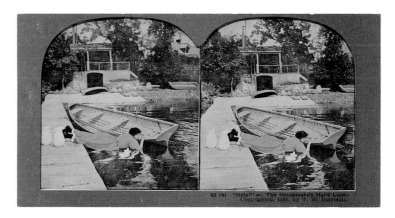

No. 83. "HEL--" SPLASH; OR THE HOUSEMAID'S HARD LUCK

Her cries are wasted on the desert air. There is no one near enough to hear her, and with a splash she goes down, when her fingers are no longer able to hold onto the boat. She is touching bottom now and will be on her feet directly. Then she will clamber out, fill her jugs and hasten up to the house, dripping wet, but happy that there was nobody round to witness her mishap and to laugh at her.

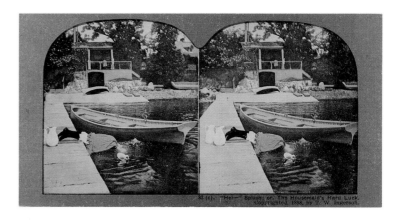

Text printed on reverse of the stereographs.

T. W. Ingersoll
The Housemaid's Hard Luck, copyright 1898

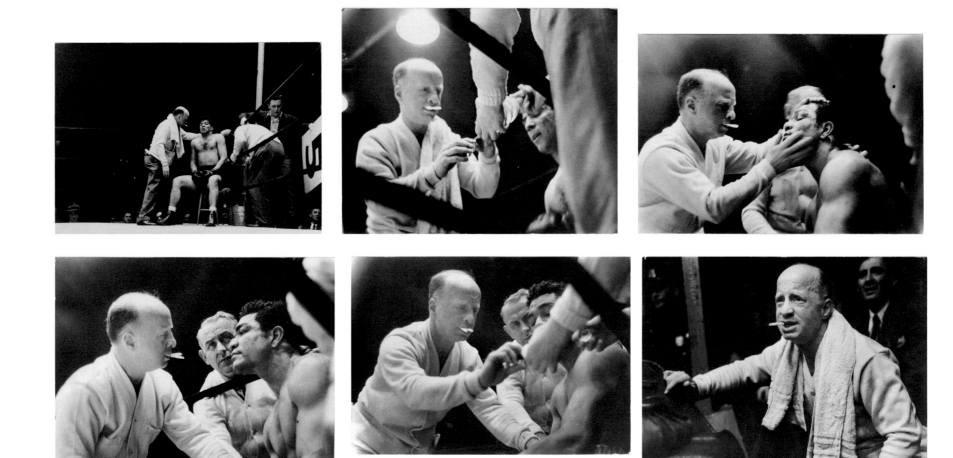

Sidney Grossman
Whitey Bimstein, Trainer, 1951

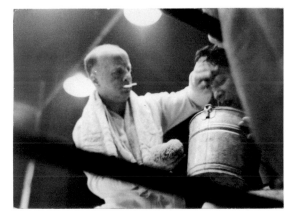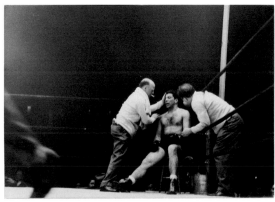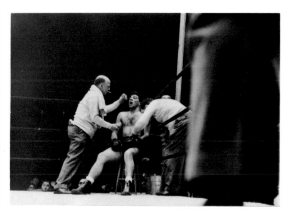

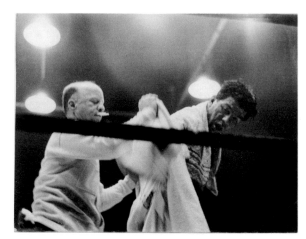

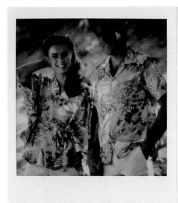 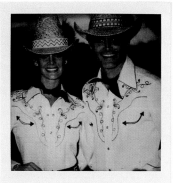 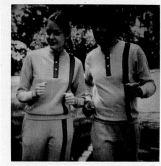 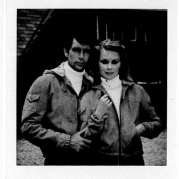 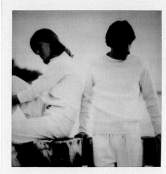

Current sociological statistics indicate that one out of every two people in the United States have been or will be divorced. Marriage counselors who concern themselves with this issue feel that a large part of the problem stems from the fact that modern couples do not have enough in common. They seem not to be significantly involved in fulfilling goals, activities or interests which are intimately shared.

This plate illustrates one recent attempt at a solution to this growing nation-wide societal problem. These photographs were taken at a secluded coastal workshop retreat outside of Los Angeles where psychologists are experimenting with a test group of ten couples who volunteered in an attempt to improve their troubled relationships and hopefully save their marriages. For 30 days the subjects participate jointly in a variety of given activities and must wear sets of identical clothing at all times during the month. The scientists feel that dressing alike on this continual basis will enable the person to more clearly see aspects of themselves in their spouse and gradually cause them to identify completely with the needs of the other person.

As these candid photographs verify, a rather high percentage of the test couples (between 70% and 80% depending upon interpretation) are responding well as a result of the experiment. It is not yet known to what extent, or in what ways, these controlled apparel experiences will carry over into the subjects every-day lives and relationships. This important new research field has been dubbed "socio-duo-habliment studies," and uses as a base the early innovative work of Klaus Braun on the dressing patterns of identical twins.

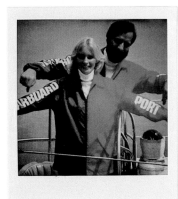 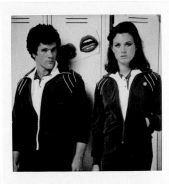 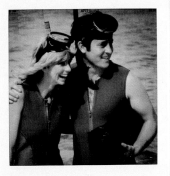 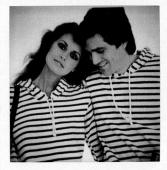 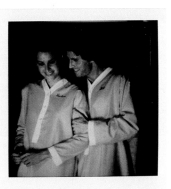

Robert Heinecken
Socio-Duo-Habliment Studies #1, 1981

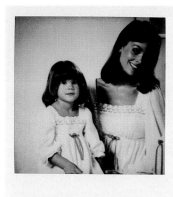 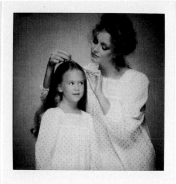 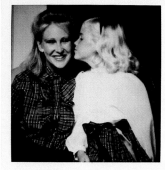 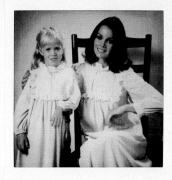

During the course of the first two S-D-H Workshops the Institute scientists isolated a group of those women who experienced the most difficulty responding to dressing identically to their husbands. It was felt that their difficulty stemmed initially from their early relationship with their mothers (a currrent sociological interest). Sensing that this trait

might be heritable, the Institute staff inaugurated a special workshop where these women brought their daughters to the retreat and again dressed in identical outfits for extended periods of time. It was thought that this experience would "head-off" any problems which may develop later in life between mother and daughter.

The scientists tested three basic types of clothing. a. Solid color jogging wear. b. A specific plaid of red, green and white. c. White or light colored long nightgowns. All the mothers and daughters were asked to concentrate in the nightgown (as evidenced by the % in the candid photographs) because

it was thought that this garment above all produced the highest sensation of well being and "life is but a dream" kinds of thoughts. One scientist (no longer employed at the Institute) raised the question of whether the husbands might subsequently be confused

by the vision of their daughters wearing identical nightgowns as their wives. His feeling was that this might unwittingly contribute to a growing, more serious societal problem. The director of the Institute responded; "There is always the solution of designing new workshops."

Robert Heinecken.
Socio-Duo-Habliment Studies #3, 1981

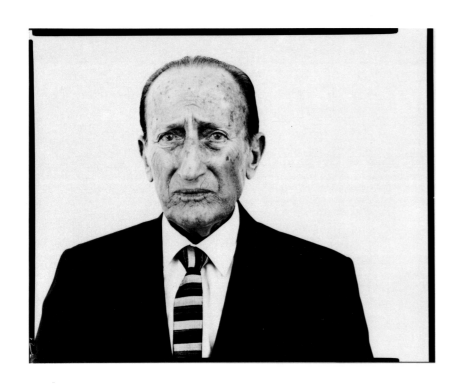

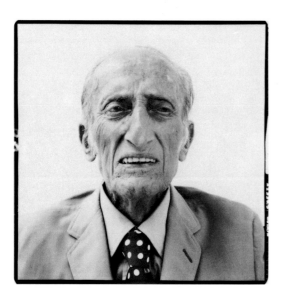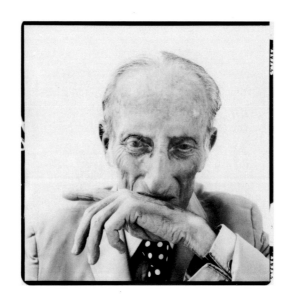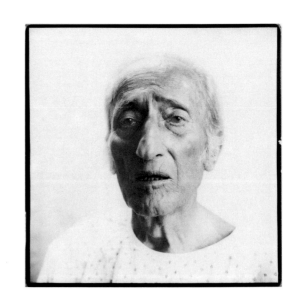

Richard Avedon
Jacob Israel Avedon, father of the photographer, 1969-1973

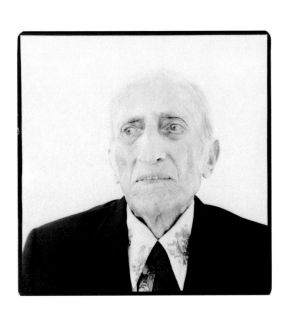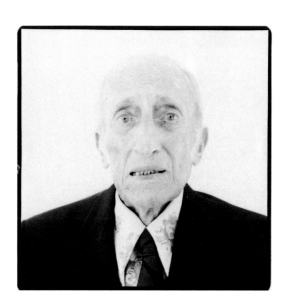

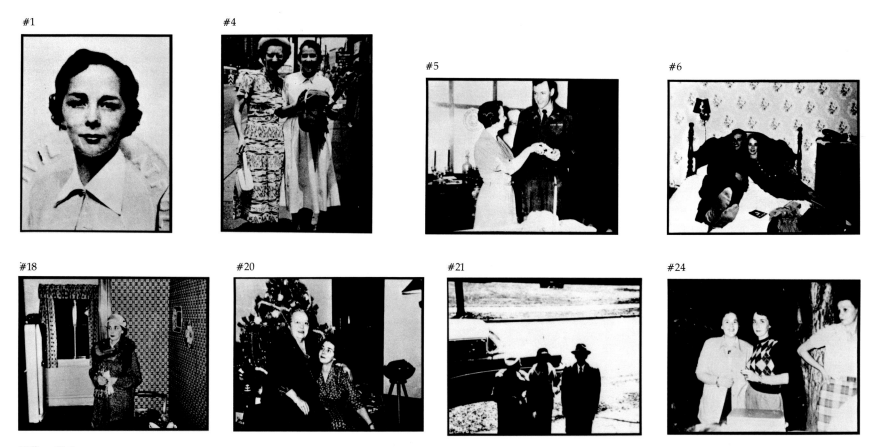

#1 #4 #5 #6

#18 #20 #21 #24

William DeLappa
The Portraits of Violet and Al, 1975 [selected images from a series of twenty-eight]

#8

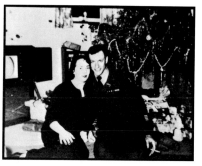

#9

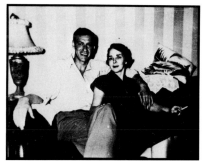

#12

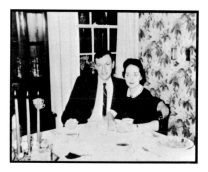

#13

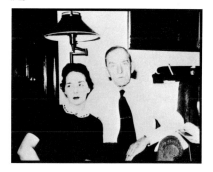

#25

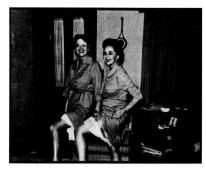

#26

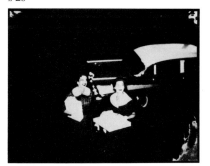

#27

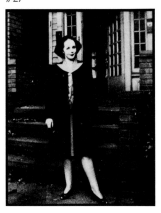

#28

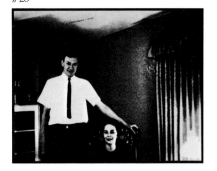

5:15 AM, APRIL 22, 1903

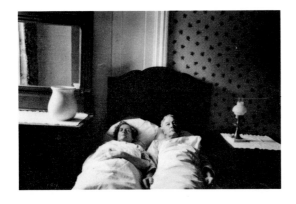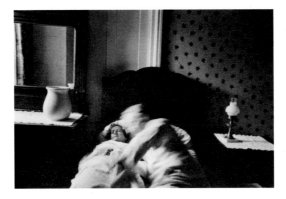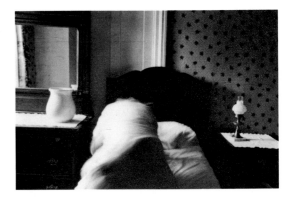

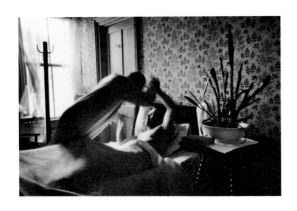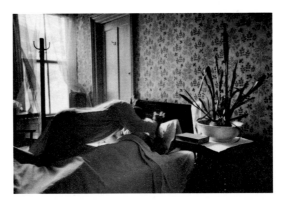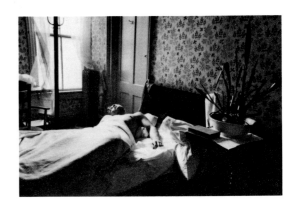

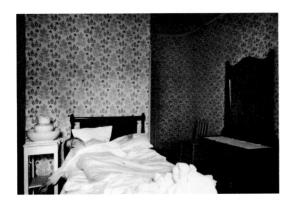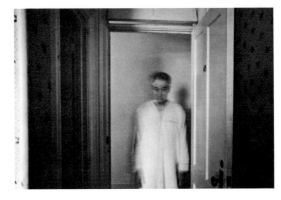

Duane Michals
5:15 AM, April 22, 1903, 1973

56

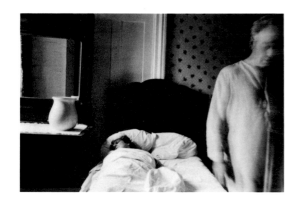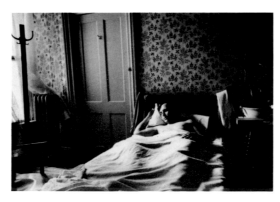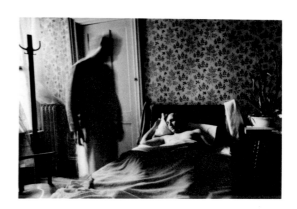

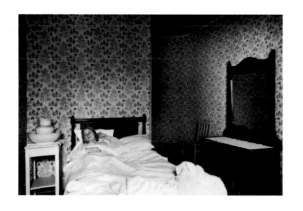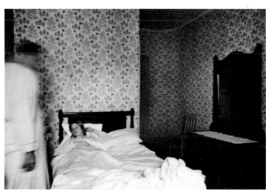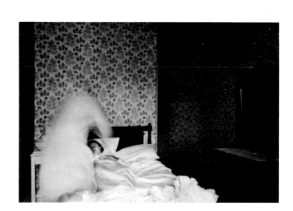

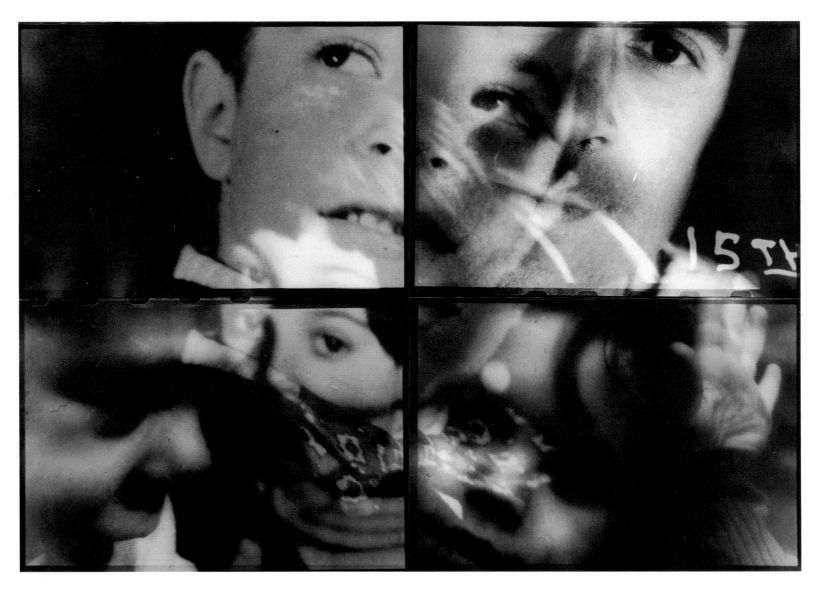

Esther Parada
Past Recovery, 1979 [*detail: photographs #78, 79, 88 and 89*]

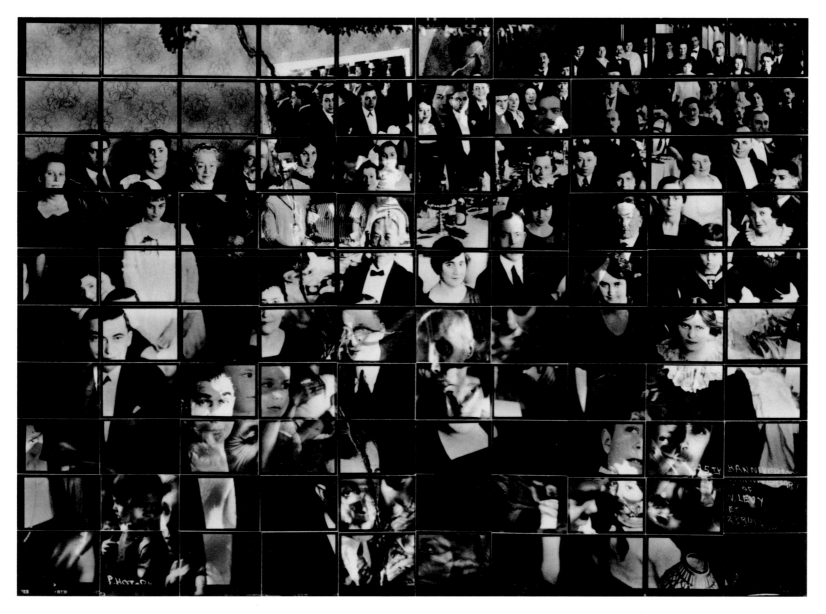

Esther Parada
Past Recovery, 1979

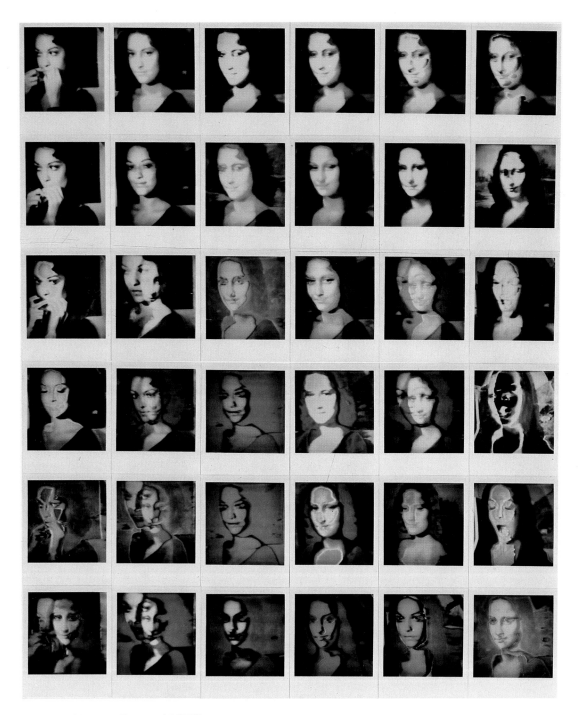

MANUAL (Suzanne Bloom and Ed Hill)
Identifying with Mona Lisa (The problematic of identity theory I and II), 1977, from the series *Art in Context: Homage to Walter Benjamin*

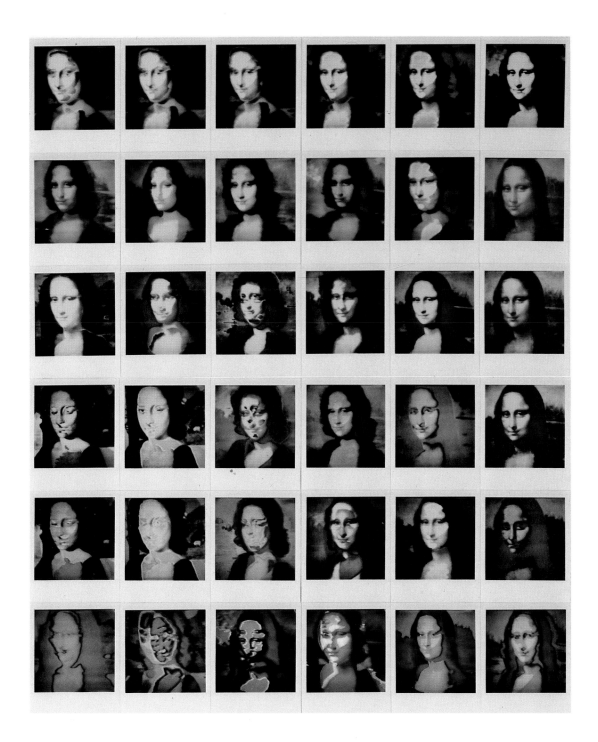

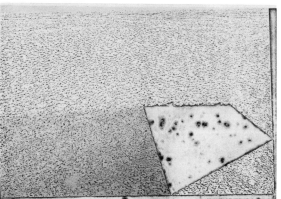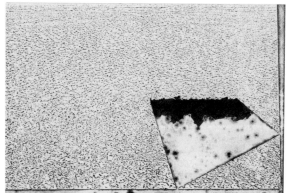

John Wood
Untitled, 1975

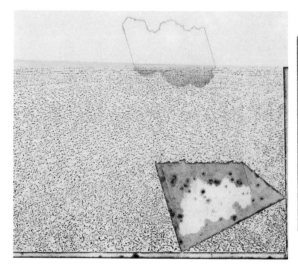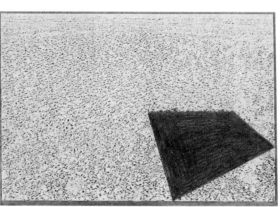

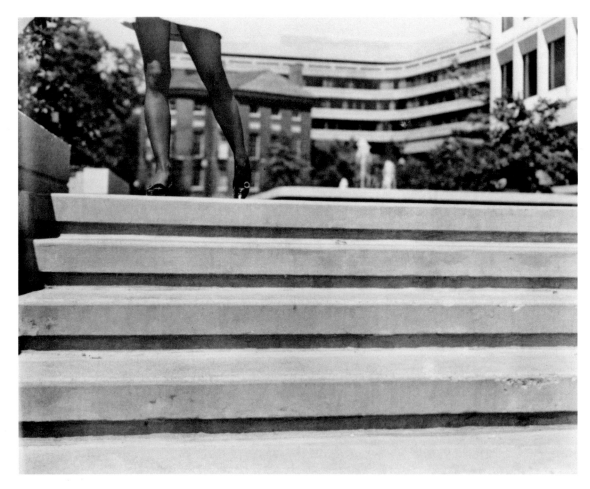

Robert Cumming
Walking Shoes Turned Momentarily in Profile (Denise in Heels), 1975

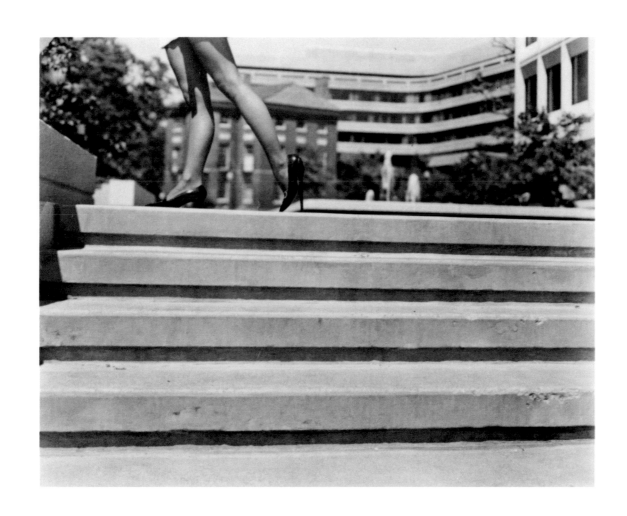

Ray K. Metzker
Spruce Street Boogie, 1966-1967

Robert Frank
The Sin of Jesus, 1969

Bart Parker
Leave & Fall, 1979

 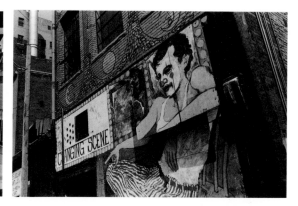

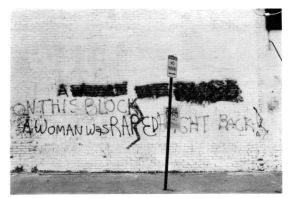 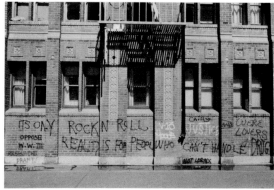

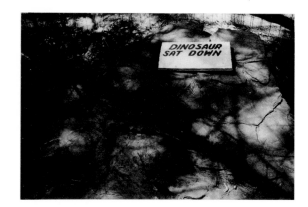

Nathan Lyons
Verbal Landscape, 1982

70

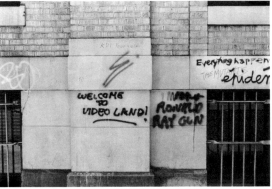
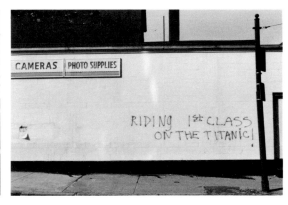
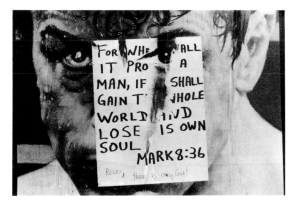
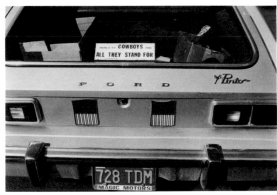
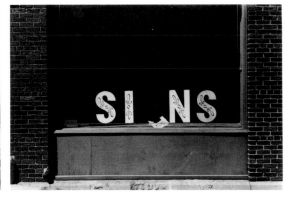

71

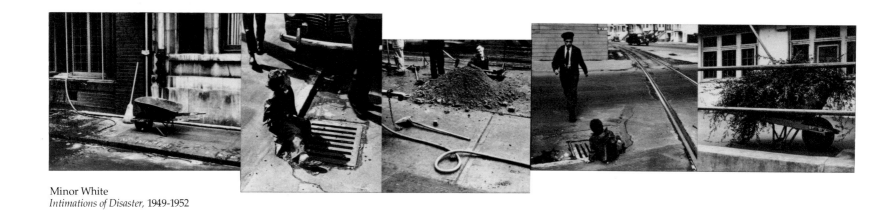

Minor White
Intimations of Disaster, 1949-1952

Economy & Business

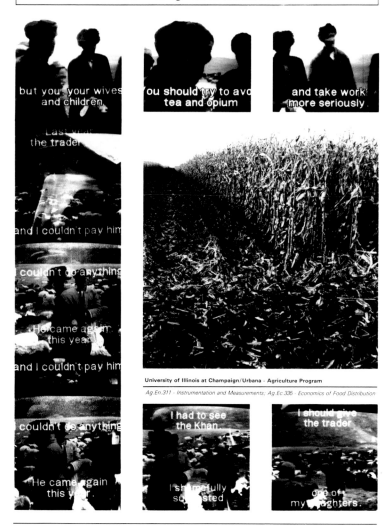

University of Illinois at Champaign/Urbana - Agriculture Program

Ag.En.311 - Instrumentation and Measurements; Ag.Ec.335 - Economics of Food Distribution

but you, your wives and children

You should try to avoid tea and opium

and take work more seriously.

Last year the trader

and I couldn't pay him

I couldn't do anything

He came again this year

and I couldn't pay him

couldn't do anything

He came again this year

I had to see the Khan.

I should give the trader

I shamefully suggested

one of my daughters.

University of Illinois at Urbana/Champaign - Mathematics Program

A forest is an undirected graph which contains no cycles. A connected forest is a tree.

Paul Berger
Economy and Business, 1981, from *Seattle Subtext* series

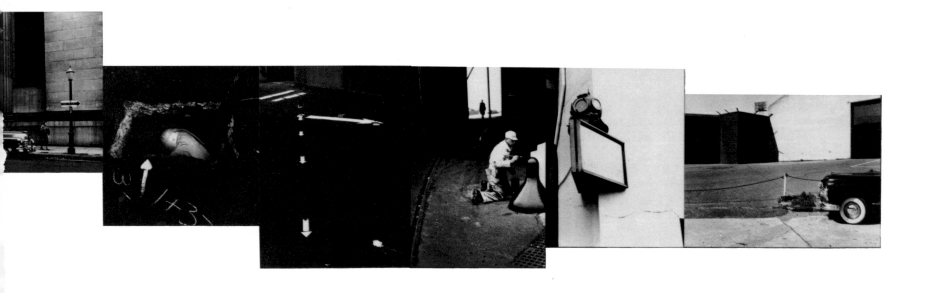

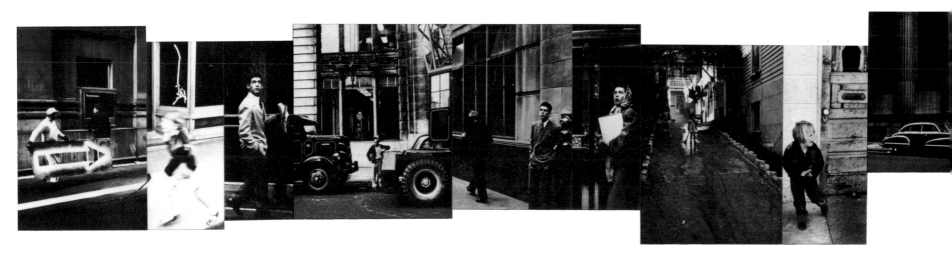

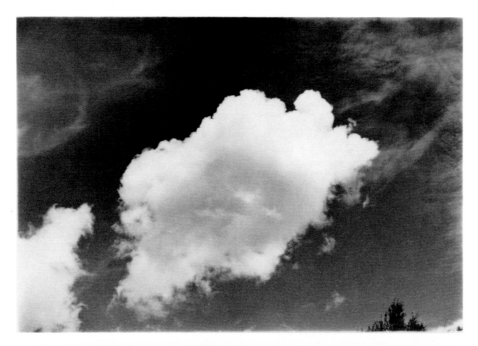

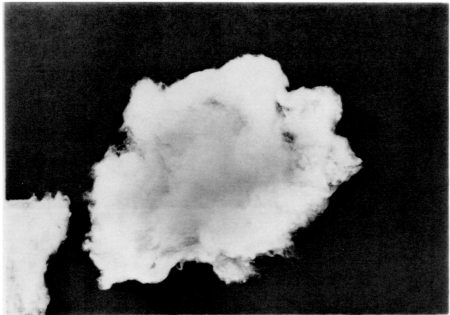

Marcia Resnick
landscape – loftscape, 1976

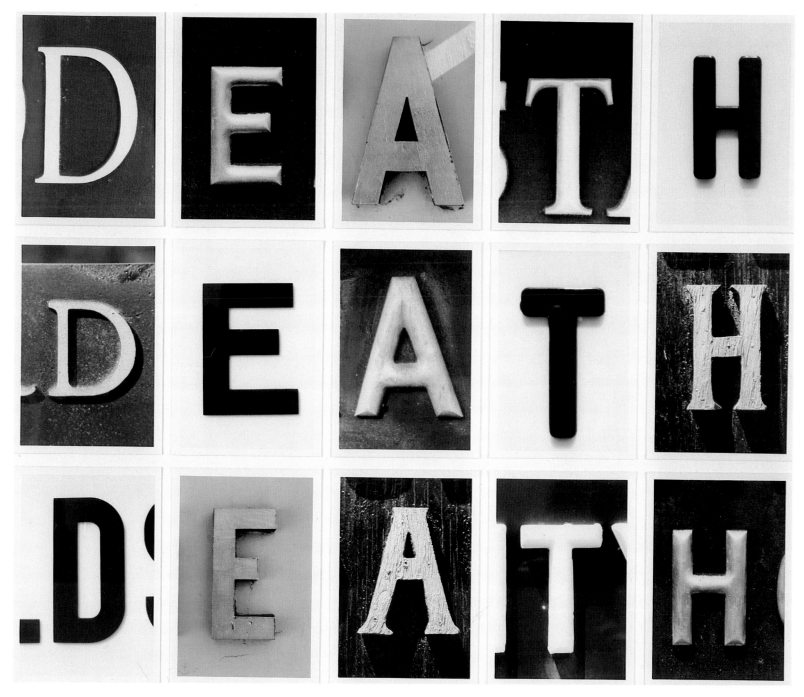

Al Souza
Death, 1975

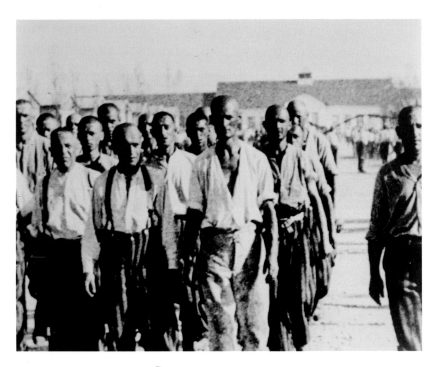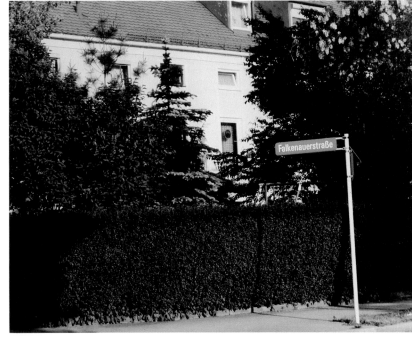

Douglas Huebler
DM 1 Variable Piece #70: 1971, June 11, 1978

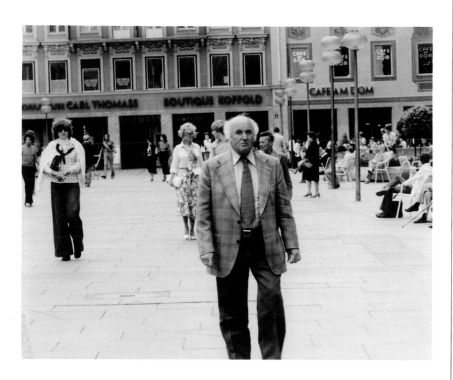

Variable Piece no. 70 (In Process)
Global

Throughout the remainder of the artist's lifetime he will photographically document, to the extent of his capacity, the existence of everyone alive in order to produce the most authentic and inclusive representation of the human species that may be assembled in that manner.

Editions of this work will be periodically issued in a variety of topical modes: '100,000 people,' '1,000,000 people,' '10,000,000 people,' 'people personally known by the artist,' 'look-alikes,' 'over-laps,' etc.

November 1971 — Douglas Huebler

During a three-hour period of time, documentation was made for the 'everyone alive' project at three discrete locations in Bavaria, West Germany. They were:

 a. Inside the former concentration camp at Dachau*
 b. Outside, in the community of Dachau
 c. On the streets of nearby Munich

Three photographs resulting from that specific activity have been arbitrarily selected to represent...

 AT LEAST ONE PERSON WHO WOULD LEAVE NO STONE UNTURNED

and they join with this statement as the form of this piece:

 DM 1 Variable Piece #70: 1971

June 11, 1978

* Inside the Wirtschaftsgebaude, now a museum, photographs were made from photographs originally made approximately forty years ago.

DOUGLAS HUEBLER

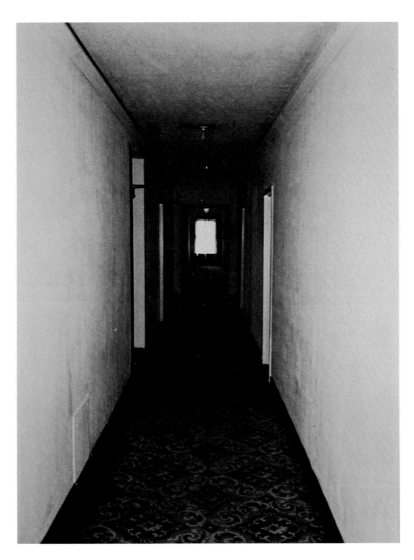

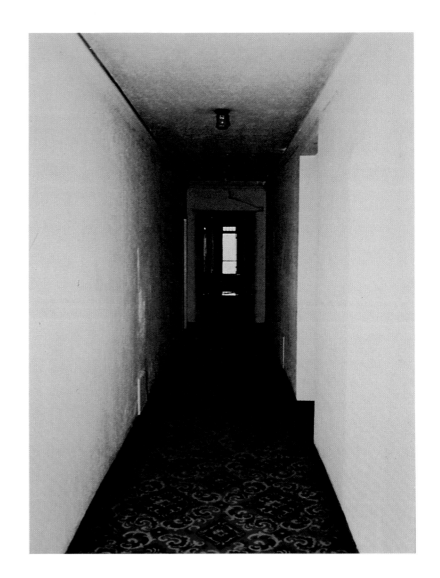

Steve Kahn
Corridor #6, 1980

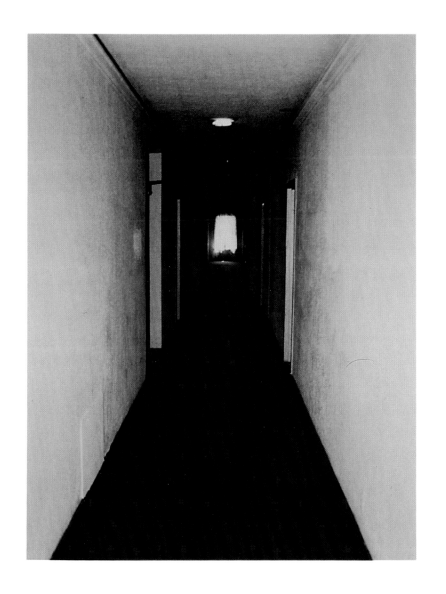
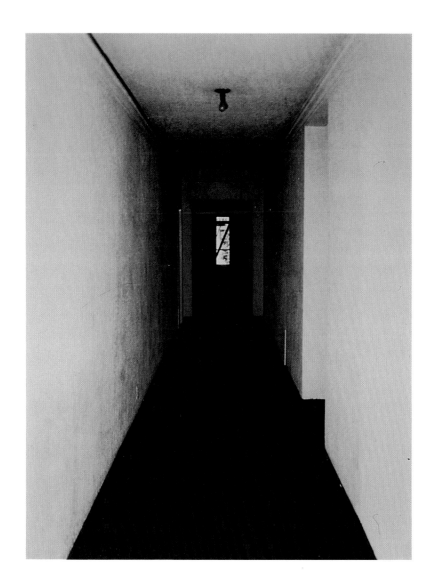

Checklist of the Exhibition

Titles and dates are given as inscribed by the photographer. The date of the negative is given following the title. If the print is not approximately contemporary with the negative, the date of the print is given following the name of the process.

Measurements are given in inches, then centimeters; height precedes width. The size of individual images is listed first. Where two or more photographs are mounted together, the overall image size is given. Sheet refers to the size of the photographic paper on which images are printed if they are printed on one sheet. Mount size is given for the board on which the photographs are mounted.

"ACC" refers to The Museum of Fine Arts, Houston's identification number. All photographs were purchased with funds provided by Target Stores unless otherwise stated.

Richard Avedon, b. New York, 1923
Jacob Israel Avedon, father of the photographer, 1969-1973
Stamped in ink on verso of each: title, date printed, edition guarantee, copyright restriction, edition #5 of 10, negative number; also signed in ink on verso of each
Seven gelatin silver photographs, printed 1980, displayed horizontally
Images: #1 — 8 x 9 15/16 (20.3 x 25.2), #2-7 — each approx. 6¼ x 6¼ (15.9 x 15.9); sheets: each 13 15/16 x 107/8 (35.4 x 27.6)
ACC: 80.28.1-.7

Paul Berger, b. Dalles, Ore., 1948
Economy and Business, 1981, from *Seattle Subtext* series
Verso at lower left signed, titled, dated in ink, w/p 1981
Gelatin silver photograph
Image: 10½ x 15⅜ (26.8 x 39.2); sheet: 19 x 237/8 (48.3 x 60.6); mount: 20 x 25 (50.8 x 63.5)
ACC: 82.37

Barbara Blondeau, b. Detroit, 1938; d. Philadelphia, 1974
Karen Series, 1972
On verso of mount in ink: signed, titled, dated with address of artist; in pencil: negative number "B654 77;012:15 Copy 1" and "#51"
Gelatin silver photograph
Image: 2⅛ x 30 7/16 (5.4 x 77.3); mount: 7½ x 36 (19.1 x 91.4)
ACC: 80.2

Laurie Brown, b. Austin, Tex., 1937
Tracking: Chryse Crater Passage, 1978
On the last photograph, signed and dated in pencil lower right corner of mount and on verso; verso frame #1 on label: "Hang frames one through five, left to right at ½" intervals."
Five gelatin silver photographs, hand-tinted, displayed horizontally
Images: each 9⅜ x 13 9/16 (24.0 x 34.4); overall: 10 x 71 (25.4 x 80.3)
ACC: 81.216.1-.5

Wynn Bullock, b. Chicago, 1902; d. Monterey, Calif., 1975
Sleeping Girl, 1968
Signed and dated in ink on recto; on verso, titled, dated, "6" and "3483"
Gelatin silver photograph
Image: 97/8 x 7 9/16 (25.1 x 18.1); original mount: 15 x 13¼ (38.1 x 33.6); second mount: 20 x 16 (50.8 x 40.6)
ACC: 80.49

Harry Callahan, b. Detroit, 1912
Cattails Against the Sky, 1948
Each sheet signed lower right below image; verso of each sheet in pencil "EM 100"
Four gelatin silver photographs, printed 1979, mounted together vertically
Images: each 7⅛ x 7 (18.1 x 17.8); sheets: each 10 x 8 (25.4 x 20.3); overall: 37½ x 8 (95.2 x 20.3); mount: 44 x 16 (111.8 x 40.6)
ACC: 80.123.1-.4

Robert Cumming, b. Worchester, Mass., 1943
Walking Shoes Turned Momentarily in Profile (Denise in Heels), 1975
Recto on mat in pencil under photographs titled, signed, dated
Two gelatin silver photographs, mounted together horizontally
Images: #1 — 7⁹/₁₆ x 9⁹/₁₆ (19.3 x 24.3), #2 — 7¹/₂ x 9¹/₂ (19.1 x 24.2); mount: 20 x 30 (50.8 x 76.2)
ACC: 82.42

William DeLappa, b. Santa Monica, Calif., 1943
The Portraits of Violet and Al, 1975
Recto signed and dated in pencil on mount below image; verso in ink number of the individual photograph
Twenty-eight gelatin silver photographs, displayed horizontally
Images: varying dimensions, vertical and horizontal formats, average 10⁷/₈ x 13⁷/₈ (27.6 x 35.3); mounts: each 20 x 16 (or 16 x 20) (50.8 x 40.6)
ACC: 81.2.1-.28

Thomas Copperthwaite Eakins, b. Philadelphia, 1844; d. Philadelphia, 1916
Laura, ca. 1883, from *Naked Series*
On verso in ink: "Eakins. Olympia Galleries, Ltd. Philadelphia, Cat. H03310-24 #0-3310-24"; in pencil "D (or 0)-24-3310" and signed "Laura"
Seven albumen photographs, mounted together horizontally on blue paper board
Images: average 3 x 3¹/₄ (7.6 x 8.1); overall: 3 x 8⁹/₁₆ (7.6 x 21.7); board: 3¹/₁₆ x 10¹/₁₆ (7.8 x 25.6); mount: 17 x 21 (43.2 x 53.3)
ACC: 81.116

William Eggleston, b. Memphis, Tenn., 1939
Seven, 1978
Recto of sheet lower left below image in pencil: #1 — "Seven #1 2/3 1977, (i.e. 1979)," #2-7 — "Seven #(2-7) 2/3 1979"; recto of sheet lower right below image signed in pencil
Seven EK 74 color photographs, printed 1979, displayed horizontally
Images: average 10¹/₈ x 14⁷/₈ (25.7 x 37.9); original mounts: each 18¹/₄ x 24 (46.4 x 61.0); mounts: each 22 x 28 (55.9 x 71.1)
ACC: 80.29.1-.7

Hollis Frampton and **Marion Faller,** b. Wooster, Ohio, 1936, and Wallington, N.J., 1941
Scallop Squash Revolving (var. "Patty Pan"), 1975, from the series "Sixteen Studies from *Vegetable Locomotion*"
On verso in pencil signed, titled, and dated
Twelve gelatin silver contact photographs on one sheet in three rows of four images each
Image, overall: 8 x 13¹/₄ (20.3 x 33.7); sheet: 10⁷/₈ x 14 (27.6 x 25.6); mount: 16 x 20 (40.6 x 50.8)
ACC: 81.97

Robert Frank, b. Zurich, Switzerland, 1924
The Sin of Jesus, 1969
Signed, titled, and dated in blue ink recto of sheet below image
Nine columns of gelatin silver contact photographs from movie negatives, one to five negative strips per column, printed on one sheet
Images: average strip — 10¹/₂ x 2 (26.7 x 5.1); overall: 10¹/₂ x 13¹/₂ (26.7 x 34.3); sheet: 11 x 14 (28.0 x 35.6); mount: 20 x 24 (50.8 x 61.0)
ACC: 81.120

Sidney Grossman, b. New York, 1913; d. New York, 1955
Whitey Bimstein, Trainer, 1951
Stamped in ink on verso with name and reproduction restriction notice; five stamped "Esquire Magazine"; also numbered F 1 (-10) in ink
Ten gelatin silver photographs, displayed horizontally
Images: average 10 x 13¹/₂ (25.5 x 34.5); mounts: each 16 x 20 (40.6 x 50.8)
ACC: 81.96.1-8, .10 & .11

Robert Heinecken, b. Denver, 1931
Socio-Duo-Habliment Studies #1, October 1981
On recto, typeset: numbered #1, titled, text; dated and signed with edition number 3/20 in pencil
Ten Polacolor photographs in two rows of five with eight lines of text in columns between the rows
Images: each 3¹/₈ x 3¹/₁₆ (7.9 x 7.8); overall: 15 x 20 (38.1 x 50.8); mount: 16¹/₄ x 21¹/₄ (41.4 x 54.0)
ACC: 81.212

Robert Heinecken
Socio-Duo-Habliment Studies #2, October 1981
On recto, typeset: numbered #2, titled, text; dated and signed with edition number 3/20 in pencil
Ten Polacolor photographs in two rows of five with six lines of text in columns between the rows
Images: each 3¹/₈ x 3¹/₁₆ (7.9 x 7.8); overall: 15 x 20 (38.1 x 50.8); mount: 16¹/₄ x 21¹/₄ (41.4 x 54.0)
ACC: 81.213

Robert Heinecken
Socio-Duo-Habliment Studies #3, October 1981
On recto, typeset: numbered #3, titled, text; dated and signed with edition number 3/20 in pencil
Ten Polacolor photographs in two rows of five with eight lines of text in columns between the rows
Images: each 3¹/₈ x 3¹/₁₆ (7.9 x 7.8); overall: 15 x 20 (38.1 x 50.8); mount: 16¹/₄ x 21¹/₄ (41.4 x 54.0)
ACC: 81.214

Douglas Huebler, b. Ann Arbor, Mich., 1924
DM 1 Variable Piece #70: 1971, June 11, 1978
Document signed recto in pencil
Three Ektacolor photographs and one ink-on-paper document; photographs displayed vertically with document to left
Images: each 16 x 19¹⁵/₁₆ (40.7 x 50.6); document: 11 x 8¹/₂ (28.0 x 21.7)
ACC: 81.123.1-.4

T.W. Ingersoll, publisher, active 1898-1907
The Housemaid's Hard Luck, copyright 1898
Numbered, titled, copyright typeset recto; text, verso
Three multicolored half-tone lithoprint stereographs, mounted together vertically
Cards: each 3¹/₂ x 7 (8.8 x 17.8); mount: 18 x 14 (45.7 x 35.6)
ACC: 80.122.1-.3

Steve Kahn, b. Los Angeles, 1943
Corridor #6, 1980
On verso in pencil at bottom, dated and signed with edition number 2/5
Four Cibachrome photographs, mounted together horizontally
Images: each 16 x 11⁷/₈ (40.7 x 27.8); overall: 14¹/₈ x 48³/₄ (35.9 x 123.8); mount: 21 x 55¹/₂ (53.3 x 141.0)
ACC: 81.210.1-.4

Sol LeWitt, b. Hartford, Conn., 1928
Brick Wall, B#4, 1977, from the book *Brick Wall*
Signed in pencil, recto mount
Two gelatin silver photographs, mounted together horizontally
Images: each 10⁷/₈ x 8⁵/₈ (27.6 x 21.9); overall: 10⁷/₈ x 17¹/₄ (27.6 x 43.8); mount: 14⁷/₁₆ x 23¹/₁₆ (36.2 x 58.7)
ACC: 81.127

Joan Lyons, b. New York, 1937
Prom Dress Portfolio, 1975
On verso sheet 3 signed in pencil; recto sheet 6 signed and dated in pencil and chop of Coach House Press; cover sheet accompanying portfolio typeset with pencilled entries: "prom/A Six sheet Offset Lithograph/ Joan Lyons 1975. / This is no. 5 of 24 prints / Supported by a grant from CAPS / Presswork by the Coach House Press, Toronto"
Six photo-offset lithographs, mounted together in three rows of two
Images: each 23⅛ x 17³⁄₁₆ (58.7 x 43.7); overall: 69⁵⁄₁₆ x 34⁷⁄₁₆ (175.9 x 86.9); mount: 72¼ x 37½ (183.5 x 95.3)
ACC: 80.121.1-.6

Nathan Lyons, b. New York, 1930
Verbal Landscape, 1982
On verso mat in pencil "untitled," dated and numbered; on verso sheets lower right in pencil, signed and dated
Thirteen gelatin silver photographs, displayed horizontally; negatives made 1975-1981, printed 1982
Images: each 4⁷⁄₁₆ x 6¾ (11.3 x 17.2); mounts: each 14 x 11 (35.6 x 27.9)
ACC: 82.44.1-.13

MANUAL (Suzanne Bloom and **Ed Hill),** b. Philadelphia, 1943, and Springfield, Mass., 1935
Identifying with Mona Lisa (The problematic of identity theory I and II), 1977, from the *Art in Context: Homage to Walter Benjamin* series
Recto of mounts in pencil, "The problematic of identity theory I (and II)"; stamped in red ink Ⓜ
Two panels of 36 SX-70 Polacolor photographs per panel in six rows of six; panels displayed side by side
Images: each 3⅛ x 3⅛ (8.0 x 7.9); overall per panel: 25½ x 20 ¹⁵⁄₁₆ (64.8 x 53.2); panels: each 30⁹⁄₁₆ x 24¹⁵⁄₁₆ (77.5 x 63.3)
ACC: 80.88.1-.2

Ray K. Metzker, b. Milwaukee, 1931
Spruce Street Boogie, 1966-1967
No signature or marks
Ten strips of gelatin silver photographs, mounted vertically on one board, printed and assembled 1981
Overall: 35 x 33½ (88.8 x 85.1); mount: 47½ x 43 (120.6 x 109.2)
ACC: 81.98

Duane Michals, b. McKeesport, Penn., 1932
5:15 AM, April 22, 1903, 1973
Recto above image title in ink on #1; #2-14 numbered in ink above image; #14 signed with edition number 3/25 in ink below image
Fourteen gelatin silver photographs, displayed horizontally
Images: each 3⅜ x 5¹⁄₁₆ (8.6 x 12.8); sheets: each 5 x 7¹⁄₁₆ (12.7 x 17.9);
ACC: 80.151.1.-.14

Eadweard Muybridge, English, b. Kingston-upon-Thames, 1830; d. Kingston-upon-Thames, 1904
Panorama of San Francisco from California Street Hill, 1877
Front cover, center, printed in gold leaf: title, artist; recto of first panel, below image, signed by the artist in ink, "Lilas Lellech / with compliments of / Muybridge / Septr 1877"; recto sixth panel below image typeset title, artist's name, copyright, date and Morse's Gallery; inside back cover, center, handwritten in ink, "Property / of / Warren Manley / 130 Locust St. / San Francisco." and in upper left corner, "For / Edward Curtis / from / Sis."
Eleven albumen photographs mounted on paper, which is mounted horizontally on cloth, allowing it to accordion-fold; left end of cloth attached to album cover
Images: each 7⁵⁄₁₆ x 8³⁄₁₆ (18.6 x 20.7); overall: 7⁵⁄₁₆ x 85⁹⁄₁₆ (18.6 x 217.3); sheets: each 12⅛ x 8³⁄₁₆ (30.8 x 20.7); folded size: 12½ x 9 (31.6 x 22.9)
Accompanied by an albumen photo-key index listing 220 locations
Image: 7¼ x 10⅝ (19.4 x 26.9); mount: 8⅛ x 12 (20.4 x 30.5)
ACC: 80.35.1-.2

Eadweard Muybridge
Drawing a Circle, 1887, from the *Movement of the Hand* series, Plate 532, in the *Animal Locomotion* project
Below image typeset title, copyright, date, "by Eadweard Muybridge. All rights reserved."
Collotype with twenty-four images on one sheet in four rows of six
Overall: 7⁵⁄₁₆ x 5⁵⁄₁₆ (18.5 x 38.9); sheet: 18½ x 23⁵⁄₁₆ (47.0 x 59.3)
ACC: 81.132

Eadweard Muybridge
Clasping Hand, 1887, from the *Movement of the Hand* series, Plate 533, in the *Animal Locomotion* project
Below image typeset title, copyright, date, "by Eadweard Muybridge. All rights reserved."
Collotype with twenty-four images on one sheet in four rows of six
Overall: 8¹³⁄₁₆ x 12¾ (22.4 x 32.4); sheet: 18½ x 23⁵⁄₁₆ (47.0 x 59.3)
ACC: 81.133

Eadweard Muybridge
Lifting a Ball, 1887, from the *Movement of the Hand* series, Plate 534, in the *Animal Locomotion* project
Below image typeset title, copyright, date, "by Eadweard Muybridge. All rights reserved."
Collotype with twenty-four images on one sheet in four rows of six
Overall: 9⅛ x 13⅜ (23.2 x 34.0); sheet: 18½ x 23⁵⁄₁₆ (47.0 x 59.3)
ACC: 81.134

Eadweard Muybridge
Beating Time, 1887, from the *Movement of the Hand* series, Plate 535, in the *Animal Locomotion* project
Below image typeset title, copyright, date, "by Eadweard Muybridge. All rights reserved."
Collotype with twenty-four images on one sheet in four rows of six
Overall: 9½ x 11⅞ (24.2 x 30.2); sheet: 18½ x 23⁵⁄₁₆ (47.0 x 59.3)
ACC: 81.135

Eadweard Muybridge
Hand Changing Pencil, 1887, from the *Movement of the Hand* series, Plate 536, in the *Animal Locomotion* project
Below image typeset title, copyright, date, "by Eadweard Muybridge. All rights reserved."
Collotype with twenty-four images on one sheet in four rows of six
Overall: 7⅜ x 15¹³⁄₁₆ (18.8 x 40.2); sheet: 18½ x 23⁵⁄₁₆ (47.0 x 59.3)
ACC: 81.136

Esther Parada, b. Grand Rapids, Mich., 1938
Past Recovery, 1979
Verso each sheet in pencil #1 through #10, exposure values, "THIS SIDE UP."; on #100 signed and dated 1979/1982 lower right in pencil
One hundred hand-toned gelatin silver photographs displayed in ten rows of ten
Images: each 8¹³⁄₁₆ x 13⅜ (22.4 x 33.50); sheets: each 9⁵⁄₁₆ x 13¾ (23.7 x 35.0); overall: 96 x 144 (243.8 x 365.8)
ACC: 82. 74.1-.100

Bart Parker, b. Fort Dodge, Iowa, 1934
Leave & Fall, 1979
Verso of #1-4 initialled and dated in ink; #5 verso titled, signed, and dated in ink
Five Ektacolor photographs, mounted together horizontally
Sheets: each 20 x 16 (50.7 x 40.6); overall: 20 x 80¼ (50.8 x 203.8); mount: 24 x 84⅛ (61.0 x 213.7)
ACC: 82.43.1-.5

Marcia Resnick, b. Brooklyn, N.Y., 1950
landscape – loftscape, 1976
Verso in pencil titled, signed, and dated with edition number a/p
Two gelatin silver photographs, displayed horizontally
Images: each 8 x 11⅝ (20.3 x 29.5); sheet: each 15¹¹⁄₁₆ x 19⅞ (40.5 x 50.4); mounts: each 16 x 20 (40.6 x 50.8)
Anonymous gift to The Target Collection of American Photography
ACC: 81.129.1-.2

Edward Ruscha, b. Omaha, Neb., 1937
Every Building on the Sunset Strip, 1966
No signature or marks
Book of photographic offset prints on continuous horizontal sheet
Accordioned into 51 sections; overall: 7 x 280½ (17.8 x 529.6); closed: 7⅛ x 5⅝ (18.1 x 14.3)
Library call number: TR 654 .R873 RB

Eve Sonneman, b. Chicago, 1946
Coney Island, 1974
Signed and titled on verso in pencil
Two Kodacolor and two gelatin silver photographs, mounted together in two rows, color above black-and-white
Images: each 4½ x 6½ (11.4 x 16.5); mount: 23 x 25⁷⁄₁₆ (58.4 x 64.7)
Purchase, funds provided by Target Stores and the National Endowment for the Arts
ACC: 76.302

Al Souza, b. Plymouth, Mass., 1944
Death, 1975
Signed, titled, and dated verso of mount
Fifteen Machine-processed Kodacolor photographs, mounted together in three rows of five
Images: each 4⅝ x 3⅛ (11.7 x 7.9); mount: 25 x 27 (63.5 x 68.6)
Purchase, funds provided by Target Stores and the National Endowment for the Arts
ACC: 76.303

Athena Tacha, b. Larissa, Greece, 1936
Gestures I: A Study of Finger Positions, 1973
Verso of sheets numbered in pencil 1 through 48
Forty-eight gelatin silver photographs, mounted together in six rows of eight
Images: each 7⅞ x 8 (20.1 x 20.3); overall: 48 x 64 (121.9 x 162.6)
ACC: 81.275.1-.48

Lew Thomas, b. San Francisco, 1932
Time Equals 36 Exposures, 1971
Numbered 1 through 36 in pencil verso on each sheet
Seventy-two gelatin silver photographs, mounted on two panels (displayed side by side) in six rows of six each
Images: each 8 x 8 (20.3 x 20.3); overall: each panel 48 x 48 (121.9 x 121.9)
Purchase, funds provided by Target Stores and the National Endowment for the Arts
ACC: 82.58.1.1-.36, .2.1-.36

Todd Webb, b. Detroit, 1905
6th Avenue between 43 & 44 St. New York City, April 1948
Verso of eighth panel signed, titled, and dated in ink; verso of each panel numbered 1 through 8 in pencil
Eight gelatin silver photographs, mounted together horizontally forming a panorama
Images: varying dimensions, 11 x from 6¹⁄₁₆ to 13⅝ (27.9 x 15.3 to 34.9); overall: 10 x 79⁹⁄₁₆ (25.4 x 209.9); mount: 15 x 85 (38.1 x 220.9)
ACC: 80.52

Alice Wells, b. Erie, Penn., 1929
Sue & Sam, Vick Park B, 1968, from *The Glass Menagerie* series
No signature or marks
Gelatin silver photograph with two negatives printed side by side on same sheet
Images: each 4⅛ x 6³⁄₁₆ (10.5 x 15.7); overall: 4⅛ x 12⅝ (10.5 x 31.4); mount: 16 x 20 (40.6 x 50.8)
Anonymous gift to The Target Collection of American Photography
ACC: 81.130

Minor White, b. Minneapolis, 1908; d. Cambridge, Mass., 1976
Intimations of Disaster, 1949-1952
Verso of mount in ink "Photograph Minor White / 2" on panel #2 and "Photograph Minor White / 5" on #5; recto panel #1 titled with press-type lettering
Nineteen gelatin silver photographs, printed 1952, mounted together horizontally on five masonite panels (photographs cleaned, press-type lettering replaced 1982)

Panel #1 — 23 x 43½ (58.3 x 110.5), with three photographs: 11⅝ to 10 x 9½ to 10⅛ (29.6 to 25.9 x 24.2 to 25.7); #2 — 22⅞ x 39 (58.0 x 102), with five photographs: 9⁹⁄₁₆ to 13⅛ x 11 to 8¾ (24.2 to 33.8 x 28.0 to 22.1); #3 — 22⅞ x 38⁹⁄₁₆ (58.0 x 98.0), with five photographs: 12¾ to 12 x 10⅝ to 4⅝ (31.2 to 30.7 x 26.9 to 11.8); #4 — 22⅞ x 33⅛ (58.2 x 84.2), with three photographs: 10½ to 13⅛ x 12⁷⁄₁₆ to 10⅛ (26.7 to 33.5 x 31.5 to 25.7); #5 — 22¹⁵⁄₁₆ x 37⅞ (58.3 x 95.7), with three photographs: 13 to 9¹⁵⁄₁₆ x 9⁹⁄₁₆ to 13⅛ (33.0 to 25.2 x 23.4 to 33.3)
ACC: 79.281.1-.5

John Wood, b. Delhi, Calif., 1922
Untitled, 1975
Recto in pencil lower edge of mounts signed; verso of mounts labelled Visual Studies Workshop, Print Sale and in pencil, lower right corner, the print sale numbers
Five xerox drawings from photographic negative made in 1970; mounted individually and displayed horizontally
Images: each 5 x 7 (12.7 x 17.8); original mounts: each 17 x 14 (43.2 x 35.6); mounts: 18 x 15 (45.7 x 38.1)
Anonymous gift to The Target Collection of American Photography
ACC: 81.131.1-.5

Concurrent with this exhibition

The museum exhibited books by the following artists: Robert Cumming, Marion Faller, Hollis Frampton, Robert Heinecken, Douglas Huebler, Steve Kahn, Sol LeWitt, Joan Lyons, Duane Michals, Bart Parker, Marcia Resnick, Edward Ruscha, Eve Sonneman, Al Souza, Athena Tacha and Lew Thomas. Most of the books were from The Museum of Fine Arts, Houston Collection. Others were borrowed from the photographers, an anonymous collector, and the Texas Gallery.

Jonas Mekas, director of the Anthology Film Archives in New York, organized a special film series entitled *On the Relationship Between Cinema and (Still) Photography.* Filmmakers whose works were shown included Charles Sheeler, Paul Strand, Man Ray, Ralph Steiner, Laszlo Moholy-Nagy, Willard Van Dyke, Leo Hurwitz, Rudy Burckhardt, Weegee, Helen Levitt, Robert Frank, Chris Marker, Jean-Luc Godard, Oscar Fischinger, Robert Breer, Stan Brakhage, George Landow, Michael Snow, Morgan Fisher, Ken Jacobs, Larry Gottheim, James Herbert, Ernie Gehr, and Hollis Frampton.

Bibliography

General

Compiled by Anne Tucker, Margaret Moore, Anne Bushman, Maggie Olvey, and Kelly Conner.

BOOKS — General

Newhall, Beaumont. *The History of Photography from 1839 to the Present Day*. New York: The Museum of Modern Art, 1949; rev. ed., 1964.

Pollack, Peter. *The Picture History of Photography: From the Earliest Beginnings to the Present Day*. New York: Abrams, 1958, rev. ed., 1969.

Lyons, Nathan, ed. *Photographers on Photography*. Englewood Cliffs, N.J.: Prentice Hall and Rochester, N.Y.: The George Eastman House, 1966.

Scharf, Aaron. *Art and Photography*. Baltimore: Penguin, 1969; rev. ed., 1969.

Jay, Bill. *Views on Nudes*. London: Local Press, Ltd., 1971.

Coke, Van Deren. *The Painter and the Photograph: From Delacroix to Warhol*. Rev. and enl. ed. Albuquerque: University of New Mexico Press, 1972.

Gassan, Arnold. *A Chronology of Photography: A Critical Survey of the History of Photography*. Athens, Ohio: Handbook Co., 1972.

Szarkowski, John. *Looking at Photographs: 100 Pictures from the Collection of The Museum of Modern Art*. New York: The Museum of Modern Art, 1973.

Kahmen, Volker. *Art History of Photography*. New York: Viking, 1974.

Beaton, Cecil, and Buckland, Gail. *The Magic Image: The Genius of Photography from 1839 to the Present Day*. Boston: Little, Brown & Co., 1975.

Wise, Kelly, ed. *The Photographer's Choice: A Book of Portfolios and Critical Opinion*. Danbury, N.H.: Addison House, 1975.

Thornton, Gene. *Masters of the Camera: Stieglitz, Steichen & Their Sources*. New York: American Federation of Arts and Ridge Press, 1976.

Sontag, Susan. *On Photography*. New York: Farrar, Straus and Giroux, 1977.

Coke, Van Deren. *Photography in New Mexico*. Albuquerque: University of New Mexico Press, 1979.

Coleman, Allan D. *Light Readings: A Photography Critic's Writings, 1968-1978*. New York: Oxford University Press, 1979.

Hill, Paul, and Cooper, Thomas. *Dialogue with Photography*. New York: Farrar, Straus and Giroux, 1979.

Kozloff, Max. *Photography & Fascination*, Danbury, N.H.: Addison House, 1979.

Barthes, Roland. *La Chambre Claire*. Paris: Editions du Seuil, 1980 (*Camera Lucida: Reflections on Photography*. Trans. by Richard Howard. New York: Hill & Wang, 1981).

Malcolm, Janet. *Diana & Nikon: Essays on the Aesthetic of Photography*. Boston: David R. Godine, 1980.

Goldberg, Vicki, ed. *Photography in Print: Writings from 1839 to the Present*. New York: Simon & Schuster, 1981.

Jeffrey, Ian. *Photography: A Concise History*. New York and Toronto: Oxford University Press, 1981.

Traub, Charles, ed. *The New Vision: Forty Years of Photography at the Institute of Design*. Millerton, N.Y.: Aperture, 1982 (exhibition, Light Gallery, New York, 1980).

Life Library of Photography: *The Art of Photography, The Camera, Caring for Photographs, Color, Documentary Photography, Frontiers of Photography, Great Photographers, The Great Themes, Light and Film, Photographing Children, Photographing Nature, Photography as a Tool, Photojournalism, The Print, Special Problems, The Studio, Travel Photography, Photography Year 1973, 1974, 1975, 1976, 1977, 1978, 1979, 1980, 1981*. New York: Time-Life Books, 1970-1981.

BOOKS — Sequential Art

Picard, Capt. *Album d'hippiatrique et d'equitation de l'Ecole de Cavalerie*. Paris: Berthaud Freres, 1892 (approx. 200 photographs of horses and riders in motion by E. Marey and George Demeny).

Richer, Dr. Paul. *Physiologie artistique de l'homme en mouvement*. Paris: Octave Doin, 1895.

Marey, E.J. *Movement*. Trans. by Eric Pritchard. London: William Heinemann, 1895.

Huntington, Edward V. *The Continuum (and Other Types of Serial Order)*. 2nd ed. Cambridge: Harvard University Press, 1921.

Roh, Franz. *Foto Auge, Oeil et Photo, Photo-Eye*. Stuttgart: Fritz Wedeken Co., 1929.

Edgerton, Harold E., and Killian, James R., Jr. *Flash! Seeing the Unseen by Ultra High Speed Photography*. 2nd ed. Boston: C.T. Branford Co., 1954.

Moholy-Nagy, Laszlo. *Vision in Motion*. Chicago: Paul Theobald & Co., 1956.

Perle, George. *Serial Compositions and Atonality*. Berkeley and Los Angeles: University of California Press, 1962.

Ehrenzweig, Anton. *The Hidden Order of Art*. Berkeley and Los Angeles: University of California Press, 1967.

White, Minor. *Mirrors, Messages, Manifestations*. Millerton, N.Y.: Aperture, 1969.

Edgerton, Harold E., and Killian, James R., Jr. *Moments of Vision: The Stroboscopic Revolution in Photography*. Cambridge: MIT Press, 1979.

Abramson, Sue. *Extended Frames*. Barrytown, N.Y.: Station Hill Press, 1981.

EXHIBITION CATALOGUES — General

Steichen, Edward, ed. *The Family of Man*. New York: The Museum of Modern Art, 1955.

The Sense of Abstraction. New York: The Museum of Modern Art and Rochester, N.Y.: Aperture, 1960.

Lyons, Nathan, ed. *Photography 63 / An International Exhibition*. Syracuse, N.Y.: The New York State Exposition and Rochester, N.Y.: The George Eastman House, 1963.

Lyons, Nathan, ed. *Photography 64 / An International Exhibition*. Syracuse, N.Y.: The New York State Exposition and Rochester, N.Y.: The George Eastman House, 1964.

Maddox, Gerald C., ed. *American Photography: The Sixties*. Lincoln, Neb.: Sheldon Memorial Art Gallery, University of Nebraska, 1966.

Szarkowski, John, ed. *The Photographer's Eye*. New York: The Museum of Modern Art and Doubleday & Co., Inc., 1966.

Lyons, Nathan, ed. *Photography in the Twentieth Century*. New York: Horizon Press and Rochester, N.Y.: The George Eastman House, 1967.

Walkey, Frederick P. *Photography U.S.A.* Lincoln, Mass.: DeCordova Museum, 1967.

Lyons, Nathan, ed. *Vision and Expression*. New York: Horizon Press and Rochester, N.Y.: The George Eastman House, 1967.

Photography 1968. Lexington, Ky.: Lexington Camera Club, 1968.

Forth, Richard. *Exhibition as a form of dialogue*. Oakland, Calif.: Visual Dialogue Foundation, Center of the Visual Arts, 1969.

Riss, Murray. *1971 Photography Invitational*. Fayetteville, Ark.: Arkansas Arts Center Gallery, University of Arkansas, and Memphis, Tenn.: The Memphis Academy of Arts, 1971.

Photographic Portraits. Philadelphia: Moore College of Art, 1972.

11 American Photographers. Hempstead, L.I., N.Y.: The Emily Lowe Gallery, Hofstra University, 1972.

Medium Fotographie. Fotoarbeiten bildener Kunstler von 1910 bis 1973. Leverkusen, Germany: Stadtisches Museum Leverkusen, 1973.

Werner, Donald L., ed. *Light and Lens: Methods of Photography*. Yonkers, N.Y.: Hudson River Museum and Morgan & Morgan, 1973.

Through One's Eyes. A Photographic Exhibition. Fullerton, Calif.: Muckenthaler Cultural Center, 1973.

Massar, Phyllis Dearborn, ed. *Landscape/Cityscape. A Selection of Twentieth-Century American Photographs*. New York: The Metropolitan Museum of Art, 1973.

Doty, Robert, ed. *Photography in America*. New York. The Whitney Museum of American Art and Random House, 1974.

Photography Unlimited. Cambridge, Mass.: Fogg Art Museum, 1974.

Noggle, Anne, and Mann, Margery, eds. *Women of Photography. An Historical Survey*. San Francisco: San Francisco Museum of Art, 1975.

Lives: Artists who Deal with People's Lives (Including Their Own) as the Subject (and/or the Medium) of Their Work. New York: The Fine Arts Building, 1975.

Jenkins, William, ed. *The Extended Document*. Rochester, N.Y.: The International Museum of Photography at George Eastman House, 1975.

The Photographer and the Artist. New York: Sidney Janis Gallery, 1976.

Rice, Leland, ed. *New Portfolios*. Claremont, Calif.: Galleries of the Claremont Colleges, Pomona College and Chicago: School of The Art Institute of Chicago, 1976.

Kaplan, Howard, ed. *Contemporary Trends*. Chicago: The Chicago Photographic Society of Columbia College, 1976.

Livingston, Rosanne T. *Photographic Process as Medium*. New Brunswick, N.J.: Rutgers University Art Gallery, 1976.

Link, Richard, ed. *Photographic*. Buffalo, N.Y.: Visual Arts Board, State University College at Buffalo and Hallwalls Gallery, ca. 1976.

Tucker, Jean S., ed. *Aspects of American Photography, 1976*. Saint Louis: University of Missouri, Saint Louis, 1976.

Wortz, Melinda. *Exhibitions '76 '77*. Los Angeles: Advisory Council for the Arts, Cedars-Sinai Medical Center, 1977.

Hume, Sandy; Manchester, Ellen; and Metz, Gary, eds. *The Great West: Real/Ideal*. Boulder, Colo.: University of Colorado, 1977.

Welpott, Jack; Rice, Leland; and Jonas, Harold, eds. *Contemporary California Photography*. San Francisco: Camerawork Gallery, 1978.

Sidwall, A., ed. *Tusen och en bild*. Stockholm, Sweden: Moderna Museet Fotografiska, 1978.

Szarkowski, John, ed. *Mirrors and Windows: American Photography Since 1960*. New York: The Museum of Modern Art, 1978.

Amerikanische Landschaftsphotographie. Munich, West Germany: Die Neve Samlung Staatliches Museum für angewandt Kunst, 1978.

Lloyd, Valerie, ed. *23 Photographers 23 Directions*. Liverpool, England: Walker Art Gallery, 1978.

The Quality of Presence. Washington, D.C.: Lunn Gallery, Graphics International Ltd., 1978.

Clisby, Roger D., and Himelfarb, Harvey, eds. *Forty American Photographers*. Sacramento, Calif.: E.B. Crocker Gallery, 1978.

Alinder, James, ed. *The Photographer's Image Self-Portrayal*. Carmel, Calif.: The Friends of Photography, 1978.

Rice, Shelley, ed. *The Male Nude. A Survey in Photography*. New York: Marcuse Pfeifer Gallery, 1978.

Photographic Directions: Los Angeles, 1979. Los Angeles: Security Pacific Bank, 1979.

Masteller, Richard N., ed. *Auto as Icon*. Walla Walla, Wash.: Whitman College, 1979 [exhibition organized by International Museum of Photography at The George Eastman House].

Approaches to Photography: A Historical Survey. Amarillo, Tex.: Amarillo Art Center, 1979.

Parker, Fred R., ed. *Attitudes: Photography in the 1970s*. Santa Barbara, Calif.: Santa Barbara Museum of Art, 1979.

Photography: Venice '79. Milan, Italy: Gruppo Editoriale Electa and New York: Rizzoli International Publications, 1979.

Wise, Kelly, ed. *Photo Facts and Opinions*. Andover, Mass.: The Addison Gallery of American Art, Phillips Academy, 1981.

Aspects of the 70's: Photography. Lincoln, Mass.: DeCordova Museum, 1980.

Gee, Helen, ed. *Photography of the Fifties: An American Perspective*. Tucson, Ariz.: Center for Creative Photography, The University of Arizona, and Flagstaff, Ariz.: Northland Press, 1980.

Cohn, Robert, and Ketchum, Robert Glenn, eds. *American Photographers and The National Parks*. New York: The Viking Press and Washington, D.C.: National Park Foundation, 1981.

Hyman, Therese, ed. *Slices of Time: California Landscapes 1860-1880 and 1960-1980*. Oakland, Calif.: The Oakland Museum, 1982.

Repeated Exposure: Photographic Imagery in the Print Media. Kansas City, Mo.: Nelson Gallery of Art, Atkins Museum of Fine Arts, 1982.

Upton, John, ed. *Color as Form: A History of Color Photography*. Rochester, N.Y.: The International Museum of Photography at The George Eastman House, 1982.

Traub, Charles, ed. *The New Vision: Forty Years of Photography at the Institute of Design*. Millerton, N.Y.: Aperture, 1982; exhibition, Light Gallery, New York, 1980.

EXHIBITION CATALOGUES — Collections

Photographs from The George Eastman House Collection 1900-1964. Rochester, N.Y.: Organized by The George Eastman House for New York World's Fair, 1965 [checklist].

George Eastman House Collection. Rochester, N.Y.: Japan, 1968. (combined nine traveling exhibitions organized by George Eastman House: *Photographs from the George Eastman House Collection 1840-1915* and eight individual exhibitions including Bullock, Callahan, Frank).

Contemporary Photographs. Los Angeles: Dickson Art Center, UCLA Art Galleries, 1968.

Recent Acquisitions 1969: Modern Painting, Drawing, Prints, and Photography. Pasadena, Calif.: Pasadena Art Museum, 1969.

Language of Light. A Survey of the Photography Collection of the University of Kansas Museum of Art. Lawrence, Kan.: University of Kansas Museum of Art, 1974.

Catalog of the UCLA Collection of American Photographs. (Catalog for exhibition: *Contemporary American Photographs.*) Los Angeles, Calif.: Frederick S. Wight Art Gallery, University of California, 1976.

American Photography: Past into Present – Prints from the Monsen Collection of American Photography. Seattle: Seattle Art Museum, 1976.

Tucker, Anne, ed. *The Target Collection of American Photography.* Houston: The Museum of Fine Arts, Houston, 1977.

Geske, Norman, ed. *Photographs: Sheldon Memorial Art Gallery Collections.* Lincoln, Neb.: University of Nebraska-Lincoln, Nebraska Art Association, 1977.

Class of 1928 Photography Collection. Amherst, Mass.: The University Gallery, University of Massachusetts, 1978.

The Anthony G. Cronin Memorial Collection. Houston: The Museum of Fine Arts, Houston, 1979.

Intentions and Techniques: Photographs from the Lehigh University Collection. Bethlehem, Pa.: Lehigh University, 1979.

Diverse Images: Photographs from the New Orleans Museum of Art. New Orleans: New Orleans Museum of Art, 1979.

Kalamazoo Collects Photography. Kalamazoo, Mich.: Kalamazoo Institute for the Arts, 1980.

Kismaric, Susan, ed. *American Children.* New York: The Museum of Modern Art, 1980.

Photographs from the Collection of Dan Berley. Jerusalem: Israel Museum and Roslyn Heights, N.Y.: DBF Editions, 1980.

Travis, David, ed. *A History of Photography from Chicago Collections.* Chicago: The Art Institute of Chicago, 1982.

EXHIBITION CATALOGUES — Sequential Art

Lyons, Nathan, ed. *The Persistence of Vision.* New York: Horizon Press and Rochester, N.Y.: The George Eastman House, 1967.

Coplans, John, ed. *Serial Imagery.* Pasadena, Calif.: Pasadena Art Museum, 1968.

Manipulated Image. Clemson, S.C.: Clemson University, 1969.

Serial/Modular Imagery in Photography, 1969. Lafayette, Ind.: Purdue University, 1969.

McShine, Kynaston L., ed. *Information.* New York: The Museum of Modern Art, 1970.

Borcoman, James, ed. *The Photograph as Object 1843-1969.* Ottawa, Canada: The National Gallery of Canada, 1970.

Wilson, Tom Muir, ed. *Into the 70's: Photographic Images by Sixteen Artists/Photographers.* Akron, Ohio: Akron Art Institute, 1970.

Tancock, John L., ed. *Multiples: The First Decade.* Philadelphia: Philadelphia Museum of Art, 1971.

Martinelli, Frank, ed. *The Multiple Image.* Kingston, R.I.: The University of Rhode Island Arts Council, 1972.

Photography into Art. London: The Arts Council of Great Britain and William Kampner Ltd., 1972.

Jones, Harold, ed. *The Expanded Photograph.* Philadelphia: Philadelphia Civic Center Museum, 1972.

Upton, John, ed. *Minor White / Robert Heinecken / Robert Cumming: Photograph as metaphor – Photograph as object – Photograph as document of concept.* Long Beach, Calif.: California State University, Long Beach, 1973.

Palazzoli, Daniela, and Carluccio, Luigi, eds. *Combattimento per un'Immagine: Fotografi e pittori.* Turin, Italy: Galerie Civica d'Arte Moderna, 1973.

Bourdon, David, ed. *(photo) (photo)² ... (photo)ⁿ: Sequenced Photographs.* Baltimore: University of Maryland Art Gallery, 1975.

Repeated Images. Johnson City, Tenn.: Elizabeth Slocomb Gallery, East Tennessee State University, 1975.

Wong, Jason D. *Photo-Synthesis.* Ithaca, N.Y.: The Herbert F. Johnson Museum of Art, Cornell University, 1976.

de Wilde, E., ed. *Foto-Sequenties.* Amsterdam, The Netherlands: Stedelijk Museum Amsterdam, 1976.

Thomas, Lew, ed. *Photography and Language.* San Francisco: Camerawork Gallery, 1976.

Lyons, Nathan, ed. *The Extended Frame.* Rochester, N.Y.: Visual Studies Workshop, 1977 (checklist).

Wilson, Martha, ed. *Artists Books.* Hamilton, N.Y.: Gallery Association of New York State, 1977.

Neususs, Floris M., ed. *Photography as Art – Art as Photography 2.* Kassel, West Germany: Kassel Fotoforum, Kassel University, 1977.

London, Barbara, ed. *Bookworks.* New York: The Museum of Modern Art, 1977.

James, Geoffrey, ed. *Transparent Things / Transparencies. The artist's use of the Photograph.* Ottawa, Canada: The Canada Council, 1977.

Johnson, Diana, and Siskind, Aaron, eds. *Spaces.* Providence, R.I.: Museum of Art, Rhode Island School of Design, 1978.

Schimmel, Paul, ed. *American Narrative / Story Art: 1967-1977.* Houston: Contemporary Arts Museum, 1978.

Hoffberg, Judith, and Hugo, Joan, eds. *Artwords and Bookworks.* Los Angeles: Los Angeles Institute of Contemporary Art, 1978.

Berens, Stephen L., ed. *Art Books:; . Books as Original Art.* Palatka, Fla.: Florida School of the Arts, 1978.

Lyons, Joan, and Russell, Don, eds. *Visual Studies Workshop Book Show.* New York: Franklin Furnace Archive, 1978.

Berens, Stephen L., ed. *Cultural Artifacts, A Photographic Exhibition.* Palatka, Fla.: Florida School of the Arts, 1979.

McCray, Marilyn, ed. *Electroworks.* Rochester, N.Y.: The International Museum of Photography at The George Eastman House, 1979.

Weiermaier, Peter, ed. *Photographie als Kunst 1879-1979 / Kunst als Photographie 1949-1979.* Innsbruck, Austria: Allerheiligenpresse, 1979.

Druckrey, Timothy, and Gillett, Marnie, eds. *Reasoned Space.* Tucson, Ariz.: Center for Creative Photography, University of Arizona, 1980.

Desmarais, Charles, ed. *The Portrait Extended.* Chicago: The Museum of Contemporary Art, 1980.

Parker, Fred R., ed. *Sequence Photography.* Santa Barbara, Calif.: The Santa Barbara Museum of Art, 1980.

Eskildsen, Ute, and Schmalriede, Manfred. *Absage an das Einzelbild (Renunciation of the Single Image).* Essen, West Germany: Fotographische Sammlung, Museum Folkwang, 1980.

Marioni, Tom, ed. *Vision #5. Artists' Photographs.* Oakland, Calif.: Crown Point Gallery and Point Publications, 1981.

Richman, Gary, ed. *Re: Pages. An Exhibition of Contemporary American Bookworks.* Cambridge, Mass.: Hera Educational Foundation and New England Foundation for the Arts, Inc., 1981.

Tucker, Marcia, and Pincus-Witten, Robert, eds. *John Baldessari.* New York: The New Museum and Dayton, Ohio: University Art Galleries, Wright State University, 1981.

Weibel, Peter, and Auer, Anna, eds. *Erweiterte Fotographie (Extended Photography).* Vienna, Austria: 5th International Biennal, 1981.

Colp, Norman R. *To be continued. The sequential image in photographic books.* Rochester, N.Y.: Visual Studies Workshop and New York: International Center for Photography, 1981.

PERIODICALS — Sequential Art

Nadar, Paul. "L'art de vivre cent ans, Trois entretiens avec Monsieur Chevreul photographies a la veille de sa cent et unieme annee." *Le Journal Illustre* (Paris) (September 5, 1866).

Moholy-Nagy, Laszlo. *Telehor: The International Review (for) New Vision* (Brno, Czechoslovakia 1936).

"Picture Sequences in Painting and Photography." *Camera* (January 1965), pp. 22-33.

Lee, David. "Serial Rights." *Art News* (December 1967), pp. 42-45, 68-69.

Bochner, Mel. "The Serial Attitude." *Artforum* (December 1967), pp. 28-33.

Mellow, James R. "New York Letter." *Art International* (February 1968), pp. 73-74.

Stevens, C. "Series Photography: More Is More." *Print* (September 1970).

"Sequence; still photography relating events and sequences." *Camera* (February 1971), pp. 4-43.

"Sequence." *Camera* (October 1972), pp. 11-54.

Greenberg, Jane. "More than one . . ." *Modern Photography* (February 1973), pp. 76-83.

Deutsch, Jean-Jacques, and Gomez, Bernard. "Sequences." *Chroniques de l'art vivant* (France, November 1973), pp. 17-19.

Weiss, Evelyn. "Phenomenology of a time-space system." *Studio* (April 1974), pp. 174-180.

Power, Mark. "Sequential Photography." *The Washington Post,* March 15, 1975, Sec. B, pp. 9-10.

Searle, Leroy. "Poems, Pictures and Conceptions of Language." *Afterimage* (May-June 1975), pp. 33-39.

Foote, Nancy. "The Anti-Photographers." *Artforum* (September 1976), pp. 46-54.

Scharf, Aaron. "Marey and Chronophotography." *Artforum* (September 1976), pp. 62-70.

Frank, Peter. "Visual, Conceptual, and Poetic Sequences." *Art News* (March 1976), pp. 48-50.

Schwartzbauer, G.F. "Art — photography: photography — art." *Magazin Kunst* (Germany, 1976), pp. 60-76.

Porter, Allan. "The Picture Story." *Camera* (February 1977), pp. 3, 23, 33-35.

Krauss, Rosalind. "Notes on the Index: Seventies Art in America." *October 3* (Spring 1977), pp. 68-81.

Taubin, Amy. "Doubled Visions." *October 4* (Fall 1977), pp. 33-42.

de Duve, Thierry. "Time Exposure and Snapshot: The Photograph as Paradox." *October 5* (Summer 1978), pp. 113-125.

Grundberg, Andy. "One + One = One." *Modern Photography* (March 1978), pp. 108-113.

Searle, Leroy. "Language Theory and Photographic Praxis." *Afterimage* (Summer 1979), pp. 26-34.

Muller-Pohle, A. "Series — cycle — sequence — tableau." *European Photography* (Germany, January — March 1980), pp. 28-32

Hagen, Charles. "Photographs and Time." *Afterimage* (April 1980), pp. 6-7.

Artner, Alan. "MCA's photo exhibit darkens season opening." *Chicago Tribune,* Sept. 14, 1980, Arts-Book Section.

Horak, Jan-Christopher. "Exponential notation." *Afterimage.* (February 1981), p. 11.

Lyons, Nathan. Untitled lecture. *Camera Austria 4/80* (1981), pp. 75-79

Solomon-Godeau, Abigail. "Playing in the Fields of the Image." *Afterimage* (Summer 1982), pp. 10-13.

Bibliography

Photographers

This material was provided by the artists or their representatives and supplemented by the staff of The Museum of Fine Arts, Houston with original source material whenever possible. Information is listed chronologically within each section.

Group exhibitions are included only if (a) there was a catalogue or a brochure, or (b) the exhibition traveled, or (c) it was a two-person exhibition, or (d) it was an exhibition outside the United States. Where only the exhibition title is given, the reader is referred by one or more asterisks or by the designation (book) to the General Bibliography for more complete information:

*	— See "Exhibitions Catalogues/ General"
**	— See "Exhibitions Catalogues/ Collections"
***	— See "Exhibitions Catalogues/ Sequential Art"
(book)	— See "Books / General"

In the event the title of any exhibition or article consists of only the artist's name, the title has been omitted.

The following abbreviations have been used throughout:

CUNY	— City University of New York
GEH	— George Eastman House
IMP/GEH	— International Museum of Photography at the George Eastman House
LAICA	— Los Angeles Institute of Contemporary Art
MIT	— Massachusetts Institute of Technology
MOMA	— The Museum of Modern Art
SUNY	— State University of New York
UCLA	— University of California, Los Angeles
VSW	— Visual Studies Workshop

When an institution is listed in one section more than once, its location is not repeated.

Richard Avedon

Born: New York, 1923

Resides: New York

Education: Columbia University, New York, 1941; New School for Social Research design laboratory (taught by Alexy Brodovitch), New York, 1944-1945.

Professional Experience: Served in Photography Department of U.S. Merchant Marines, 1942-1944; staff photographer, *Junior Bazaar*, 1945-1947; staff photographer, *Harper's Bazaar*, 1945-1965; editor and staff photographer, *Theatre Arts*, 1952; visual consultant for film, *Funny Face*, Paramount Studios, 1957; staff photographer, *Vogue*, 1966-present.

Recognition and Awards: Five-year grant from the Amon Carter Museum of Western Art, Fort Worth, Tex., to photograph the working man in the West, 1979.

Individual Exhibitions: 1962 — Smithsonian Institution, Washington, D.C. (November). 1964 — *Avedon: A Collage*, McCann-Erickson, Inc., New York (November); The Minneapolis Institute of Arts (July 2 - Aug. 30; catalogue). 1974 — *Jacob Israel Avedon, 1889-1973: Photographed by Richard Avedon*, MOMA, New York (May 1-June 16). 1975 — Marlborough Gallery, New York (Sept. 10-Oct. 4; catalogue). 1978 — *Portraits*, Stephen Wirtz Gallery, San Francisco (Jan. 9-Feb. 10); *Avedon: Photographs 1947-1977*, The Metropolitan Museum of Art, New York (Sept. 14-Nov. 5; book and catalogue; traveled). 1980 — *Richard Avedon 1946-1980*, University Art Museum, University of California at Berkeley (Mar. 5-May 4; catalogue; combines four exhibitions: Minneapolis, 1973; MOMA, 1974; Marlborough Gallery, 1975; and Metropolitan, 1978); *A Portrait of Francis Bacon*, Stephen Wirtz Gallery (Mar. 5-Apr. 12); G. Ray Hawkins Gallery, Los Angeles (Oct. 10-Nov. 15; catalogue); Cronin Gallery, Houston (May 2-30). 1982 — Jane Corkin Gallery, Toronto (Feb. 27-Apr. 10).

Selected Group Exhibitions: 1955 — *The Family of Man*.* 1959 — *Photography in the Fine Arts I*, The Metropolitan Museum of Art, New York (catalogue). 1960 — *Photography in the Fine Arts II*, The Metropolitan Museum of Art (catalogue). 1961 — *Photography in the Fine Arts III*, The Metropolitan Museum of Art (catalogue). 1963 — *Photography in the Fine Arts IV*, The Metropolitan Museum of Art (catalogue). 1966 — *The Photographer's Eye*.* 1967 — *International Exhibition of Photography – The Camera as Witness*, Expo '67, Montreal (Apr. 28-Oct. 27; catalogue); *Photography in the Fine Arts V*, The Metropolitan Museum of Art (catalogue). 1970 — *The Universal Eye*, Eastman Kodak Company pavilion, Expo '70, Osaka, Japan (catalogue). 1974 — *Photography in America*.* 1976 — *American Photography: Past into Present***; *Modern Portraits: The Self and Others*, Wildenstein Gallery, New York (Oct. 20-Nov. 28; catalogue); *Exhibitions '76 '77*; *The Photographer and the Artist*.* 1977 — *History of Fashion Photography*, IMP/GEH, Rochester, N.Y. (June 25-Oct. 2;

book). 1979 — *Diverse Images***; *Kunst als Photographie 1949-1979/Photographie als Kunst 1879-1979*.*** 1980 — *Photography of the Fifties*; *Aspects of the 70s*.* 1981 — *Surrealist Photographic Portraits 1920-1980*, Marlborough Gallery, New York (Apr. 9-May 9; catalogue); *Inside Out, Self Beyond Likeness*, Newport Harbor Art Museum, Newport Beach, Calif. (May 22-July 12; catalogue; traveled).

Monographs: *Observations*. Text by Truman Capote. Simon & Schuster, New York, 1959 • *Nothing Personal*. Text by James Baldwin. Atheneum, New York, 1964 • *Alice in Wonderland: The Forming of a Company and the Making of a Play*. Text by Doon Arbus. Merlin House, New York, 1973 • *Portraits*. Text by Harold Rosenberg. Farrar, Straus & Giroux, New York, 1976 • *Avedon Photographs 1947-1977*. Essay by Harold Brodkey. Farrar, Straus & Giroux, New York, and McGraw-Hill & Ryerson, Toronto, 1978.

Books Edited by the Photographer: *Diary of a Century*. Photographs by Jacques-Henri Lartigue. Viking Press, New York, 1970.

Monograph Magazine: "The Family 1976." *Rolling Stone* (Oct. 21, 1976), pp. 5, 50-97.

Other Books: Devlin, Polly. *Vogue: Book of Fashion Photography 1919-1979*. Simon & Schuster, New York, 1979 • Hall-Duncan, Nancy. *History of Fashion Photography*. Alpine Book Co., New York, 1979 • See also Beaton and Buckland, *The Magic Images*; Malcolm, *Diana and Nikon*; Witkin and London, *The Photograph Collector's Guide*;

Goldberg, *Photography in Print*; Kozloff, *Photography & Fascination*; and Jeffrey, *Photography: A Concise History.*

Selected Articles, Essays and Reviews about the Photographer: Sargeant, Winthrop. "Profile: A Woman Entering a Taxi in the Rain." *New Yorker* (Nov. 8, 1958), pp. 49-84 • Waugh, Evelyn. "The Book Unbeautiful." *The Spectator* (Nov. 20, 1959), p. 728 • Lahr, John. "The Silent Theatre of Richard Avedon." *Evergreen Review* (August 1970), pp. 34-41, 68-69 • Ashton, Dore. "The Mature Portraitist: Richard Avedon." *Studio International* (October 1974), pp. 89-92 • Malcolm, Janet. "Avedon." *New Yorker* (May 13, 1974), pp. 12-13 • Edwards, Owen. "Richard Avedon will sell you this picture." *The Village Voice* (Sept. 15, 1975), pp. 84-86 • Edwards, Owen. "Let's Let Photography Lie." *The Village Voice* (Dec. 8, 1975), pp. 73-74 • Barthes, Roland. "Avedon." *Photo* (January 1977), pp. 58-75, 79 • Michener, Charles. "The Avedon Look." *Newsweek* (Oct. 16, 1978), pp. 58-72 • Edwards, Owen. "Richard Avedon and the Art of Infinite Control." *American Photographer* (November 1978) • Malcolm, Janet. "A Series of Proposals." *New Yorker* (Oct. 3, 1978), pp. 132-43.

Paul Eric Berger

Born: The Dalles, Ore., Jan. 20, 1948
Resides: Seattle
Education: University of California at Davis, 1965-1967; Art Center College of Design, Los Angeles, 1967-1969; UCLA, B.A., 1970; VSW, Rochester, N.Y. (program in photographic studies of the SUNY at Buffalo), M.F.A., 1973.
Professional Experience: Visual communications teacher (photography, film, video), Davis Senior High School, Calif., 1971-1972; photography instructor, University of Northern Iowa, Cedar Falls, 1973-1974; visiting professor of photography, Summer Photography Institute, Colorado College, Colorado Springs, summers 1977, 1978; visiting lecturer in photography, Unit One program, College of Liberal Arts and Sciences, University of Illinois, Urbana, 1974-1978; associate professor of art, School of Art, University of Washington, Seattle, 1978-present.
Recognition and Awards: Materials grants, awarded by the University of Illinois Research Board, 1957, 1977; Young Photographer's Award, 6e Recontres Internationales de la Photographie, Festival d'Arles, France, 1975; nominated for "Discoveries" section, *Photography Year 1978* and *1979*, Time-Life Books Inc.; National Endowment for the Arts Photography Fellowship, 1979.

Individual Exhibitions: 1972 — Significant Directions Photogallery, Davis, Calif. 1973 — Krannert Lounge Gallery, University of Illinois, Champaign. 1974 — University of Northern Iowa, Cedar Falls. 1975 — The Art Institute of Chicago; Utah State University, Logan. 1977 — Light Gallery, New York; Colorado College, Colorado Springs. 1978 — Orange Coast College, Costa Mesa, Calif.; Colorado College; Colorado Mountain College, Breckenridge. 1979 — Tyler School of Art, Temple University, Philadelphia; Eastern Washington University, Cheney. 1980 — Light Gallery, New York (Jan. 31-Feb. 23); Seattle Art Museum; Blue Sky Gallery, Portland, Ore.; The Evergreen State College, Olympia, Wash.; Photography at Oregon Gallery, University of Oregon, Eugene. 1982 — *Paul Berger: Seattle Subtext 1981-1982,* Light Gallery (Apr. 10-May 22) and Equivalents Gallery, Seattle (May 6-June 6; brochure); Viking Union Gallery, Western Washington University, Bellingham (May-June 10).

Selected Group Exhibitions: 1969 — *Roots,* Focus Gallery, San Francisco. 1970 — *California Photographers 1970,* Memorial Union Art Gallery, Davis, Calif. (Apr. 6-May 9; catalogue; traveled). 1975 — *Portrait of America,* Paine Art Center, Oshkosh, Wis. (traveled under the auspices of the Smithsonian Traveling Exhibitions Service); *Magic Silver Show,* Murray State University, Ky. (catalogue). 1976 — *Acquisitions 1975,* Musée Reattu, Arles, France; *Magic Silver Show,* Murray State University (catalogue). 1978 — *The Criticism of Photography,* University Gallery, Fine Arts Center, University of Massachusetts, Amherst (Apr. 8-May 7; catalogue); *Berger, Ginsberg, Gossage,* Chicago Center for Contemporary Photography; *Class of 1928 Photography Collection**; Aesthetics of Graffiti,* San Francisco Museum of Modern Art (catalogue); *Illinois Photography '78,* Illinois State Museum, Springfield (catalogue); *Recent Photographs from Light Gallery,* University of Minnesota, Minneapolis (traveled). 1979 — *Attitudes;* Photoworks '79,* Bellevue Art Museum, Wash. (catalogue); *Bernard Freemessar Memorial Exhibition* (traveled in Washington State); two-person show, Henry Art Gallery, University of Washington, Seattle. 1980 — *Alternatives 1980,* Siegfried Gallery, Ohio University, Athens (Feb. 18-Mar. 3; catalogue; traveled); *Fifth Anniversary Show,* Blue Sky Gallery, Portland, Ore. (catalogue); *Polaroid 20 x 24,* Galerie Zabriskie, Paris; two-person show, VSW Gallery, Rochester, N.Y. 1981 — *American Photographs 1920-1980,* Whatcom Museum of History and Art, Bellingham, Wash. (catalogue); two-person show, FITC Gallery, St. Paul, Minn.; *Portopia '81,* Kobe, Japan; *New York,* The Friends of Photography Gallery, Carmel, Calif.; *Image Connections,* Visual Arts Resources, University of Oregon, Eugene (traveled). 1982 — *An Urban Vernacular: Narrative American Art,* Henry Art Gallery; *Erweiterte Fotografie***; New American Photographs,* Art Gallery, California State College, San Bernardino (Oct. 13-November; catalogue; will travel).

Books: Cravens, George M. *Object and Image.* 2nd ed. Prentice-Hall, New York, 1982 • See also Life Library, *The Art of Photography.*

Selected Articles, Essays, and Reviews: *The Print Collector's Newsletter* (September-October 1977), p. 14 • Searle, Leroy F. "Paul Berger's 'Mathematics' Photographs." *Afterimage* (March 1978), pp. 10-17 • Glowen, Ron. "Perceiving in Series." *Artweek* (Feb. 23, 1980), p. 13 • Gerrit, Henry. "Paul Berger: An Interview." *The Print Collector's Newsletter* (May-June 1980), pp. 38-42 • Grundberg, Andy. "Currents - American Photography Today." *Modern Photography* (April 1980), pp. 142, 146 • Berger, Paul. "Triangulating Art and Culture: The Rephotographic Survey Project." *Northwest Photography* (December 1980) • Kerns, Ben. "On the Photography of Paul Berger." *Northwest Review* (Summer 1981).

Barbara Blondeau

Born: Detroit, May 6, 1938
Died: Philadelphia, Dec. 24, 1974
Education: School of The Art Institute of Chicago, B.F.A., 1961; Institute of Design, Illinois Institute of Technology, Chicago, M.F.A., 1968 (studied with Aaron Siskind and Joseph Jachna).
Professional Experience: Instructor, St. Mary's College, Notre Dame, Ind., 1966-1968; instructor, Moore College of Art, Philadelphia, 1968-1970; assistant professor, Philadelphia College of Art, 1970-1971; chairperson, Photography/Film Department, and associate professor, Philadelphia College of Art, 1971-1974.
Individual Exhibitions: 1967 — St. Mary's College, Notre Dame, Ind. 1968 — University of Kentucky, Lexington; Northern Illinois University, De Kalb. 1975 — *Barbara Blondeau 1938-1974,* Philadelphia College of Art (Dec. 4, 1975-Jan. 23, 1976; catalogue). 1977 — VSW, Rochester, N.Y. (May 27-July 30; traveled).
Selected Group Exhibitions: 1968 — *Chicago Area Photographers* (traveled). 1969 — *The Manipulated Image,* Clemson University, S.C.; *Vision and Expression.* 1970 — *Into the 70's.*** 1971 — *A Variety Show,* Critics Choice Gallery, Arcata, Calif. (traveled). 1972 — *The Multiple Image***; The Expanded Photograph.*** 1973 — Kansas City Art Institute, Mo. 1974 — *Visual Interface,* Tyler School of Art, Philadelphia. 1975 — *Ars Moriendi,*

Jefferson Hospital Commons Building, Philadelphia. 1976 — *Three Centuries of American Art*, Philadelphia Museum of Art (Apr. 11-Oct. 10; catalogue). 1978 — *Spaces*.*** 1980 — *The New Vision* (book). 1981 — *Cliché-Verre: Hand-Drawn, Light-Printed – A Survey of the Medium from 1839 to the Present*, The Detroit Institute of Arts (July 12-Aug. 21; catalogue; traveled). 1982 — *A History of Photography from Chicago Collections*.**

Monographs: Lebe, David; Redmond, Joan; and Walker, Ron, eds. *Barbara Blondeau 1938-1974*. VSW, Rochester, N.Y., and Philadelphia College of Arts, 1976.

Books: See Life Library, *The Print* and *Frontiers of Photography*; and Traub, *The New Vision*.

Selected Articles, Essays, and Reviews: Perloff, Stephen. "Haunting Images by a Restless Spirit." *The Philadelphia Photo Review* (January 1976), pp. 4-5 • Hagen, Charles. "Barbara Blondeau." *Afterimage* (March 1976), pp. 10-13 • Grundberg, Andy. "Chicago, Moholy and After." *Art in America* (September-October 1976), pp. 34-39.

Laurie Brown

Born: Austin, Tex., 1937

Resides: Laguna Beach, Calif.

Education: Scripps College, Claremont, Calif., B.A., 1959; California State University at Fullerton, M.A., 1976.

Professional Experience: Photography instructor, Orange Coast College, Costa Mesa, Calif., 1976-1979.

Recognition and Awards: National Endowment for the Arts Photography Fellowship, 1978-1979.

Individual Exhibitions: 1976 — California State University at Fullerton (May 9-13); B.C. Space, Laguna Beach, Calif. 1977 — Floating Wall, Santa Ana, Calif. 1978 — G. O. Gallery, UCLA; ARCO Center for Visual Arts, Los Angeles. 1979 — Janus Gallery, Venice, Calif. 1980 — Stage One Gallery, Orange, Calif. 1982 — Janus Gallery, Los Angeles (Apr. 30-May 29).

Selected Group Exhibitions: 1975 — *First All-California Photo Show*, Laguna Beach Museum of Art, Calif.; *Zy-mur-gy*, Cameraworks/Soho Photo Gallery, Los Angeles. 1976 — *Second All-California Photo Show*, Laguna Beach Museum of Art; *The Altered Photograph*, Cedars-Sinai Medical Center, Los Angeles (catalogue: *Exhibitions '76-'77*). 1978 — *First Biennial Juried Show*, Los Angeles Municipal Art Gallery (catalogue). 1979 — *Photographic Directions, Los Angeles, 1979*, Security Pacific Bank, Los Angeles (catalogue); *Attitudes**; *Our Own Artists: Art of Orange County*, Newport Harbor Art Museum, Newport Beach, Calif. (catalogue); *L.A. Issue*, LAICA. 1980 —

Los Angeles Photographers, Center for Creative Photography, University of Arizona, Tucson; *Sequence Photography****; *New Landscapes Part II*, The Friends of Photography, Carmel, Calif. (Dec. 5, 1980-Jan. 11, 1981; catalogue). 1981 — *California, The State of Landscape 1872-1981*, Newport Harbor Art Museum (catalogue). 1982 — *Slices of Time**; *Of No Particular Theme*, Baxter Art Gallery, California Institute of Technology, Pasadena (May 12-June 20; catalogue).

Selected Articles, Essays, and Reviews: Askey, Ruth. "Figures, Landforms, Grids." *Artweek* (July 1, 1978), p. 8 • Lerner, Eric, ed. "In Situ . . . Photographs by Grant Mudford, Laurie Brown and Robert Glenn Ketchum." *ZERO*, vol. 4 (1980), pp. 76-84 • Wilson, William. "Galleries." *Los Angeles Times*, May 7, 1982, Part VI, p. 8 • Nicholson, Chuck. "Contemporary Romanticism." *Artweek* (May 22, 1982), pp. 13-14.

Wynn Bullock

Born: Chicago, 1902

Died: Pacific Grove, Calif., Nov. 16, 1975

Education: Studied voice and languages in New York, 1921-1928; continued studies in Paris, Milan, and Berlin, where he first saw the work of Laszlo Moholy-Nagy and became interested in photography, 1928-1931; attended University of West Virginia as a pre-law student, 1932-1937; studied under Edward Kaminski at Los Angeles Art Center School, 1938-1940.

Professional Experience: Began to do free-lance commercial and portrait photography, 1940; did photographic work in the aircraft industry, first at Lockheed Aircraft Company, then at Gonners-Joyce Company, where he headed the photographic department until the end of World War II; traveled throughout California, producing and selling post card pictures, 1945-1946; obtained the photographic concession at Fort Ord military base in Monterey, Calif., and established a commercial photography business, 1946; after eight years of research in solarization, received patents in U.S., Canada, and Great Britain for a "photographic process for producing line image," 1948; received second U.S. patent on "methods and means for matching opposing densities in photographic film," early 1950s; instructor in advanced photography, San Francisco State College, 1959; left photographic concession at Fort Ord, 1959; continued free-lance work until 1968; became trustee and chairman of the exhibition committee at inception of The Friends of Photography, Carmel, Calif. 1970.

Recognition and Awards: Photograph, *Let There Be Light*, voted outstanding favorite in *Family of Man* exhibition by overwhelming majority of 65,000

viewers at Corcoran Gallery of Art, Washington, D.C., 1956; awarded honor medal for photographs in *Salon of International Photography*, sponsored by Photo Cine Club du Val de Bievre (jurors included Man Ray and Daniel Masclet), 1957; given highest annual award of Professional Photographers of Northern California in "national recognition of the contributions to professional photography as a fine art," 1960; awarded certificate of excellence at *26th Annual Exhibit* of Art Director's Club of Philadelphia, 1961; given achievement award by Professional Photographers of Southern California in recognition of distinguished accomplishments in the profession, 1961; awarded honors at *17th Annual Western Exhibit of Advertising and Editorial Art*, sponsored by Professional Photographers of America and by the City of Versailles, France, 1962; awarded honorary life membership by Camera Craftsmen, 1970; his book, *Wynn Bullock*, chosen one of the 50 best books of 1971 by American Institute of Graphic Arts.

Individual Exhibitions: 1941 — Los Angeles County Museum of Art. 1947 — Santa Barbara Museum of Art, Calif. 1955 — Limelight Gallery, New York. 1956 — M. H. DeYoung Museum, San Francisco; GEH, Rochester, N.Y. 1957 — The Johannesburg Photographic and Cine Society, South Africa (traveled); Oakland Public Museum, Calif. 1958 — Art Center of Czechoslovakia, Prague. 1960 — Graphic Arts Department, Princeton University, N.J.; Ikon Gallery, Venice, Calif. 1961 — Fine Arts Gallerie Pierre Vanderborght, Brussels, Belgium. 1962 — Carl Siembab Gallery, Boston. 1963 — Toren Art Gallery, San Francisco. 1964 — University of Florida, Gainesville. 1966 — GEH (traveled). 1967 — Institute of Design, Illinois Institute of Technology, Chicago; Jacksonville Museum of Art, Fla. 1968 — Rhode Island School of Design, Providence; Camerawork Gallery, Newport Beach, Calif. 1969 — San Francisco Museum of Art (catalogue); Media Center, University of St. Thomas, Houston; The Witkin Gallery, New York. 1970 — Amon Carter Museum of Western Art, Fort Worth, Tex. 1971 — Museum of New Mexico, Santa Fe (opened June 27); The Friends of Photography, Carmel, Calif. (September-October). 1972 — *Wynn Bullock: 20 Color Photographs/Light Abstractions*, de Saisett Gallery and Museum, University of Santa Clara, Calif. (catalogue); Royal Photographic Society, London. 1973 — Bibliothèque Nationale, Paris; Light Gallery, New York; Pasadena Art Museum, Calif. 1974 — Madison Art Center, Wis.; Focus Gallery, San Francisco. 1975 — United States Information Agency traveling exhibition, Wash-

ington, D.C. 1976 — The Metropolitan Museum of Art, New York; The Art Institute of Chicago; San Francisco Museum of Art. 1978 — *Wynn Bullock: 1902-1975*, Pallas Photographica Gallery, Chicago (Apr. 26-June 3).

Selected Group Exhibitions: Several major monographs with bibliographies exist for this photographer, so group exhibitions and major articles, essays, and reviews previous to the publication of the monographs have been omitted. See *Wynn Bullock: Photography, A Way of Life*, 1973, and *Wynn Bullock*, 1976. Group exhibitions which occurred after the publication of these monographs include the following: 1976 — *The Photographer's Choice* (book); *American Photography: Past into Present.** 1977 — *Photographs: Sheldon Memorial Art Gallery Collections.*** 1978 — *Amerikanische Landschaft-Photographie.** 1979 — *Diverse Images***; *Approaches to Photography**; *Photography: Venice '79.** 1980 — *Photographs from the Collection of Dan Berley***; *Kalamazoo Collects Photography***; *American Children***; *Southern California Photography 1900-1965: An Historical Survey*, Los Angeles County Museum of Art (Dec. 18, 1980-Mar. 15, 1981; catalogue; organized by The Photography Museum). 1981 — *American Landscapes*, MOMA, New York (July 9-Sept. 27). 1982 — *Color as Form.**

Monographs: Mack, Richard. *The Widening Stream.* Poetry with photographs by Wynn Bullock. Peregrine, Carmel, Calif., 1965 • *Wynn Bullock.* Text by Barbara Bullock, notes by Wynn Bullock. Scrimshaw, San Francisco, 1971 • DeCock, Liliane, ed. *Wynn Bullock: Photography, A Way of Life.* Text by Barbara Bullock-Wilson. Morgan & Morgan, Dobbs Ferry, N.Y., 1973 • Bullock, Wynn. *The Photograph as Symbol.* Artichoke Press, Capitola, Calif., 1976 • *Wynn Bullock.* Introduction by David Fuess. Aperture, Millerton, N.Y., 1976.

Books: Lewis, Eleanor, ed. "Photograph as Symbol." *Darkroom.* Lustrum Press, New York, 1971, pp. 7-21 • Hill, Paul, and Cooper, Thomas. "Wynn Bullock." *Dialogue with Photography.* Farrar, Straus and Giroux, New York, 1979, pp. 313-37. See also Life Library, *The Great Themes*; Lyons, *Photographers on Photography*; Jay, *Views on Nudes*; and Gassan, *A Chronology of Photography.*

Harry Callahan

Born: Detroit, Oct. 22, 1912
Resides: Providence, R.I.
Education: Self-taught photographer; began as hobbyist, 1938; attended photography lectures while a member of the Detroit Photo Guild, 1941.

Professional Experience: Worked as a processor in the photography lab at General Motors Corporation, 1944-1945; became an instructor in the Photography Department of Chicago's Institute of Design (which became part of the Illinois Institute of Technology in 1950); appointed head of the Photography Department of the Institute of Design of the Illinois Institute of Technology, 1949; taught a summer course at Black Mountain College, N.C., with Aaron Siskind, 1951; appointed chairman of the Photography Department at the Rhode Island School of Design (R.I.S.D.), Providence; became an associate professor, developing undergraduate and master's programs in photography, 1961; promoted to full professor, 1964; taught master class in photography, University of California at Berkeley, 1966; received appointment as a Visitor to the School at the Boston Museum of Fine Arts, 1970; resigned as chairman of the R.I.S.D. Department of Photography, but returned to teach after several months' leave of absence, 1973; lectured at University of Massachusetts, Boston, as part of the photography lecture series, "Photographic Perspectives," 1974; retired from the R.I.S.D. faculty, 1977.

Recognition and Awards: Received award for "remarkable photographic work" exhibited at *Photokina: International Photo and Cinema Exhibition*, Cologne, West Germany, 1951; received The Graham Foundation Award for Advanced Studies in the Fine Arts, a $10,000 stipend (highest grant given to a still photographer, first photographer to receive the award), 1956; won Photographic Award at the Rhode Island Arts Festival, Providence, 1963; attended White House Festival of the Arts at the invitation of Pres. Lyndon B. Johnson, 1969; received Governor's Award for Excellence in the Arts, Providence, 1969; received citation for distinguished contribution as an artist, photographer, and educator from the National Association of Schools, Rochester, N.Y., 1972; received John Simon Guggenheim Memorial Foundation Fellowship, 1972; honored as photographer and educator by the Society for Photographic Education, 1976; honored photographer at the 8e Recontres Internationales de la Photographie, Arles, France, 1977; selected (with painter Richard Diebenkorn) by International Exhibitions Committee of the American Federation of Arts to represent U.S. at the *XXXVIII Venice Biennial* (first time a photographer had been selected), 1978; elected Fellow of the American Academy of Arts and Sciences, Boston, 1979; received honorary Doctorate of Fine Arts from the Rhode Island School of Design, Providence, 1979; awarded for "Distin-

guished Career in Photography" by The Friends of Photography, Carmel, Calif., 1981; designated a Fellow of the R.I.S.D., 1981.

Individual Exhibitions: 1946 — 750 Studio Gallery, Chicago. 1951 — *Harry Callahan: Photographs by Series*, The Art Institute of Chicago (April); Black Mountain College, N.C.; *Leading Photographers* (organized by MOMA, New York; traveled). 1956 — Kansas City Art Institute, Mo. 1958 — GEH, Rochester, N.Y. 1961 — Superior Street Gallery, Chicago. 1962 — University of Warsaw, Poland. 1963 — Galeria Krysztofory, Krakow, Poland; Galeria Towawsystwo, Warsaw, Poland; Carl Siembab Gallery, Boston. 1964 — The Heliography Gallery, New York; The Hallmark Gallery, New York. 1966 — Kiosk Galleries, Reed College, Portland, Ore. 1968 — Creative Photography Gallery, MIT, Cambridge; MOMA, New York (catalogue; traveled). 1969 — GEH (traveled). 1970 — The Friends of Photography, Carmel, Calif.; The Witkin Gallery, New York; Carl Siembab Gallery. 1971 — 831 Gallery, Birmingham, Mich.; *Harry Callahan: The City*, GEH (Sept. 25, 1971-Jan. 3, 1972; traveled). 1972 — Light Gallery, New York (Dec. 5, 1972-Jan. 6, 1973). 1974 — Light Gallery (Nov. 12-Dec. 7); Middle Tennessee State University Photographic Gallery, Murfreesboro (Sept. 29-Oct. 17). 1975 — Creative Photography Gallery; Cronin Gallery, Houston (Nov. 18-Dec. 27). 1976 — The Minneapolis Institute of Arts; *Harry Callahan: Studies in Nature*, Picture Gallery, Zurich, Switzerland; Galerie Lichttropfen, Aachen, West Germany; MOMA, New York (catalogue; traveled); Light Gallery. 1977 — Galerie Zabriskie, Paris; Enjay Gallery, Boston; David Mirvish Gallery, Toronto (Apr. 16-May 10); 8e Recontres Internationales de la Photographie, Musée Réattu, Arles, France; Susan Spiritus Gallery, Newport Beach, Calif. (Sept. 16-Oct. 29); Grapestake Gallery, San Francisco. 1978 — Museum of Art, University of Arizona, Tucson (Sept. 10-Oct. 15); *XXXVIII Venice Biennial*, Italy (catalogue); *Harry Callahan/City*, Davidson College Art Gallery, N.C. (Jan. 15-Feb. 15); Galerie Fiolet, Amsterdam, The Netherlands; *Harry Callahan – Color Photographs*, Light Gallery (Mar. 29-Apr. 22); *The Beach Series*, Galerie Zabriskie; *Harry Callahan – Original Photographs*, The Gilbert Gallery, Chicago (Oct. 6-Nov. 3). 1979 — Atlanta Gallery of Photography; *Photographs in Color – Harry Callahan – The Years 1946-1978*, Center for Creative Photography, University of Arizona, Tucson (catalogue; traveled); Afterimage Photographic Gallery, Dallas. 1980 — *The Beach Series*, Light Gallery (Mar. 29-May 5); Halsted Gallery, Detroit; Museum of New Mexico, Santa Fe; Akron Art Institute,

Ohio; Hudson River Museum, Yonkers, N.Y.; Light Gallery (September); Grapestake Gallery (Oct. 9-Nov. 15); Jane Corkin Gallery, Toronto (Oct. 4-29). 1981 — Hallmark exhibition (catalogue; traveled). 1982 — Clemons Gallery, Houston (May 7-June 5).

Selected Group Exhibitions: Several major monographs with bibliographies exist for this photographer; therefore, group exhibitions and major articles, essays, and reviews previous to the publication of the monographs have been omitted. These monographs are listed below. Group exhibitions which occurred after the publication of these monographs include the following: 1979 — *American Images: New Work by Twenty Contemporary Photographers*, Corcoran Gallery of Art, Washington, D.C. (sponsored by American Telegraph and Telephone Co.; catalogue and book; traveled); *Approaches to Photography**; *Attitudes.** 1980 — *The New Vision* (book); *American Children***; *Photography of the Fifties**; *Kalamazoo Collects Photography***; *Photographs from the Collection of Dan Berley***; *Aspects of the 70's: Photographs.** 1981 — *American Photographers and the National Parks**; *Acquisitions 1973-1980*, IMP/GEH, Rochester, N.Y. (July 12-Sept. 13; catalogue); *The New Color: A Decade of Color Photography*, International Center of Photography, New York (October; book; traveled); *American Landscapes*, MOMA, New York (July 9-Sept. 27; catalogue); *Transfixed by Light – Photographs from the Menil Foundation Collection: Selected by Beaumont Newhall*, Rice Museum, Houston (Mar. 21-May 24; catalogue); *A Photographic Patron – The Carl Siembab Gallery*, Institute of Contemporary Art, Boston (Mar. 17-May 10; catalogue). 1982 — *A History of Photography from Chicago Collections***; *Color as Form.**

Monographs: Martin, Gordon, and Siskind, Aaron, eds. *The Multiple Image: Photographs by Harry Callahan.* Introduction by Jonathan Williams. Press of the Institute of Design, Chicago, 1961 • *Photographs: Harry Callahan.* Introduction by Hugo Weber. Van Riper & Thompson, Santa Barbara, Calif., 1964 • *Harry Callahan.* Introduction by Sherman Paul. MOMA, New York, 1967 • *Callahan.* Edited and with an introduction by John Szarkowski. Aperture, Millerton, N.Y., 1976 • *Harry Callahan.* Edited and with an introduction by Peter Bunnell. American Federation of Arts and Rizzoli International, New York, 1978 • Callahan, Harry. *Harry Callahan: Color.* Matrix Publications, Providence, R.I., 1980 • Callahan, Harry. *Water's Edge.* Callaway Editions, Old Lyme, Conn., 1980.

Books: Abbott, Berenice. *New Guide to Better Photography.* Rev. ed. Crown Publishers, New York, 1935, pp. 20, 52 • Downs, Bruce, ed. *Color Photography Annual 1956.* Ziff-Davis, New York, 1956, p. 90 • *American Society of Magazine Photographers Picture Annual.* Simon & Schuster, New York, 1957, pp. 22-27 • Dorfles, Gillo. "Photography." In *Encyclopedia of World Art*, vol. 11. McGraw-Hill, New York, 1959, p. 31 • *Photography Annual 1960.* Compiled by the editors of *Popular Photography.* Ziff-Davis, 1959, p. 115 • Eigner, Larry. *On My Eyes.* Jonathan Williams, Highland, N.C., 1960 • Knapp, Dee. "Callahan." In *Encyclopedia of Photography*, vol. 3. Edited by Willard Morgan. Greystone, New York, 1963 • *Photography of the World '66.* Heibousha, Tokyo, Japan, 1966, pp. 17, 18 • Coleman, Allan D. "Harry Callahan: An Interview." In *Creative Camera International Yearbook 1977.* Edited by Colin Osman and Peter Turner. Cool Press Ltd., London, 1976, pp. 74-108 • Kelly, Jain, ed. *Nude: Theory.* Lustrum Press, New York, 1979, pp. 27-47 • di Grappa, Carol, ed. *Landscape Theory.* Lustrum Press, 1980, pp. 41-58 • Alinder, James, ed. "Harry Callahan, Distinguished Career in Photography." *Discovery and Recognition Untitled 25.* The Friends of Photography, Carmel, Calif., 1981, pp. 10-15 • Diamonstein, Barbaralee. *Visions and Images: American Photographers on Photography.* Rizzoli International, New York, 1981, pp. 11-22 • See also Steichen, *The Family of Man*; Lyons, *Photographers on Photography*; Szarkowski, *The Photographer's Eye*; Lyons, *Photography in the Twentieth Century*; Life Library, *The Art of Photography*, *Great Photographers*, and *Great Themes*; Pollack, *The Picture History of Photography*; Szarkowski, *Looking at Photographs*; Goldberg, *Photography in Print*; Wise, *The Photographer's Choice*; Traub, *The New Vision*; Jay, *Views on Nudes*; Jeffrey, *Photography, A Concise History*; Newhall, *The History of Photography*; and Gassan, *A Chronology of Photography.*

Robert Cumming

Born: Worcester, Mass., 1943

Resides: Orange, Calif.

Education: Massachusetts College of Art, Boston, B.F.A. in painting, 1965; University of Illinois, Champaign, M.F.A. in painting, 1967.

Professional Experience: Teaching assistant, University of Illinois, Champaign, 1965-1967; instructor, University of Wisconsin, Milwaukee, 1967-1970; assistant professor, California State College, Fullerton, 1970-1972. Visiting lecturer: California State University, Long Beach, 1972-1974; University of California, Riverside, 1973; Chapman College, Orange, Calif., 1974; UCLA Extension, 1974-1977; The Art Institute of Chicago, 1976; Otis

Art Institute, Los Angeles, 1975-1976; Orange Coast College, Costa Mesa, Calif., 1976; California Institute of the Arts, Valencia, 1976-1977; University of California, Irvine, 1977-1978; associate professor, Hartford Art School, West Hartford, Conn., 1978-present.

Recognition and Awards: Elmer Winter Award, Milwaukee Art Center, 1968; Frank Logan Prize (sculpture), The Art Institute of Chicago, 1969; outdoor sculpture commission, Walker Art Center, Minneapolis, 1970; Purchase Prize (sculpture), San Diego State College, 1972; outdoor sculpture commission, Walker Art Center, Minneapolis, 1970; National Endowment for the Arts Photography Fellowship, 1972, Conceptual Art Fellowship 1974; one-month working residence, Corcoran Gallery of Art, Washington, D.C., 1975; *Commissioned Video Works*, University Art Museum, Berkeley, Calif., 1976; John Simon Guggenheim Memorial Foundation Fellowship, 1980; Japan-U.S. Friendship Commission, Washington, D.C. (Artist-in-Residence Exchange Program), 1981.

Individual Exhibitions: 1973 — Phoenix College, Ariz.; California Institute of the Arts, Valencia; John Gibson Gallery, New York; University of California, Irvine. 1975 — Verelst-Poirer Gallery, Brussels, Belgium; John Gibson Gallery; A Space Gallery, Toronto. 1976 — University of Iowa, Iowa City; Newspace Gallery, Los Angeles; Los Angeles Institute of Contemporary Art; *The Nation's Capital in Photographs, 1976*, Corcoran Gallery of Art, Washington, D.C. (Feb. 14-May 9; catalogue). 1977 — *Prop Reality Propositions – A Selection of Works 1970 - 76 – Robert Cumming*, Arton's, Calgary, Alberta, Canada (Aug. 24-Sept. 24); John Gibson Gallery. 1978 — University of Rhode Island, Kingston; Grossmont College, El Cajón, Calif.; Thomas Lewallen Gallery, Santa Monica, Calif. (May 16-June 17); Real Artways, Hartford, Conn.; The Gilbert Gallery, Chicago. 1979 — *Robert Cumming: Recent Work*, The Gilbert Gallery (Jan. 5-Feb. 3); retrospective, The Friends of Photography, Carmel, Calif. (catalogue); retrospective, Institute of Modern Art, Brisbane, Australia (traveled); Nova Gallery, Vancouver, B.C., Canada (Nov. 20-Dec. 25); Blue Sky Gallery, Portland, Ore.; Evergreen State College, Olympia, Wash.; *Robert Cumming: Original Photographs*, The Gilbert Gallery (Nov. 7-24). 1980 — Bard College, Annandale, N.Y.; Rhode Island School of Design, Providence; Film in the Cities Gallery, Minneapolis; *Robert Cumming: Recent Photographs*, The Gilbert Gallery (Oct. 31-Nov. 22). 1981 — *Robert Cumming: Retrospective Photographs and Assemblages*, The Gilbert Gallery.

1982 — *Robert Cumming's – Silhouettes, Drawings, and Photos,* Castelli Uptown, New York (May 1-June 12).

Selected Group Exhibitions: 1968 — *Wisconsin Painters and Sculptors,* Milwaukee Art Center (also 1969, 1970, and 1974; catalogue). 1969 — *Chicago and Vicinity,* The Art Institute of Chicago (catalogue); two-man exhibition with William Wegman, Bradford Junior College, Mass.; *Art by Telephone,* Museum of Contemporary Art, Chicago (catalogue); *Other Ideas,* Detroit Institute of Arts (catalogue). 1970 — *Is Art Doing Away with Museums?,* University of Wisconsin, Milwaukee; *Art in the Mind,* Oberlin College, Ohio (catalogue); *9 Artists/ 9 Spaces* (outdoor commission), Walker Art Center, Minneapolis (catalogue). 1971 — Allan Frumkin Gallery, Chicago; *24 Young Los Angeles Artists,* Los Angeles County Museum; Hundred Acres Gallery, New York. 1972 — *Books by Artists,* Newport Harbor Art Museum, Newport Beach, Calif.; *Small Sculpture,* San Diego State College; California State College, Hayward (catalogue); *Artists' Films,* Montgomery Art Center, Pomona College, Claremont, Calif.; *New Art in Orange County,* Newport Harbor Art Museum (catalogue). 1973 — *National Community Art Competition,* Housing and Urban Development, Washington, D.C. (catalogue); *Festival of Contemporary Art,* Oberlin College (catalogue); Ruth Schaffner Gallery, Santa Barbara, Calif.; *Minor White/Robert Heinecken/Robert Cumming. Photograph as metaphor – Photograph as object – Photograph as documentation of concept***; *Record as Artwork,* Francoise Lambert Gallery, Milan, Italy. 1974 — *Art Fair,* Dusseldorf, West Germany (also 1975 and 1976); *International Art Fair,* Basel, Switzerland (also 1975 and 1976); *Narrative Two,* John Gibson Gallery; two-man exhibition, Newport Harbor Art Museum; Jack Glenn Gallery, Newport Beach; *14 American Photographers,* Baltimore Museum of Art (traveled; catalogue); *Art Fair,* Cologne, West Germany (also 1975 and 1976); Cannaviello Gallery, Rome. 1975 — Livorno Museum, Italy; *Chair Show,* Art Gallery of Toronto (catalogue); *Narrative Art,* Palais des Beaux Arts, Brussels, Belgium (catalogue); *(photo) (photo)² ... (photo)ⁿ: Sequenced Photographs***; *Photography 2,* Jack Glenn Gallery (catalogue); *Wisconsin Directions,* Milwaukee Art Center (catalogue); *Word-Image-Number,* Sarah Lawrence College, Bronxville, N.Y. (catalogue); *Narrative Art,* University of Guelph, Toronto (catalogue); *Narrative Two,* Cannaviello Gallery. 1976 — *Pan Pacific Biennial,* Auckland, New Zealand (catalogue); *Conceptual Photography,* La Mamelle Gallery, San Francisco; California State University at Northridge; *The Photographer's Choice* (book); *The Printed Work,* San José State College, Calif. (catalogue); *Sequences,* Broxton Gallery, Los Angeles; *Southland Video Anthology,* Long Beach Museum of Art, Calif. (catalogue); *LAXSIX,* Mount St. Mary's College Art Gallery, Los Angeles (catalogue); *Narrative Art,* Diagramma, Luciano Inga-Pin, Milan, Italy; *Narrative Art,* Daniel Templan Gallery, Paris; *American Photography: Past into Present***; *Photography and Language,* co-sponsored by La Mamelle Gallery and Camerawork Gallery, San Francisco (catalogue). 1977 — *Copying/Re-copying,* Galerie Gaetan, Geneva, Switzerland (catalogue); Robert Self Gallery, London (traveled); *Bent Photography – West Coast U.S.A.,* Australian Center for Photography, Sydney, Australia (catalogue; traveled: 1977, 1978); *Paris Bienniale* (catalogue; traveled); *Whitney Biennale,* Whitney Museum of American Art, New York (catalogue); *The Artist and the Photograph,* Israel Museum, Jerusalem (catalogue); *The Artist's Book,* University of California at San Diego, La Jolla (catalogue); *Contemporary American Photographic Works,* The Museum of Fine Arts, Houston (Nov. 4-Dec. 31; catalogue; traveled); *American Narrative/Story Art.*** 1978 — *40 American Photographers*; two-man show with William Wegman, Baxter Art Gallery, California Institute of Technology, Pasadena (catalogue); Hallswalls Gallery, Buffalo, N.Y. (catalogue); *Contemporary California Photography*; *Photograph as Artifice,* California State University, Long Beach (catalogue; traveled); *Mirrors and Windows*; *Children in America,* The High Museum of Art, Atlanta (catalogue). 1979 — *Attitudes*; *Fabricated to Be Photographed,* San Francisco Museum of Modern Art (Nov. 15-Dec. 30; catalogue; traveled); *Story Art/Narrative Art,* Heidelberg Museum and Bonn Museum, West Germany (catalogue); *Lis '79, International Exhibition of Drawing,* National Modern Art Gallery, Lisbon, Portugal (catalogue; traveled); *Inverted Images,* University of California, Santa Barbara (traveled; catalogue); *The Photographer's Hand,* IMP/GEH (July 17-Sept. 16; traveled). 1980 — *20 x 24 Light,* Light Gallery, New York (catalogue; traveled); *Farbwerke,* Kunsthaus, Zurich, Switzerland (catalogue; traveled); *The Artist's Book,* Art Metropole, Toronto (travels through 1982); *Aspects of the '70's. Photography.* 1981 — *Photo Facts and Opinions.* 1982 — *Color as Form.*

Monographs (privately printed unless otherwise stated): *Picture Fictions.* Anaheim, Calif., 1971 (reprinted 1973) • *The Weight of Franchise Meat.* Anaheim, 1971 • *A Training in the Arts.* Coach House Press, Toronto, 1973 (reprinted 1977) • *A Discourse on Domestic Disorder.* Irvine, Calif., 1975 • *Interruptions in Landscape and Logic.* Los Angeles, 1977 • Alinder, James. *Cumming, Photographs.* The Friends of Photography, Carmel, Calif., 1979 • *Equilibrium and the Rotary Disc.* Diana's Bimonthly Press, Providence, R.I., 1980 • *Robert Cumming, Drawings for Photographs and Props.* Experimental Art Foundation, Adelaide, Australia, 1980.

Other Books: Davis, Douglas. *Art in the Future.* Praeger Publishers, New York, 1974, p. 180 • Huebler, Douglas. *Global Duration Piece #8.* Bradford, Mass., Spring 1974, p. 39 • Lord, Chip. *Autoamerica.* Ant Farm, San Francisco, and E.P. Dutton, New York, 1976, pp. 5,7,66,80,114 • Phillips, D.L., ed. *Eros and Photography.* NFS Press, San Francisco, 1977 • See also Wise, *The Photographer's Choice.*

Selected Articles, Essays, and Reviews since 1974 (for complete prior listing, see *Contemporary American Photographic Works,* The Museum of Fine Arts, Houston): Foschi, Patricia G. "Robert Cumming: Parodist of Logical Systems." *Midwest Art* (July 1974) • Foschi, Patricia G. "Robert Cumming's Eccentric Illusions." *Artforum* (Summer 1975), pp. 38-39 • DeAk, Edit. "Robert Cumming at Gibson." *Art in America* (September-October 1975), pp. 94-95 • Murray, Joan. "Photograph in Sequence." *Artweek* (Oct. 4, 1975), pp. 13-14 • Woolard, Robert W. "Uses and Misuses of Sequential Images." *Artweek* (May 22, 1976), p. 11 • Coleman, A.D. "The Directional Mode." *Artforum* (September 1976), pp. 55-61 • Chrissmas, Dwight. "Reviews: Two Cherries and a Lemon." *The Dumb Ox* (Winter 1977), pp. 20-22 • Fishman, Lois. "The Photographer and the Drawing — Cumming, Fitch, Misrach." *Creative Camera,* London (August 1977), pp. 256-73 • Rubinfein, Leo. "Through Western Eyes." *Art in America* (September-October 1978), pp. 75-83 • Onorato, Ronald J. "Reviews: Robert Cumming/Kingston, Rhode Island." *Artforum* (April 1978), pp. 73-74 • Hugunin, James. "Robert Cumming: 'trucage' falsehoods." *Afterimage* (December 1978), pp. 8-9 • Hugunin, James. "Robert Cumming, Photograph." *LAICA Journal* (March/April 1979), pp. 47-50 • Wortz, Melinda. "Crawling, like Alice, down the rabbit hole." *Art News* (January 1979), pp. 71-74 • Fisher, Hal. "Curatorial Constructions." *Afterimage* (March 1980), pp. 7-9 • Excerpted short stories and drawings. *FILE,* Toronto (Summer 1980) • "The Altered Subject." *Quiver* (1980) • Gever, Martha. "Reviews: Circular Reasoning." *Afterimage* (April 1982), p. 16 • Grundberg, Andy. "Pho-

tography View: A Purposeful Blurring of Illusion and Reality." *New York Times*, May 30, 1982, Sec. 2, p. 29.

William DeLappa

Born: Santa Monica, Calif., Dec. 8, 1943

Resides: Albany, Calif.

Education: Ohio University and Baldwin-Wallace College (studied history, English, and drama), 1962-1964; Graphic Arts Workshop, San Francisco, 1973-1978; University of California at Berkeley, 1980-1982 (studied photography and nonsilver processes).

Professional Experience: Set up portrait photography studio, San Francisco, 1969-1974; worked free-lance, 1965-present; taught photography at Graphic Arts Workshop, San Francisco, 1975-1976; various other teaching positions, 1976-1979; taught private classes, 1972-present.

Recognitions and Awards: National Endowment for the Arts Photography Fellowship, 1979; James D. Phelan Art Award in Photography, 1980.

Individual Exhibitions: 1975 — Graphic Arts Workshop, San Francisco (March-April); Thackrey/Robertson Gallery, San Francisco (December-January 1976). 1976 — Light Work, Syracuse, N.Y. (June-July); California Gallery, San Francisco (June-July); *Portraits of Violet and Al*, Community Darkrooms Gallery, Syracuse, N.Y. (June 15-July 13); Center for Creative Photography, University of Arizona, Tucson (July-August); Arkansas Arts Center, Little Rock (August-September); Colorado Photographic Arts Center, Denver (September-October); Kalamazoo Institute of Arts, Mich. (September-October); Meramec Humanities Gallery, St. Louis (September); Sun Valley Center for the Arts, Idaho (October); Infinite Eye Gallery, Milwaukee (October-November); Grand Rapids Art Museum, Mich. (November); Hackley Art Museum, Muskegon, Mich.; *The Portraits of Violet and Al — a photographic fiction*, College of Marin, Kentfield, Calif. (November-December). 1977 — Front Space Gallery, Seattle (February); Mt. San Antonio College, Walnut, Calif. (April-May); 13 x 15 Gallery, St. Louis (May); *Portraits of Violet and Al, Timeways, Regeneration, and The Diary*, The International Center of Photography, New York (Mar. 17-April); Virginia Intermont College, Bristol (April-May); Untitled Gallery, Harrisonburg, Va. (June); Mendocino Art Center, Calif. (June-July); Photoworks, Richmond, Va. (July); PFMI Gallery, Pittsburgh (September-October); Florida Center for the Arts, Tampa (September-October); Norton Art Museum, West Palm Beach, Fla. (October-December). 1980 — *Portraits of Violet and Al*, Nexus Gallery, At-

lanta (Jan. 6-23); *Portraits of Violet and Al — a photographic fiction*, Columbia Gallery of Photography, Mo. (Feb. 4-29); Maine Photographic Workshop, Rockport; University of California, Riverside (July); University of New Mexico Art Museum, Albuquerque (November).

Selected Group Exhibitions: 1974 — Graphic Arts Workshop, San Francisco (December-January 1975). 1976 — Camerawork Gallery, San Francisco. 1977 — International Center of Photography, New York; Ohio University, Athens (May). 1978 — *Contemporary California Photography**; *Three Photographic Visions*, Trisolini Gallery, Athens, Ohio (May 10-June 4; catalogue; traveled). 1980 — *Photographs by William DeLappa, John Takami Morita, Marcia Resnick – Three Approaches to Visual Biographies*, The Friends of Photography, Carmel, Calif. (Apr. 25-May 25; brochure). 1981 — *James D. Phelan Art Award in Photography, 1980*, Camerawork Gallery (Feb. 10-Mar. 14); *Claire Burch/William DeLappa*, Berkeley Art Center, Calif. (Oct. 2-31).

Selected Articles, Essays, and Reviews: Fischer, Hal. "An Album of Two Lives." *Artweek* (December 1975), p. 11 • Albright, Thomas. "Study of a Marriage." *San Francisco Chronicle*, December 1975 • "Interview: John Marlowe with William DeLappa." *Currant Art* (January 1976) • *Art News* (March 1976), p. 88 • Tipmore, David. "Memories of Time Fake." *Village Voice* (Apr. 11, 1977), p. 77 • Gross, Fred. "Theater and Still Photography." *Photograph*, vol. 1, no. 4 (1977), pp. 14-15, 38 • *Creative Camera* (October 1977), cover, pp. 330-53 • Costello, Michael. "Tabletop History." *Afterimage* (April 1978), pp. 18-19 • Coleman, A.D. "Is It Time to Stop Believing Photographs?" *Camera 35* (October 1978), pp. 68-71 • Fischer, Hal. "Levels of Content and Perception." *Artweek* (Feb. 25, 1981), p. 15 • *Afterimage* (March 1981), p. 19.

Thomas Eakins

Born: Philadelphia, July 1844

Died: Philadelphia, June 25, 1916

Education: Pennsylvania Academy of Fine Arts, Philadelphia (studied drawing), 1862-1866; Jefferson Medical School, Philadelphia (studied anatomy), 1864-1865; Ecole des Beaux Arts, Paris, 1866-1869.

Professional Experience: Taught anatomy (without pay), 1876-1879, Pennsylvania Academy of Fine Arts, Philadelphia, professor of drawing and painting, 1879-1886; began taking photographs, 1880; met Muybridge, saw stop-action photographs of bathing and wrestling figures, 1883; resigned from Pennsylvania Academy of Fine Arts, 1886; Philadelphia Art Students League formed by his students, 1886; taught at National

Academy of Design, Women's School of Art, and Cooper Union, all in New York, 1888-1894.

Recognition and Awards: Elected to National Academy of Design, New York, 1902; received Temple Gold Medal from Pennsylvania Academy of Fine Arts Annual Exhibition, Philadelphia, 1904.

Individual Exhibitions: 1896 — Exhibition of 29 paintings, Earle's Galleries, Philadelphia (only one-man exhibition in his lifetime). 1917 — Memorial exhibition, The Metropolitan Museum of Art, New York (November); memorial exhibition, Pennsylvania Academy of Fine Arts, Philadelphia (December-January). 1923 — Brummer Galleries, New York. 1925 — Brummer Galleries (traveled). 1930 — Philadelphia Museum of Art (catalogue); Milch Galleries, New York. 1933 — Milch Galleries. 1936 — The Baltimore Museum of Art. 1937 — Kleeman Galleries, New York. 1939 — Joint exhibition, Babcock and Kleeman Galleries, New York. 1944 — Centennial exhibition of Eakins' work, Philadelphia Museum of Art and M. Knoedler & Co., New York. 1945 — Centennial exhibition, Carnegie Institute, Pittsburgh. 1961 — *Thomas Eakins: A Retrospective Exhibition*, National Gallery of Art, Washington, D.C. (Oct. 6-Nov. 12; catalogue; traveled). 1969 — Retrospective exhibition, Whitney Museum of American Art, New York (catalogue); *The Sculpture of Thomas Eakins*, Corcoran Gallery of Art, Washington, D.C. (May 3-June 10; catalogue); *Thomas Eakins: His Photographic Works*, Pennsylvania Academy of Fine Arts (catalogue; traveled). 1976 — *The Olympia Galleries Collection of Thomas Eakins Photographs*, Olympia Gallery, Philadelphia; *A Family Album: Photographs by Thomas Eakins 1880-1890*, Philadelphia Art Alliance (January; catalogue; traveled). 1977 — *The Thomas Eakins Collection of the Hirshhorn Museum and Sculpture Garden*, Washington, D.C. (May 24-Sept. 5; catalogue); *Thomas Eakins, Susan Macdowell Eakins, Elizabeth Macdowell Kinton*, Slack Hall, North Cross School, Roanoke, Va. (Sept. 18-Oct. 2; catalogue). 1980 — *Eakins at Avondale and Thomas Eakins: A Personal Collection*, Brandywine River Museum, Chadds Ford, Pa. (Mar.15-May 18; catalogue). 1981 — *Photographer Thomas Eakins*, ACA Gallery, New York (organized by Olympia Galleries; May; catalogue; traveled). 1982 — *Thomas Eakins: Artist of Philadelphia*, Philadelphia Museum of Art (May 29-Aug. 1; catalogue).

Selected Group Exhibitions: A major monograph with an extensive bibliography exists for this photographer; therefore, group exhibitions and major articles, essays, and reviews previous to

the publication of the monograph have been omitted. See *The Life and Work of Thomas Eakins,* 1974. Group exhibitions which occurred after the publication of this monograph or were not included in the monograph include the following: 1973 — *Combattimento per un'Immagine: Fotografie Pittori.**** 1974 — *Photography in America.** 1976 — *Three Centuries of American Art,* Philadelphia Museum of Art (Apr. 11-Oct. 10; catalogue). 1978 — *A Book of Photographs from the Sam Wagstaff Collection,* Corcoran Gallery of Art, Washington, D.C. (Feb. 4-Mar. 30; book; traveled); *The Male Nude: A Survey in Photography.**

Monographs: Goodrich, Lloyd. *Thomas Eakins: His Life and His Works.* Whitney Museum of American Art, New York, 1933 • McHenry, Margaret. *Thomas Eakins Who Painted.* Privately printed, Oreland, Pa., 1946 • *Metropolitan Museum of Art Miniatures: Thomas Eakins.* The Metropolitan Museum of Art, New York, 1956 • Schendler, Sylvan. *Eakins.* Little, Brown, Boston, 1967 • Soyer, Raphael. *Homage to Thomas Eakins.* South Brunswick, N.J., 1967. Hendricks, Gordon. *The Photographs of Thomas Eakins.* Grossman Publishers, New York, 1972 • Hoopes, Donelson. *Eakins Watercolors.* New York, 1971.

Other Related Books: McKinney, Roland J. *Thomas Eakins.* Crown, New York, 1942 • Porter, Fairfield. *Thomas Eakins.* G. Brayeller, New York, 1959 • Hendricks, Gordon. *The Life and Work of Thomas Eakins.* Grossman Publishers, New York, 1974 • Siegel, Theodore. *The Thomas Eakins Collection.* Grossman Publishers, 1974 • See also Scharf, *Art and Photography;* Coke, *The Painter and the Photograph;* Kahmen, *Art History of Photography;* Witkin and London, *The Photograph Collector's Guide;* Jay, *Views on Nudes;* Sullivan, *Nude: Photographs 1850-1980;* and Gassan, *A Chronology of Photography.*

Selected Articles, Essays, and Reviews: Onorato, Ronald J. "Photography and Teaching: Eakins at the Academy." *American Art Review* (July-August 1976), pp. 127-40 • Wilmerding, John. "Review." *Art Bulletin* (June 1976), pp. 310-12 • Parry, E.C. "Thomas Eakins and the Everpresence of Photography." *Arts Magazine* (June 1977) • "Special Issue: Thomas Eakins." *Arts Magazine* (May 1979), pp. 96-160 (13 articles on Eakins).

William Eggleston

Born: Memphis, Tenn., 1939

Resides: Memphis, Tenn.

Education: Vanderbilt University, Nashville, Tenn.; Delta State College, Cleveland, Miss.; University of Mississippi, Oxford.

Professional Experience: Began photographing, 1957; became seriously interested in photography, 1962; has worked almost exclusively with color materials since late 1960s; lecturer in visual and environmental studies, Carpenter Center, Harvard University, Cambridge, Mass., 1974; taught at MIT, Cambridge, 1978.

Recognition and Awards: John Simon Guggenheim Memorial Foundation Fellowship, 1974; National Endowment for the Arts Photography Fellowship, 1975, 1978.

Individual Exhibitions: 1974 — Jefferson Place Gallery, Washington, D.C. 1975 — Carpenter Center, Harvard University, Cambridge, Mass. 1976 — MOMA, New York (catalogue; traveled). 1977 — Brooks Memorial Art Gallery, Memphis, Tenn.; Grapestake Gallery, San Francisco; Allan Frumkin Gallery, Chicago (Dec. 3, 1977-Jan. 5, 1978); Castelli Graphics, New York (Nov. 26-Dec. 10); Lunn Gallery, Washington, D.C. (Dec. 13, 1977-Jan. 7, 1978). 1979 — Photographer's Gallery, South Yarra, Australia. 1980 — *William Eggleston – Troubled Waters,* Charles Cowles Gallery, New York (Nov. 1-22).

Selected Group Exhibitions: 1974 — *Art Now '74,* Kennedy Center for the Performing Arts, Washington, D.C. 1975 — *14 American Photographers,* Baltimore Museum of Art (Jan. 21-Mar. 2; catalogues; traveled); *Color Photography: Inventors and Innovators 1850-1975,* Yale University Art Gallery, New Haven, Conn. (catalogue); *Photography 2,* Jack Glenn Gallery, Corona del Mar, Calif. (June 14-July 31; catalogue). 1976 — *Aspects of American Photography, 1976*; Masters of the Camera* (book). 1977 — *The Contemporary South,* United States Information Agency traveling exhibition organized by the New Orleans Museum of Art (catalogues published for individual exhibitions in Asia and Europe); *Contemporary American Photographic Works,* The Museum of Fine Arts, Houston (Nov. 14-Dec. 31; catalogue; traveled). 1978 — *Mirrors and Windows*; 23 Photographers, 23 Directions*; The Quality of Presence*; Amerikanische Landschafts-Photographie.** 1979 — *American Images: New Work by Twenty Contemporary Photographers,* Corcoran Gallery of Art, Washington, D.C. (sponsored by American Telephone and Telegraph Co.; catalogue and book; traveled); *Attitudes*; One of a Kind,* The Museum of Fine Arts, Houston (organized by Polaroid Corporation; book; traveled); *Diverse Images**; Photography: Venice 1979*; Photographie als Kunst 1879-1979/ Kunst als Photographie 1949-1979.**** 1980 — *Aspects of the 70's: Photography.** 1981 — *The New Color,* International Center of Photography, New York (October; book; traveled); *Photography: A Sense of Order,* Institute of Contemporary Art, University of Pennsyl-

vania, Philadelphia (Dec. 11, 1981 — Jan. 27, 1982; catalogue). 1982 — *Slices of Time*; Color as Form.**

Monographs: *William Eggleston's Guide.* Edited and with an essay by John Szarkowski. MOMA, New York, 1976.

Books by the Photographer (all limited edition books with original photographs, published by Caldecott Chubb, New York): *Election Eve,* 1977 • *Morals of Vision,* 1978 • *Flowers,* 1978 • *Wedgewood Blue,* 1979 • *Seven,* 1979 • *Jamaica Botanica,* 1979.

Other Books: *Catalogue 5: 19th and 20th-Century Photographs,* Lunn Gallery / Graphic International Ltd., Washington, D.C., 1976 • See also Malcolm, *Diana and Nikon,* and Jeffrey, *Photography: A Concise History.*

Selected Articles, Essays, and Reviews: "Eggleston at M.O.M.A." *Photograph* (Summer 1976), pp. 12, 26 • Scully, Julia. "Seeing Pictures." *Modern Photography* (August 1976), pp. 26, 31, 36 • Fondiller, Harvey V. "Shows We've Seen." *Popular Photography* (October 1976), pp. 31 • Kozloff, Max. "How to Mystify Color Photography." *Artforum* (November 1976), pp. 50-51 • Szarkowski, John. "Choice: Gallery without Walls." *Camera* (November 1976), pp. 12-19 • Porter, Allan. "The Second Generation of Color Photographs." *Camera* (July 1977), p. 15, bio. p. 19 • Zimmer, William. "Review." *Arts Magazine* (March 1978), p. 25 • Thornton, Gene. "New Photography: Turning Traditional Standards Upside Down." *Art News* (April 1978), pp. 74-78 • Frey, H. "Amerika, du hältest es bessor gehabt! (America, you could have had it better!)." *Tendenzen* (January-February 1979), pp. 21-25 • "Review: Morals of Vision." *Print Collector's Newsletter* (May 1979), p. 57 • Lifson, Ben. "Another Way of Seeing." *Village Voice* (Sept. 3, 1979), p. 79 • Lawson, Thomas. Review. *Artforum* (January 1981), pp. 74-75 • Solomon-Godeau, Abigail. "Formalism and Its Discontents; Photography: A Sense of Order." *Print Collector's Newsletter* (May-June 1982), pp. 44-47.

Marion Faller

Born: Wallington, N.J., Nov. 5, 1941

Resides: Eaton, N.Y.

Education: Hunter College, CUNY, B.A. in art and education, 1971; VSW, SUNY at Buffalo (photographic studies), 1979; William Paterson College, Wayne, N.J.; New York University.

Professional Experience: Lecturer, Hunter College, CUNY, 1971-1974; lecturer, Marymount Manhattan College, New York, 1973-1974; assistant professor of fine arts, Colgate University, Hamilton, N.Y., 1974-1982; taught after-school photography seminars for high school students, Colgate High Achievement Program, January 1975-

March 1980; taught college course for high school juniors, Colgate Advanced Placement Summer Session, summer 1980; conducted workshops, Hamilton Central School, N.Y., September 1975-May 1979; assistant professor of photography, SUNY at Buffalo, 1982.

Recognition and Awards: Richter Grant, Hunter College, CUNY, 1970; Abrams Fund Grant and Westchester Alumni Grant, Hunter College, CUNY, 1971; Humanities Development Award, Colgate University, Hamilton, N.Y. (for travel), 1975, 1977, 1980, for materials, 1976, 1978, 1979, 1982; Faculty Research Grant, Colgate University, for conservation research, 1975, for materials, 1979, 1980; Council for Faculty Development Grant, Mellon Foundation, Colgate University, for travel, 1976, for research, 1981, photographer's grant, Light Work Visual Studies, Inc., Syracuse, N.Y., 1976; Creative Artists Public Service Program photographer's fellowship, 1977; equipment grant, Colgate University and Polaroid Foundation, Cambridge, Mass., 1980.

Individual Exhibitions: 1972 — Discovery Modernage Gallery, New York (February); Soho Photo Foundation, New York (November). 1973 — Marymount Manhattan College, New York (April-May); Soho Photo Foundation (June). 1974 — Midtown "Y" Gallery, New York (November). 1975 — *Hey, Baby, Take My Picture,* Agfa-Gevaert, Teterboro, N.J. (October). 1977 — College of Technology, SUNY at Utica/Rome (March/April); Gertrude Thomas Chapman Art Center, Cazenovia College, N.Y. (November-December). 1978 — The Picker Art Gallery, Colgate University, Hamilton, N.Y. (October); VSW, Rochester, N.Y. (November). 1979 — Light Fantastic Gallery, Kresge Art Center, Michigan State University, East Lansing (June-July; catalogue); Community Darkrooms/Light Work Gallery, Syracuse, N.Y. (November). 1980 — Rutger Gallery, Utica, N.Y. (May-June). 1981 — Edith Barrett Gallery, Utica College of Syracuse University, N.Y. (March-April; brochure). 1982 — University Art Museum, University of New Mexico, Albuquerque (Jan. 16-Feb. 21); Gallery of Art, University of Northern Iowa, Cedar Falls (March-April); Foto Gallery, New York (September).

Selected Group Exhibitions: 1972 — Discovery Modernage Gallery, New York (January-March; traveled). 1975 — *Vegetable Locomotion,* VSW, Rochester, N.Y. (with Hollis Frampton); *The First NYC Post Card Show,* Contemporary Art Gallery, New York University (May 1975; traveled). 1976 — *Surface Appearances: an exhibition in blur,* Mid-

town "Y" Gallery, New York (February-March); *A. C. Champagne – Photographic Images from the Collection of A. D. Coleman,* Carlson Gallery, University of Bridgeport, Conn. (November-December; catalogue). 1977 — *Locations in Time,* IMP/GEH, Rochester, N.Y. (February-April). 1978 — *The Visual Studies Workshop Artists' Book Show,* Franklin Furnace, New York (April; catalogue). 1979 — *New Photographics/79,* Sarah Spurgeon Gallery, Central Washington University, Ellenburg (April-May; slide-set catalogue); *The Image Considered: Recent Work by Women,* VSW Gallery (Dec. 19, 1979-Feb.1, 1980; catalogue: *Afterimage*). 1980 — *Collage,* Watson Gallery, Wheaton College, Norton, Mass. (February; catalogue); *U.S. Eye,* Myers Fine Arts Gallery, SUNY at Plattsburgh, presented by the National Fine Arts Committee of the XIII Olympic Winter Games, Lake Placid, N.Y. (February; traveled under the auspices of the VSW); *Visual Studies Workshop – the First Decade: 1970-1980,* Pratt Manhattan Center Gallery, New York (May-June); *Woman/Image/Nature,* Elkins Hall Galleries, Tyler School of Art, Philadelphia (December; catalogue: *Quiver;* traveled). 1981 — *CAPS at the State Museum,* New York State Museum, Albany (May-August; checklist); *Recent Acquisitions: 1973-80,* IMP/GEH, (June 12-Sept. 13; catalogue); *Photographic Alternatives,* Liberty Gallery, Louisville, Ky. (October-November; catalogue); *Third Annual Photography Invitational Exhibition,* Marymount College of Kansas, Salina (November; brochure).

Books by the Artist: Faller with Anderson, Charles; Trend, David; Stevens, Robert; and Van Dusen, Ray. *5x5,* VSW Press, Rochester, N.Y., 1977 • *A Resurrection of the Exquisite Corpse.* VSW Press, 1978.

Other Related Books: Arnow, Jan. *Handbook of Alternative Photographic Processes.* Van Nostrand Reinhold Co., New York, 1982.

Selected Articles, Essays, and Reviews: "Marion Faller." *35mm Photography* (Summer 1973), pp. 92-93 • "Marion Faller: Portfolio." *Creative Camera* (July 1974), pp. 220, 228-29 • "Portfolio: Marion Faller." *MS* (April 1975), p. 75 • "Marion Faller." Light Work *Contact Sheet,* no. 11 (1979) • "Connections: An Invitational Portfolio of Images and Statements by Twenty-Eight Women." *Exposure,* vol. 19, no. 3 (1981), p. 26 • Asbury, Dana. "Shows We've Seen." *Popular Photography* (June 1981), p. 19.

Hollis Frampton
Born: Wooster, Ohio, 1936
Resides: Eaton, N.Y.
Education: Phillips Academy, Andover, Mass., 1951-1954; Western Reserve University, Cleveland, 1954-1957; independent study with Ezra Pound, Washington, D.C., 1957-1958
Professional Experience: Worked as laboratory technician in still photography and cinema, 1961-1969; taught filmmaking, Free University of New York, 1966-1967; taught film history, School of Visual Arts, New York, and Cooper Union, New York, 1970-1973; assistant professor, Hunter College, CUNY, 1969-1973; associate professor, SUNY at Buffalo, 1973-present.
Recognition and Awards: Prize, Third Independent Filmmakers Festival, St. Lawrence University, Canton, N.Y., November 1968; Prize, Maryland Film Festival III, Baltimore, March 1969; Grant, Friends of New Cinema, New York, 1969-1970; Prize, Yale Film Festival, New Haven, Conn., November 1969; Prize, USA Film Festival, Dallas, March 1971; Prize, Bellevue Film Festival, Wash., 1971, 1972; National Endowment for the Arts Film/Video Production Fellowship, 1975-1976; Creative Artists Public Service Program Filmmaking Fellowship, 1975-1976; New York State Council on the Arts & Media Study Program, SUNY at Buffalo, grant 1977-1978; American Film Institute Fellowship, 1977-1978.
Individual Exhibitions of Still Photographs: 1965 — Peninsula Gallery, Palo Alto, Calif.; Goddard College, Plainfield, Vt. 1966 — APB Gallery, Tacoma, Wash. 1970 — The Art Institute of Chicago; Konrad Fischer Gallery, Düsseldorf, West Germany. 1975 — VSW, Rochester, N.Y. (with Marion Faller).
Individual Screenings of Films: 1966 — Film-makers' Cinematheque, New York. 1968 — Millennium Film Workshop, New York; Hunter College, CUNY. 1969 — Film-makers' Cinematheque; Paula Cooper Gallery, New York. 1970 — Yale University, New Haven, Conn; UCLA; *Cineprobe,* MOMA, New York; Goddard College, Plainfield, Vt.; Denison University, Granville, Ohio; Bard College, Annandale-on-Hudson, N.Y.; Millennium Film Workshop. 1971 — Carnegie Institute Museum of Art, Pittsburgh (catalogue: *Carnegie Magazine*); University of Iowa, Iowa City; Harpur College, SUNY at Binghamton; Canyon Cinematheque, Berkeley, Calif.; Musée de l'Art Moderne, Paris; SUNY at Potsdam; Antioch College, Yellow Springs, Ohio; Chatham College, Pittsburgh; Millennium Film Workshop; Yale University; Philadelpia Institute of Cinema. 1972 — Hansen Fuller Gallery, San Francisco;

Museum of Contemporary Art, Chicago; SUNY at Buffalo; Harpur College, SUNY at Binghamton; Sarah Lawrence College, Bronxville, N.Y.; London Film-makers' Cooperative; United States Information Agency, Washington, D.C.: Pacific Film Archive, Berkeley, Calif.; VSW, Rochester, N.Y.; Pittsburgh Film Workshop; Walker Art Center, Minneapolis (catalogue); Millennium Film Workshop (brochure). 1973 — *Retrospective,* MOMA, New York (brochure); Anthology Film Archives, New York; U.F.S.C. Summer Institute, Hampshire College, Amherst, Mass.; Indianapolis Museum of Art; Skidmore College, Saratoga Springs, N.Y.; Blossom/Kent Art Program, Kent State University, Ohio; Contemporary Arts Museum, Houston; Princeton University, N.J.; School of The Art Institute of Chicago. 1974 — Cooper Union, New York; Carnegie Institute Museum of Art; California Institute of the Arts, Valencia; Millennium Film Workshop; *Five Evenings,* Boston Museum of Fine Arts; Yale University; Pratt Institute, Brooklyn, N.Y.; Center for Understanding Media, New York; Nova Scotia College of Art and Design, Halifax, Canada; Skidmore College; Goddard College; Anthology Film Archives; *Experimentals* (retrospective), Fifth International Festival of Experimental Film and Video, Knokke-Heist, Belgium. 1975 — Name Gallery, Chicago; Media Study, SUNY at Buffalo; Anthology Film Archives; University of Colorado, Boulder; Rocky Mountain Film Center, Boulder; University of Oklahoma, Norman; Colgate University, Hamilton, N.Y.; Whitney Museum of American Art, New York; Millennium Film Workshop; U.F.S.C. Summer Institute, Hampshire College; Skidmore College; SUNY at Brockport; Ramapo College, Mahwah, N.J. 1976 — SUNY at Buffalo; Princeton University; San Francisco Art Institute; Canyon Cinematheque, San Francisco; Pacific Film Archive; Northwestern University, Evanston, Ill.; Jan Abbemuseum, Eindhoven, The Netherlands; Fort Worth Art Museum, Tex.; Millennium Film Workshop; Colgate University; Wadsworth Atheneum, Hartford, Conn.; Media Study, SUNY at Buffalo Summer Institute; London Film-makers' Cooperative; Boston Museum of Fine Arts School; University of Rhode Island, Kingston; Bard College; Albright-Knox Gallery, Buffalo. 1977 — Anthology Film Archives; School of The Art Institute of Chicago; Name Gallery; University of Wisconsin, Milwaukee; Otis Art Institute, Los Angeles; Dickson Art Center, UCLA; University of California, Santa Barbara; California Institute of the Arts, Valencia; Film Oasis, Los Angeles; San Francisco Art Institute; Canyon Cinematheque, San Francisco; Pacific Film Archive; Mills College, Oakland, Calif.; Bleecker Street Cinema, New York; Rice University, Houston; Rijksmuseum, Otterloo, The Netherlands; Colgate University; Harvard University, Cambridge, Mass. 1978 — Rochester Institute of Technology, N.Y.; Bucknell University, Lewisburg, Pa.; Pittsburgh Filmmakers' Workshop (brochure); Carnegie Institute Museum of Art; Otis Art Institute; Theatre Vanguard, Los Angeles; University of California, Irvine; San Francisco State College; San Francisco Art Institute; Utica College of Syracuse University, N.Y.; Stedelijk Museum & Filmmuseum, Amsterdam, The Netherlands. 1979 — *Alternative Imaging Systems,* Everson Museum of Art, Syracuse; Albright-Knox Gallery; Antioch College.

Group Exhibitions of Still Photographs: 1975 — *The First NYC Post Card Show,* Contemporary Arts Gallery, New York University (May 1975; traveled). 1976 — *The Photographer and the Artist*; Locations in Time,* IMP/GEH, Rochester, N.Y.; Electroworks.**

Group Screenings of Films: 1969 — American International School, New Delhi, India; United States Embassy, Paris. 1970 — SVA Gallery, School of Visual Arts, New York (with Michael Snow); *Information.**** 1971 — Bellevue Film Festival, Wash. (catalogue). 1972 — Elgin Theatre, New York (with Stan Brakhage and Michael Snow); Yale Film Festival, New Haven, Conn. (brochure); *New Forms in Film,* Solomon R. Guggenheim Museum, New York (brochure); *Form and Structure in Recent Film,* Vancouver Art Gallery, Vancouver, B.C., Canada (catalogue). 1973 — *Seven Days of Films and Filmmakers,* Annenberg Communications Center, Philadelphia (brochure); *Options and Alternatives – Some Directions in Recent Art,* Yale University Art Gallery (catalogue). 1975 — *Autobiography,* Picker Art Gallery, Colgate University, Hamilton, N.Y. (with Robert Huot and Melissa Shook). 1976 — *Masters of the American Independent Cinema,* Filmex, Los Angeles (brochure); *New American Filmmakers,* Whitney Museum of American Art (brochure); *A History of the American Avant-Garde Cinema,* MOMA, New York (catalogue: American Federation of Arts); Edinburgh Film Festival, Scotland (catalogue).

Films by the Artist: 1962 — *Clouds Like White Sheep.* 1963 — *A Punning Man.* 1964 — *Ten-Mile Poem.* 1965 — *Obelisk Ampersand Encounter.* 1966 — *Manual of Arms; Process Red; Information; A&P in Ontario* (with Joyce Wieland). 1967 — *States; Hetepodyne.* 1968 — *Snowblind; Maxwell's Demon; Surface Tension.* 1969 — *Palindrome; Carrots & Peas; Lemon; Prince Rupert's Drops; Works & Days; Artificial Light.* 1970 — *Zorns Lemma.* 1971 — *Nostalgia; Travelling Matte; Critical Mass.* 1971-1972 — *Hapax Legomena.* 1972 — *Special Effects; Poetic Justice; Ordinary Matter; Remote Control; Apparatus Sum; Tiger Balm; Yellow Springs; Magellan* (in progress). 1973 — *Monsieur Phot: A Film by Joseph Cornell* (in progress); *Public Domain; Less.* 1974 — *Autumnal Equinox: Noctiluca; Winter Solstice; Straits of Magellan: Drafts & Fragments; Summer Solstice; Banner.* 1974-1975 — *Solariumagelani.* 1975 — *Ingenium Nobis Ipsa Puella Fecit; Drum; Pas de Trois.* 1976 — *Magellan: At the Gates of Death, Part I: The Red Gate, Part II: The Green Gate; Otherwise Unexplained Fires; Not the First Time; For Georgia O'Keefe; Quaternion; Tuba; Procession.* 1977-1979 — *The Birth of Magellan: Dreams of Magellan: Parts I-VI; The Birth of Magellan: Mindfall: Parts I-VII; The Birth of Magellan: Fourteen Cadenzas.* 1979 — *More Than Meets the Eye; Gloria!*

Books by the Artist: *Poetic Justice.* VSW, Rochester, N.Y., 1973.

Books and Exhibition Catalogues with Essays by the Artist: "Carl Andre." *Carl Andre.* Haggs Gemeentemuseum, The Hague, The Netherlands, August 1969, pp. 7-13 • "A Pentagram for Conjuring the Narrative." *Form and Structure in Recent Film.* Vancouver Art Gallery, Vancouver, B.C., Canada, October 1972 • "A Stipulation of Terms from Maternal Hopi." *Options and Alternatives: Some Directions in Recent Art.* Yale University Art Gallery, New Haven, Conn., April-May 1973. Reprinted in *Film Dimension* (Apr. 18, 1975), p. 10 (Supplement to *The Spectrum,* Boston University) • "Fictcryptokrimsographology," *Fictcryptokrimsographs.* Humpy Press, Buffalo, N.Y., December 1975 • "Lecture." *The Avant-Garde Film: A Reader of Theory and Criticism.* Edited by P. Adams Sitney. New York University Press, New York, 1978 • "Trio." *Break Glass in Case Of Fire,* Center for Contemporary Music, Mills College, Oakland, Calif. (anthology).

Other Books: Sitney, P. Adams. "Structural Film." *Film Culture Reader.* Praeger, New York, 1978 • Sitney, P. Adams. "Hollis Frampton." *The American Independent Film.* Boston Museum of Fine Arts, Spring 1971 • Sitney, P. Adams, ed. *The Avant-Garde Film: A Reader of Theory and Criticism.* New York University Press, 1979 • Sitney, P. Adams. *Visionary Film.* Oxford University Press, New York, 1979 • Jenkins, Bruce L. "Hollis Frampton: Approaching the Infinite Cinema." *Film Studies Annual: Theory.* Edited by Ben Lawton and Janet Staiger. Purdue Research Foundation, Purdue University, West Lafayette, Ind., 1976.

Articles by the Artist: Frampton with Jacobs, Ken, and Snow, Michael. "Filmmakers vs. The Museum of Modern Art." *Filmmakers' Newsletter* (May 1969), pp. 1-2 • "For a Metahistory of Film: Commonplace Notes and Hypotheses." *Artforum* (September 1971), pp. 32-35 • "Nostalgia: Voice-Over Narration for a Film of That Name." *Film Culture* (Spring 1972), pp. 105-14 • "Notes on Nostalgia." *Film Culture* (Spring 1972), p. 114 • "Meditations around Paul Strand." *Artforum* (February 1972), pp. 52-57 • "Digressions on the Photographic Agony." *Artforum* (November 1972), pp. 43-51 • "Stan and Jane Brakhage, Talking." *Artforum* (January 1973), pp. 72-79 • "Eadweard Muybridge: Fragments of a Tesseract." *Artforum* (March 1973), pp. 43-52 • "Incisions in History/Segments of Eternity." *Artforum* (October 1974), pp. 39-50 • "The Withering Away of the State of Art." *Artforum* (December 1974), pp. 50-55. Reprinted in *The New Television: A Public/Private Art*, MIT Press, Cambridge, 1977 • "Letter to the Editor." *Artforum* (March 1975), p. 9 • "Notes on Composing in Film." *October* (Spring 1976), pp. 104-110 • Frampton with Andre, Carl. "Three Dialogues on Photography." *Interfunktionen*, Cologne, West Germany (Spring 1976), pp. 1-12. • "Letter from Hollis Frampton to Peter Gidal on *Zorns Lemma*." British Film Institute *Structural Film Anthology* (Spring 1976), pp. 75-77 • "Impromptus on Edward Weston: Everything in Its Place." *October* (Summer 1978), pp. 49-69 • "Mind over Matter: Seven Short Fictions." *October* (Fall 1978), pp. 81-92.

Interviews with the Artist: Snow, Michael. *Film Culture* (Spring 1970), pp. 6-12 • Field, Simon, and Sainsbury, Peter. *Afterimage*, London (Autumn 1972), pp. 44-47 • Mekas, Jonas. *Village Voice* (Jan. 11, 1973) • Gidal, Peter. British Film Institute, *Structural Film Anthology* (Spring 1976), pp. 64-72 • Tuchman, Mitch. "Frampton at the Gates." *Film Comment* (September-October 1977), pp. 55-59 • Broughton, James. "Hollis Frampton in San Francisco." *Cinemanews* (Nov. 12, 1977), pp. 10-11 • MacDonald, Scott. *Film Culture*, Nos. 67-69 (1969), pp. 158-180.

Articles about the Artist: Mekas, Jonas. "Movie Journal." *Village Voice* (Apr. 16, 1970) • Thompson, Howard. "3 Visit Pig Butchery in Fontaine's 'Double Pisces, Scorpio Rising.'" *New York Times*, Sept. 14, 1970 • Sitney, P. Adams. *The American Independent Film*, Boston Museum of Fine Arts (Spring 1971) (program notes) • Segal, Mark. "Hollis Frampton/*Zorns Lemma*." *Film Culture* (Spring 1971), pp. 88-95 • Bershen, Wanda. "Zorns Lemma." *Artforum* (September 1971), pp. 41-45 • Cornwell, Regina. "Some Formalist Tendencies in the Current American Avant-Garde Film." *Kansas Quarterly* (Spring 1972), pp. 60-70. Reprinted in *Studio* (October 1972), p. 112 • Field, Simon. "Alphabet as Ideogram." *Art and Artists*, London (August 1972), pp. 22-26 • Simon, Bill. "New Forms in Film." *Artforum* (October 1972), pp. 82ff • Rossell, Deac. "The Films of Hollis Frampton." *University Film Center Newsletter*, Cambridge, Mass. (June 1973), p. 105 • Francastel, Pierre. "Seeing . . . decoding." *Afterimage* (Spring 1974), pp. 4-21 • Mekas, Jonas. "Movie Journal" columns. *Village Voice* (April 4 & 11, Sept. 19, 1974) • Lehman, Boris. "Hollis Frampton: mathmétician, philosophe, poète et cinéaste." *Cléas*, Brussels, Belgium (February 1975), pp. 30-31 • Rayns, Tony. "Lines Describing an Impasse: Experimental 5." *Sight and Sound* (Spring 1975), pp. 78-80 • Gunning, Tom. "The Participatory Film." *American Film* (October 1975), pp. 81-83 • Eder, Richard. "Abstract Films by Hollis Frampton Shown at Whitney." *New York Times*, Jan. 8, 1976 • Gidal, Peter. "Notes on *Zorns Lemma*." British Film Institute *Structural Film Anthology* (Spring 1976), pp. 73-74 (see Articles by the Artist) • Beal, Greg. *"Zorns Lemma (1970)."* *Cinema Texas* (Nov. 1, 1976), pp. 37-40 • Fischer, Lucy. "Magellan: Navigating the Hemispheres." Supplement to *University Film Study Center*, vol. 7, no. 5, pp. 5-10 • Tuchman, Mitch. *Film Comment* (September-October 1977), pp. 55-60 • MacDonald, Scott. "Hollis Frampton's 'Hapax Legomena.'" *Afterimage* (January 1978), pp. 8-13 • Tuchman, Mitch. "A Film-Maker for the Long Hand." *Los Angeles Times*, Apr. 10, 1978, p. 16 • Taubin, Amy. "Spring Wind Up: Hollis Frampton at the Millennium." *The Soho Weekly News* (June 15, 1978), p. 38 • Sitney, P. Adams. "Autobiography in Avante-Garde Film" *Millennium Film Journal* (Spring 1978), pp. 86-90 • Simon, Bill. "Reading *Zorns Lemma*." *Millennium Film Journal* (Spring-Summer 1978), pp. 38-49 • Fischer, Lucy. "Frampton and the Magellan Metaphor." *American Film* (May 1979), pp. 58-63 • Jenkins, Bruce. "Frampton Unstructured: Notes for a Metacritical History." *Wide Angle* (Fall 1978) • MacDonald, Scott. "Long and Short of It: Some Thoughts on Film Length." *Afterimage* (March 1981), pp. 7-8.

Robert Frank

Born: Zurich, Switzerland, Nov. 9, 1924
Resides: Mabou, Nova Scotia, Canada
Education: Apprenticed in photography with Herman Eidenberg (Basel, Switzerland) and Michael Wolgersinger (Zurich), 1942-1944.
Professional Experience: Still photographer for Gloria Films, Zurich, Switzerland, 1942; fashion photographer for *Harper's Bazaar* (worked with Alexy Brodovitch), 1946-1947; worked as a free-lance photographer for *Fortune, Life, Look, McCall's*, and other popular magazines, 1948-1955; traveled through Peru and Bolivia, 1948, England, Wales, and France, 1949-1950; worked in Europe and New York, 1950-1955; began filmmaking, 1959; with Alfred Leslie, completed filming of *Pull My Daisy*, 1959; *The Sin of Jesus*, 1961; *OK, End Here*, 1963; *Me and My Brother*, 1965-1968; *Conversations in Vermont*, 1969; *Life-Raft – Earth*, 1969; *About Me: A Musical Film About Life in New York City*, 1971; *Cocksucker Blues*, 1972; *Keep Busy* (with Rudi Wurlitzer), 1975.
Recognition and Awards: John Simon Guggenheim Memorial Foundation Fellowship, New York, 1955 (first European to receive this award); New York State Grant from the Creative Artists Public Service Program for filmmaking, 1971.
Individual Exhibitions: 1959 — The Helmhaus, Zurich, Switzerland; The Art Institute of Chicago. 1965 — GEH, Rochester, N.Y. (traveled). 1976 — The Kunsthaus, Zurich, (catalogue). 1977 — Yajima Galeria, Montreal. 1978 — *Robert Frank: Photography and Films, 1945-1977*, Mary Porter Sesnon Art Gallery, College V, University of California, Santa Cruz (March; catalogue; traveled); *Basel Art Fair* (organized by Lunn Gallery/Graphics International, Ltd., Washington, D.C.; June). 1979 — *Robert Frank's The Americans*, Sidney Janis Gallery, New York (February); *Robert Frank: Photographer/Filmmaker, Works from 1945-1979*, Long Beach Museum of Art, Calif. (Mar. 25-May 6; catalogue); A Gallery for Fine Photography, New Orleans (Dec. 6-31); Lunn Gallery/Graphic International, Ltd. (July-August); *Robert Frank – the vision behind contemporary photographic expression*, Afterimage Photograph Gallery, Dallas (Feb. 13-Mar. 24); Cronin Gallery, Houston (Jan. 9-Feb. 10); Galerie Zabriskie, Paris (Nov. 6-Dec. 8). 1980 — Jane Corkin Gallery, Toronto (Mar. 8-Apr. 2). 1981 — *Robert Frank – Unpublished Vintage Prints*, Light Gallery, New York (Feb. 5-28); *Thirteen Pictures of New York*, simultaneously exhibited with *Louis Faurer, Photographs from Philadelphia and New York, 1937-1973*, Art Gallery, University of Maryland, College Park (Mar. 10-Apr. 23; brochure); Light Gallery (Apr. 11-May 9).
Selected Group Exhibitions: 1948 — *In and Out of Focus: A Survey of Today's Photography*, MOMA, New York (Apr. 6-July 11; traveled). 1949 — MOMA, New York. 1952 — *Then (1839) and Now (1952)*, MOMA, New York. 1953 — *Post-War European Photography*, MOMA, New York (May 26-Aug. 2; traveled). 1954 — MOMA, New York.

1955 — *The Family of Man.** 1962 — *Photographs by Harry Callahan and Robert Frank,* MOMA, New York (July 28-Aug. 6). 1963 — *Photography 63.** 1965 — *Photographs from The George Eastman House Collection, 1900-1964.*** 1966 — *John Simon Guggenheim Memorial Foundation Fellows in Photography 1937-1965,* Philadelphia College of Art (catalogue: *Camera*); *American Photography: The Sixties**; *The Photographer's Eye.** 1967 — The San Francisco Museum of Art; *Photography in the Twentieth Century**; *12 Photographers of the American Social Landscape,* Rose Art Museum, Brandeis University, Waltham, Mass. (Jan. 9-Feb. 12; catalogue). 1968 — *The George Eastman House Collection***; *Class of 1928 Photography Collection.*** 1970 — *The Photograph as Object 1843-1969.**** 1971 — *Photographs of Women,* MOMA, New York (catalogue: *Camera*). 1972 — *11 American Photographers.** 1974 — *Photography in America.** 1975 — *14 American Photographers,* Maryland Museum of Art, Baltimore (catalogue; traveled); *Photography within the Humanities,* Jewett Arts Center, Wellesley College, Mass. (Apr. 7-25; book). 1976 — The Marlborough Gallery, New York; *Catalog of the UCLA Collection of American Photographs.*** 1977 — *Robert Frank and Gotthard Schuh,* Marlborough Gallery; *The Target Collection of American Photography***; *Concerning Photography – Some Thoughts About Reading Photographs,* The Photographers' Gallery, London (July 6-Aug. 27; catalogue). 1978 — *New Standpoints: Photography, 1940-1955,* MOMA, New York (Feb. 6-Apr. 30; catalogue: *Aperture*); *Mirrors and Windows**; *The Presence of Walker Evans,* Institute of Contemporary Art, Boston (June 28-Sept. 3; catalogue); The Cleveland Museum of Art; *The Quality of Presence**; *Forty American Photographers.** 1979 — *Auto as Icon**; *Approaches to Photography: A Historical Survey**; *The Anthony G. Cronin Memorial Collection***; *Diverse Images***; *Photographie als Kunst 1879-1979/Kunst als Photographie 1949-1979****; *Photography: Venice '79.** 1980 — *Robert Frank, Walker Evans,* G. Ray Hawkins Photo Gallery, Los Angeles (July 15-Aug. 2; catalogue); *Southern California Photography 1900-1965: An Historical Survey,* Los Angeles County Museum of Art (Dec. 18, 1980-Mar. 15, 1981; catalogue); *Photography of the Fifties: An American Perspective.** 1981 — *Walker Evans and Robert Frank: An Essay on Influence,* Yale University Art Gallery, New Haven, Conn. (Mar. 31-Apr. 25; catalogue); *Aspects of the 70's: Photography.**

Monographs: Arnaud, Georges. *Indiens pas morts.* Photographs by Werner Bischof, Robert Frank, and Pierre Verger. Robert Delpire, Paris, 1956 (American edition: *Incas to Indians*) • Frank, Robert *New York Is.* New York Times, 1957 • Bosquet, Alain, ed. *Les Americains.* Photographs by Robert Frank, Robert Delpire, Paris, 1958 • Frank, Robert. *The Americans.* American edition. Grove Press, New York, 1959. Reprint, Grossman Publishers, New York, 1969. Rev. ed. Aperture, Millerton, N.Y., 1978 • Kerouac, Jack. *Pull My Daisy.* Photographs by Robert Frank. Grove Press, 1961 • *Zero Mostel Reads a Book.* New York Times, 1963 • *The Lines of My Hand.* Lustrum Press, Los Angeles, 1972 (Japanese edition: Kazuhiko Motomura, Tokyo, 1971) • Wurlitzer, Rudi. *Robert Frank.* Aperture, 1976.

Books: Evans, Walker. "Photography." *Quality: Its Image in the Arts.* Edited by Louis Kronenberg. Atheneum, New York, 1969, pp. 169-71, 174-75 • Green, Jonathan, ed. *The Snapshot.* Aperture, Millerton, N.Y., 1974 • Osman, Colin, and Turner, Peter, eds. *Creative Camera International Year Book 1975.* Coos Press, Ltd., London, 1974, pp. 10-36 • Janis, Eugenia P., and MacNeil, Wendy. *Photography Within the Humanities.* Addison House, Danbury, N.H., 1977, pp. 52-65 (see also exhibition) • Liebling, Jerome, ed. *Photography: Current Perspectives.* Light Impressions, Rochester, N.Y., 1978, pp. 32-39 • Tucker, Anne. "Robert Frank's Hoboken, 1955." *A Guide to the Collection.* The Museum of Fine Arts, Houston, 1981, p. 162. • Whelan, Richard. *Double Take: A Comparative Look at Photographs.* Clarkson N. Potter, Inc., New York, 1981, pp. 155, 158, 164 • See also Coleman, *Light Readings;* Malcolm, *Diana & Nikon;* Szarkowski, *Looking at Photographs;* Life Library, *Art and Documentary;* Witkin and London, *The Photograph Collector's Guide;* Jeffrey, *Photography;* Sontag, *On Photography;* Goldberg, *Photography in Print;* Coke, *Photography in New Mexico;* and Gassan, *A Chronology of Photography.*

Selected Articles, Essays, and Reviews: Dobell, Byron. "Feature Pictures, Robert Frank, the Photographer as Poet." *U.S. Camera* (September 1954), p. 79-84 • Frank, Robert. "Ben James — Story of a Welsh Miner." *U.S. Camera Annual* (1955), pp. 82-93 • Schuh, Gotthard. "A Letter Addressed to Robert Frank." *Camera* (1957), pp. 339-40 • Evans, Walker, "Robert Frank," and Frank, Robert, "Portfolio and Statement." *U.S. Camera Annual* (1958), pp. 89-115 • Frank, Robert. "One Man's U.S.A." *Pageant* (April 1958), pp. 24-35 • Reviews by Les Berry, Bruce Downes, John Durrick, Arthur Goldsmith, H.M. Kinzer, Charles Reynolds, and James Zanuto. *Popular Photography* (May 1960) • Frank, Robert, "Portfolio," and Bennett, Edna, "Black and White Are the Colors of Robert Frank." *Aperture* (1961), pp. 3-22 • Frank, Robert. "Photographs." *Aperture* (1961), pp. 2-19 • Talese, Gay. "42nd St., How It Got That Way." *Show* (December 1961), pp. 62-71 • Rozler, Willy. "Robert Frank." *DU* (January 1962), pp. 2-33 • Weiss, Margot. "Book Review: American Photographs." *Infinity* (September 1962) • Porter, Allan. "Bus Ride through New York: The bridge from photography to cinematography." *Camera* (January 1966), pp. 32-35 • Porter, Allan. "Robert Frank" *Camera* (March 1969), pp. 6-14 • Frank, Robert. "Letter from New York." *Creative Camera* (July 1969), pp. 234-35 • Frank, Robert. "Letter from New York." *Creative Camera* (December 1969), p. 414 • Gibson, Ralph. "The Americans." *Artforum* (May 1970), p. 92 • Kerouac, Jack. "On the Road to Florida." *Evergreen Review* January 1970 , Sec. 6, p. 14 • Porter, Allan. "Coney Island." *Camera* (March 1971), pp. 19-25 • Hagen, Charles. "Robert Frank: Seeing Through the Pain." *Afterimage* (February 1973), pp. 4-5 • Jeffrey, Ian. "Robert Frank." *Photographic Journal* (July 1973), pp. 347-49 • Scott, William. "Walker Evans, Robert Frank and the Landscape of Disassociation." *Arts Canada* (December 1974), pp. 83-89 • Hellman, Roberta, and Hoshino, Marvin. "What Frank Saw." *Village Voice* (February 1975), p. 3 • Marcus, Greil. "The Stones Movie You'll Never See." *Village Voice* (June 9, 1975), p. 126 • Jeffrey, Ian. "Photography." *Studio International* (September-October 1976), pp. 199-201 • Badger, Gerry. "Lee Friedlander." *British Journal of Photography* (Mar. 5, 1976), pp. 198-200 • Bunnell, Peter. "Robert Frank's Photographs." *Print Collector's Newsletter* (July 1976), p. 81 • Cosgrove, Gillian. "The Rolling Stone Movie That Can't Be Shown." *New York Daily News,* Sept. 12, 1977, p. 31 • Wheeler, Dennis. "Robert Frank Interviewed." *Criteria* (June 1977), pp. 4-7 • King, Pam. "Frank, Rolling Stones Reach Settlement on Films." *Afterimage* (May-June 1977), p. 2 • Rubinfein, Leo. Frank in Ottawa: Photo Gallery of National Film Board of Canada." *Art in America* (May 1978), pp. 52-55 • Manning, Jack. "Review of 'The Americans'." *New York Times Book Review* (Dec. 3, 1978), p. 80 • Hellman, Roberta, and Hoshino, Marvin. "Review: Frank at Sidney Janis." *Arts* (September 1979), p. 18 • Brumfield, John. "'The Americans' and the Americans." *Afterimage* (Summer 1980), pp. 8-15 • Baier, Leslie. "Visions of Fascination and Despair: The Relationship Between Walker Evans and Robert Frank." *Art Journal* (Spring 1981), pp. 55-63 • Papageorge, Tod. "From Walker Evans to Robert Frank: A Legacy Received, Embraced and Transformed." *Artforum* (April 1981), pp. 33-37 • Cassell, James. "Robert Frank's 'The Americans' An Original Vision Despite Tod Papageorge's Challenge." *The New Art Examiner* (Summer 1981), pp. 1,8 • Cook, Jno. "Robert Frank's America." *Afterimage* (March 1982), pp.

9-14 • Westerbeck, Colin L. "Tod Papageorge." *Artforum* (September 1981), pp. 75-76.

Sidney Grossman

Born: New York, June 25, 1913

Died: New York, Dec. 31, 1955

Education: City College of New York, 1932-1935; Hans Hofmann's School of Painting, Provincetown, Mass. (summers) 1949-1953.

Professional Experience: Free-lanced commercial photography, 1936-1955; founding member of the Photo League, New York, 1936; taught documentary photography at the Photo League School, 1938-1949, with interruptions; director of Photo League School, 1940-1947, with interruptions; class in home(s) in New York and Provincetown, Mass. (summers), 1949-1955.

Individual Exhibitions: 1961 — *Sid Grossman, Part I,* Image Gallery, New York (May 19-June 14); *Sid Grossman, Part II,* Image Gallery (Oct. 6-Nov. 8). 1981 — *Sidney Grossman: Photographs 1936-1955,* The Museum of Fine Arts, Houston (Feb. 20-April 26; catalogue forthcoming; traveled).

Selected Group Exhibitions: 1940 — *The Chelsea Document* (with Sol Libsohn), The Photo League, New York (February; traveled); *A Pageant of Photography, (Photo League, NY: Harlem Document and Other Work)* Palace of Fine Arts, Golden Gate International Exposition on Treasure Island, San Francisco (catalogue: *US Camera*). 1941 — *Image of Freedom,* MOMA, New York (Oct. 29, 1941-Jan. 11, 1942; traveled). 1944 — *Photography Today,* ACA Gallery, New York (July 31-Aug. 31; catalogue). 1948 — *This is the Photo League,* The Photo League (Dec. 3, 1948-Feb. 4, 1949; catalogue). 1978 — *New Standpoints: Photography 1940-1955,* MOMA, (Feb. 6-Apr. 30; catalogue: *Aperture*); *Photographic Crossroads: The Photo League* (organized by VSW, Rochester, N.Y., and Anne Tucker; catalogue: National Gallery of Canada, Ottawa; traveled). 1981 — *American Children.***

Monographs: Pratt, Charles, ed. *Journey to the Cape: Photographs by Sid Grossman.* Text by Millard Lampell. Grove Press, New York, 1959.

Books: Deschin, Jacob. *Say It With Your Camera: An Approach to Creative Photography.* Whittlesley House (McGraw-Hill), New York 1950, pp. 170-72 • Vestal, David. *The Craft of Photography,* Harper & Row, New York, 1972, pp. 322, 327 • Vestal, David. "Sidney Grossman." In *Contemporary Photographers.* Edited by George Walsh. St. Martin's Press, New York, and MacMillan Press, London, 1982. See also Life Library, *Documentary, Photography Year, 1979.*

Edited by the artist: Grossman and Libsohn, Sol, ed. *Photography: Syllabus and Readings.* Photo League, New York, 1938.

Articles by the Artist: "Autumn Issue of U.S. Camera Magazine." *Photo Notes* (December 1938), p. 4 • "Hine Exhibition Opens." *Photo Notes* (January 1939), p. 2 • "Exhibitions." *Photo Notes* (February 1939), p. 4 • "Book Reviews." *Photo Notes* (February 1939), p. 4 • "'P.P.A. Salon' at the Museum of Natural History." *Photo Notes* (June 1939), pp. 3-4 • "Documentary Film Problems Discussed at Writers' Congress." *Photo Notes* (June 1939), p. 4 • "These Are Our Lives." *Photo Notes* (May 1940), pp. 6-7 • "Reviewed for Photo Notes by Sid Grossman." *Photo Notes* (December 1941), pp. 2-3 • "Three Young Photographers Exhibit." *Photo Notes* (November 1947), pp. 4-5 • "Dancers Involved: A Photographic Experience." *Dance* magazine (June 1953), pp. 26-31.

Selected Articles, Essays, and Reviews: McCausland, Elizabeth. "Social Scene by Camera, Young Photographers Show New York City." *The Springfield Sunday Republican,* Aug. 27, 1939 • Meltzer, Milton. "Behind the Candid Cameraman: How the Job Is Learned at the Photo League." *The Daily Worker,* Oct. 17, 1941, p. 7 • Deschin, Jacob. "Flash! Camera Club Carries Out Program." *Modern Photography* (February 1943), pp. 54-55, 93 • "People: American Faces by Corporal Sid Grossman." *U.S. Camera* (November 1944), p. 36 • Bildersee, Barnett. "Photo League Teaches Cerebral Technique." *PM's Weekly* (July 1947), pp. 8, 10, 11 • Deschin, Jacob. "Contrast in Schools: Examples of Two Ways of Teaching Photography." *New York Times,* June 13, 1948 • Deschin, Jacob. "Best Work of League: Members Show Pictures in Their Own Way." *The New York Times,* Dec. 5, 1948 • Terraciano, Jack L. "Photo League Show: Three Hundred Prints by Famous Photographers and Talented Unknowns to be Sent Abroad in Exchange for French Exhibit." *U.S. Camera* (February 1949), pp. 51-55 • Rushmore, Howard. "Girl Tells of 7-Year Role as FBI's Red 'Mata Hari.'" *New York Journal-American,* Apr. 26, 1949 • Neugass, Fritz. "Photo League, New York." *Camera* (September 1950), pp. 262-75 • Deschin, Jacob. "Broadening Realism: Current Shows Illustrate Modern Points of View." *New York Times,* July 1, 1951, p. 10 • Barry, Les. "The Legend of Sid Grossman." *Popular Photography* (November 1961), pp. 50-51, 91-94 • Stettner, Lou. "Sid Grossman: A Perspective." *U.S. Camera Annual* (1977), pp. 20-27.

Articles Illustrated with Photographs by the Artist: "What Makes an American: These Arkies Joined a Union and Stuck to the Land," *PM's Weekly* (Feb. 2, 1941), pp. 61-63 • "America Discovers Its Own Musical Culture," *PM's Weekly* (Feb. 23, 1941), pp. 44 • "Folk Music in Kentucky and Oklahoma," *New York Times,* June 1, 1941 • "Oscar Arnerginger, Publisher" and "The Hungry Hermit Meets a Flapper." *Good Photography,* #7 (1941), pp. 71, 118 • "Arkansas Farmers Cooperative." *Good Photography* #8 (1942), p. 97 • "Portrait of Henry Modgilin." *U.S. Camera Annual* (1943), p. 125 • *Safeguard Their Future: A Rational Approach to the Problems of Juvenile Delinquency in Wartime,* Teachers Union of the City of New York (January 1943), pp. 13-32 • "Emotion." *U.S. Camera Annual* (1947) • "Black Christ Festival." *U.S. Camera Annual* (1949), p. 191 • Ellsworth, P. "Hans Hofmann: Reply to a Questionnaire and Comments on a Recent Exhibition." *Arts and Architecture* (November 1949), pp. 22-28 • "Coney Island." *U.S. Camera Annual* (1950) • Smith, Red. "Sports: Hail or Farewell?" *Esquire* (September 1951), pp. 89-93.

Robert Heinecken

Born: Denver, 1931

Resides: Los Angeles and Chicago

Education: UCLA, B.A., 1959, M.A., 1960.

Professional Experience: Professor, UCLA, 1960-present; vice chairman, Art Department, UCLA, Los Angeles, 1979-1980.

Recognition and Awards: John Simon Guggenheim Memorial Foundation Fellowship, 1975-1976; UCLA Faculty Research Grant (with Judith Golden and Bart Parker), 1976; National Endowment for the Arts, Individual Artist's Grant, 1977, 1981.

Individual Exhibitions: 1960 — Thesis exhibition, UCLA. 1964 — Fine Arts Gallery, Mount St. Mary's College, Los Angeles. 1965 — Long Beach Museum of Art, Calif. (with Coar, Rink). 1966 — Fine Arts Gallery, California State College, Los Angeles; Mills College, Oakland, Calif. 1968 — Focus Gallery, San Francisco. 1969 — Thorne Hall Gallery, Occidental College, Los Angeles. 1970 — Phoenix College, Ariz.; The Witkin Gallery, New York. 1971 — University of Oregon, Eugene; University of Colorado, Boulder. 1972 — Pasadena City College, Calif.; University of Rhode Island, Kingston; Pasadena Art Museum, Calif. (July 11-Aug. 6; catalogue). 1973 — Fine Arts Gallery, California State College, San Bernardino (Apr. 9-May 4); The Friends of Photography, Carmel, Calif. (Sept. 1-Oct. 6); Light Gallery, New York (Oct. 9-Nov. 3). 1974 — Madison Art Center, Wis. 1976 — Light Gallery (Feb. 10-

Mar. 6); The Texas Center for Photographic Studies, Dallas (May 21-June 12); IMP/GEH, Rochester, N.Y. (Oct. 29, 1976-Jan. 31; 1977; poster/checklist; traveled). 1978 — Old Dominion University, Norfolk, Va.; *Robert Heinecken: Polaroid Writings 1974-1978*, Susan Spiritus Gallery, Newport Beach, Calif. (Nov. 17-Dec. 30; brochure). 1979 — Light Gallery; Mary Porter Sesnon Art Gallery, College V, University of California, Santa Cruz; University of Northern Illinois, DeKalb; Forum Stadtpark, Graz, Austria. 1980 — University of Nevada, Las Vegas; Nova Gallery, Vancouver, B.C., Canada; Werkstadt Für Fotographie, Berlin. 1981 — Light Gallery, Los Angeles (Mar. 27-Apr. 4); Oregon Gallery, University of Oregon; Light Gallery.

Selected Group Exhibitions: A major monograph with bibliography exists for this photographer; therefore, group exhibitions and major articles, essays and reviews previous to this monograph have been omitted. See *Heinecken* (1980). 1980 — *Silver Interactions*, Fine Arts Gallery, University of Florida, Tampa (May 30-July 18; book); *Aspects of the 70's: Photography.* * 1981 — *American Photographs 1970-1980*, The Whatcom Museum of History and Art, Bellingham, Wash. (catalogue); *Altered Images*, Center for Creative Photography, University of Arizona, Tucson (catalogue); *Photo Facts and Opinions**; *Libres d'Artista/Artist's Books*, El Centro Documentacio d'Art Actual, Metronom, Barcelona, Spain (catalogue); *Recent Acquisitions 1973-1980*, IMP/GEH, Rochester, N.Y. (June 12-Sept. 13; catalogue). 1982 — *Robert Heinecken /Joyce Neumanas*, North Light Gallery, Arizona State University, Tempe; *A History of Photography from Chicago Collections***; *Contemporary Art*, 19th Annual Art Show, Goddard-Riverside Community Center, Calif.; *Color as Form.**

Monographs and Portfolios: Heinecken, Robert. *Are You Rea.* Published by the photographer, Los Angeles, 1968 • Heinecken, Robert. *Mansmag.* Published by the photographer, 1969 • *Color.* Introduction by Henry Holmes Smith. Florida State University, Tallahassee, 1975 • Enyeart, James L., ed. *Heinecken.* The Friends of Photography, Carmel, Calif., 1980 • Heinecken, Robert. *He / She.* A Chicago Book, Chicago, 1980.

Other Books: Niece, Robert. *Photo Imagination.* Amphoto, New York, 1966 • Halter, Patra. *Photography Without A Camera.* Studio Vista, London, and Nostrand Reinhold Co., New York, 1972, pp. 15, 16, 88, 118 • Lewis, Steven; McQuaid, James; and Tait, David. *Photography Source and Resource; a source book for creative photography.* Turnip Press, State College, Pa., 1973, pp. 29-34 • Coleman, A.D. *The Grotesque in Photography.* Ridge Press,

N.Y., 1977, pp. 200-5 • Willman, Manfred, and Frisinghelli, Christine, eds. "Robert Heinecken." *Symposium Uber Fotografie.* Forum Stadtpark, Graz, Austria, 1980, pp. 14-23 • Thomas, Lew, and D'Agostino, Peter. *Still Photography: the problematic model.* NFS Press, San Francisco, 1981 • See also Coleman, *Light Readings*; Life Library, *The Art of Photography* and *The Print*; Wise, *The Photographer's Choice*; Jay, *Views on Nudes*; Witkin and London, *The Photograph Collector's Guide*; and Gassan, *A Chronology of Photography.*

Selected Articles, Essays, and Reviews: Wollheim, Peter. "Robert Heinecken." *Vanguard*, Vancouver Art Gallery (November 1980), p. 28 • Crane, Tricia. "His Camera Zeroes in as a Microscope on the World." *New York Daily News*, Feb. 27, 1981, pp. 10-11 • Knight, Christofer. "Capturing Elements of the Real World." *Los Angeles Herald Examiner*, Mar. 22, 1981, Sec. E, p. 5 • Portner, Dinah. "Book Review: Heinecken." *Obscure: The Journal of the Los Angeles Center for Photographic Studies* (March-April 1981), pp. 46-48 • Johnstone, Mark. "Hee Hee, He: / She by Robert Heinecken." *Afterimage* (March 1981), pp. 13-14 • Coleman, A.D. "What Happens When You Cross a Photograph with a Rock." *Art News* (April 1981), p. 154 • Grundberg, Andy. "Robert Heinecken — Asking Provocative Questions." *New York Times*, June 7, 1981, sec. 2, p. 31 • Meinwald, Dan. "Heinecken." *Camera Arts* (July-August 1981), p. 112 • Borger, Irene. "Bob Heinecken: Outside on the Inside." *L. A. Weekly* (July 17-23, 1981), pp. 10-11 • Grover, Jan Zita. "Heinecken." *Exposure*, vol. 19, no. 3 (1981), p. 66 • Fischer, Hal. "Heinecken." *Artforum* (September 1981), p. 73 • Portner, Dinah. "An Interview with Robert Heinecken." *LAICA Journal* (September-October 1981), pp. 49-55 • Hugunin, James. "Conversational Detente." *Afterimage* (November 1981), pp. 8-9 • Yamagichi, Koko. "Robert Heinecken." *Camera Mainichi*, no. 1 (1982).

Douglas Huebler

Born: Ann Arbor, Mich., Oct. 7, 1924
Resides: Newhall, Calif.
Education: Academie Julian, Paris, 1948; Cleveland School of Art, 1948; University of Michigan, Ann Arbor, B.S. in design, 1952; University of Michigan, Ann Arbor, M.F.A. in drawing and painting, 1955.
Professional Experience: Commercial artist, New York and Detroit, 1948-1952; taught at Miami University, Oxford, Ohio, 1954-1957; taught at Bradford College, Mass. (became department chairman), 1957-1973; visiting professor, Harvard University, Cambridge, Mass., 1973-1975; Dean, School of Art and Design, California Institute of

the Arts, Valencia, 1976-1979, became director of art program, 1979-present.
Individual Exhibitions: 1953 — Phillips Gallery, Detroit. 1967 — Obelisk Gallery, Boston. 1968 — Windham College, Putney, Vt.; Seth Siegelaub, New York (catalogue). 1969 — Eugenia Butler Gallery, Los Angeles. 1970 — Galerie Konrad Fischer, Düsseldorf, West Germany; Addison Gallery of American Art, Andover, Mass. (May 8-June 14; catalogue); Galleria Sperone, Turin, Italy; Galerie Yvon Lambert, Paris; art & project, Amsterdam, The Netherlands. 1971 — Leo Castelli Gallery, New York; Galerie Konrad Fischer; art & project, Amsterdam. 1972 — California Institute of the Arts, Valencia; Galerie Yvon Lambert; Galleria Toselli, Milan, Italy; Jack Wendler Gallery, London; Galerie Konrad Fischer; Leo Castelli Gallery; Museum of Fine Arts, Boston (catalogue). 1973 — Westfalischer Kunstverein, Munster, West Germany; Kunsthalle (Stadtische), Kiel, West Germany; Kunsthalle (von der Heydt Museum), Wuppertal, West Germany; Kunsthalle, Bielfeld, West Germany; Fischer/Sperone Galleria, Rome; Jack Wendler Gallery; Israel Museum, Jerusalem (August; catalogue); MTL Gallery, Brussels, Belgium; Museum of Modern Art, Oxford, England; Leo Castelli Gallery; Nova Scotia College of Art and Design, Halifax. 1974 — Lia Rumma, Naples, Italy; Galleria Sperone; Jack Wendler Gallery; MTL Gallery; Galerie Yvon Lambert; Galerie Konrad Fischer; Galerie Rolf Preisig, Basel, Switzerland. 1975 — Galleria Francoise Lambert, Milan, Italy. 1976 — Galleri Cheap Thrills, Helsinki, Finland; Galleri St. Petri, Lund, Sweden; ICA Gallery, London (June 4-30); Barbara Cusack Gallery, Houston; Leo Castelli Gallery (May 15-June 5); Galeria AKUMULATORY 2, Poznan, Poland; Sperone, Westwater, Fischer, Inc., New York (Apr. 24-May 8). 1977 — Thomas Lewallen Gallery, Santa Monica, Calif. (Nov-Dec. 10). 1978 — Rudiger Schottle, Munich, West Germany; Leo Castelli Gallery (Sept. 30-Oct. 21). 1979 — Ink (Halle die Internationale neue Kunst), Zurich, Switzerland; MTL Gallery; Stedelijk Vanabbemuseum, Eindhoven, The Netherlands (catalogue); University of California at San Diego Galleries, La Jolla; *An Installation*, Los Angeles County Museum of Art (Oct. 4-Dec. 30). 1980 — *Douglas Huebler: 10+*, Northwestern University, Evanston, Ill. (Apr. 2-May 2; catalogue); Galerie Yvon Lambert. 1981 — Leo Castelli Gallery (Apr. 4-May 2); P.S.1, Long Island City, N.Y.

Selected Group Exhibitions: 1966 — *Primary Structures*, Jewish Museum, New York (catalogue). 1969 — *557,087*, Seattle Art Museum (catalogue); *Prospect 69*, Kunsthalle, Düsseldorf, West Germany (catalogue); *When Attitudes Become Form*, Kunsthalle, Bern, Switzerland (Spring; catalogue); *Op Losse Schroeven*, Stedelijk Museum, Amsterdam, The Netherlands (catalogue); *Summer Show*, Seth Siegelaub Gallery, New York (catalogue); *Konzeption/Conception*, Stadisches Museum, Leverkusen, West Germany. 1970 — *The Highway*, Institute of Contemporary Art, University of Pennsylvania, Philadelphia (Jan. 14-Feb. 25; catalogue; traveled); *Software*, Jewish Museum (Sept. 16-Nov. 8; catalogue; traveled); *Information****; *Conceptual Art and Conceptual Aspects*, New York Cultural Center; *Conceptual Art / Land Art / Arte Povera*, Galleria Civica d'Arte Moderna, Turin, Italy. 1971 — *Multiples: The First Decade****; 1972 — *Documenta V*, Kassel, West Germany (catalogue); *Random*, Kunsthistorisches Institut, Utrecht, West Germany. 1973 — *Combattimento per un'Immagine****; *Kunst als Boek*, Stedelijk Museum. 1975 — *Lives****. 1977 — *American Narrative / Story Art: 1967-1977****; *Art Books:;,. Books as Original Art****; *Documenta VI*, Westfalischer Kunstverein, Kassel; *Bookworks.**** 1978 — *Southland Video Anthology* (collaboration with Stephani Weinschel), Long Beach Museum of Art, Calif.; *Artwords and Bookworks.**** 1979 — *Attitudes**; *Artemisia Genteleschi*, Galerie Yvon Lambert (book; traveled). 1980 — *Reasoned Space**; *Artist and Camera*, The Arts Council of Great Britain, London (traveled); *Aspects of the 70's: Photography**; *Visual Articulations of Idea*, VSW, Rochester, N.Y. (traveled). 1981 — *Mapped Art: Charts, Routes, Regions*, University of Colorado Art Galleries, Boulder, and Independent Curators Incorporated, New York (traveled); *International Art Since 1939*, Westkunst, Cologne, West Germany (catalogue).

Books by the Artist: *Duration / Durati*. Sperone, Turin, Italy, 1970 • *Selected Drawings 1968-1973*. Sperone, Hong Kong, 1975 • *Variable Piece 4: Secrets*. Printed Matter, New York, 1979.

Books: Huebler with Andre, Carl; Barry, Robert; Kosuth, Joseph; LeWitt, Sol; Morris, Robert; and Weiner, Lawrence. *The Xerox Book*. Seth Siegelaub and John Wendler, New York, 1968 • Celant, Germano. *Ars Povera*. Praeger, Milano/Tubingen/New York, 1969 • Burnham, Jack. *The Structure of Art*. Braziller, New York, 1971 • Poinsot, Jean Marc. *Mail Art / Communication at a Distance / Concept*. Cedic, Paris, 1971 • Honnef, Klaus. *Concept Art*. Cologne, West Germany, 1972 • Har-

ryo, Ichiro, ed. *Art Now: Art as Action and Concept*. Kodansha Ltd., Tokyo, 1972 • Meyer, Ursula. *Conceptual Art*. E. P. Dutton, New York, 1972 • Lippard, Lucy. *Six Years: The Dematerialization of the Art Object from 1966 to 1972*. Praeger, New York, 1972 • Hunter, Sam. *American Art of the 20th Century*. Abrams, New York, 1972 • Kostelanetz, Richard, ed. *Breakthrough Fictioneers*. Something Else Press, W. Glover, Vt., 1973 • Burnham, Jack. *Great Western Saltworks*. Braziller, New York, 1974 • de Vries, Gerd, ed. *Uber Kunst – On Art*. Paul Maenz, Cologne, West Germany, 1974 • Bail, Murray. *Contemporary Portraits: Huebler*. University of Queensland Press, St. Lucia, Queensland, Australia, 1975 • Gottlieb, Carla. *Beyond Modern Art*. E. P. Dutton, Inc., New York, 1976 • *Contemporary Artists*. St. James Press, London, 1977 • *Dumont's Künstler Lexikonvon 1945*. Dümon Bachverlag, Cologne, 1977, pp. 189-90 • Lucie-Smith, Edward. *Art Today*. Phaidon, New York, 1977 • Battcock, Gregory, ed. *Idea Art*. E. P. Dutton, New York, 1978 • *Gnome Baker VI*. Gnome Baker Magazine, Inc., Great River, N.Y., 1980.

Selected Articles, Essays, and Reviews: Benedikt, Michael. "New York; Notes on the Whitney Annual, 1966." *Art International* (February 1967), pp. 56-60 • Brown, Gordon. "The Dematerialization of the Object." *Arts Magazine* (September-October 1968), p. 56 • Rose, Arthur. "Four Interviews." *Arts Magazine* (February 1969), pp. 21-22 • Ashton, Dore. "New York Commentary." *Studio International* (March 1969), p. 135-37 • Blok, C. "Letter from Holland." *Art International* (May 1969), pp. 52-53 • Shirey, David. "Thinkworks." *Art in America* (May-June 1969), pp. 39-41 • Schjeldahl, Peter. "New York Letter." *Art International* (October 1969), pp. 74-76 • Meyer, Ursula. "De-Objectification of the Object." *Arts Magazine* (Summer 1969), pp. 20-21 • Alloway, Lawrence. "The Expanding and Disappearing Work of Art." *Auction III* (1969), pp. 34-37 • Burnham, Jack. "Real Time Systems." *Artforum* (September 1969), pp. 49-55 • Harrison, Charles. "Against Precedents." *Studio International* (September 1969), pp. 90-93 • Plagens, Peter. "The Possibilities of Drawing." *Artforum* (October 1969), pp. 50-55 • Kosuth, Joseph. "Art After Philosophy." *Studio International* (November 1969), p. 160 • Lippard, Lucy. "Time: A Panel Discussion." *Art International* (November 1969), pp. 20-23, 39 • Burnham, Jack. "Alice's Head: Reflections on Conceptual Art." *Artforum* (February 1970), pp. 38ff • Lippard, Lucy. "Groups." *Studio International* (March 1970), pp. 93-99 • Goldin, Amy, and Kushner, Robert. "Conceptual Art as Opera." *Art News* (April 1970), pp. 40-43 • Allo-

way, Lawrence. "Artists and photographs." *Studio International* (April 1970), pp. 162-64 • Celant, Germano. "Conceptual Art." *Casabella* (April 1970), pp. 42-49 • Honnef, Klaus. "Concept Art." *Magazin Kunst* (May 1970) • Huebler, Douglas. "Statements and Location Pieces." *VH 101* (France), no. 3 • Lippard, Lucy. *Studio International* (July 1970), pp. 33-40 • Karshan, Donald C. "The seventies: post object art." *Studio International* (September 1970), pp. 69-70 • Vinkers, Bitte. "Art and Information." *Arts Magazine* (September/October 1970), pp. 46-49 • Antin, David. "Lead Kindly Blight!!" *Art News* (November 1970), pp. 37-39, 87-90 • Sharp, Willoughby. "Interview with Jack Burnham." *Arts Magazine* (November 1970), pp. 21-23 • Domingo, Willis. "Huebler at Castelli." *Arts Magazine* (September 1971), p. 59 • Kingsley, April. *Artforum* (May 1972), pp. 74-78 • Thwaitos, John A. "Cologne." *Art and Artists* (July 1972), p. 49 • Kurtz, Bruce. "Interview with Giuseppi Panza Di Biumo." *Arts Magazine* (March 1972), pp. 40-43 • Pluchart, Francois. "Spring in Paris." *Artitudes* (April-May 1972), pp. 2-3 • *Flash Art* (May-July 1972), p. 18 • Kozloff, Max. "The Trouble with Art-as-Idea." *Artforum* (September 1972), pp. 33-37 • Antin, David. "Talking at Pomona." *Artforum* (September 1972), pp. 38-47 • Lippard, Lucy. "Everything About Everything." *Art News* (December 1972), pp. 29-31 • "Douglas Huebler: Trois Traveaux." *VH 101*, France, no. 6 (1972), pp. 56-61 • Kingsley, April, ed. "Concept vs. Art Object, A Conversation Between Douglas Huebler and Budd Hopkins." *Arts Magazine* (April 1972), pp. 50-53 • Rosenberg, Harold. "Myths and Rituals of the Avant-Garde." *Art International* (September 1973), p. 67 • Honnef, Klaus. *Art and Artists* (January 1973), pp. 22-25 • Norris, Lynda. *Studio International* (April 1973), p. 198 • Lebeer, Irmeline. "Douglas Huebler: Le Monde en Jeu." *Chroniques de L'Art Vivant* (April 1973), pp. 20-23 • Davis, Douglas. "Art Without Limits." *Newsweek* (Oct. 24, 1973), pp. 68-74 • Gilbert-Rolfe, Jeremy. "Douglas Huebler's Recent Work." *Artforum* (February 1974), pp. 59-60 • Burnham, Jack. "Huebler's Pinwheel and the Letter Tau." *Arts Magazine* (October 1974), pp. 32-35 • Johnson, Walter. "Hueb, Huebler, Hueblist." *Artrite* (Spring 1974), pp. 4-6 • Kaprow, Alan. "The Education of the Un-Artist, III." *Art in America* (January 1974), p. 90 • "Douglas Huebler: Two Recent Works." *Studio International* (December 1974), pp. 224-25 • Special Photography Issue. *Flash Art*, Italy (February-March 1975), p. 33 • "Alternative Piece #3, North, Paris, 1970." *Kunstwerk* (September 1975) • Friedrichs, Y.

"Douglas Huebler: Galerie Konrad Fischer." *Kunstwerk* (January 1975), p. 79 • Goldin, Amy. "Post Perceptual Portrait." *Art in America* (January 1975), pp. 79-82 • "Douglas Huebler, Variable Piece #96." *Europa* (April 1975), p. 21 • Sclafani, R.J. "What Kind of Nonsense Is This?" *Journal of Aesthetics* (September 1975) • "Douglas Huebler Portfolio." *Paris Review* (Fall 1975), pp. 111-21 • Foote, Nancy. "The Anti-Photographers." *Artforum* (September 1976), pp. 46-54 • Lippard, Lucy R. "Going over the Books." *Artwork* (October 30, 1976), pp. 11-12 • Kelly, Jain. *Studio International* (September-October 1976), pp. 192, 215-16 • Auping, Michael. "Talking with Douglas Huebler." *LAICA Journal* (July-August 1977), pp. 37-44 • Welling, James. "Douglas Huebler's Strategies." *Artweek* (Dec. 3, 1977), p. 3 • Desmarais, Charles. "Photo Folks Gather for Polaroid's 'Instant' Soiree." *Afterimage* (February 1977), p. 3 • Ratcliff, Carter. "The American Artist from Loner to Lobbyist." *Art in America* (March-April 1977), pp. 10-12 • Larsen, Susan C. "Random Matches, States of Confusion." *Art News* (February 1978), pp. 103-4 • Levy, Lawrence, and Perreault, John, eds. "Anti-Object Art." Northwestern University *Triquarterly,* no. 32 (Winter 1975) • Morschel, Jürgen. "Ich Sehe Was, Was du Nichte Siehet: Douglas Huebler." *Munchner Kulturberichte,* West Germany (July 12, 1978), p. 27 • Erhardt, Robbie. Reviews. *Arts Magazine* (December 1978), pp. 30-31 • Burnside, Madeleine. Reviews. *Art News* (December 1978), p. 146 • Morgan, Robert. "Conceptual Art and the Continuing Quest for a New Social Context." *LAICA Journal* (June-July 1979), pp. 30-36 • Millet, Catherine. *Art Press* (July-August 1980) • Ratcliff, Carter. "Modernism and Melodrama." *Art in America* (February 1981), pp. 105-9 • Lippard, Lucy, and Kearns, Jerry. "Cashing in a Wolf Ticket (Activist Art and Fort Apache)." *Artforum* (October 1981), pp. 64-73 • Stimson, Paul. "Fictive Escapades: Douglas Huebler." *Art in America* (February 1982), pp. 96-99 • Huebler, Douglas. "Sabotage or Trophy? Advance or Retreat?" *Artforum* (May 1982), pp. 72-76

Steve Kahn

Born: Los Angeles, 1943

Resides: Venice, Calif.

Education: Reed College, Portland, Ore., B.A. in mathematics and physics, 1966

Professional Experience: Taught at the California Institute of the Arts, Valencia, 1978-1979.

Recognition and Awards: Young Talent Purchase Award, Los Angeles County Museum of Art, 1979; National Endowment for the Arts Photography Fellowship, 1980.

Individual Exhibitions: 1974 — The Photographer's Gallery, London. 1975 — California State University, Los Angeles; American Cultural Center, Paris; USIS Cultural Program: Milan, Rome, and Naples, Italy. 1976 — The Texas Center for Photographic Studies, Dallas (Aug. 13-Sept. 12). 1977 — *Photographs from the Hollywood Suites,* Broxton Gallery, Los Angeles (Feb. 19-Mar. 17). 1979 — Young/Hoffman Gallery, Chicago; *Storm/Wall Series,* Cronin Gallery, Houston (March); *Door/Window Series,* Rosamund Felsen Gallery, Los Angeles. 1980 — Rosamund Felsen Gallery; International Cultural Centrum, Antwerp, Belgium (catalogue). 1981 — *Hollywood Suites,* Yvon Lambert Gallery, Paris (March); *Mens en Omgeving: Steve Kahn,* De Beyerd Museum, Breda, The Netherlands (catalogue); *Basel Art Fair* (organized by Yvon Lambert), Switzerland.

Selected Group Exhibitions: 1973 — *24 from LA,* San Francisco Museum of Art (Sept. 21-Nov. 11; catalogue). 1974 — *Light and Substance,* University of New Mexico, Albuquerque (catalogue). 1976 — *Exposing: Photographic Definitions,* LAICA (Oct. 26-Dec. 3; catalogue); *Sequences,* Broxton Gallery, Los Angeles; *Catalog of the UCLA Collection of American Photographs.*** 1977 — *Creative Photography from the 20th Century from the Collection of the Bibliotheque Nationale,* Musée Nationale d'Art Moderne et de Culture George Pompidou, Paris; *Emerging LA Photographers,* The Friends of Photography, Carmel, Calif., and International Center of Photography, New York (catalogue); *Exhibitions '76, '77.*** 1978 — *Interchange,* Mount St. Mary's College, Los Angeles (Jan. 16-Feb. 26; catalogue); *Contemporary California Photography.** 1979 — *Attitudes*; The Anthony G. Cronin Memorial Collection**; Photographic Directions.** 1981 — *Wallworks,* University of Southern California, Los Angeles (Dec. 14, 1981-Jan. 31, 1982; catalogue).

Books by the Artist: *Stasis.* Privately published, 1973.

Books by Others: Osman, Colin, and Turner, Peter C. *Creative Camera International Year Book 1976.* Coos Press, Ltd., London, 1975. pp. 52-55.

Selected Articles, Essays, and Reviews: Coleman, A.D. "The Photography Book as Autobiography." *New York Times,* Aug. 11, 1974, Sec. 2, p. 25 • Nuridsany, Michel. "Une étoile est née: Stephen Kahn." *Le Figaro,* Paris (Feb. 10, 1975) • Novak, Al'n. "Photography." *Iconoclast* (Sept. 13, 1976), p. 6 • Woolard, Robert W. "Uses and Misuses of Sequential Images." *Artweek* (May 22, 1976), p. 11 • Scarborough, John. "Kahn photo show pithy." *Houston Chronicle,* Mar. 9, 1979, Sec. 6, p. 4 • Muchnic, S. "Steve Kahn in Rosamund Felsen Gallery." *Los Angeles Times,* May 1, 1979 • Nye, M. "Steve Kahn." *New Art Examiner* (April

1979) • Johnstone, Mark. "Seeing Photographically." *Artweek* (Nov. 22, 1980), p. 16 • Nuridsany, Michel. "Dans le silence de Steve Kahn." *Le Figaro,* Paris (Mar. 18, 1981) • Rickey, Carry. "Art Attack!" *Art in America* (May 1981), pp. 41-48.

Sol LeWitt

Born: Hartford, Conn., Sept. 9, 1928

Resides: New York

Education: Syracuse University, N.Y., B.F.A., 1949; Cartoonists and Illustrators School (later known as The School of Visual Arts), New York, 1953.

Professional Experience: Design department, *Seventeen* magazine, 1954-1955; free-lance graphic artist, 1955-1960; worked at information and book sales desk and as night receptionist at MOMA, New York, 1960-1965; part-time teacher, MOMA's school, The People's Art Center, 1964-1967; taught at Cooper Union, New York, 1967-1968, School of Visual Arts, New York, 1969-1970, and Education Department, New York University, 1970-1971; founder of *Printed Matter,* artist book publisher and distributor, 1976.

Individual Exhibitions: 1965 — Daniels Gallery, New York (May 4-29). 1966 — Dwan Gallery, New York (Apr. 1-29). 1967 — Dwan Gallery, Los Angeles (May 10-June 4). 1968 — Galerie Konrad Fischer Düsseldorf, West Germany (Jan. 6 - Feb. 3); Dwan Gallery, New York (Feb. 3-28); Galerie Bischofberger, Zurich, Switzerland (Feb. 8 - Mar. 14); Galerie Heiner Friedrich, Munich, West Germany (Feb. 13 - Mar. 8); *Set II A, 1-24,* Ace Gallery, Los Angeles (Dec. 3, 1968 - Jan. 11, 1969; artist book). 1969 — Galerie Konrad Fischer (Apr. 22 - May 16); Galleria L'Attico, Rome (May 2 - 20); Galerie Ernst, Hanover, West Germany; Dwan Gallery, New York (Oct. 4-30); Museum Haus Lange, Krefeld, West Germany (Oct. 26 - Nov. 30; catalogue); *49 Three-Part Variations Using Three Different Kinds of Cubes, 1967-68,* Galerie Bischofberger (artist book). 1970 — *Lines and Combinations of Lines,* Art & Project, Amsterdam, The Netherlands (January; artist book); Wisconsin State University, River Falls (Apr. 14 - May 8); Galerie Yvon Lambert, Paris (June 4-27); Galleria Sperone, Turin, Italy (June 12-28); Dwan Gallery, New York; Lisson Gallery, London (June 15 - July 24); Gemeentemuseum, The Hague, The Netherlands (July 25 - Aug. 30; catalogue); Galerie Heiner Friedrich (September); Pasadena Art Museum, Calif. (Nov. 17, 1970 - Jan. 3, 1971; catalogue). 1971 — *Ten Thousand Lines / Six Thousand Two Hundred and Fifty-Five Lines,* Art &

Project (January; artist book); Protetch-Rivkin Gallery, Washington, D.C. (Apr. 17 - May); Dwan Gallery, New York (May 1-26); *Four Basic Colours and Their Combinations,* London (June; artist book); Galerie Stampa, Basel, Switzerland; Galleria Toselli, Milan, Italy (July); Informations-raum 3, Basel (Aug. 24 - Sept. 18); Galerie Konrad Fischer (Sept. 3 - Oct. 1); Art & Project (Sept. 7 - Oct. 2); John Weber Gallery, New York (Sept. 25 - Oct. 20); Dunklemann Gallery, Toronto; Galerie Ernst (December 1971 - January 1972); Solomon R. Guggenheim Memorial Museum, New York; MOMA, New York. 1972 — Hayden Gallery, MIT, Cambridge (Feb. 28 - Mar. 28); Harkus-Krakow Gallery, Boston; Dayton Art Institute, Ohio; *Arcs, Circles & Grids,* Kunsthalle, Bern, Switzerland (artist book); Gallery A-402, California Institute of the Arts, Valencia (April); *Lithographs and Wall Drawings,* Nova Scotia College of Art and Design, Halifax (catalogue); Galerie MTL, Brussels, Belgium; *Lines & Lines, Arcs & Arcs & Lines & Arcs,* Art & Project (Sept. 25 - October; artist book). 1973 — *Cercles & Lignes,* Galerie Yvon Lambert (January; artist book); John Weber Gallery (Jan. 27 - Feb. 14); Rosa Esman Gallery, New York (Feb. 3-28); Vehicule Art, Inc., Montreal; Lisson Gallery; MOMA, Oxford, England; Gallerie L'Attico; Galleria Toselli; Galleria Marilena Bonoma, Bari, Italy (catalogue); *Wall Drawings: Seventeen Squares of Eight Feet with Sixteen Lines and One Arc,* Portland Center for Visual Arts, Ore. (Sept. 16 - Oct. 14; artist book); *Six Wall Drawings: Arcs with Straight Lines, Not Straight Lines, and Broken Lines,* Cusack Gallery, Houston (October; catalogue); *Vier Muurtekeningen / Quatre Dessins Muraux,* Art & Project / Galerie MTL (Nov. 13 - Dec. 8; artist book). 1974 — *Incomplete Open Cubes,* Galerie Yvon Lambert (artist book; traveled); *The Location Lines,* Lisson Gallery (Apr. - May; artist book); *The Location of Eight Points,* Max Protetch Gallery, Washington, D.C. (April; artist book); Galerie December, Munster, West Germany; *Location of Three Geometric Figures,* Palais des Beaux Arts, Brussels, (May - June; artist book); *Incomplete Open Cubes* and *Wall Drawings & Structures: The Location of Six Geometric Figures / Variations of Incomplete Open Cubes,* John Weber Gallery (Oct. 26 - Nov. 20; artist books); *Prints,* Stedelijk Museum, Amsterdam (Nov. 29, 1974 - January 1975); Ace Gallery; Daniel Weinberg Gallery, San Francisco; *La posizione di tre figure geometriche / The Location of Three Geometric Figures,* Galleria Sperone (artist book); Galerie Vega, Liege, Belgium; Gian Enzo Sperone, New York (Decem-

ber 1974 - January 1975); *Fifty Drawings 1964 - 1974,* New York Cultural Center (traveled). 1975 — Lucio Amelio Modern Art Agency, Naples, Italy; *Wall Drawings, Drawings, and Incomplete Open Cubes,* Daniel Weinberg Gallery; *Incomplete Open Cubes,* Art & Project (Mar. 4-15); *Incomplete Open Cubes and Wall Drawings,* Scottish National Gallery of Modern Art, Edinburgh; Gallery Konrad Fischer; Saman Gallery, Genoa, Italy; Aronowitsch Gallery, Stockholm, Sweden; *Lines & Color,* Annemarie Verna, Zurich (artist book); Rolf Preisig Gallery, Basel; *Red, Blue and Yellow Lines from Sides, Corners and the Center of the Page to Points on a Grid,* Israel Museum, Jerusalem (artist book); *Graphik 1970-1975,* Kunsthalle Basel (Oct. 18 - Nov. 23; catalogue); Claire Copley Gallery, Inc., Los Angeles (Oct. 25 - Nov. 20); Printmakers' Workshop, Edinburgh (Nov. 1-22). 1976 — Visual Arts Museum, New York (Mar. 1-19); *Five Structures,* Dag Hammarskjöld Plaza Sculpture Garden, New York (March - May; catalogue); *Incomplete Open Cubes,* Kölnischer Kunstverein, Cologne, West Germany (May 26 - Aug. 1); Gian Enzo Sperone (June - July); *Drawings, Prints and Cubes,* Kornblatt Gallery, Baltimore (Sept. 5-30); *Wall Drawings, Structures and Prints,* Fine Arts Gallery, University of Colorado, Boulder (Oct. 4 - Nov. 12; artist book: *Geometric Figures within Geometric Figures),* Claire Copley Gallery, Inc. (Oct. 12 - Nov. 8); *Geometric Figures,* Galerie MTL; *Wall Drawings,* Wadsworth Atheneum, Hartford, Conn. 1977 — John Weber Gallery (Mar. 2-19); Lisson Gallery (Mar. 12 - Apr. 9); *Geometric Figures,* Galerie Konrad Fischer; *Wall Drawings in Australia,* The Art Gallery of New South Wales, Sydney, Australia (Mar. 19 - Apr. 1; catalogue); National Gallery of Victoria, Melbourne, Australia; Joslyn Art Museum, Omaha, Neb.; Utah Museum of Fine Arts, Salt Lake City; University of North Dakota Art Gallery, Grand Forks; *Incomplete Open Cubes,* MOMA, Oxford (Apr. 24 - May 29); Saman Gallery (June); Art and Architecture Gallery, Yale School of Art, New Haven, Conn. (Sept. 5-30); *Sol LeWitt: Drawings, Silkscreen Prints, Multiples up to 1971,* University Gallery, University of Massachusetts, Amherst (September - October). 1978 — *Geometric Figures,* Rolf Preisig Gallery; John Weber Gallery; Protetch-McIntosh Gallery; Michael Berger Gallery, Pittsburgh; Halle für Internationale Neue Kunst, Zurich; *Prints,* Brooklyn Museum, N.Y. (January); *Retrospective,* MOMA, New York (January; catalogue; traveled). 1979 — *Open Geometric Structures: Five Geometric Structures and their Combinations,* Lisson Gallery (artist book); Konrad Fischer Gallery; Young/Hoffman

Gallery, Chicago; Galerie Yvon Lambert; Margo Leavin Gallery, Los Angeles; Rosa Esman Gallery. 1980 — John Weber Gallery; *All Four Part Combination of Six Geometric Figures,* Galerie Watari, Tokyo (artist book); Marlena Bonomo Gallery; *Grids & Color,* Rudiger Schottle, Munich, West Germany; *Photo Grids,* Protetch-McIntosh Gallery; Young/Hoffman Gallery; Ugo Ferranti Gallery, Rome; *Statues (A Melodrama),* John Weber Gallery; Texas Gallery. 1981 — Daniel Weinberg Gallery; Paula Cooper Gallery; Konrad Fischer Gallery; Max Protetch Gallery, New York; Real Art Ways, Hartford (Sept. 29 - Oct. 28); The Center for Arts and The Davison Art Center, Wesleyan University, Middletown, Conn. (Oct. 21 - Dec. 20); Wadsworth Atheneum.

Selected Group Exhibitions: A major monograph with bibliography exists for this artist; therefore, group exhibitions and major articles, essays, and reviews previous to the publication of the monograph have been omitted here. See Legg, Alicia, ed. *Sol LeWitt,* MOMA, New York, 1978. Introduction by Alicia Legg with essays by Bernice Rose, Lucy Lippard, and Robert Rosenblum. 1978 — *Art Books:;,. Books as Original Art***; Artwords and Bookworks***; Artists Books, U.S.A.,***;* Dalhousie University, Nova Scotia (traveled); *Numerals: Mathematical Concepts in Contemporary Art,* Leo Castelli Gallery, New York (traveled). 1979 — *Super Show,* Hudson River Museum and Independent Curators, Inc., New York (traveled); *Kunst als Photographie 1879-1949/Photographie als Kunst 1949-1979***; 73rd American Exhibition,* The Art Institute of Chicago (June 9-Aug. 5; catalogue); *Sculpture and Construction,* Ashmolean Museum, Oxford, England (Nov. 3-Dec. 17; catalogue). 1980 — *Reasoned Space**.* 1981 — *Artists' Photographs, Vision #5**; An Exhibition of Contemporary Bookworks, Re: Pages***; Erweiterte Fotographie (Extended Photography***.)* 1982 — *Concepts in Construction: 1910-1980,* Independent Curators, Inc. (catalogue; traveled).

Books by the Artist (see also individual exhibitions): *Serial Project No. 1.* Aspen Magazine, No. 5 and No. 6, 1966 • *Four Basic Kinds of Straight Lines.* Studio International, London, 1969 • *Diciassette quadrati con sedici linee ed un arco.* Galleria Toselli, Milan, Italy, 1974 • *Grids, Using Straight Lines, Not-Straight Lines & Broken Lines in All Their Possible Combinations.* Parasol Press, Ltd., New York, 1973 • *Squares with Sides and Corners Torn Off.* MTL, Brussels, Belgium, 1974 • *Drawing Series I, II, III, IIII A & B.* Galleria Sperone, Turin, Italy, and Konrad Fischer, Düsseldorf, West Germany, 1974 • *Arcs and Lines.* Editions des Massons,

S.A.,Lausanne, Switzerland, and Galerie Yvon Lambert, Paris, 1974 • *Grids, Using Straight, Not-Straight and Broken Lines in Yellow, Red & Blue and All Their Combinations.* Parasol Press, Ltd., 1975 • *Grids.* Pour Ecrire La Liberté, Brussels, 1975 • *Stone Walls.* Crown Point Press, Oakland, Calif., 1975 • *The Location of Straight, Not-Straight & Broken Lines and All Their Combinations.* John Weber Gallery, New York, 1976 • *Modular Drawings.* Adelina von Furstenberg, Geneva, Switzerland, 1976 • *Brick Wall.* Tanglewood Press, Inc., New York, 1977 • *Photogrids.* Paul David Press, New York, 1977 • *Color Grids.* Multiples, New York, 1977 • *Five Cubes/Twenty-Five Squares.* Galleria Marilena Bonomo, Bari, Italy, 1977 • *Geometric Figures & Color.* Harry N. Abrams, Inc., New York, 1979 • *Cock Fight Dance.* Rizzoli International Publications, Inc., and Multiples, Inc., New York, 1980 • *Sunrise and Sunset at Praiano.* Rizzoli International Publications, Inc. and Multiples, Inc., 1980 • *Autobiography.* Multiples, Inc. and Lois and Michael K. Torf, Boston, 1980 • *Statues (A Melodrama).* Texas Gallery, Houston, 1982.

Book designed by the Artist: Lippard, Lucy R. *Eva Hesse.* New York University Press, 1976.

Other Books: Battcock, Gregory, ed. *Minimal Art: A Critical Anthology.* E. P. Dutton, New York, 1968 • Burnham, Jack. *Beyond Modern Sculpture. The Effects of Science and Technology on the Sculpture of this Century.* Braziller, New York, 1968 • Kulturmann, Udo. *The New Sculpture: Environments and Assemblages.* Translated by Stanley Baron. Praeger, New York, 1968 • Siegelaub, Seth, and Wendler, John W., eds. *The Xerox Book.* Siegelaub/Wendler, New York, 1968 • Müller, Grégoire, and Gorgoni, Gianfranco. *The New Avant-Garde: Issues for the Art of the Seventies.* Praeger, 1972 • Lippard, Lucy R., ed. *Six Years: The Dematerialization of the Art Object,* Praeger, 1973 • Battock, Gregory. *Idea Art.* E. P. Dutton, 1973 • Hunter, Sam. *American Art of the 20th Century.* Harry N. Abrams, Inc., 1974 • deVries, Gerd, ed. *Über Kunst – On Art: Artists' Writings on the Changed Notion of Art after 1965.* Verlag M. DuMont Schauberg, Cologne, West Germany, 1974 • Alloway, Lawrence. *Topics in American Art Since 1945.* W. W. Norton, New York, 1975 • Cork, Richard. "Alternative Developments." *English Art Today 1960-76,* vol. 2. Electa Editrice, Milan, Italy, 1976, pp. 310-43 • Pincus-Witten, Robert. *Post Minimalism: American Art of the Decade.* Out of London Press, New York, 1977 • Harvey, Michael. *Notes on the Wall Drawings of Sol LeWitt.* Editions Centre d'Art Contemporain, Salle Patiño & Ecart Publications, Geneva, 1977.

Selected Articles, Essays, and Reviews: Tuchman, Phyllis. "Minimalism and Critical Response." *Artforum* (May 1977), pp. 26-31 • Masheck, Joseph. "Cruciformality." *Artforum* (Summer 1977), pp. 56-63 • Pincus-Witten, Robert. "Strategies worth pondering: Bochner, Shapiro, Reise, LeWitt." *Arts Magazine* (April 1978), pp. 142-45 • Kuspit, Donald B. "Sol LeWitt: the Wit." *Arts Magazine* (April 1978), pp. 118-24 • Schwartz, Ellen. "Catching conceptual art by the tail." *Art News* (April 1978), pp. 106-07 • Baker, Kenneth. "Sol LeWitt: Energy as Form." *Art in America* (May-June 1978), pp. 76-81 • Wooster, Ann Sargent. "LeWitt goes to school." *Art in America* (May 1978), pp. 82-84 • "LeWitt's Christmas gift to the Franklin Furnace." *The Print Collector's Newsletter* (March 1979), p. 17 • Saulnier, Adam. "L'Abstrait dessin." *Opus International* (Summer 1979), pp. 28-29 • LeWitt, Sol. "On the walls of the lower east side." *Artforum* (December 1979), pp. 46-51 • Wortz, Michael. "The Power of the Idea." *Artweek* (Sept. 22, 1979), pp. 1, 20 • Margolin, V. "Corporate art minimalist logotypes." *New Art Examiner* (March 1980), pp. 1, 12 • Perlberg, Deborah. "Dance: Lucinda Childs, Philip Glass and Sol LeWitt." *Artforum* (January 1980), pp. 52-53 • Wooster, Ann Sargent. "Sol LeWitt's Expanding Grid." *Art in America* (May 1980), pp. 143-147 • Ratcliff, Carter. "Modernism and Melodrama." *Art in America* (February 1981), pp. 105-09 • Burnett, David. "David Bellman Gallery: review." *Artscanada* (March-April 1981), pp. 56-57 • Blisteine, B. "Galerie Yvon Lambert: Review." *Flash Art* (March-April 1981), p. 22 • Ammann, J.C. "Was die sebziger Jahre von dem sechzigern unterscheidet: der Weg in die achtzeger Jahre (What differentiates the seventies from the sixties: the way into the eighties)." *Kuntsforum International,* no. 3 (1981), pp. 172-84.

Joan Lyons

Born: New York, 1937

Resides: Rochester, N.Y.

Education: New York State College of Ceramics at Alfred University, B.F.A., 1957; graduate assistantship, Mills College, Oakland, Calif. (one semester), 1957; photographic studies program, SUNY at Buffalo, M.F.A., 1973.

Professional Experience: Worked on a series of graphic design and printing production jobs, staff and free-lance: New York, 1958-1959; Rochester, N.Y., 1959-1970; consultant to GVSDA Art Service, designing traveling exhibitions, 1967-1968; coordinator of VSW Press, responsible for development and operation of the Press and training program in design and production for artists and students who are publishing books, 1972-present; taught workshops in printing, printmaking, and bookmaking at VSW and elsewhere including Center of the eye (Aspen, Colo.) Arles Festival (Arles, France) CCAC (Oakland, Calif.), 1970-present; taught at Rochester Memorial Art Gallery, 1968-1971. Served on grant panels: New York State Council for the Arts (Creative Artists Public Service Photography Fellowships), 1976; Visual Arts Panel, 1977-1979; Appeals Panel, 1980-1981), National Endowment for the Arts (Photography Exhibitional and Publications Fellowships, 1978, 1979; Printmaking Fellowships, 1980).

Recognition and Awards: Photography fellowships from Creative Artists Public Service, New York State Council on the Arts, 1975, 1981; Lillian Fairchild Award, University of Rochester, N.Y., 1979.

Individual Exhibitions: 1963 — Schuman Gallery, Rochester, N.Y. 1965 — Schuman Gallery. 1968 — Schuman Gallery. 1969 — Nazareth College Arts Center, Pittsford, N.Y. (Nov. 4-27). 1970 — Milan Gallery, Italy (traveled). 1972 — Schuman Gallery (Feb. 15-Mar. 8). 1975 — Jorgensen Auditorium Gallery, University of Connecticut, Storrs, with Eileen Cowin (Feb. 18-Mar. 8; brochure); The Moncton Museum Inc., N.S., Canada. 1976 — Vision Gallery, Boston (Mar. 20-April). 1979 — Catskill Center for Photography, Woodstock, N.Y. 1982 — Portland School of Art, Me. (January-February); *Joan Lyons: "Presences,"* Art Museum, University of New Mexico, Albuquerque (June-July).

Selected Group Exhibitions: 1963 — American Federation of Arts, New York (traveled in Middle East). 1965 — *Joan Lyons/Nathan Lyons,* Alfred University, N.Y. 1969 — *Serial/Modular Imagery in Photography***.* 1970 — *Into the 70's***.* 1972 — *Photographic Portraits.** 1974 — *Women and the Printing Arts,* Women's Building, Los Angeles (catalogue). 1975 — *Joan Lyons/Scott Hyde,* The Picker Art Gallery, Colgate University, Hamilton, N.Y. (Nov. 21-Dec. 14; brochure); *The Photographer's Choice* (book); *Women of Photography*; 12 Women Photographers,* Nova at Park Center, Cleveland (catalogue). 1976 — *Photographic Process as Medium*; Photographic*; Photographic: Rochester, New York,* American Cultural Center, Paris (traveled through Europe); *Offset Lithography,* SAIC, Chicago (catalogue); *Joan Lyons/Paul Diamond,* University of Colorado, Boulder. 1977 — *Bookworks***; On the Offset Press,* Gallery Association of New York State, Hamilton (traveled); *The Target Collection of American Photography**; Photographs: Sheldon Memorial Art Gallery Collections**.* 1978 — *Mirrors and Windows*; Artwords and Bookworks***; Art Books:;,. Books as Original*

*Art***; Visual Studies Workshop Book Show***; American Narrative/Story Art: 1967-1977****. 1979 — *Attitudes*; Electroworks***; Translations*, Herbert P. Johnson Museum, Cornell University, Ithaca, N.Y. (catalogue); *The First Traveling Offset Rip-off Show*, VSW, Rochester, N.Y. (traveled); *Copy Machine*, Everson Museum of Art, Syracuse, N.Y.; *Joan Lyons/Eric Renner*, VSW Gallery (Jan. 21-Feb. 23). 1980 — *20 x 24/Light*, Light Gallery, New York (October; traveled); *Visual Studies Workshop – the First Decade: 1970-1980*, Pratt Manhattan Center Gallery, New York; *Women/Image/Nature*, Tyler School of Art, Philadelphia (catalogue: *Quiver*; traveled); *Aspects of the 70's: Photography**. 1981 — *Re: Pages***; Paperworks: Art on Paper, Art of Paper*, Museum of Applied Arts, Belgrade, Yugoslavia (traveled); *CAPS at the State Museum*, New York State Museum, Albany, N.Y. (May-August; checklist); *CAPS, Photographers*, The Picker Art Gallery, Colgate University (catalogue; traveled). 1982 — *American Photography Today*, University of Colorado, Denver (Mar. 6-Apr. 3; slide-catalogue); *Joan Lyons/Rita DeWitt*, Light Factory, Syracuse (March).

Books by the Artist (privately published): *Self Impressions*, 1972 • *In Hand*, 1973 • Lyons in collaboration with McGrath, Juliet. *Wonder Woman*, 1973 • *Busform Shadows*, 1973 • *Bride Book Red to Green*, 1975 • *Abbey Rogers to her Granddaughter*, 1977 • *Perspectives I, Australian National Railroad; Perspectives II, The Matterhorn; Perspectives III, Tamiami Trail; Perspectives IV, The Moon at 17 Days of Age; Perspectives V, Sea Cliffs; Perspectives VI, Mountain Lake; Perspectives VII, Pool of Bethesda; Perspectives VII, Coral Reef*, 1978 • *Full Moon*, 1978 • *Sunspots*, 1978 • Lyons with Zimmerman, Phillip. *Spine*, 1978 • *Seed Word Book*, 1981.

Books: Dugan, Thomas, ed. *Photography Between Covers: Interviews with Photo-Bookmakers*, Light Impressions, Rochester, N.Y., 1979, pp. 91-100.

Selected Articles, Essays, and Reviews: "Drawings." *Statements* (Spring 1962), pp. 18-19 • *Photographia Italiana*, 1970 • "New Directions in Photography." *Christian Science Monitor* (Jan. 3,1977) • Scully, Julia. "Portraits." *Modern Photography* (June 1977) • McWillie, Judith. "Exploring electrostatic print media." *Print Review*, no. 7 (1977), pp. 75-81 • Lippard, Lucy. "Women's Books." *Chrysalis* (Fall 1978) • Eauclaire, Sally. "Xerox 'super technology' becomes artist's medium." *Rochester Democrat & Chronicle*, Feb. 18, 1979, Sec. E, pp. 1, 3 • Tsuchiya, Nancy. "Women artists and their work: Joan Lyons." *City Newspaper*, Rochester, Dec. 6, 1979, pp. 21-22 • Scholl, James D. "Press the button — and out comes art." *Smithsonian* (October 1980), pp. 26-27.

Nathan Lyons
Born: Jamaica, N.Y., 1930
Resides: Rochester, N.Y.
Education: Alfred University, N.Y., B.A., 1957
Professional Experience: Photographer in the U.S. Air Force, 1950-1954; editor of publications and assistant director, GEH, Rochester, N.Y., 1957-1964, associate director and curator of photography, 1965-1969; founder and director, VSW, Rochester, N.Y., 1969-present; professor, Department of Art, SUNY at Buffalo, 1968-present; director of photographic studies program, SUNY at Buffalo, 1969-1980; lectured and taught workshops in United States, Canada, and Europe, 1959-present; founding member and first chairman, Society for Photographic Education, 1962-1965; visiting lecturer and teacher, Institute of Design, Illinois Institute of Technology, Chicago, 1963; University of Minnesota, Minneapolis, 1965, Center of the Eye, Aspen, Colo., summers 1971, 1973, and Rochester Institute of Technology, N.Y., 1966-1967; presently adjunct professor, Master of Fine Arts Photography Program, Rochester Institute of Technology, and the Art Department, SUNY at Albany; editor, *Afterimage*, 1972-present; editor, "The Visual Studies Reprint Series," 1974-present. Previous and present service on Boards of Trustees or Boards of Directors: New York Foundation for the Arts, 1971-present (chairman, 1976-1980); Gallery Association of New York State; Center of the Eye, Aspen, Colo., 1970-1973; Media Alliance, 1981-present.

Previous and present service as panelist: National Endowment for the Arts (Photography Surveys, 1980; Photography Fellowships, 1976; Photography Exhibitions, 1976; Photography Task Force, 1980; Visual Arts Program Policy Panel, 1977-1980); New York State Council on the Arts (Museum Aid); Creative Artists Public Service Program (Review and Advisory Committee, 1971-74); Governor Carey's Task Force on the Arts, 1975.

Individual Exhibitions: 1958 — Glidden Gallery, Alfred University, N.Y. 1959 — *Seven Days a Week*, GEH, Rochester, N.Y.; Indiana University, Bloomington; Boston University. 1960 — Rochester Institute of Technology, N.Y. 1961 — Carl Siembab Gallery, Boston (October). 1962 — Arizona State University, Tempe. 1963 — University of Florida, Gainesville. 1965 — University of Minnesota, Minneapolis. 1967 — Jacksonville Art Museum, Fla.; University of Oregon, Eugene; Phoenix College, Ariz. 1968 — University of Iowa, Iowa City. 1969 — Alfred University; University of Connecticut, Storrs; Carl Siembab Gallery (Nov. 7-29). 1971 — University of Col-

orado, Boulder. 1972 — Columbia College, Chicago; National Gallery of Canada, Ottawa (traveled). 1973 — Addison Gallery of American Art, Andover, Mass. 1974 — Light Gallery, New York (Feb. 5-Mar. 2); Light Impressions Bookstore, Rochester, N.Y.; Chapman College, Orange, Calif. 1975 — Upton Gallery, SUNY at Buffalo; *Nathan Lyons: Notations in Passing*, Carl Siembab Gallery (Jan. 10-31); Oakton Community College, Ill. 1976 — Cronin Gallery, Houston (Mar. 30-May 15). 1977 — *Nathan Lyons: 100 Photographs from Notations in Passing*, Library, University of Maryland, Baltimore County (Feb. 9-Mar. 23).

Selected Group Exhibitions: 1957 — American Institute of Graphic Arts, New York. 1959 — *Photography at Mid-Century*, GEH, Rochester, N.Y. 1960 — *The Sense of Abstraction in Contemporary Photography.** 1963 — *Photography 63*; Six Photographers*, University of Illinois, Urbana (catalogue); *Nathan Lyons – Alice Wells*, Institute of General Semantics, New York University. 1964 — *Permanent Collection Installation*, Edward Steichen Photography Center, MOMA, New York. 1965 — *Nathan Lyons/Joan Lyons*, Alfred University, N.Y. 1966 — *American Photography: The Sixties*; The Photographer's Eye**. 1967 — *Photography in the Twentieth Century*; Photography, USA**; United States Information Agency Exhibition touring Latin America. 1968 — *Photography 1968*; Contemporary Photographs***. 1969 — *Recent Acquisitions 1969***. 1970 — *The Photograph as Object****. 1973 — Contemporary Art Festival of Royan, Paris. 1974 — *Photography in America**. 1975 — *Nathan Lyons/Jack Welpott: Photographs*, University of Colorado, Boulder (Jan. 20-Feb. 16); Sao Paulo, Brazil. 1976 — *Contemporary American Photographs**; Photographic*; Photography: Rochester, N.Y.*, American Cultural Center, Paris (traveled Europe); *Nathan Lyons/Joan Lyons*, Deja Vu Gallery, Toronto (Apr. 9-30). 1977 — *The Target Collection of American Photography**; The Great West: Real/Ideal*; Mirrors and Windows**. 1979 — *Intentions and Techniques***. 1980 — *Aspects of the 70's: Photography**. 1982 – *American Photography Today*, University of Colorado, Denver (Mar. 6-Apr. 3; slide catalogue).

Monographs: Lyons, with Labrot, Syl, and Chappell, Walter. *Under the Sun, the Abstract Art of Camera Vision*. Braziller, New York, 1960 (reprinted, *Aperture*, Millerton, N.Y., 1972) • *Notations in Passing*. MIT Press, Boston, 1974.

Books and Catalogues Edited by the Artist: *Photography 63* • Photography 64* • Aaron Siskind, Photographer*. GEH, Rochester, N.Y., 1965 • *Photographers on Photography* (book) • *Towards a Social Landscape*. Horizon Press, New York,

and GEH, 1965 • *The Persistence of Vision**** • *Photography in the Twentieth Century** • *Vision and Expression.**

Books with Essays by the Artist: "Photography." *World Scope Encyclopedia Year Book.* Gache, New York, 1958-1971 • Lyons, Nathan. "Landscape Photography." *The Encyclopedia of Photography,* vol. 11. Greystone, New York, 1963, pp. 1935-48 • "Photographic Books." *The Encyclopedia of Photography,* vol. 14. Greystone, 1963, pp. 2680-88 • Lyons, Nathan, et al. "Photography — Events of 1972." *Funk and Wagnalls Yearbook, 1973* • Dugan, Thomas, ed. *Photography Between Covers: Interviews with Photo-Bookmakers.* Light Impressions, Rochester, 1979, pp. 33-46 • Lyons, Nathan. "Visual Descriptions of the West." *That Awesome Space, Human Interaction with the Intermountain Landscape.* Edited by Brewster Ghiselen, William Goetzmann, and Stephen Pyne. The Sun Valley Center for the Arts and Humanities, Idaho, 1981, pp. 36-37.

Other Books: See also Witkin and London, *The Photograph Collector's Guide,* and Gassan, *A Chronology of Photography.*

Articles and Essays by the Artist: "Poem." *Statements #1* (Spring 1952), p. 24 • *Statements #2* (Winter 1959-1960), pp. 2, 11-12 • *Statements #3* (1960), p. 2 • "Ghost." *Modern Photography* (February 1959), p. 71ff • "To the Spirit of a Time: In Consideration." *Aperture,* vol. 8, no. 2 (1960; catalogue: *The Sense of Abstraction*), pp. 118-21 • "Book Review: Form in Art and Nature." *Aperture,* vol. 9, no. 4 (1961), p. 40 • "The Idea of the Workshop in Photography." *Aperture,* vol. 9, no. 1 (1961), pp. 163-67 • "Meaning Must Come from the Picture." *Popular Photography,* vol. 57, no. 3 (1965), pp. 61ff • "Photography in the '70s — What's Ahead." *35mm Photography* (Spring 1970), p. 14 • "Notations in Passing." *Aperture,* vol. 16, no. 2 (1971), pp. 1-17 • "Weston on Photography." *Afterimage* (May-June 1975), pp. 8-12 • "Reply." *Afterimage* (December 1975), pp. 16-17 • "SPE Present: Where is it now, and where is it going? Future considerations." *Afterimage* (February 1977), p. 4 • "Triangulating Misology — 'To mistake the trapping of intellectual authority for its substance.'" *Afterimage* (Summer 1979), pp. 8-9 • "... the outline of its mountains, will be made familiar to us." *The Great West: Real/Ideal** • *Camera Austria 4/80* (1980), pp. 75-79 • "Photographic Education — A Brief Commentary." *Teaching Photography* (special issue of *Exposure*) (1981), pp. 23-25.

Selected Articles, Essays, and Reviews about the Artist: Newhall, Beaumont. "New Talent USA: Photography." *Art in America,* vol. 48, no. 1 (1960), pp. 38-47, 59 • *Contemporary Photographer*

(1960) • "Moments in the Real World." *Statements #4* (1961) • White, Minor. "Special Supplement in Honor of the Teaching Conference Sponsored by GEH of Photography, 1962." *Aperture* Special Supplement, vol. 11 (1963), pp. 1-8 • Coke, Van Deren. "Review: Photographers on Photography." *Art Journal* (Summer 1967), pp. 436-37 • Leach, Frederick D. "Review: Photographers on Photography." *Aperture,* vol. 13, no. 2 (1967), pp. 116-17 • White, Minor. "Review: Photography in the 20th Century and The Persistence of Vision." *Aperture,* vol. 13, no. 4, pp. 58-60 • Converse, Margaret. "Photography as Seen From Lyons' Den." *Upstate Magazine* in the *Rochester Democrat & Chronicle,* Feb. 15, 1970, pp. 17-20 • "A Selection of Photographs from the Pasadena Art Museum Permanent Collection." *San Francisco Camera,* vol. 1, no. 5 (1971) pp. 5-6 • Scarborough, John. "Lyons Show Documents the Teacher as Artist." *Houston Chronicle,* April 3, 1976, Sec. 2, p. 5 • Searle, Leroy. "Poems, Pictures, and Conceptions of 'Language.'" *Afterimage* (May-June 1975), pp. 33-39 • Schwarz, Angelo. "Nathan Lyons" (interview). *Fotografie Italiana* (June 1977), pp. 33-34.

MANUAL

In 1974, Edward Hill and Suzanne Bloom began working collaboratively, principally in photography and video, and exhibiting under the name MANUAL. Both Hill and Bloom came to the collaboration with experience in other media. Their individual bibliographies precede that of MANUAL.

MANUAL: Edward Hill

Born: Springfield, Mass., 1935

Resides: Houston

Education: Rhode Island School of Design, Providence, B.F.A. in painting, 1957; Yale University School of Art and Architecture, New Haven, Conn., M.F.A. in painting, 1960 (studied with Rico Lebrun and Josef Albers).

Professional Experience: Teacher, Florida State University, Tallahassee, 1959-1962; Smith College, Northampton, Mass., 1962-1976; Dartmouth College, Hanover, N.H., 1969-1970; associate professor of art (taught drawing, painting, photography, and video), University of Houston, 1976-present.

Recognitions and Awards: National Institute of Arts and Letters Grant, 1964; Edward MacDowell Fellowship, 1964; Louis Comfort Tiffany Foundation Grant, 1967; National Endowment for the Arts Photography Fellowship, 1972; Research-Enabling Grant, University of Houston, 1979.

Individual Exhibitions: 1963 — SUNY at Albany. 1967 — The Martin Gallery, New York; University of Massachusetts, Amherst. 1970 — Beaumont-

May Gallery, Hopkins Center, Dartmouth College, Hanover, N.H. 1971 — George Walter Vincent Smith Museum, Springfield, Mass. (catalogue); Art Gallery of Middlebury College, Vt. 1973 — *The Rural Environment: a photographic diary,* Smith College Museum of Art, Northampton, Mass. 1979 — *Drawings,* College of the Mainland, Texas City (March 3-23).

Books: Hill, Edward. *The Language of Drawing.* Prentice-Hall, Inc., Englewood Cliffs, N.J., 1966.

Selected Articles, Essays, and Reviews by the Artist: "Book review: *Goya: The Origins of the Modern Temper in Art.*" The Museum of Fine Arts, Houston *Calendar* (May-June 1981) • "The Lone Star Photographer." *Texas Photo Sampler,* Washington Project for the Arts, D.C. (1981) • "The Inherent Phenomenology of Alberto Giacometti's Drawing." *Drawing* (January-February 1982), pp. 97-102.

MANUAL: Suzanne Bloom

Born: Philadelphia, Nov. 25, 1943

Resides: Houston

Education: Attended Stella Elkins Tyler School of Fine Arts, Pa., 1959-1960; Philadelphia College of Art, 1961-1962; University of Pennsylvania, Philadelphia, B.F.A. through its coordinated program with the Pennsylvania Academy of Fine Arts, 1965; University of Pennsylvania, Philadelphia, M.F.A., 1968 (studied with Angelo Savelli and Piero Dorazio).

Professional Experience: Teacher at Pennsylvania State University, Ogontz, 1969-1970; Smith College, Northampton, Mass., 1970-1976; assistant professor of art (teaches photography), University of Houston, 1976-present.

Recognitions and Awards: National Endowment for the Arts Individual Fellowship Grant in Video, 1976; National Endowment for the Arts Photography Fellowship, 1978.

Individual Exhibitions: 1971 — Peale Galleries, Pennsylvania Academy of Fine Arts, Philadelphia (painting). 1973 — *Sand and Paper Paintings, the Last Works,* Ward-Nasse Gallery, New York.

Selected Articles, Essays, and Reviews by the Artist: "Sidney Grossman — Images of Integrity." *Artweek* (Mar. 18, 1981), pp. 1, 16.

MANUAL — Ed Hill and Suzanne Bloom

Collaborative Individual Exhibitions: 1975 — Gallery of Art, Robert Frost Library, Amherst College, Mass. 1976 — Cronin Gallery, Houston (Sept. 7-Oct. 2). 1978 — Cronin Gallery (May 2-27); University of Massachusetts, Amherst. 1980 — *Suzanne Bloom and Ed Hill (MANUAL): Research and Collaboration,* The Museum of Fine Arts, Houston (Feb. 20-Apr. 13; catalogue). 1981 — *Vermont Landscapes (Thirteen Ways of Coping with*

Nature and *Kerrville (An Allegorical Documentary)*, Cronin Gallery.

Selected Collaborative Group Exhibitions: 1977 — *The Target Collection of American Photography***; *1977 Artist Biennial*, New Orleans Museum of Art (catalogue); *Four Texas Photographers*, Fort Worth Art Museum, Tex. (catalogue). 1979 — *Doors; Houston Artists*, Alley Theater, Houston (catalogue); *Photography: Venice '79**; *Photographie als Kunst 1879-1979 / Kunst als Photographie 1949-1979****; *The Anthony G. Cronin Memorial Collection***; *Fifth Anniversary Exhibition*, Photopia Gallery, Philadelphia (catalogue). 1980 — *U.S. Eye*, Winter Olympic Games, Lake Placid, N.Y. (January-February; slide catalogue; traveled); *Response*, Tyler Museum of Art, Tex. (Feb. 9-Mar. 23; catalogue); *Fifth Anniversary Exhibition 1975-1980*, Cronin Gallery (catalogue). 1981 — *Collection '81: The Road Show*, 2 Houston Center (Mar. 5-Apr. 3; catalogue); *Texas Photo Sampler – A Survey of Contemporary Texas Photography*, Washington Project for the Arts, D.C. (Jan. 6-31; catalogue); *Color in Photography*, Museum of Art, Rhode Island School of Design, Providence (catalogue); *The Image of the House in Contemporary Art; exploring the relationship of art and architecture to society*, The Lawndale Annex, Houston (catalogue). 1982 — *Art from Houston in Norway, 1982*, Stavanger Kunstforening (June 3-28; catalogue; traveled).

Articles by the Artists: "Wringing the Goose's Neck One Last Time ... or painting US photography and the deconstruction of modernism." *Afterimage* (May 1982), cover, pp. 9-14.

Selected Articles, Essays, and Reviews: Scarborough, John. "Oblique little photo exhibit that keeps calling you back." *Houston Chronicle*, Aug. 20, 1976, Sec. 2, p. 8 • Scarborough, John. "Challenging photo concept at Cronin's." *Houston Chronicle*, Sept. 16, 1976 • "Prints & Photographs Published: MANUAL." *The Print Collector's Newsletter* (September-October 1976), p. 118 • Holmes, Jon. "The Photographers of Texas." *Camera Magazine* (August 1977), pp. 33-34 • A.G. "Does Anybody Out There Know from Landscapes?" *Popular Photography* (August 1977) • Scarborough, John, and Tucker, Anne. "Contemporary Photography in Houston." *Artspace* (Summer 1977), pp. 4-8 • Webb, Paula. "Nine Top Photographers Discuss Their Work." *City Magazine* (April 1978) • Scarborough, John. "MANUAL's second photography exhibit richly mysterious." *Houston Chronicle*, May 25, 1978 • Schjeldahl, Peter. "Art and Money in the City of Future-Think." *City Magazine* (February 1980) • Hoffman, F. "Out of the regionalist shadow."

Artweek (March 1, 1980), pp. 1, 20 • Scarborough, John. "Research and Collaboration succeeds more with wit than with excess words." *Houston Chronicle*, Mar. 19, 1980 • McFarland, Gay F. "Work/Home." *Houston Chronicle*, Apr. 4, 1980, Sec. 4, pp. 1,6 • Kalil, Susie. "Analysis through Collaboration." *Artweek* (Apr. 5, 1980), p. 1, 13 • Sussman, Hal. "Houston's Museum of Fine Arts gives local artists Suzanne Bloom and Ed Hill major showing." *Art Scene* (May/June 1980) • Barrow, Ken. "The Arts Frontier: Six Rising Stars." *Texas Homes* (October 1980) • Harris, Paul Rogers. "The traditions of Texas art." *Texas Homes* (October 1980) • Tucker, Anne. "Art in Context: MANUAL (Ed Hill & Suzanne Bloom)." *Afterimage* (November 1980), pp. 10-14 • Cassell, James. "Images From Texas in a Sprawling Shop." *The Washington Star*, Jan. 18, 1981 • Scarborough, John. "MANUAL team's exhibit offers a shift in style." *Houston Chronicle*, Jan. 28, 1981 • Lewis, Jo Ann. "Galleries" (review of Texas Sampler). *The Washington Post*, Jan. 31, 1981 • Peters, Marsha. "Color becomes part of the big picture." *The Providence Sunday Journal*, April 1981, Arts and Travel Section, • Kalil, Susie. "MANUAL at Cronin." *Art in America* (October 1981), p. 150.

Ray K. Metzker

Born: Milwaukee, Sept. 10, 1931

Resides: Philadelphia

Education: Beloit College, Wis., B.A., 1953; Institute of Design of the Illinois Institute of Technology, Chicago, M.S. in photography, 1959 (studied under Aaron Siskind, Harry Callahan, and Frederick Sommer).

Professional Experience: Worked as an assistant in a commercial and portrait photography studio, 1953-1954; traveled and studied in Europe, 1962; teacher at the Philadelphia College of Art, 1962 (became professor of art, teaching until 1979); visiting associate professor, University of New Mexico, Albuquerque, 1970-1972; visiting adjunct professor, Rhode Island School of Design, Providence, spring 1977; visiting adjunct professor, Columbia College, Chicago, 1980-present.

Recognition and Awards: John Simon Guggenheim Memorial Foundation Fellowships for experimental studies in black-and-white photography, 1966, 1979; National Endowment For the Arts Photography Fellowship, 1974.

Individual Exhibitions: 1959 — The Art Institute of Chicago. 1967 — MOMA, New York. 1970 — Milwaukee Art Center (traveled). 1971 — University of New Mexico Art Museum, Albuquerque. 1972 — Wright Art Center, Beloit College, Wis. 1974 — The Print Club of Philadelphia; Dayton

College of Art, Ohio. 1976 — The Picture Gallery, Zurich, Switzerland. 1978 — *Pictus Interruptus*, Marian Locks Gallery, Philadelphia (Apr. 17-May 9); International Center of Photography, New York (September-October; traveled); 1979 — Light Gallery, New York (Mar. 7-31); Chicago Center for Contemporary Photography; Galerie Delpire, Paris. 1980 — *Hazlett Memorial Awards Exhibition*, Harrisburg, Pa.; *Sand Creatures*, Pennsylvania Academy of Fine Arts, Philadelphia (Jan. 18-Mar. 2); Light Gallery (Jan. 31-Feb. 23). 1981 — Light Gallery (Apr. 30-May 30); Paul Cava Gallery, Philadelphia (Feb. 13-Mar. 14). 1982 — Page & Page Photographic Art, Dallas (Apr. 25).

Selected Group Exhibitions: 1959 — *Photography in the Fine Arts I*, The Metropolitan Museum of Art, New York (catalogue); *Photography at Mid-Century*, GEH, Rochester, N.Y. (catalogue). 1960 — *The Sense of Abstraction in Contemporary Photography*.* 1961 — *Seven Contemporary Photographers*, GEH (catalogue: *Contemporary Photographer*). 1963 — *Photography 63**. 1965 — *Contemporary Photographs from The George Eastman House Collection, 1900-1964*.** 1966 — *Contemporary Photography Since 1950*, GEH and the New York State Council on the Arts, New York (traveled); *American Photography: The Sixties*.* 1967 — *Photography in the Twentieth Century**; *The Persistence of Vision****; *Photography USA*, De-Cordova Museum, Lincoln, Mass. 1968 — *Contemporary Photographs**; *Photography and the City*, Smithsonian Institution, Washington, D.C.; *Photography as Printmaking*, MOMA, New York (catalogue: *Artist's Proof*). 1970 — *New Photography USA*, (catalogue; traveled in Europe, second version traveled in Latin America); *Bennet, Steichen, Metzker: The Wisconsin Heritage in Photography*, Milwaukee Art Center (catalogue); *12 x 12*, Carr House Gallery, Rhode Island School of Design, Providence (catalogue). 1971 — *The Figure and the Landscape*, GEH (catalogue); *Variety Show*, organized by Western Association of Art Museums (traveled). 1973 — *Combattimento per un'Immagine**; *Landscape / Cityscape*.* 1975 — *For You, Aaron*, The Renaissance Society Gallery, University of Chicago (catalogue). 1976 — *Philadelphia: Three Centuries of American Art*, Philadelphia Museum of Art (Apr. 11-Oct. 10; catalogue); *The Photographer's Choice* (book); *Contemporary American Photographers**; *Contemporary Trends*.* 1977 — *The Photographer and the City*, Museum of Contemporary Art, Chicago (Jan. 15-Mar. 6; catalogue); *The Target Collection of American Photography***; *The Extended Frame****; *Photographs: The Sheldon Memorial Art Gallery Col-*

lections**; *Les Expositions Inaugurales,* Centre National d'Art et de Culture Georges Pompidou, Paris (catalogue); *Photography: The Selected Image,* Pennsylvania State University, University Park, and Edinboro State College (traveled). 1978 — *Spaces***; Forty American Photographers*; Mirrors and Windows.* 1979 — *Photography: Venice '79*; Intentions and Techniques.** 1980 — The New Vision* (book); *Aspects of the 70's: Photography*; Deconstruction / Reconstruction – The Transformation of Photographic Information into Metaphor,* The New Museum, New York (July 12-Sept. 18; catalogue); *Absage an das Einzelbild***; The Imaginary Photo Museum,* Photokina, Cologne, West Germany (catalogue). 1981 — *Photography: A Sense of Order, Institute of Contemporary Art,* University of Pennsylvania, Philadelphia (Dec. 11, 1981-Jan. 27, 1982; catalogue); *Erweiterte Fotografie (Extended Photography)***; Contemporary Photography by Barbara Crane, Joseph Jachna, Kenneth Josephson, William Larson, Ray K. Metzker,* University of Arkansas, Fayetteville (October; traveled). 1982 — *A History of Photography from Chicago Collections.**

Monographs: Metzker, Ray K. *Sand Creatures.* Aperture, Millerton, N.Y., 1979.

Books: Ferebee, Ann. *A History of Design from the Victorian Era to the Present.* Nostrand, Reinhold Company, New York, 1970 • Trachtenberg, Alan; Neill, Peter; and Bunnell, Peter. C. *The City: American Experience.* Oxford University Press, New York, 1971, p. 354 • Leontief, Estelle. *Razerol.* The Janus Press, West Burke, Vt., 1973 • Faulkner, Ray, et al. *Art Today.* Holt, Rinehart, and Winston, Inc., New York, 1974 • Swedlund, Charles. *Photography: A Handbook of History, Materials, and Processes.* Holt, Rinehart, and Winston, Inc. 1974, pp. 46-47 • Craven, George. *Object and Image: An Introduction to Photography.* Prentice-Hall, Inc., Englewood Cliffs, N.J., 1975 • Snyder, Norman. *The Photography Catalog.* Harper & Row, New York, 1976 • Tausk, Peter. *Die Geschichte der Fotografie im 20 Jahrhundert.* DuMont Buchvertug, Cologne, West Germany, 1977 • Simon & Morse. *First Lessons in Black & White Photography.* Holt, Rinehart & Winston, 1978 • Lockwood, Margo. *Bare Elegy.* The Janus Press, 1979 • Seeley, J. *High Contrast.* Curtin & London, Somerville, Mass., 1980 • See also Life Library, *The Camera, Light and Film, The Print,* and *The Art of Photography;* Szarkowski, *Looking at Photographs;* Wise, *Photographer's Choice;* Witkin and London, *The Photograph Collector's Guide;* Coke, *Photography in New Mexico;* and Gassan, *A Chronology of Photography.*

Selected Articles, Essays, and Reviews: "New Talent U.S.A.: Photography." *Art in America,* vol. 49, no. 1 (1961), p. 56 • White, Minor, ed. "Five Photography Students from The Institute of Design, Illinois Institute of Technology." *Aperture,* vol. 9, no. 2 (Spring 1961) • "Ray K. Metzker." *Contemporary Photographer 2,* vol. 2, no. 2 (1961) • Lyons, Nathan. "Photography: The Younger Generation." *Art in America* (1963), p. 74 • Wasserman, Emily. "Photography." *Artforum* (January 1968), pp. 67-70 • *Creative Camera* (January 1968) • Metzker, Ray K. "Portfolio." *Aperture,* vol. 13, no. 2 (1967), pp. 2-13 • *Camera* (May 1968) • Zucker, Harvey. "Ray Metzker: Fabulous Multiple Images," *Popular Photography* (July 1968), p. 93 • Bunnell, Peter C. "Photography as Printmaking." Pratt Graphics Center *Artist's Proof* (1969), pp. 24-40 • Porter, Allan, ed. "Ray K. Metzker." *Camera* (November 1969), pp. 40-49 • "Gallery: Ray K. Metzker's photocomposition." *Life* (Apr. 10, 1970) • *Art & Society* (Summer 1971), pp. 8,9 • *Camera* (February 1971), pp. 5, 31 • *Vue Images* (November 1975) • Bondi, Inge, and Misani, Marco. "Ray K. Metzker — An American Photographer and Teacher." *Printletter 3* (May-June 1976) • Grundberg, Andy. "Chicago, Moholy and After." *Art in America* (September-October 1976), pp. 34-39 • Perloff, Stephen. "Philadelphia: An 'explosion' of interest and activity." *Afterimage* (May-June 1977), p. 17 • Seiberling, Christopher. "Ray Metzker's Consideration of Light." *Exposure* (September 1977), pp. 36-39. Reprinted from *Bulletin #9* of the University of New Mexico Art Museum, Albuquerque • Isaacs, Chuck. "Ray K. Metzker: An Interview." *Afterimage* (November 1978), pp. 12-17 • Edwards, Owen. "Exhibitions: Ray Metzker." *American Photographer* (November 1978), pp. 10-11 • Kardon, Janet. "Ray K. Metzker at Marion Locks." *Art in America* (November-December 1978), pp. 157 • Grundberg, Andy, and Scully, Julia. "Currents: American Photography Today." *Modern Photography* (November 1978), p. 116 • Squiers, Carol. "Mirrors and Windows." *The New Art Examiner* (December 1978) • Grundberg, Andy. "Currents: American Photography Today." *Modern Photography* (January 1979), p. 114 • Bunnell, Peter C. "Ray Metzker." *The Print Collector's Newsletter* (January-February 1979), pp. 177-79 • *Afterimage* (April 1979), p. 15 • Marincola, Paula. "Reviews: Obstacle Course." *Afterimage* (May 1981), pp. 17-18 • Grundberg, Andy. "Ray K. Metzker: Form as Expression." *Modern Photography* (November 1981), pp. 122-31 • Solomon-Godeau, Abigail. "Formalism & Its Discontents: Photography: A Sense of Order." *The Print Collector's Newsletter* (May-June 1952), pp. 44-47.

Duane Michals

Born: McKeesport, Pa., Feb. 18, 1932

Resides: New York

Education: University of Denver, Colo., B.A., 1953; Parsons School of Design, New York.

Professional Experience: Worked as free-lance photographer, published in *Vogue, Mademoiselle, Show, Esquire,* 1958-present; taught at the Silver Eye/Photographic Workshop, summer 1976.

Individual Exhibitions: 1963 — The Underground Gallery, New York. 1965 — The Underground Gallery. 1968 — The Underground Gallery; The Art Institute of Chicago. 1970 — *Stories by Duane Michals,* MOMA, New York (Oct. 7-Dec. 6). 1971 — GEH, Rochester, N.Y. 1972 — Museum of New Mexico, Albuquerque; San Francisco Art Institute, School of Visual Arts, New York (Sept. 25-Oct. 18). 1973 — Galerie Delpire, Paris; International Cultural Center, Antwerp, Belgium. 1974 — Frankfurter Kunstverein, West Germany; Galeria 291, Milan, Italy; Documenta, Torino, Italy; School of Visual Arts, New York; Light Gallery, New York, (Oct. 15-Nov. 9). 1975 — Light Gallery (Oct. 14-Nov. 8); The Broxton Gallery, Los Angeles. 1976 — Jacques Bosser, Paris; Sidney Janis Gallery, New York (Oct. 19-Nov. 13; catalogue); Gallerie Die Brucke, Vienna, Austria; The Texas Center for Photographic Studies, Dallas (Jan. 9-Feb. 10); Contemporary Arts Center, Cincinnati; Ohio State University, Columbus; Felix Hanschin Galerie, Basel, Switzerland; Douglas Drake Gallery, Kansas City, Mo. 1977 — Galerie Breiting, Berlin; Paul Maenz, Cologne, West Germany; G. Ray Hawkins Gallery, Los Angeles; Philadelphia College of Art (Aug.29-Oct. 1; catalogue); Focus Gallery, San Francisco. 1978 — Douglas Drake Gallery; The Collection at 24, Miami; Camera Obscura, Stockholm, Sweden; Galerie Fiolet, Amsterdam, The Netherlands; Sidney Janis Gallery; Galerie Wilde, Cologne, West Germany; Akron Art Institute, Ohio. 1979 — La Remise du Parc, Paris; Canon Photo Gallery, Geneva, Switzerland; Douglas Drake Gallery; The Collection at 24; Art Gallery, University of Denver, Colo.; Galerie Wilde; Galerie Nouvelles Images, The Hague, The Netherlands; Nova Gallery, Vancouver, B.C., Canada. 1980 — Carl Solway Gallery, Cincinnati; Galerie Nouvelles Images; Susan Spiritus Gallery, Newport Beach, Calif. (June 21-July 19); Museum of Modern Art, Bogota, Columbia; *Duane Michals – Sequences and Narra-*

tives, Image Gallery, Seattle (Aug. 20-Sept. 14); Sidney Janis Gallery; Art Gallery, University of Pittsburgh. 1981 — Galerie Fiolet; Gemeentemuseum, Apeldoorn, The Netherlands (catalogue); Halstead Gallery, Birmingham, Miss.; Swarthmore College, Pa.; The Atlanta Gallery of Photography; The Huntsville Museum of Art, Ala.; Work Galerie, Zurich, Switzerland; Colorado Photo Arts Center, Denver; Philadelphia College of Art.

Selected Group Exhibitions: 1966 — *American Photography: The 60's**; Contemporary Photographers since 1950*, GEH, Rochester, N.Y. (catalogue); *Towards a Social Landscape.** 1967 — *Twelve Photographers of the American Social Landscape*, Brandeis University, Waltham, Mass. (Jan. 9-Feb. 12; catalogue); *Photography in the Twentieth Century.** 1968 — *Contemporary Photographs.** 1969 — *Recent Acquisitions 1969***; Vision and Expression.** 1970 — *12 x 12*, Rhode Island School of Design, Providence; American Pavilion, Expo 70, Osaka, Japan (catalogue); *Being Without Clothes*, MIT, Cambridge (catalogue: *Aperture*). 1971 — *Photographs of Women*, MOMA, New York (catalogue: *Camera*). 1972 — *New York/New Mexico II* (two-man show with Richard Faller), Museum of New Mexico, Santa Fe (Feb. 27-Apr. 3); *11 American Photographers**; Fotographien 1900-1970: L. Fritz Gruber Collection*, Kölnischer Kunstverein, Photokina, Cologne, West Germany (catalogue); *The Multiple Image*, The Creative Photography Gallery, MIT (February-March; catalogue; traveled). 1973 — *Das Technische Bild und DoKumentationsmittel Fotografie*, Museum Folkwang, Essen, West Germany (catalogue); *Combattimento per un'Immagine***; Festival Internationale d'Art Contemporain, Royan, France; *Photographers in New York*, Tokyo (catalogue). 1974 — *Photograpy in America**; Contemporanea, Rome; *Zwei Amerikanische Fotografen*, Haus an du Redorite, Bonn, West Germany. 1975 — (photo) (photo)² . . . (photo)ⁿ.*** 1976 — *Catalogue of the UCLA Collection of American Photographers**; Photographer's Choice* (book); *Modern Portraits: The Self and Others*, Wildenstein Gallery, New York (Oct. 20-Nov. 28; catalogue); Arles Festival, France; *Festival d'Automne*, Musée Galliera, Fondation Nationale de la Photographie, Paris (October; catalogue); *Aspects of American Photography 1976**; Foto-Sequenties***; American Photography: Past into Present**; The Photographer and the Artist**; Photographic.** 1977 — *Photographs: The Sheldon Memorial Art Gallery Collections**; Exhibitions '76 '77**; La Photo Comme Photographie*, Centre d'Arts Plastiques Contemporain de Bordeaux, France; Documenta, Kassel, West Germany; *Künsterphotoghen in XX Jahrhundert*, Kestner-Gesellschaft, Hanover, West Germany (Aug. 12-Sept. 18; book); *New Aspects of Self in American Photography*, Herbert F. Johnson Museum, Cornell University, Ithaca, N.Y. (traveled); *Concerning Photography: Some Thoughts About Reading Photographs*, The Photographers' Gallery, London (July 6-Aug. 27; catalogue). 1978 — *American Narrative/Story Art***; 40 American Photographers**; Tusen och en bild**; Mirrors and Windows**; The Photographer's Image Self-Portrayal**; 23 Photographers 23 Directions**; Manipulative Photography*, Virginia Commonwealth University, Richmond; *Duane Michals & Nicholas Africano*, Nancy Lurie Gallery, Chicago. 1979 — *Nude: Theory*, Witkin Gallery, New York (book); *Artemisia Gentleleschi*, Galerie Yvon Lambert, Paris, (book, traveled); *A Ten Year Salute – A Selection of Photographs in Celebration – The Witkin Gallery 1969-1979*, Witkin Gallery (book); *Photographie als Kunst 1879-1979/ Kunst als Photographie 1949-1979***; Diverse Images**; Attitudes: Photography in the 70's.** 1980 — *Deja Vu: Updated Masterpieces*, Western Association of Art Museums, San Francisco (traveled); Viviane Esders Rudzinoff Gallery, Paris; *Aspects of the 70's: Photography.** 1981 — *Photo Facts and Opinions.**

Books by the Artist: *Sequences*. Doubleday & Co., Garden City, N.Y., 1970 (Italian edition: *Sequenze*. Forum Editoriale, Milan, Italy, 1970.) • *The Journey of the Spirit After Death*. Winter House, New York, 1972 • *Things are Queer*. Galerie Wilde. Cologne, West Germany, 1972 • *Chance Meeting*. Galerie Wilde, 1973 • *The Photographic Illusion*. Crowell, New York, and Thames & Hudson, London, 1975 • *Take One and See Mt. Fujiyama and Other Stories*. Light Impressions/Stefan Mihal, Rochester, N.Y., 1976 • *Real Dreams*. Addison House, Danbury, N.H., 1976 • *Vrais Reves*. Editions Chene, Paris, 1977 • *The Wonders of Egypt*. DeNoel, Paris, 1978 • *Homage to Cavafy: Ten Poems by Constantine Cavafy, Ten Photographs by Duane Michals*. Addison House, 1978 • *Changes*. Editions Chene, 1980 • *Changes*. Editions Herscher, Paris, 1981 • *A Visit with Magritte*. Matrix, Providence, R.I., 1981 • *Duane Michals Traveling Pocket Gallery*. Privately published, date unknown.

Books with essays by the Artist: Tress, Arthur. *Theatre of the Mind*. Introduction by Duane Michals. Morgan & Morgan, Dobbs Ferry, N.Y., 1976 • "An Interview with Professor Gassan and His Students." *The Camera Viewed – Writings on Twentieth-Century Photography – Volume 2: Photography After World War II*. Peninah R. Petruck, ed. E. P. Dutton, New York, 1979, pp. 76-90.

Books: Barrow, Thomas. "Three Photographers and Their Books." *One Hundred Years of Photographic History – Essays in honor of Beaumont Newhall*. Van Deren Coke, ed. University of New Mexico Press, Albuquerque, 1975, pp. 7-14 • Gibson, Ralph. *The Darkroom*. Lustrum Press, New York, 1976 • *Masterpieces of Erotic Photography*. Introduction by M. Pellerin. Talisman Press, London, 1977 • Willmann, Manfred, ed. *American Photographers*. Fotogalerie im Forum Staadpark, Graz, Austria, 1977 • Lewis, Eleanor, ed. "Camera as Darkroom," *Darkroom*. Lustrum Press, 1977, pp. 131-41 • Osman, Colin, and Turner, Peter, eds. *Creative Camera Collection 5*. Coos Press, Ltd., London, 1978, pp. 76-109 • Dugan, Thomas, ed. *Photography Between Covers: Interviews with Photo-Bookmakers*. Light Impressions, Rochester, N.Y., 1979, pp. 131-48 • Kelly, Jain, ed. *Nude: Theory*. Lustrum Press, 1979, pp. 131-50 • Minkkinen, Arno, ed. *New American Nudes*. Morgan & Morgan, Dobbs Ferry, N.Y., 1981 • Diamondstein, Barbaralee. *Visions and Images. American Photographers on Photography*. Rizzoli, New York, 1981, 1982 • See also Life Library: *The Art of Photography, The Camera, The Print, The Great Themes*; Szarkowski, *Looking at Photographs*; Wise, *The Photographer's Choice*; Coleman, *Light Readings*; Witkin and London, *The Photograph Collector's Guide*; Jay, *Views on Nudes*; Kozloff, *Photography & Fascination*; Gassan, *A Chronology of Photography*; Beaton and Buckland, *The Magic Image*; and Kahmen: *Art History of Photography*.

Selected Articles, Essays, and Reveiws: "Duane Michals: Portfolio." *Infinity* (June 1964), pp. 16-23 • "Duane Michals: Portfolio," *Contemporary Photographer*, V:2 (1964-1965), pp. 11-36 • Fox, Martin. "Duane Michals: People and Places," *Print* (March/April), pp. 28-33 • "The Empty Environment: A Photographic Essay." *Art in America* (July/August 1967), pp. 104-109 • Wasserman, E. "Review," *Artforum* (January 1969), p. 61 • *Creative Camera* (February 1969), pp. 76, 77 • "Sequence: Duane Michals." *Camera* (July 1969), pp. 22-30 • "Portfolio and Text," *Album* (August 1970), pp. 34-41 • Stevens, Carol. "Series Photographs, More is More," *Print* (September 1970), pp. 31-37 • Cipnic, Dennis. "Sequences, Duane Michals." *Infinity*, 20:2 (1971), p. 20 • "Sequence." *Camera* (February 1971), pp. 6-7, 31 • Rosenheck, Natalie. "Duane Michals' Transcendental Camera." *Popular Photography* (December 1971), pp. 126-29 • Gassen, Arnold. "Conversations with Duane Michals." *Image*, 14:1 (1971), pp. 2-8 • Davis, Douglas. "The Magic of Raw Life: New Photography," *Newsweek* (Apr. 3, 1972), pp. 74-76 • Jamas, Guy. "Duane Michals." *Foto* (August 1972) • Ratcliff,

Carter. "Review," *Artforum* (December 1972), pp. 89-91 • Porter, Allan. "Sequences: Part II."*Camera* (October 1972), pp. 13, 30 • Wiegan, Wilfred. "Der Alltag Wird zum sprechen gebracht." *Frankfurter Allegemeine Zeitung* (Feb. 25, 1973) • Bejar, Ethy. Interview. *L'Officiel* (May-June 1973) • Sekvensar, Nya. "Mastarttavlan: Vinnarbilderna Duane Michals." *Foto* (August 1973) • Gautrand, J. C. "Duane Michals Sequences." *Photo Cine Review* (September 1973) • Kinzer, H. M. "Most portraits are lies." *Popular Photography* (November 1973), pp. 116-20 • Palazolli, Daniella. "Le Sequenze di Duane Michals." *Domus* (January 1974), pp. 51-53 • Colombo, Attilio. "Duane Michals." *Progresso Fotografico* (January 1974) • Johnson, Sy. "The Sequential Imagination of Duane Michals." *Changes* (October 1974) • Pincus-Witten, Robert. Review. *Artforum* (January 1975), pp. 58-60 • "Duane Michals." *Camera* (May 1975), pp. 4-9 • Grundberg, Andy. "Duane Michals at Light." *Art in America* (May 1975), pp. 78-79 • Ratcliff, Carter. "Duane Michals." *The Print Collector's Newsletter* (September/October 1975), pp. 93-96 • Stevens, Carol. "Public Faces." *Print* (October 1975), pp. 54-68 • Kozloff, Max. "Photos with Photographs." *Artforum* (February 1976), pp. 34-39 • Louis, E. "Duane Michals." *Art Direction* (May 1976), pp. 80-81 • Coleman, A. D. "The Directional Mode." *Artforum* (September 1976), pp. 55-61 • Hayot, Monelle. "Photographie: Les 7e Recontres d'Artes." *Oeil* (September 1976), p. 53 • Davis, Douglas. "Two Visionaries." *Newsweek* (Oct. 18, 1976), pp. 109-13 • Rice, Shelley. "Duane Michals says it is no accident that you are reading this." *The Village Voice* (Nov. 8, 1976) • "Portfolio." *Creative Camera* (October 1976), pp. 329-39 • Naggar, Carole. "De l'Autre Cote du Miroir, Duane Michals." *ZOOM* (October 1976) • Allen, Casey. "Duane Michals, Master of Sequential Photography." *Camera 35* (October 1976), pp. 48-51, 66-67 • Crary, Jonathan. "Duane Michals." *Arts Magazine* (December 1976), p. 25 • Ellenzweig, Allen. Review. *Arts Magazine* (December 1976), p. 30 • Rice, Shelley. "Duane Michals' 'Real Dreams.'" *Afterimage* (December 1976), pp. 6-8 • Patton, Phil. "Captioned pictures, Pictured captions." *Art News* (January 1977), p. 109 • Perrone, J. "Duane Michals: The Self as Apparition." *Artforum* (January 1977), pp. 22-27 • Joseph, Frank. "Duane Michals: Real Dreams." *The Philadelphia Photo Review* (September 1977) • Goldberg, Vicki. "Real Dreams." *Photograph*, no. 3 (1977), p. 12-13 • Michals, Duane. "How Duane Michals creates his mystical master-

pieces." *Popular Photography* (October 1977), pp. 136-41, 147 • Guebert, Herve. "Histoires Photographiques de Duane Michals: La Necessite du Contact." *Le Monde* (Feb. 9, 1978) • Laskin, Dan. "Duane Michals in Egypt." *Horizon* (August 1978) • Larsen, Kay. Review. *Art News* (January 1979), pp. 148-49 • "Duane Michals," *Neuva Lenta*, no. 28 (February 1979), pp. 59-69 • Coleman, A. D. "Books in Review: Homage to Cavafy: The Kindred Spirit of Duane Michals." *Camera 35* (March 1979), pp. 24-25 • Scully, Julia, and Grundberg, Andy. "Currents: American Photography Today." *Modern Photography* (March 1979), pp. 96-99, 115-17, 164, 170 • Thornton, Gene. "Post Modern Photography: it doesn't look modern at all." *Art News* (April 1979), pp. 64-68 • "Flash: A New Pyramid for an Old Giza," *American Photographer* (April 1979) • Ratcliff, Carter. Review. *Art in America* (May 1979), pp. 145-46 • Roger, D. "Photographs," *Print* (July 1979), pp. 46-47 • Fike, Don. "Homage to Cavafy." *Photography Forum* (August 1979) • "La mort de Duane Michals — le Remise du parc exposition." *Connaissance Arts* (September 1979), p. 40 • Labar, Elizabeth. "Conversation with Duane Michals." (November/December 1979) • "Resenas: Duane Michals," *Revista del Arte y la Arquitectura en America Latina*, vol. 2, no. 5, (1980) • "Medellin/Museo de Arte Moderno: Duane Michals." *Sobre Arte* (July/August 1980) • Ambler, Craig. "The 20-Year Odyssey of Duane Michals." *Camera 35* (December 1980), pp. 28-35, 78 • Kernan, Sean. "Duane Michals Interview." *Camera Arts* (January/February 1981), pp. 32-38, 80-87, 118 • Edwards, Owen. "Exhibitions — Duane Michals." *American Photographer* (January 1981), pp. 16-18 • Lawson, Thomas. "Michals, Sidney Janis Gallery." *Artforum* (March 1981), p. 83 • Zelevansky, Lynn. Review, *Flash Art* (Summer 1981), pp. 54-55

Eadweard Muybridge

(née Edward James Muggeridge)
Born: Kingston-on-Thames, England, Apr. 9, 1830
Died: Kingston-on-Thames, England, May 8, 1904
Education: Learned photography from a New York daguerreotypist in the early 1850s.
Professional Experience: Immigrated to America, 1852; operated a bookstore specializing in illustrated books, San Francisco, 1855-1860; began study of photography, 1861; operated commercial photography studio, San Francisco, associated with Silas Selleck, ca. 1866, with Arthur and Christian Nohl, 1869, with Bradley and Rulufson, 1873; photographed Alaska, 1868, Yosemite, Calif., 1868 and 1872, routes of Central Pacific

Railroad, 1870, Modoc Indian War, 1873, Central America, 1875; began his studies of motion when hired by Leland Stanford to analyze movement of a running horse, 1872; invented the 200 praxiscope, 1879; worked under the auspices of the University of Pennsylvania on his series of humans and animals in motion, 1884-1886.
Recognition and Awards: International Gold Medal for Landscape, Vienna International Exhibition, 1873, for his 1872 photographs of Yosemite.
Individual Exhibitions: 1972 — *Eadweard Muybridge*, IMP/GEH, Rochester, N.Y. (traveled); *Eadweard Muybridge: The Stanford Years, 1872-1882*, The Stanford University Museum of Art, Calif. (catalogue; traveled). 1973 — *Eadweard Muybridge: Animal Locomotion Plates*, The Witkin Gallery, New York (July 18-Aug. 19); *The Partial Witness: an exhibition of photography*, Wellesley College Art Museum, Jewett Arts Center, Mass. (Mar. 23-Apr. 25; catalogue). 1976 — Wurttembergischer Kunstverein, Stuttgart, West Germany (Oct. 21-Nov. 28; catalogue; traveled). 1977 — Boris Gallery of Photography, Boston (May 20-June 27). 1979 — *Eadweard Muybridge*, G. Ray Hawkins Gallery, Los Angeles (May 20-June 19; catalogue). 1980 — *Animal Locomotion: An Electro-Photographic Investigation of Consecutive Phases of Animal Movements, 1872-1885, by Eadweard Muybridge*, 20 Hanway Street Gallery, London (Jan. 22-Feb. 23). 1981 — *A Survey of Photographs by Eadweard Muybridge*, Fraenkel Gallery, San Francisco (Apr. 1-May 9).
Selected Group Exhibitions: Several major monographs with bibliographies exist for this photographer, so group exhibitions and major articles, essays, and reviews previous to the publication of the monographs have been omitted. See Hendricks, Gordon, *Eadweard Muybridge: The Father of the Motion Picture*, and Haas, Robert Bartlett. *Muybridge: Man in Motion*. 1970 — *The Photograph as Object***; Newly Re-Created*, Fogg Art Museum, Harvard University, Cambridge, Mass. (Oct. 26-Dec. 2; catalogue); *Figure in Landscape*; *Landscape and Discovery*, The Emily Lowe Gallery, Hofstra University, Hempstead, N.Y. (Jan. 29-Mar. 7; catalogue); *Combattimento per un'Immagine.**** 1974 — *Language of Light.** 1975 — *Photography in America.** 1975 — *Era of Exploration — The Rise of Landscape Photography in the American West, 1860-1885*, Albright-Knox Art Gallery, Buffalo, N.Y. (book; traveled). 1976 — *Foto-Sequenties***; Celebration of the Body*, Agnes Etherington Art Center, Kingston, Ont., Canada (June 9-July 3; catalogue); *American Photography: Past into Present**; Photography: The First Eighty Years*, P. & D. Colnaghi and Co., Ltd., London

(Oct. 27-Dec. 1; catalogue); *19th-Century Photographs from the Collection*, Art Museum, University of New Mexico, Albuquerque (catalogue); *The Documentary Photograph as a Work of Art: American Photographs, 1860-1876*, The David and Alfred Smart Gallery, The University of Chicago (catalogue). 1977 — *Photographs: Sheldon Memorial Art Gallery Collections**; Panoramic Photography*, Grey Art Gallery and Study Center, New York University, Faculty of Arts and Sciences (Sept. 23-Nov. 2; catalogue). 1978 — *Amerikanische Landschafts-photographie*; Tusen och en bild*; Quality of Presence*; The Male Nude.* 1979 — Approaches to Photography*; A Ten-Year Salute – A Selection of Photographs in Celebration – The Witkin Gallery 1969-1979*, The Witkin Gallery, New York (book); *Photography: Venice '79*; Photographie als Kunst 1879-1979/Kunst als Photographie 1949-1979***; Diverse Images.** 1980 — Kalamazoo Collects Photography**; Photographs from the Collection of Dan Berley**; The Olympics in Art: an exhibition of works of art related to Olympic sports*, Munson-Williams-Proctor Institute, Utica, N.Y. (Jan. 13-Mar. 2; catalogue). 1981 — *American Photographers and the National Parks*; Recent Acquisitions 1973-1980*, IMP/GEH, Rochester, N.Y. (June 12-Sept. 13; catalogue). 1982 — *Slices of Time.**

Books by the Artist: *Animal Locomotion: An Electro-Photographic Investigation of Consecutive Phases of Animal Movement*. 11 Volumes. University of Pennsylvania, Philadelphia, 1887. Reprinted, Arno Press, New York, 1973 • *Animal Locomotion, The Muybridge Work at the University of Pennsylvania*. J. B. Lippincott Co., Philadelphia, 1888 • *Descriptive Zoopraxography*. Philadelphia, 1893 • *Animals in Motion*. Chapman & Hall, London, 1899. Edited by Lewis S. Brown. Dover Publications, New York, 1957 • *The Human Figure in Motion*. Chapman & Hall, 1901. Reprinted, Dover Publications, 1955 • *Muybridge's Complete Human and Animal Locomotion: All 781 Plates from the 1887 Animal Locomotion*. Dover Publications, 1979.

Books about the Artist: Hittel, Jahn Shertzer. *Yosemite: Its Wonders and Its Beauties*. Bancroft, San Francisco, 1868 • Stillman, J.D.B. *The Horse in Motion*. Osgood, Boston, 1882 • Taft, Robert. *Photography and the American Scene: A Social History: 1839-1889*. MacMillan, New York, 1938 • *Photography's Great Inventors*. American Museum of Photography, Philadelphia, 1965 • McDonnell, Kevin. *Eadweard Muybridge: The Man Who Invented the Moving Picture*. Little, Brown, Boston, 1972 • Hendricks, Gordon. *Eadweard Muybridge: The Father of the Motion Picture*. Grossman Publishers, New York, 1975 • Haas, Robert Bartlett. *Muybridge: Man in Motion*. University of California Press, Berkeley, 1976 • Scharf, Aaron. *Pioneers of Photography*. Abrams, New York, 1976 • Whelan, Richard. *Double Take: A Comparative Look at Photographs*. Clarkson N. Potter, Inc., New York, 1981 • See also Szarkowski, *Looking at Photographs*; Witkin and London, *The Photograph Collector's Guide*; Sullivan, *Nude: Photographs 1850-1980*; Jay, *Views on Nudes*; Newhall, *The History of Photography*; Scharf, *Art and Photography*; Coke, *The Painter and the Photograph*; Kozloff, *Photography & Fascination*; and Gassan, *A Chronology of Photography*.

Selected Articles, Essays, and Reviews: Newhall, Beaumont. "Muybridge and the First Motion Picture; the Horse (in) the History of the Movies." *Image* (January 1956), pp. 4-11. Reprinted in *U.S. Camera Annual* (1957), pp. 235-42 • Hood, Mary V. Jessup, and Haas, Robert Bartlett. "Eadweard Muybridge's Yosemite Valley Photographs, 1867-1872." *California Historical Society Quarterly* (March 1963), pp. 5-26 • Homer, W.I., with Talbot, J. "Eakins, Muybridge and the Motion Picture Process." *The Art Quarterly* (Summer 1963), pp. 194-216 • Graham, D. "Muybridge Moments." *Arts Magazine* (February 1967), pp. 23-24 • Thomas, D.B. "The Lantern Slides of Eadweard Muybridge." *British Journal of Photography Annual* (1967), pp. 15-26 • Hamilton, H. "Les allures du cheval, Eadweard James Muybridge's Contribution to the Motion Picture." *Film Comment* (Fall 1969), pp. 18-35 • "Muybridge and Time and Motion." *British Journal of Photography* (Aug. 24, 1973), pp. 756-58 • Lindquist-Cock, Elizabeth. "Stereoscopic photography and the western paintings of A. Bierstadt." *Art Quarterly* (Winter 1970), pp. 360-78 • Frampton, Hollis. "Eadweard Muybridge: Fragments of a Tesseract." *Artforum* (March 1973), pp. 43-52 • Pajunen, Timo Tauno. "Eadweard Muybridge, Part I." *Camera* (January 1973), pp. 33-44 • Pajunen, Timo Tauno. "Eadweard Muybridge, Part II." *Camera* (February 1973), pp. 41-43 • Reff, Theodore. "Degas: a master among masters." *Metropolitan Museum Bulletin* (Spring 1977), pp. 1-48 • Kersham, Donald. "L'art in Amerique avant 1910: neuf profils de novateurs." *Paris - New York*. Centre National d'Art et de Culture Georges Pompidou, Musée National d'art Modern, Paris (1977) • Morris, Wright. "Motion Pictures 1887." *New York Times Book Review* (Sept. 30, 1979) • Ratcliff, Carter. "Anatomy of Motion." *Art in America* (November 1979), p. 17.

Esther Parada

Born: Grand Rapids, Mich., 1938
Resides: Oak Park, Ill.
Education: Swarthmore College, Pa., B.A. with honors in art, art history, literature, 1960; Pratt Institute, Brooklyn, N.Y., M.F.A. in painting and drawing, 1962; Institute of Design, Illinois Institute of Technology, Chicago, M.S. in photography, 1971.

Professional Experience: Peace Corps volunteer (art instructor, Escuela de Artes Plásticas, University de San Francisco Xavier, Sucre, Bolivia, and photography instructor, Escuela de Turismo), 1964-1966; graphic designer, Publications Office, Chicago State University, 1967-1969; graphics designer, Science Research Associates, Chicago, 1969-1971; photography lecturer, Department of Art, University of Illinois, Chicago, 1972-1975; associate professor of photography, School of Art and Design, University of Illinois, Chicago, 1975-present.

Recognitions and Awards: National Merit Scholarship for undergraduate study at Swarthmore College, Pa., 1956-1960; Sarah Lippincott Fellowship from Swarthmore College for graduate study at Pratt Institute Art School, Brooklyn, N.Y., 1961; Ford Foundation Study Fellowship in International Development for graduate study in photography at Illinois Institute of Technology, Chicago, 1967-1968; Certificate of Excellence Award, American Institute of Graphic Arts, 1973; research leave from Chicago Circle Research Board, University of Illinois, 1978; Project Completion Grant, Illinois Arts Council, 1980.

Individual Exhibitions: 1966 — Centro Boliviano Americano, La Paz, Bolivia; Centro Boliviano Americano, Cochabamba, Bolivia; Salón de la Biblioteca Municipal, Oruro, Bolivia; Salon Municipal, Sucre, Bolivia; Galeria John F. Kennedy, Asunción, Paraguay. 1968 — Chicago Public Library. 1969 — Pan-American Society of New England, Boston. 1970 — Grand Rapids Art Museum, Mich. 1976 — *Site Unseen*, MoMing, Chicago. 1979 — *Past Recovery*, Artemisia Gallery, Chicago (Jan. 9-Feb. 3). 1980 — *Past Recovery*, Florence Wilcox Gallery, Swarthmore College, Pa. (May 26-June 20). 1982 — Northlight Gallery, Arizona State University, Tempe.

Selected Group Exhibitions: 1978 — *Chicago, The City and Its Artists, 1945-1978*, University of Michigan Museum of Art, Ann Arbor (catalogue). 1980 — *The Portrait Extended.*** 1981 — *John Brumfield – Esther Parada*, VSW, Rochester, N.Y. (Jan. 16-Feb. 13); *Visions from Chicago*, Saiaye Bronfman Centre Museum, Montreal (Feb. 1-26; catalogue). 1982 — *New Women / New Work*, Light Gallery, New York (Jan. 28-Feb. 27).

Books: Seeley, J. *High Contrast*. Curtin and London, Boston, 1980 • See also Life Library, *Art of Photography* (1981 revised edition).

Selected Articles, Essays, and Reviews: Lyon, Christopher. "Illusions of Real People." *Reader* (Oct. 17, 1980), p. 38 • Fondiller, Harvey. "Shows We've Seen." *Popular Photography* (May 1982), pp. 48, 58 • Elliott, David. "Breaking Boundaries." *Chicago-Sun Times*, Sept. 14, 1980 • Hormel, C. "Portrait Extended." *Afterimage* (December 1980), p. 17 • "Connections: An Invitational Portfolio of Images and Statements by 28 Women." *Exposure*, vol. 19, no. 3 (1981), p. 41 • Parada, Esther. "Notes on Latin American Photography." *Afterimage* (November 1981), pp. 10-16.

Bart Parker
Born: Fort Dodge, Iowa, 1934
Resides: Providence, R.I.
Education: University of Colorado, Boulder, B.A. in English literature, 1956; independent study with Larry Colwell, Jacksonville, Fla., 1964-1967; Rhode Island School of Design, Providence, M.F.A., 1969 (studied with Harry Callahan).
Professional Experience: Photojournalist for southern daily papers, Time-Life publications, *Newsweek, National Observer,* Associated Press, and United Press International, 1959-1967; taught at the University of Illinois at Urbana-Champaign, 1969-1971; professor of art, University of Rhode Island, Kingston, 1971-present; visiting artist, San Francisco Art Institute summer program, 1973; fieldmaster for Joseph Hyde, 1974, and Dwight Primiano, 1978, University without Walls, Photographic Studies Program, Providence, R.I.; UCLA, 1975-1976; Visual Arts Program Policy Panel, National Endowment for the Arts, 1981-present.
Recognition and Awards: Rhode Island School of Design Teaching Fellowship, 1968; University of Illinois Faculty Research Fellowship, 1970; University of Rhode Island Faculty Fellowship, 1974; UCLA Faculty Research Grant, with Judith Golden and Robert Heinecken, 1976; National Endowment for the Arts Photography Fellowships, 1972, 1980.
Individual Exhibitions: 1965 — Loch Haven Art Center, Orlando, Fla. 1966 — Pratt Institute, Brooklyn, N.Y. 1967 — Jacksonville Art Museum, Fla. 1969 — School of The Art Institute of Chicago. 1973 — Loomis Gallery, Loomis School, Windsor, Conn.; Rhode Island School of Design, Providence; *Photographs from East of the Mississippi and Other Strange Places,* Meramec Gallery, Meramec College, St. Louis; School of The Art Institute of Chicago; Franconia College, N.H. 1974 — Woods Gerry Mansion, Rhode Island School of Design; The Friends of Photography, Carmel, Calif.; Archetype Gallery, New Haven, Conn. 1975 — Adams Gallery, Rhode Island College, Providence; University of Northern Iowa, Cedar Falls. 1976 — Cameraworks Gallery, Los Angeles; Fine Arts Gallery, Orange Coast College, Costa Mesa, Calif.; Portland School of Art, Me.; VSW, Rochester, N.Y. 1977 — Franconia College; *Eye to Eye,* Fine Arts Center, University of Rhode Island, Kingston. 1978 — *Second Thoughts,* Fine Arts Center, University of Rhode Island; Light Gallery, New York (Mar. 7-31). 1979 — *Handy Fears,* Main Gallery, Fine Arts Center, University of Rhode Island. 1980 — University of Rhode Island (Jan. 8-Feb. 9); Tyler School of Art, Temple University, Philadelphia. (Nov. 7-28). 1981 — Lightwork Gallery, Syracuse, N.Y. (Oct. 2-Nov. 6). 1982 — Los Angeles Center for Photographic Studies (Feb. 27-Apr. 10); Shepherd College, Shepherdstown, W.Va. (Mar. 1-27); University Art Museum, University of New Mexico, Albuquerque (Apr. 10-May 21).
Selected Group Exhibitions: 1969 — *Serial / Modular Imagery in Photography***; *Recent Acquisitions 1969**; *Vision and Expression.* 1970 — *Into the 70's***; *Three Photographers,* San Fernando State University at Northridge, Calif. (Nov. 2-27; catalogue). 1971 — *Photography Invitational 1971*; *Two Photographers,* Jorgenson Gallery, University of Connecticut at Storrs (with Lee Dejasu). 1972 — *Photographic Portraits*; *The Multiple Image***; *60s Continuum,* IMP/GEH, Rochester, N.Y. (Feb. 5-May 1; catalogue: *Image;* traveled). 1973 — *National Photography Invitational,* Anderson Gallery, Virginia Commonwealth University, Richmond (Dec. 11, 1973-Jan. 12, 1974; catalogue). 1974 — *Flick, Dutton, Parker,* VSW, (traveled); *National Photography Invitational,* Anderson Gallery, Virginia Commonwealth University (catalogue). 1975 — *Photovision '75,* Hartford Civic Center, Conn. (traveled); *18 Faculty Artists,* The Frederick S. Wight Art Gallery, UCLA (catalogue). 1976 — *Portfolio Exhibition,* Pomona College, Claremont, Calif.; *New Portfolios.* 1977 — *Bart Parker, Brent Sikkema,* New England School of Photography, Boston; *Underware,* Archetype Gallery, New Haven, Conn. (traveled); *The Extended Frame***; *Contemporary Photographers,* Fogg Museum of Art, Harvard University, Cambridge, Mass. (catalogue). 1978 — *Photo-Electric,* Cleveland State University (Nov. 17-Dec. 13; catalogue); *Forty American Photographers*; *The Photograph as Artifice,* California State University at Long Beach (catalogue; traveled); *I shall save one land unvisited,* Corcoran Gallery of Art, Washington, D.C. (Aug. 25-Oct. 10; catalogue; traveled); *More Than Once,* Fine Arts Center, University of Rhode Island, Kingston (traveled). 1979 — *Object, Illusion, Reality,* State University of California at Fullerton (catalogue); *Attitudes*; *Auto as Icon*; *Divola, Henkel, Parker, Pfahl,* VSW (traveled). 1980 — *Silver Interactions,* Fine Arts Gallery, University of South Florida, Tampa (May 30-July 18; book); *Aspects of the 70's*. 1981 — *The Manipulated Landscape II,* The Plaza Gallery, SUNY at Albany (Mar. 13-Apr. 16; catalogue). 1982 — *Color as Form.*
Monographs: *A Close Brush with Reality, Photographs and Writings 1972-1981.* VSW, Rochester, N.Y., 1981.
Other Books: Thomas, Lew, ed. *Photography and Language.* Cameraworks Press, San Francisco, 1976 • *Color Photography.* Ziff Publishing Co., New York, 1972 • Clark, Thomas. *Some Particulars.* Jargon Society, Millerton, N.Y., 1971 • See also Life Library, *The Print;* Witkin and London, *The Photograph Collector's Guide;* and Gassan, *A Chronology of Photography.*
Selected Articles, Essays, and Reviews: "A Selection of Photographs from The Pasadena Art Museum Permanent Collection." *San Francisco Camera,* vol. 1, no. 5 (1971) • Porter, Allan. "Sequence, Part II." *Camera,* Lucerne, Switzerland (October 1972), pp. 49, 52 • Murray, Joan. "New Photography: San Francisco and Bay Area." *Artweek* (Apr. 20, 1974), p. 11 • *Bulletin of the Rhode Island School of Design* (December 1974) • Mautner, Robert. "Parker and Takama." *Artweek* (Jan. 24, 1976), p. 12 • Parker, Bart. "Bart Parker: I Subsist on Analogy." *Afterimage* (November 1976), pp. 10-12 • Davis, Douglas, with Rourke, Mary. "Photography: Doctored Images." *Newsweek* (Aug. 15, 1977), p. 71 • Charoudi, Martha. "Talking Pictures." *Afterimage* (April 1977), p. 17 • "More Than One." *AnyArt Journal* (Winter 1978), pp. 34-35 • "New Acquisitions." *Bulletin,* Art Museum, University of New Mexico, Albuquerque, vol. 11 (1978), p. 33 • Abshire, Martha. "I Shall Save One Land Unvisited." *Arts Journal* (September 1978), pp. 4-5 • Kuspit, Donald B. "The Indispensable Land." *Art Voices South* (January-February 1978) • Johnstone, Mark. "Meaning and Ambiguity." *Artweek* (March 20, 1982), p. 12 • Brumfield, John. "Bart Parker's Paradoxical Systems." *Afterimage* (Summer 1982), pp. 8,9.

Marcia Resnick
Born: New York, 1950
Resides: New York
Education: New York University, 1967-1969; Cooper Union, New York, B.F.A., 1972; California Institute of the Arts, Valencia, M.F.A., 1973.
Professional Experience: Photography instructor in Cooper Union Saturday program, New York, 1970-1971; photography instructor at Children's Art Workshop, New York, 1971-1972; assisted at

summer workshop at Center of the Eye, Aspen, Colo., 1972; assisted at the summer workshop at The Friends of Photography, Carmel, Calif., 1973; photography instructor at California Institute of the Arts, Valencia, 1972-1973; adjunct instructor of photography at Queens College, CUNY, 1973-1980; adjunct instructor of photography at New York University School of the Arts, 1974-1979; adjunct instructor of photography, Cooper Union, 1976-1979; teacher at Manhattanville College and International Center of Photography, New York, 1979; staff photographer and author of weekly column, *Soho Weekly News,* New York, 1979-1982; free-lance photographer, 1979-present.

Recognition and Awards: National Endowment for the Arts Photography Fellowship, 1975, 1978; Creative Artists Public Service Programs Grant, 1977.

Individual Exhibitions: 1974 — Gallery 115, Santa Cruz, Calif. (June-July). 1976 — Susan Penzer, New York (May 8-June 15); Galerie Ricke-Projektions, Cologne, West Germany (March). 1977 — Lightworks Gallery, Syracuse, N.Y.; *The Fabric of Night,* Photoworks Gallery, New York (Jan. 22-Feb. 22). 1978 — Galerie Rolf Ricke, Cologne, West Germany; Gotham Book Mart, New York (Apr. 17-May 8).

Selected Group Exhibitions: 1972 — *Revealings, Photographs of People in Their Places,* Ohio Silver Gallery, Los Angeles. 1973 — *New Photographics, 1973,* Central Washington State College, Ellensburg (catalogue). 1974 — *Photography Unlimited.* * 1975 — *Women Look at Women,* Lyman Allyn Museum, New London, Conn. (Feb. 9-Mar. 2; catalogue; traveled); *The Extended Document*; Women of Photography*; Art Contemporain et Photographie,* Arles, France; *International Show of Video,* Espace Pierre Cardin, Paris; *Narrative in Contemporary Art,* Ontario; Amerika Haus, Berlin; *Lives.** 1976 — *Pan-Conceptuals,* Gallery Maki, Tokyo; *Photograph as Art,* Galerija Grada Zagreba, Zagreb, Yugoslavia (catalogue); *Photo and Idea,* Parma, Italy. 1977 — *The Great West, Real/Ideal*; The Extended Frame.**** 1978 — *The Photographer's Image Self-Portrayal*; Marcia Resnick and Larry Williams,* Chicago Center for Contemporary Photography, Columbia College; *Punk Art,* Washington Project for the Arts, Washington, D.C. (catalogue); *Artwords and Bookworks***; Art Books:;,.Books as Original Art.**** 1979 — *Approaches to Photography*; Intentions and Techniques**; Attitudes*; Kunst als Photographie 1949-1979 / Photographie als Kunst 1879-1979***; WARM (Women Art Registry of Minnesota),* Minneapolis (traveled). 1980 — *Invented Images,*

UCSB Art Museum, University of California at Santa Barbara (Feb. 20-Mar. 23; catalogue; traveled); *Photographs by William DeLappa, John Takami Morita, and Marcia Resnick - Three Approaches to Visual Biographies,* The Friends of Photography, Carmel, Calif. (Apr. 24-May 25; brochure). 1981 — *New York; New Wave,* P.S. 1, New York (traveled to France and Italy); *Alumni Show,* California Institute of the Arts, Valencia (catalogue).

Books by the Artist (all privately published unless otherwise indicated): *Tahitian Eve,* 1975 • *Landscape,* 1975 • *See,* 1975 • *landscape/loftscape.* Printed Matter, New York, Inc., 1977 • *Re-Visions.* Coach House Press, Toronto, 1978.

Books by Others: Holabird, Katharine. *Women on Women.* A & W Publishers, Inc., New York, 1978 • See also Life Library, *Photography Year 1974.*

Selected Articles, Essays, and Reviews: Lobron, Barbara. "The Layered Eye, The Painted Photographs of Marcia Resnick." *Camera 35* (July 1974), pp. 46-51 • Frank, Peter. "Picture Books." *Soho Weekly News* (July 17, 1975) • Thornton, Gene. "Reportage, Soul, and Diverse Outrages." *New York Times,* Aug. 3, 1975, Sec. D, p. 21 • Meinwald, Dan. "Bumper Crop — Marcia Resnick's Books." *Afterimage* (October 1975), pp. 13-14 • Radici, Barbara. "Three Books by Marcia Resnick." *Data Arts* (November-December 1975) • Bourdon, David. "Not Good Ain't Necessarily Bad." *The Village Voice* (Dec. 8, 1975) • Ellenzweig, Allen. "Landscapes by Marcia Resnick." *Arts Magazine* (September 1976), p. 27 • Picard, L. "Letter from New York." *Kunstforum International* (1976), pp. 248-56 • Frank, Peter. "Auto Art — Self Indulgent? And How." *Art News* (September 1976), pp. 43-48 • Lippard, Lucy R. "Going Over the Books." *Artweek* (Oct. 30, 1976), pp. 11-12 • McDarrah, Fred. "Voice Choices. 'The Fabric of Night.'" *The Village Voice* (Feb. 14, 1977) • "Twelve Photographers." *Rolling Stone* (May 19, 1977), pp. 43-59 • Sweetman, Alex. "Interview." *Exposure* (Summer 1978), pp. 6-16 • Lifson, Ben. "Growing Pains and Grown-Up Pleasures." *The Village Voice* (May 1, 1978), p. 72.

Edward Ruscha

Born: Omaha, Neb., Dec. 16, 1937

Resides: Los Angeles

Education: Chouinard Art Institute, Los Angeles, 1956-1960.

Professional Experience: Hand typesetter and press worker at Plantain Press, 1958; layout and graphic work at advertising agency, 1960-1961; layout work for *Artforum* under pseudonym Eddie Russia, 1965-1967; visiting professor of drawing and printmaking at UCLA, 1969-1970.

Recognition and Awards: The National Council on the Arts grant, 1967; Tamarind Lithography Fellowship/Workshop (with Kenneth Price, Billy Al Bengston, Edward Moses, and John Altoon), 1969; John Simon Guggenheim Memorial Foundation Fellowship, 1971; Skowhegan School of Painting and Sculpture Medal in graphics, 1974.

Individual Exhibitions: 1963 — Ferus Gallery, Los Angeles. 1964 — Ferus Gallery. 1965 — Ferus Gallery. 1967 — *Gunpowder Drawings,* Alexander Iolas Gallery, New York. 1968 — Irving Blum Gallery, Los Angeles; Rudolf Zwirner, Cologne, West Germany. 1969 — *Edward Ruscha / New Graphics,* Multiples, Inc., Los Angeles; Irving Blum Gallery; La Jolla Museum of Art, Calif. 1970 — *Books by Edward Ruscha,* Galerie Heiner Friedrich, Munich, West Germany (catalogue); *Edward Ruscha / Prints 1966-1970 / Books 1962/1970,* Hansen Fuller Gallery, San Francisco; Galerie Alexander Iolas, Paris (catalogue); Galerie Alexandre Iolas. 1971 — *Books,* Nigel Greenwood, Inc., London; Contract Graphics Associates, Houston. 1972 — *Edward Ruscha / Books & Prints,* Mary Porter Sesnon Gallery, College V, University of California, Santa Cruz (catalogue); Corcoran & Corcoran Ltd., Coral Gables, Fla.; DM Gallery, London; Janie C. Lee Gallery, Dallas; The Minneapolis Institute of Arts (catalogue). 1973 — *Books by Edward Ruscha,* UCSD Art Gallery, University of California, San Diego; *Ed Ruscha / Drawings,* Leo Castelli Gallery, New York; *Edward Ruscha (Ed-werd Rew-shay) / Young Artist,* John Berggruen Gallery, San Francisco; *Edward Ruscha: Graphics from the Collection of Donald Marron,* Leo Castelli Gallery; *Edward Ruscha / Projection,* Galerie Ursula Wevers, Cologne; *Stains / Edward Ruscha,* Francoise Lambert, Milan, Italy; *Works by Edward Ruscha from the Collection of Paul J. Schupf '58,* The Picker Art Gallery, Colgate University, Hamilton, N.Y. (catalogue); Ace Gallery, Los Angeles; Francoise Lambert; The Greenberg Gallery, St. Louis; Nigel Greenwood, Inc. 1974 — *Books by Edward Ruscha,* Francoise Lambert; *Edward Ruscha / Prints & Books,* Root Art Center, Hamilton College, Clinton, N.Y.; *Recent Paintings,* Texas Gallery, Houston; Contemporary Graphics Center, Santa Barbara Museum of Art, Calif.; Golden West College, Huntington Beach, Calif.; H. Peter Findlay Gallery, New York; Leo Castelli Gallery. 1975 — *Edward Ruscha / Drawings / Selected Prints,* The Glaser Gallery, La Jolla, Calif.; *Edward Ruscha: Prints,* Northern Kentucky State University, Highland Heights; *Edward Ruscha / Prints & Publications 1962-1974,* The Arts Council of Great Britain (catalogue; traveled); *Tropical Fish Series,* Gemini G.E.L., Los Angeles; *Various Miracles,*

Ace Gallery; Fox Venice Theatre, Venice, Calif. (film screening); Galerie Ricke, Cologne; Jared Sable Gallery, Toronto; Leo Castelli Gallery (the film *Miracle* shown at Rizzoli screening room); Northlight Gallery, Arizona State University, Tempe; University of North Dakota Art Galleries, Grand Forks. 1976 — *Exhibitions & Presentations,* LAICA: *Paintings, Drawings and Other Work by Edward Ruscha,* Albright-Knox Art Gallery, Buffalo, N.Y. (catalogue); *Various Cheeses Series,* Gemini G.E.L.; *Various Drawings,* Ace Gallery, Vancouver, B.C., Canada; Dootson/Calderhead Gallery, Seattle; Stedelijk Museum, Amsterdam, The Netherlands (catalogue); Wadsworth Atheneum, Hartford, Conn. (catalogue). 1977 — *Edward Ruscha: Recent Drawings,* Fort Worth Art Museum, Tex.; Ace Gallery, University of Lethbridge Art Gallery, Alberta, Canada. 1978 — *Edward Ruscha / Books,* Rudiger Schottle, Munich; *Edward Ruscha: Recent Paintings & Drawings,* Ace Gallery, Vancouver; *Graphic Works by Edward Ruscha,* Auckland City Art Gallery, New Zealand; *A Selection of Paintings and Pastels, 1974-1977,* MTL Gallery, Brussels, Belgium; Castelli Uptown, New York; Galerie Ricke, Cologne; Peppers Art Gallery, University of Redlands, Calif. 1979 — *Ed Ruscha / New Works,* Texas Gallery, Houston; *Ed Ruscha / Prints & Drawings,* Getler / Pall Gallery, New York; *Neue Ausstellungen im Ink,* Halle für Internationale neue Kunst, Zurich; *New Works,* Marianne Deson Gallery, Chicago; Richard Hines Gallery, Seattle. 1980 — *Ed Ruscha / Paintings,* Ace Gallery; *Ed Ruscha / Paintings & Drawings,* Portland Center for the Visual Arts, Ore.; *New Paintings,* Leo Castelli Gallery; *Ruscha: Selected Works, 1966-1980,* Foster Goldstrom Fine Arts, San Francisco; Nigel Greenwood, Inc. 1981 — *Ed Ruscha / New Works,* ARCO Center for Visual Arts, Los Angeles (catalogue); *Ed Ruscha / Drawings,* Leo Castelli Gallery.

Selected Group Exhibitions: A major retrospective exhibition catalogue with an extensive bibliography exists for this artist; therefore, group exhibitions and major articles, essays, and reviews prior to the publication have been omitted here. See *The Works of Edward Ruscha.* With an introduction by Anne Livet and essays by Dave Hickey and Peter Plagens. Hudson Hills Press, New York, 1982.

Books by the Artist (all published by Heavy Industry Publications, Hollywood, Calif., unless otherwise indicated); *Twentysix Gasoline Stations,* 1963 • *Various Small Fires and Milk,* 1964 • *Some Los Angeles Apartments,* 1965 • *Every Building on the Sunset Strip,* 1966 • *Thirtyfour Parking Lots in Los

Angeles,* 1967 • Ruscha with Williams, Mason, and Blackwell, Patrick. *Royal Road Test,* 1967 • Ruscha with Bengston, Billy Al. *Business Cards,* 1968 • *Nine Swimming Pools and a Broken Glass,* 1968 • *Stains,* 1969 • *Crackers.* Story by Mason Williams. 1969 • *Babycakes.* Multiples, Inc., New York, 1970 • *Real Estate Opportunities,* 1970 • *A Few Palm Trees,* 1971 • *Records,* 1971 • *Dutch Details.* Octopus Foundation for Sonsbeek '71, Deventer, The Netherlands, 1971 • *Colored People,* 1972 • Ruscha with Weiner, Lawrence. *Hard Light,* 1978 • *Guacamole Airlines.* Harry N. Abrams, New York, 1980.

Other Books: Lippard, Lucy. *Pop Art.* Praeger, New York, 1966 • Pellegrini, Aldo. *New Tendencies in Art.* Crown, New York, 1966 • Kaiden, Nina, and Hayes, Bartlett. *Artist and Advocate: An Essay on Corporate Patronage.* Renaissance Editions, New York, 1967, p. 62 • Finch, Christopher. *Pop Art: Object and Image.* Studio Vista, London, 1968, p. 132 • Battcock, Gregory, ed. *Minimal Art: A Critical Anthology.* E. P. Dutton, New York, 1968, p. 100 • Compton, Michael. *Pop Art.* Hamlyn, London, 1970, pp. 92, 136 • *Art Since Mid-Century: The New Internationalism.* New York Graphic Society, Greenwich, Conn., 1971, vol. 2, *Figurative Art,* p. 232 • Banham, Reyner. *Los Angeles: The Architecture of Four Ecologies.* Penguin, Harmondworth, England, 1971, p. 241 • Lippard, Lucy. *Changing Essays in Art Criticism.* E. P. Dutton, 1971, pp. 264, 266, 315 • Trachtenberg, Alan; Neill, Peter; and Bunnell, Peter C. *The City: American Experience.* Oxford University Press, New York, 1971, pp. 552, 619 • Jacobson, Bernard. *Fourteen Big Prints.* Bernard Jacobson, Ltd., London, 1972, pp. 48-51 • Meyer, Ursula. *Conceptual Art.* E. P. Dutton, 1972, pp. 206-9. Reprint excerpts from Coplans' interview with Ruscha, *Artforum,* February 1965 • Hunter, Sam. *American Art of the 20th Century.* Harry N. Abrams, New York, 1973, pp. 497, 510 • Lippard, Lucy. *Six Years: The Dematerialization of the Art Object.* Praeger, 1973, pp. 11-12, 22, 36, 70 • Sager, Peter. *Neue Formen des Realismsus.* DuMont Schauberg, Cologne, West Germany, 1973, p. 70 • Alloway, Lawrence. *American Pop Art.* Collier Books, New York, in association with the Whitney Museum of American Art, New York, 1974, pp. 35-37, 139 • Plagens, Peter. *The Sunshine Muse: Contemporary Art on the West Coast.* Praeger, 1974, pp. 25, 30, 73, 120, 140, 142, 144-146, 149, 151, 154, 174, 176 • Wilson, Simon. *Pop.* Thames and Hudson, London, 1974 • Alloway, Lawrence. *Topics in American Art since 1945.* Norton, New York, 1975, pp. 166-167, 175, 204 • Pierre, Jose. *Dictionaire de Poche de Pop Art.* Fernand Hazan, Paris, 1975, pp. 135, 140 • Rose, Barbara. *American

Art since 1900.* Rev. and exp. ed., Praeger, 1975, p. 216 • Celant, Germano. *Precronistoria 1966-69.* Centro Di, Florence, Italy, 1976, pp. 41, 58, 131 • Müller, Hans-Jürgen. *Kunst kommt nicht von Können.* Edition für Moderne Kunst, Nuremberg, West Germany, 1976, p. 248 • Stebbins, Theodore F., Jr. *American Master Drawings and Watercolors.* Harper and Row, New York, 1976, p. 400 • Wilmerding, John. *American Art.* Penguin, 1976, p. 236 • Arnason, H.H. *History of Modern Art.* 2nd ed. Prentice-Hall, Englewood Cliffs, N.J., and Harry N. Abrams, 1977, pp. 621, 639-40, 699, 706 • Cummings, Paul. *Dictionary of Contemporary American Artists.* 3rd ed., St. Martin's Press, New York, 1977, p. 420 • Gatto, Joseph A. *Cities.* Davis Publications, Worcester, Mass., 1977, p. 60 • Lucie-Smith, Edward. *Art Now: From Abstract Expressionism to Superrealism.* Morrow, New York, 1977, pp. 233-34, 498 • Naylor, Colin, and Orridge, P. Genesis, eds. *Contemporary Artists.* St. James Press, London, 1977, pp. 833-35 (includes reprint of "The Information Man," *LAICA Journal,* June-July 1975) • Parry, Pamela Jeffcott. *Contemporary Art and Artists: An Index to Reproductions.* Greenwood Press, Westport, Conn., 1978, pp. 241-42 • Brown, Milton, et al. *American Art.* Harry N. Abrams, 1979, p. 539 • Parry, Pamela Jeffcott. *Photography Index.* Greenwood Press, 1979, p. 221 • Taylor, Joshua C. *The Fine Arts in America.* University of Chicago Press, 1979, p. 222 • Selz, Peter. *Art in Our Times: A Pictorial History 1890-1980.* Harry N. Abrams, 1981, pp. 463, 547 • See also Coleman, *Light Readings;* and Kahmen, *Art History of Photography.*

Eve Sonneman
Born: Chicago, 1946
Resides: New York
Education: University of Illinois, Champaign, B.F.A., 1967; University of New Mexico, Albuquerque, M.F.A., 1969.

Professional Experience: Free-lance photographer, New York, 1969-1971; teacher at Cooper Union College of Art and Architecture, New York, 1970-1971; visiting artist, Rice University, Houston, 1971-1972; instructor, Lehman College of CUNY (formerly Hunter College), 1972-1975; instructor, Cooper Union, 1975-1978; instructor, School of Visual Arts, New York, 1975-1982; part-time lecturer, 1970-present.

Recognitions and Awards: Boskop Foundation Grant in the Arts, New York, 1969, 1970; National Endowment for the Arts Photography Fellowship, 1971-1972, 1978; Institute for Art and Urban Resources Grant, New York, 1977; Polaroid Corporation Grant for Work in Polavision, 1978; Mademoiselle Award for 1977, *Mme* magazine.

Individual Exhibitions: 1970 — Cooper Union, New York. 1971 — Media Center, Rice University, Houston. 1972 — Art Museum of South Texas, Corpus Christi; Whitney Museum Art Resources Center, New York (Dec. 3-24). 1974 — Dayton Art Institute, Ohio; The Texas Gallery, Houston; The College of St. Catherine, St. Paul, Minn. (Nov. 3-28; brochure). 1975 — Chama Institute, New Orleans; The Texas Gallery (Aug. 29-Sept. 27). 1976 — Bard College, Annandale-on-Hudson, N.Y. (Feb. 11-29); University of Rochester, N.Y.; *Eve Sonneman: Observations – ¼ mile in the sky,* Castelli Graphics, New York (Dec. 4-24). 1977 — *Eve Sonneman: Observations – ¼ mile in the sky,* Artemisia Gallery, Chicago (Mar. 4-27); College of Wooster, Cleveland; Galerie Farideh Cadot, Paris; *New York,* The Texas Gallery (Nov. 29-Dec. 24). 1978 — Diane Brown Gallery, Washington, D.C.; Castelli Graphics, New York (Apr. 8-29). 1979 — Thomas Segal Gallery, Boston (Mar. 3-28); *Eve Sonneman: Western Views 1975-1979,* Rudiger Schottle, Munich, West Germany (June 21-July 21). 1980 — The Contemporary Arts Center, New Orleans. (Mar. 29-Apr. 27); *Photographs by Eve Sonneman, 1974-1979: Observing and Preserving,* The Contemporary Arts Center, Cincinnati (catalogue); *Eve Sonneman: Work from 1968-1978,* The Minneapolis Institute of Arts (Jan. 11-Mar. 9; catalogue); La Noveau Musée, Lyon, France; *New Photographs,* Galerie Farideh Cadot (January); The Texas Gallery (May 13-June 14); Castelli Graphics (May 10-31); Blue Sky Gallery, Portland, Ore.; Francoise Lambert, Milan, Italy; Young Hoffman Gallery, Chicago; *Eve Sonneman Photographs: 1968-1980,* Hartwick College, Oneonta, N.Y. (Sept. 11-Oct. 10). 1981 — Locus Solus, Genoa, Italy; *Future Memories,* Cirrus Gallery, Los Angeles (Jan. 4-31); Tucson Museum of Art, Ariz. (May); *Eve Sonneman: Diptych Photographs,* Burton Gallery, Toronto (Sept. 30-Oct. 31); Peter Noser Galerie, Zurich, Switzerland. 1982 — Thomas Segal Gallery; Galerie Wilde, Cologne, West Germany; The Art Institute of Chicago; *Eve Sonneman: Work from 1968-1981,* The Hudson River Museum, Yonkers, N.Y. (Mar. 25-May 9; catalogue); *Eve Sonneman: Times of Man & Nature,* Castelli Graphics (Jan. 9-30); The Texas Gallery (Jan. 9-Feb. 10).

Selected Group Exhibitions: 1968 — *Young Photographers '68,* Purdue University, Lafayette, Ind. (Apr. 1-30; catalogue); *Young Photographers,* University of New Mexico Art Museum, Albuquerque (catalogue); *Photography 1968*.* 1969 — *Serial/Modular Imagery in Photography,* Purdue University (catalogue). 1970 — Bergman Gallery, Chicago (catalogue). 1972 — *Photo Kina,* Cologne, West Germany. 1973 — *Photographs from the Coke Collection,* Museum of New Mexico, Santa Fe (Mar. 4-Apr. 30; catalogue); *Photographers in New York,* Tokyo (catalogue). 1975 — *First Light,* Humboldt Cultural Center, Eureka, Calif. (catalogue); *Lives*; Painting, Drawing, and Sculpture from the Vogel Collection,* Institute of Contemporary Art, University of Pennsylvania, Philadelphia (traveled); *Women Look at Women,* Lyman Allyn Museum,. New London, Conn. (Feb. 9-Mar. 2; catalogue; traveled). 1976 — *Works, Words 2,* P.S. 1, Long Island City, New York (catalogue). 1977 — *The Target Collection of American Photography**; Documenta VI,* Kassel, West Germany (catalogue); *Paris Biennale* (catalogue); *The Extended Frame***; Bookworks**** 1978 — *Nature: Fifteen Americans,* Iran American Society, Tehran (catalogue); *Artwords and Bookworks***; Mirrors and Windows*.* 1979 — *One of a Kind,* The Museum of Fine Arts, Houston (organized by Polaroid Corporation; book; traveled); *Attitudes*; Diverse Images**; Kunst als Photographie 1879-1979/ Photographie als Kunst 1949-1979***; Instantés,* Musée National d'Art Moderne, Centre National d'Art et de Culture Georges Pompidou, Paris; *Artemesia Gentleleschi,* Yvon Lambert, Paris, and Ugo Ferranti, Rome (catalogue; traveled); *The Altered Photograph,* P.S. 1, Long Island City, New York (catalogue). 1980 — *Ils se disent Peintres, Ils se disent Photographers,* ARC, Musée d'Art Moderne de la Ville de Paris (catalogue); *Sequence Photograhy,* Part I***; *American Photographers 1970 to 1980,* The Washington Art Consortium, Washington, D.C. (catalogue); *Absage an das Einzelbild***.* 1981 — *Re: Pages*; The New Color: A Decade of Color Photography,* International Center of Photography, New York (book; traveled); *New Portraits,* Rheinisches Landesmuseum, Bonn, West Germany (catalogue); *Photofacts and Opinions,* Addison Gallery of American Art, Phillips Academy, Andover, Mass. (Jan. 9-Feb. 9; catalogue). 1982 — *Biennale,* Sidney, Australia; *Counterparts: Form and Emotion in Photographs,* The Metropolitan Museum of Art, New York (catalogue); *Color as Form.**

Monographs by the Artist: *Real Time.* Printed Matter, Inc., New York, 1976 • Sonneman, Eve and Kertess, Klaus. *Roses Are Read.* Editions Generations, Paris, 1982.

Books: Gutman, Judith Mara. *Is America Used Up?* Grossman Publishers, New York, 1973, pp. 123-24 • Flattau, John; Gibson, Ralph; and Lewis, Arne, eds. *Contact: Theory.* Lustrum Press, New York, 1980, pp. 160-63 • *Instantés.* Paris: Centre Georges Pompidou, 1980 • See also Malcolm, Diana and Nikon; and Life Library, *Photography Year 1981.*

Major Articles, Essays, and Reviews: Porter, Allan. "Sequence, Part II." *Camera* (October 1972) pp. 49, 52 • Gilbert-Rolfe, Jeremy. Review. *Artforum* (February 1974), pp. 65-68 • Frank, Elizabeth. Review. *Art News* (February 1974), p. 92 • Lippard, Lucy R. "Going Over the Books." *Artweek* (Oct. 30, 1976), pp. 11-12. Deitch, Jeffrey. "Eve Sonneman." *Arts Magazine* (December 1976), pp. 4-5 • Rubinfein, Leo. "Subject to Change." *Artforum* (May 1977), pp. 67-72 • Lippert, Werner. "Alternatives from New York." *Heute Kunst* (February-April 1977), p. 3 • *Flash Art* (July-August, 1977), p. 48 • Kurtz, Bruce. "Eve Sonneman at Castelli Graphics." *Art in America* (January-February, 1977), pp. 126-27 • Nuridsany, Michel. "Eve Sonneman: l'instant et le moment." *Le Figaro,* Paris (Nov. 21, 1977), p. 24 • Ratcliff, Carter. "Words and Images." *Art in America* (November-December, 1977), pp. 32-33 • Leonian, Edith. *Photography Annual* (1978), pp. 24-26 • Brody, Jacqueline. Review. *The Print Collector's Newsletter* (May-June 1978), p. 53 • Frackman, Noel. "Edward Ruscha/Eve Sonneman/Keith Sonnier." *Arts Magazine* (June 1978), pp. 37-38 • Perlberg, Deborah. Review. *Artforum* (Summer 1978), pp. 65-69 • Crary, Jonathan. "Eve Sonneman" • *Arts Magazine* (November 1978), p. 3 • Malcolm, Janet. "Photography: Two Roads." *The New Yorker* (Dec. 4, 1978), pp. 227-34 • *Village Voice* (February 1979), pp. 14-20 • Bell, Tiffany. "Eve Sonneman's Progressions in Time." *Artforum* (October 1979), pp. 56-59 • Foote, N. "Situation Esthetics: Impermanent Art and the Seventies Audience." *Artforum* (January 1980), p. 29 • Russell, John. "The Photograph Transformed." *New York Times,* Feb. 22, 1980, Sec. C, p. 20 • Strasser, Catherine. "Eve Sonneman at Galerie Farideh Cadot." *Artistes* (April-May 1980) • Elton, Lynn. "Apple Crumble." *Artscribe* (1980), No. 24, p. 33 • Malcolm, Janet. "Photography: Maximilian's Sombrero" *The New Yorker* (July 6, 1981), p. 94 • Karmel, Pepe. "Photography Raising a Hue: The New Color." *Art in America* (January 1982), p. 27 • Kramer, Hilton. "Art: The Met Exhibits Some of Its Best Photos. *New York Times,* Mar. 12, 1982, sec. 3, p. 21. Phillips, Deborah C. Review. *Art News* (March 1982), p. 107 • Linker, Kate. Review. *Artforum* (April 1982), pp. 75, 76 • Photographs and article. *Life* (April 1982), pp. 13-18 • Grundberg, Andy. "Eve Sonneman's Explorations." *New York Times,* Apr. 18, 1982, pp. 29, 30. • Caldwell, John. "Whimsical Stories at Museum Gallery." *New York Times,* May 2, 1982, p. 22. •

Scully, Julia. "Seeing Pictures." *Modern Photography* (June 1982), p. 136.

Al Souza

Born: Plymouth, Mass., 1944

Resides: Amherst, Mass.

Education: University of Massachusetts, Amherst, B.S. in civil engineering, 1967, M.F.A. in studio art, 1972; Art Students' League, New York, 1967-1970; New York Studies Program at the School of Visual Arts, New York, 1970-1972.

Professional Experience: Part-time instructor in painting, University of Massachusetts, Amherst, 1972-1973; artist-teacher in the Edinburgh International Festival, Scotland (through the Scottish Arts Council and the Richard Demarco Gallery), summer 1973; visiting instructor in photography, Amherst College, Mass., 1974-1977; assistant professor, Art Department, Smith College, Northampton, Mass., 1973-1979; instructor, Greenfield Community College, Mass., 1978-1979; assistant professor, North Texas State University, Denton, 1979-1980; instructor, Rhode Island School of Design, Providence, 1980-1981; visiting artist, University of Houston, fall 1981.

Recognition and Awards: National Endowment for the Arts Photography Fellowship, 1978; Massachusetts Council on the Arts Photography Fellowship, 1981.

Individual Exhibitions: 1972 — University of Massachusetts, Amherst. 1973 — Hampshire College, Amherst; University of Rhode Island, Kingston. 1974 — University of Massachusetts, Amherst. 1975 — OK Harris Gallery, New York; Galerie im Taxispalais, Innsbruck, Austria; Galeria nächst St. Stephan, Vienna, Austria. 1976 — OK Harris Gallery; Centre Culturel Americain, Paris; Cronin Gallery, Houston (June 29-Aug. 14); Galerie Ecart, Geneva, Switzerland (opened Oct. 13); Museum of Brest, France. 1977 — OK Harris Gallery (Mar. 5-26); University of Southwestern Louisiana, Lafayette; Student Cultural Center Gallery, Belgrade, Yugoslavia (March); Museum of Angoulème, France; Canon Photo Gallery, Geneva. 1978 — OK Harris Gallery (Jan. 7-28); Cronin Gallery (Apr. 2-29); Nova Scotia College of Art and Design, Halifax, Canada; Dobrick Gallery, Chicago. 1979 — OK Harris Gallery; Berry College, Mount Berry, Ga.; *Al Souza: Photoworks, 1974-1979*, University of Massachusetts, Amherst (Mar. 28-June 3; catalogue); Moravian College, Bethlehem, Pa.; Dartmouth College Museum, Hanover, N.H.; Cronin Gallery (Sept. 29-Oct. 20). 1980 — Delahunty Gallery, Dallas; Brown University, Providence, R.I.; Dobrick Gallery. 1981 — OK Harris Gallery (Feb. 28-Mar. 21); Tiroler Kunst; pavillion, Innsbruck, Austria; Philippe Vogt Gallery, Zurich, Switzerland; Frankfurter Kunstverein, West Germany (catalogue). 1982 — *Concentration VI: Al Souza*, Dallas Museum of Fine Arts (June 6-July 18; catalogue); Sieben-Stern Galerie, Steyr, Austria (April). *Currents: Al Souza*, The New Museum, New York (June 12-July 29; catalogue).

Selected Group Exhibitions: 1971 — *Abstract Painting*, DeCordova Museum, Lincoln, Mass. 1973 — *Edinburgh Arts '73*, Richard Demarco Gallery, Edinburgh, Scotland; Greenfield Community College, Mass. (two-person show with Jerry Kearns). 1975 — *Vargen*, Moderna Museet, Stockholm, Sweden (catalogue); *Some People From . . .*, Wheaton College, Norton, Mass. (catalogue). 1976 — *Copier / Recopier*, Galerie Gaetan, Geneva, Switzerland (catalogue); *Venice Biennale*, Grupe Ecart, Swiss Pavillion, Italy; *New Photography II*, Museum of Modern Art, Belgrade, Yugoslavia (catalogue; traveled). 1977 — *Poéticas Visualis*, Museum of Contemporary Art, University of Sao Paulo, Brazil (catalogue); *Outside the City Limits*, Thorpe Intermedia Gallery, Sparkhill, N.Y. (catalogue); *Off the Beaten Path*, SUNY, Potsdam, (catalogue); *Some Color Photographs*, Castelli Graphics, New York (traveled); *Warm Truths and Cool Deceits*, University Art Gallery, California State University, Chico (catalogue; traveled); *art, irony, etc. . . .*, Happy New Art Gallery, Belgrade, Yugoslavia (catalogue); *The Target Collection of American Photography*.** 1978 — *Painting and Sculpture Today*, Indianapolis Museum of Art (catalogue); *Current Work from New York*, Central Michigan University, Mt. Pleasant (traveled); *Time: The Reproductive Media*, Hartford School of Art, Conn. (catalogue); *Artwords and Bookworks*.*** 1979 — *Photographie als Kunst 1879-1979 / Kunst als Photographie 1949-1979***; *Small Is Beautiful*, Albright College, Reading, Pa. (catalogue; traveled); *The Anthony G. Cronin Memorial Collection*.** 1980 — *Response*, Tyler Museum of Art, Tex. (Feb. 9-Mar. 23; catalogue); *Beyond Photography '80*, Alternative Museum, New York (catalogue); *Other Media*, Florida International University, Miami (Feb. 8-28; catalogue); *4 Texas Photographers*, Amarillo Art Center, Tex., (catalogue); *Das Sofortbild*, Frankfurter Kunstverein, West Germany (catalogue). 1981 — *To be continued: The Sequential Image in Photographic Books***; *New England Relief*, DeCordova Museum (catalogue); *16th San Paulo International Biennale*, Brazil (catalogue). 1982 — *Repeated Exposure*.*

Books: See Kozloff, *Photography & Fascination*.

Selected Articles, Essays, and Reviews: Review. *Kulturberichte*, Innsbruck, Austria (June 1975), pp. 237-38 • Kozloff, Max. "Reviews." *Artforum* (March 1975), pp. 65-66 • "Les Choix De L'Express." *L'Express*, Paris (Mar. 15-21, 1976), p. 14 • Scarborough, John. "Gallery moves beyond 'straight photography.'" *Houston Chronicle*, Aug. 4, 1976, p. 6 • Scarborough, John. "Souza explores lies, half-truths in photoworks." *Houston Chronicle*, August 1976, Sec. 2, p. 6 • Foote, Nancy. "The Anti-Photographers." *Artforum* (September 1976), p. 52 • Rice, Shelley. "A Step in the Right Direction." *Village Voice* (June 27, 1977), p. 87 • Fischer, Hal. "Reviews." *Afterimage* (October 1977), p. 19 • Muchnic, Suzanne. "Art Reviews." *Los Angeles Times*, Nov. 15, 1977, Part IV, p. 5 • Lifson, Ben. "Running Hot and Cold." *Village Voice* (Mar. 20, 1978), p. 71 • Frank, Peter. "Form Follows Fiction." *Village Voice* (Apr. 24, 1978), p. 84 • Scarborough, John. "Souza exhibit treats scale in whimsical way." *Houston Chronicle*, Apr. 26, 1978, Sec. III, p. 1 • Bell, Tiffany. "Reviews." *Arts Magazine* (June 1978), p. 31 • Corey, David. "Al Souza." *Arts Magazine* (June 1978), p. 9 • Harmel, Carole. "Reviews." *The New Art Examiner* (January 1979), p. 16 • Bell, Tiffany. "Reviews." *Arts Magazine* (March 1979), p. 32 • Rifkin, Ned. "Resigning the World." *Artweek* (Oct. 13, 1979), p. 13 • Hoffman, F. "Out from the regional shadow." *Artweek* (March 1980), p. 20 • Kutner, Janet. "Souza Contrasts Reality with Snapshot Images." *Dallas Morning News*, May 4, 1980, p. 5 • Tarlow, Lois. "Alternative Space — Al Souza." *Art New England* (Summer 1981), pp. 12-13 • Schloker, Edith. "Al Souza: Maler und Fotopuzzler." *Neue Tiroler Zeitung*, Innsbruck, Austria (June 29, 1981) • Taylor, Robert. "The State of Relief Today." *Boston Sunday Globe*, Nov. 11, 1981, p. 71 • Glueck, Grace. "Reviews." *New York Times*, June 18, 1982, Sec. 3, p. 27.

Athena Tacha

Born: Larissa, Greece, 1936 (naturalized 1969)

Resides: Oberlin, Ohio

Education: National Academy of Fine Arts, Athens, Greece, M.F.A. in sculpture, 1959; Oberlin College, Ohio, M.A. in art history, 1961; University of Paris (Sorbonne), Ph.D. in aesthetics, 1963.

Professional Experience: Curator of modern art, Allen Art Museum, Oberlin College, Ohio, 1963-1973 (as Athena T. Spear); professor of art (taught sculpture), Oberlin College, 1973-present.

Recognition and Awards: First prize in sculpture, May Show, Cleveland Museum of Art, 1968, 1971, 1979; American Council of Learned Societies, Research Grant-in-Aid, 1971; Fellow, Center for Advanced Visual Studies, MIT, Cambridge, 1974; National Endowment for the Arts Artist's Fellowship, 1975; Ohio Arts Council award for the visual arts, 1976; Cleveland Women's City Club Award for the Visual Arts, 1981; 14 public sculpture commissions, 1975-1982.

Individual Exhibitions: 1969 — Akron Art Institute, Ohio; *Forms of Matter,* New Gallery, Cleveland. 1971 — *Sculpture in Paper and Twine*, Cooper School of Art, Cleveland (including films by the artist). 1973 — Gallery of the Loretto-Hilton Center, Webster College, St.Louis (including films). 1974 — *Exploration of the Self: Photographic and Textural Studies*, Project Inc. Gallery, Cambridge, Mass. 1977 — Douglass College Library, Rutgers University, New Brunswick, N.J. 1978 — *Tape Sculptures*, Wright State University, Dayton, Ohio (Oct. 21-Nov. 3; catalogue). 1979 — Zabriskie Gallery, New York (Feb.-Mar. 3); Akron Art Institute (Sept. 15-Nov. 4). 1980 — *Forms of Nature II and Photographic Works*, Mudd Library, Oberlin College, Ohio (Feb. 26-Mar. 9); Ohio Wesleyan University Art Gallery, Delaware (Apr. 2-19). 1981 — *Athena Tacha: Fragmentation – New Ideas for Landscape Sculptures*, Zabriskie Gallery, (Mar. 24-Apr. 25; brochure). 1982 — *Rainforest Diptych: A Tape Installation*, Mattress Factory, Pittsburgh.

Selected Group Exhibitions: *May Show*, Cleveland Museum of Art, 1966-1969, 1971, 1974, 1977, 1979 (catalogues: *Museum Bulletins*). 1971 — *Outdoor Sculpture Exhibition*, Blossom Music Center, Peninsula, Ohio. 1972-1973 — *Six Artists*, Akron Art Institute (December-January; catalogue). 1973-1974 — *ca. 7,500*, organized by Lucy Lippard, California Institute of the Arts, Valencia, Calif. (traveled); *Artists' Books*, Pratt Graphics Center Gallery, New York (traveled). 1975 — *Nine Artists: Women's Invitational*, N.O.V.A. Gallery, Cleveland (brochure); *Site Sculpture: Hamrol, Healy, Tacha*, Zabriskie Gallery (brochure); affiliated exhibition of same artists at City College of New York. 1976 — *Wooster Invitational*, Wooster College Art Museum, Ohio (catalogue); *Site Sculpture: Hamrol, Healy, Tacha*, Zabriskie Gallery (brochure); *Sculpture '76*, Greenwich, Conn. (catalogue); Basel Art Fair, Switzerland (brochure); *Scott Burton, Athena Tacha, George Trakas*, Parrish Art Museum, Southampton, N.Y. 1977 — *Década de 70*, University of Sao Paulo,Brazil (traveled); *Art in the Mail*, Art Council of New Zealand (traveled); *Contemporary Issues*, The Woman's Building, Los Angeles (traveled); *Site Sculpture: Hamrol, Healy, Miss, Tacha*, Zabriskie Gallery (brochure); *Proposals for Sawyer Point*, Contemporary Arts Center, Cincinnati (Oct. 7-Nov.27; catalogue); *American Narrative/Story Art: 1967-1977.*** 1978 — *Artwords and Bookworks***; *Art Books:;,. Books as Original Art***; *Artists' Books U.S.A.*, organized by Independent Curators, Inc. (traveled). 1979 — *Mail, etc. Art*, University of Colorado, Boulder (traveled). 1980 — *Urban Encounters: Art, Architecture, Audience*, Institute of Contemporary Art, University of Pennsylvania, Philadelphia (Mar. 19-Apr. 30; catalogue); *Scapes: Seven Ohio Landscape Artists*, Tangeman Fine Arts Gallery, University of Cincinnati (Mar. 24-Apr. 20; catalogue; traveled); *Across the Nation: Fine Art for Federal Buildings*, National Collection of Fine Arts, Washington, D.C. (June 4-Sept. 1; catalogue; traveled); *Drawings: The Pluralist Decade*, 39th Venice Biennale, American Pavillion, Italy (June 1-Sept. 30; catalogue; traveled). 1981 — *Artists' Gardens and Parks,* Hayden Galleries, MIT, Cambridge (Jan. 16-Mar. 1; traveled); *Paintings and Sculpture by Candidates for Art Awards*, American Academy and Institute of Arts and Letters, New York (Mar. 9-Apr. 5; catalogue); *Transitions II: Landscape/Sculpture*, SUNY at Old Westbury (Oct. 5-Nov. 12; catalogue). 1982 — *Gina Brand and Athena Tacha*, National City Bank, Cleveland (Mar. 15-Apr. 9; catalogue).

Books by Artist (all privately printed): *Ten Projects for Staircases*, 1970-1971 • *Heredity Study I*, 1970-1971 • *Heredity Study II*, 1970-1971 • *Spatial Disorientation Staircases and Ramps*, 1971-1972 • *Different Notions of Cleanliness*, 1972 • *The Way My Mind Works*, 1972-1973 • *My Mother: A Psychological Portrait*, 1973 • *Who is Athena?*, 1973-1974 • *The Process of Aging*, 1974 • *Tragic Cats*, 1974-1975 • *My Adolescent Loves*, 1974-1976 • *A Picture Is Worth 1000 Words*, 1976 • *Little Pleasures*, 1978-1980 • *My Fears*, 1979-1980 • *Little Habits*, 1980 • *A Dictionary of Steps*, 1980.

Other Books by Artist: *Rodin Sculpture in the Cleveland Museum of Art*, Cleveland Museum of Art, 1967 (Supplement 1974) • Tacha, ed. *Brancusi's Birds* College Art Association and New York University Press, 1969. • *Art in the Mind*. Allen Art Museum, Oberlin, Ohio, 1970 • *Pasarile lui Brancusi*, Rev. and expanded edition of *Brancusi's Birds*. Trans. by Ana Olos. Editure Meridiane, Bucharest, Rumania, 1976, p. 158.

Other Books: Johnson, Ellen H. *Modern Art and the Object*. Thames and Hudson, London, 1976 • Lippard, Lucy. *From the Center*. E.P. Dutton, Inc., New York, 1976 • Sky, A., and Stone, M. *Unbuilt America*. McGraw-Hill, New York, 1976 •

Thalacker, Don. *The Place of Art in the World of Architecture*. Chelsea House, New York, 1979 • Munro, Eleanor. *The Originals: Women in Art*. Simon and Schuster, New York, 1979 • Johnson, Ellen H. *American Artists on Art (1940-1980)*. Harper and Row, New York, 1982.

Selected Articles by the Artist: "Brancusi: legend, reality, and impact." *Art Journal* (Summer 1963), pp. 240-41 • "Prodigal son: some new aspects of Rodin's sculpture." *Oberlin College Bulletin* (Fall 1964), pp. 23-39 • "A Contribution to Brancusi Chronology." *Art Bulletin* (March 1966), pp. 45-54 • "Sculptured Light." *Art International* (December 1967), pp. 29-49 • "A Note on Rodin's *Prodigal Son* and on the Relationship of Rodin's Marbles and Bronzes." *AMAM Bulletin* (Fall 1969), pp. 24-36 • "Reflections on the Work of Charles Close, Ron Cooper, Neil Jenney and Other Contemporary Art." *AMAM Bulletin* (Spring 1970), pp. 108-34 • "Reflections on the Work of Charles Close, Ron Cooper and Neil Jenney" (revised version of above). *Arts Magazine* (May 1970), pp. 44-47 • "Elie Nadelman's Early Heads (1905-1911)." *AMAM Bulletin* (Spring 1971), pp. 201-22 • "L'Elémentaire et la répétition: Brancusi." *Revue del'art*, no. 12 (1971), pp. 40-44. Reprinted in English as "Brancusi and Contemporary Sculpture." *Arts Magazine* (November 1971), pp. 28-31. Reprinted in Rumanian as "Brancusi si sculptura contemporana." *Arta*, vol. 20, nos. 4-5 (1973), pp. 32-34 • "Festival of Contemporary Arts." Special issue of the *AMAM Bulletin* (May 1973), containing "Some Thoughts on Contemporary Art, with Reference to Ann McCoy, Mary Miss, Ree Morton, Jacqueline Windsor, Chris Burden, Scott Burton and Joan Jonas," pp. 90-98; two short essays, and the catalogue of the entire festival, pp. 87-142 • "Multiple Styles of Elie Nadelman." *AMAM Bulletin*, vol. 31, no. 1 (1973/1974), pp. 34-58 • "Rhythm as Form." *Landscape Architecture* (May 1978), pp. 196-205. Reprinted in *New Performance*, San Francisco, vol. 1, no. 3 (1978), pp. 18-23 • "Complexity and Contradiction in Contemporary Sculpture." *Gamut* (Winter 1982), pp. 67-77.

Selected Articles,Essays, and Reviews by Others: Alloway, Lawrence. "Artists as Writers, II: The Realm of Language." *Artforum* (April 1974), pp. 33, 35 • Collins, Tara. "Athena Tacha." *Arts Magazine* (November 1975), p. 11 • McClelland, Elizabeth. "Step-Sculptures ofAthena Tacha." *Mid-West Art*, II (Feb. 10, 1976), pp. 14-15 • Howett, Catherine. "New Directions in Environmental Art." *Landscape Architecture* (January 1977), pp. 39, 41 • Lippard, Lucy. "Art Outdoors, In and Out of the Public Domain." *Studio International*

(March-April 1977), p. 85 • Foley, Van. "Three Sculptors: Helen Escobedo, Lila Katzen, Athena Tacha." *New Orleans Review*, vol. 5, no. 3 (1977), pp. 224-33 • Williams, Monica. "Athena Tacha, Sculptor." *Plain Dealer Magazine*, Cleveland (Aug. 26, 1979), pp. 36-43 • Gouma-Peterson,Thalia. "Rhythms in Space: An Installation." *Dialogue* (November-December 1979), pp. 32-33 • "Multiples and Objects and Artists Books." *The Print Collector's Newsletter* (May 1980), p. 56 • Stevens, Mark, et al. "Sculpture Out in the Open." *Newsweek* (Aug. 18, 1980), pp. 70-71 • Johnson, Ellen H. "Nature as Source of Athena Tacha's Art." *Artforum* (January 1981), pp. 58-62 • Wolff, Theodore F. "Artist Athena Tacha." *Christian Science Monitor*, Apr. 9, 1981, p. 18 • "Multiples and Objects and Artist's Books." *Print Collector's Newsletter* (May-June 1981), p. 51 • Wolff, Theodore F. "The Many Masks of Modern Art." *Christian Science Monitor*, June 23, 1981, p. 20.

Lew Thomas

Born: San Francisco, 1932
Resides: San Francisco
Professional Experience: Manager of museum bookstore at California Palace of the Legion of Honor, San Francisco, 1964-1982; various guest curatorships at Mills College Art Gallery, Oakland, Calif.; La Mamelle, San Francisco; Mill Valley Art Center, Calif.; San Francisco Museum of Modern Art, 1975-1981; publisher and editor of the NFS Press, San Francisco, 1975-present; teacher at San Francisco Art Institute, (summers) 1977, 1981; workshop teacher at The Fine Arts Museums of San Francisco, 1974, the University of California, Berkeley, 1974, and the Center for Creative Photography, University of Arizona, Tucson, 1980.

Recognition and Awards: Ilo Liston Memorial Publications Award, Mills College and Western Association of Art Museums, 1974; Printing Industries of America Graphic Arts Award, 1974, 1980; National Endowment for the Arts Photography Fellowships, 1975, 1980; SECA (Society for the Encouragement of Contemporary Art) and San Francisco Museum of Modern Art Publications Grant, 1976; National Endowment for the Arts Publication Grant, 1979; National Endowment for the Arts Services to the Field Grant, 1979; National Endowment for the Arts Visual Artists Fellowship, 1979; Design Citation (for harmony of text and format), Elliston Book Award, University of Cincinnati, 1979; National Endowment for the Arts Photography Exhibition, 1980; National Endowment for the Arts Photography Publication, 1980, 1981.

Individual Exhibitions: 1973 — *Photography of Ennui*, de Saisset Art Gallery and Museum, University of Santa Clara, Calif. 1974 — *Photographic Corners*, San Francisco Art Institute. 1975 — *8 x 10*, Mills College Art Gallery, Oakland, Calif. (catalogue; traveled; curated by Lew Thomas); *Bracketing*, Darkroom Workshop, Berkeley, Calif. 1976 — *Photographic Pieces*, William Sawyer Gallery, San Francisco; *Outside/Inside*, Coffee Gallery, San Francisco; *Vitruvian Context: 1482-1976*, San José State University Gallery, Calif. 1979 — *Bibliography(s)*, Lawson deCelle Gallery, San Francisco (catalogue in progress); *Structural(ism) and Photography*, Washington Project for the Arts, Washington, D.C. (catalogue); *Scale*, Washington Project for the Arts. 1980 — *Installation*, Zriny Hayes Gallery, Chicago; *Bookspines*, Asher/Faure Gallery, Los Angeles; Fraenkel Gallery, San Francisco (July 30-Aug. 30); *Reproductions of Reproductions*, Center for Creative Photography, University of Arizona, Tucson. 1981 — *Installation*, Ohio State University, Columbus.

Selected Group Exhibitions: 1971 — *The Annual*, San Francisco Art Institute (catalogue). 1973 — *Portfolios and Series*, Oakland Art Museum, Calif. 1974 — *New Photography: San Francisco and Bay Area*, M. H. de Young Memorial Museum, Fine Arts Museums of San Francisco (Apr. 6-June 2; catalogue; traveled); *History of Photography as Subject Matter*, The Friends of Photography, Carmel, Calif. (traveled). 1975 — *Words Work II*, San José State University Art Gallery, Calif. (catalogue); *Sequential Imagery*, Broxton Gallery, Los Angeles; *Exchange: DFW/SFO*, Fort Worth Art Museum, Tex., (traveled to San Francisco Museum of Modern Art, 1976). 1977 — *The Annual*, San Francisco Art Institute (catalogue). 1978 — *Contemporary California Photography**; *Problematic Photography*, San Francisco Museum of Modern Art (catalogue); *Mirrors and Windows.** 1979 — *Attitudes.** 1980 — *Absage an das Einsenbild (Renunciation of the Single Image).**** 1981 — *Erweiterte Fotographie (Extended Photography)****; *Photographs and Words*, San Francisco Museum of Modern Art (July 24-Aug. 30; catalogue: *Artforum;* curated by Lew Thomas).

Other Exhibitions Curated by Lew Thomas: 1976 — *Photography and Language*, La Mamelle, San Francisco; *West Coast Conceptual Photographers*, La Mamelle. 1977 — *Structuralism and Radio*, KPFA, Berkeley, Calif.; *Use Value of the Gallery*, Mill Valley Art Center, Calif.

Books by the Artist: *The Thinker*. The Fine Arts Museum of San Francisco, 1974 • *Structural(ism) and Photography*. NFS Press, San Francisco, 1979 •

Thomas and Thomas, Kesa. *Pages From a Child's Documentary*. NFS Press, San Francisco, 1980.

Books Edited by the Artist: *Photography and Language*. NFS Press, San Francisco, 1976 • Edited by Thomas and Donna-Lee Phillips. *Photography and Ideology*. Dumb Ox #5, Los Angeles, 1977 • Thomas and Phillips, Donna-Lee. *Eros and Photography*. NFS Press, 1977 • Fischer, Hal. *Gay Semiotics*. NFS Press, 1978 • Fischer, Hal. *18th Near Castro Street x 24*. NFS Press, 1979 • Thomas and Peter D'Agostino. *Still Photography: The Problematic Model*. NFS Press, 1981.

Selected Articles, Essays, and Reviews: *San Francisco Camera*, vol. 1, no. 6 (1972) • Murray, Joan. "Speaking Out Some Thoughts." *Artweek* (Jan. 5, 1974), p. 11 • Murray, Joan. "Photographic Corners." *Artweek* (Sept. 28, 1974), p. 11 • Garfinkel, Ada. "Lew Thomas Photographs Ideas." *Independent Journal*, San Rafael, Calif. (Jan. 10, 1975) • Murray, Joan. "8 x 10." *Artweek* (Feb. 1, 1975), p. 11 • Fischer, Hal. "Bracketing." *Artweek* (Sept. 27, 1975) • "Portfolio." *Intermedia*, vol. 1, no. 3 (1975), pp. 27-30 • Murray, Joan. "Texas & California Photographers." *Artweek* (Feb. 28, 1976), p. 11 • Butterfield, Jan. "Exchange DFW/SFO." *Visual Dialog* (March 1976), pp. 28-30 • Fischer, Hal. "West Coast Conceptual Photographers." *Artweek* (Mar. 27, 1976), p. 11 • Grant, Lynn. "The Printed Work." *Artweek* (Apr. 3, 1976), pp. 15-16 • Albright, Thomas. "Backyard Builders." *Art News* (May 1976), pp. 90-94 • "West Coast Conceptual Photographers." *New Art Examiner* (May 1976) • *Dumb Ox #2* (1976), pp. 16-18 • Hugunin, James, and Thomas, Lew. "Letters." *La Mamelle*, vol. 5 (1976), p. 1 • Fischer, Hal. "Photographers Using Language." *Artweek* (Nov. 6, 1976), pp. 1, 14 • Fischer, Hal. "South of Market Comes Alive." *Afterimage* (November 1976), pp. 18-19 • Chahroudi, Martha. "Reviews: Talking Pictures." *Afterimage* (April 1977), pp. 16-17 • Thomas, Lew. "The one . . . the other." *Dumb Ox* (Summer 1977), pp. 45-48 • Starenko, Michael S. "Photography and Language." *New Art Examiner* (November 1978) • Fischer, Hal. "Contemporary California Photography: The West is . . . well, different." *Afterimage* (November 1978), pp. 4-6 • "Received and Noted: Structural(ism) and Photography." *Afterimage* (Summer 1979), p. 20 • Albright, Thomas. "Time to Take a Look at the Artist's Book." *San Francisco Sunday Examiner and Chronicle*, Aug. 19, 1979 • Myers, George Jr. "Culture and Anarchy." *The Luncheon Press* (1979), p. 51 • "Near Sighted." *Creative Camera* (January 1980), p. 31 • Hedgepath, Ted, and Morey, Craig. "Photographic Pricing: Informational Interviews with six San Francisco photographers." San

Francisco Camerawork *Newsletter* (February 1980), pp. 3-6 • Murray, Joan. "Lew Thomas Library." *Artweek* (Aug. 16, 1980), p. 13 • Morgan, Robert. "You Can't Tell a Book by Its Cover (But You Can Locate a Text by Its Spine)." LAICA *Journal,* no. 28 (September 1980), pp. 49-55 • "Received and Noted: Pages from a Child's Documentary." *Afterimage* (October 1980), p. 20 • Hugunin, James. "As Good as Picasso?" *Obscura,* vol. 1, no. 2 (December 1980), pp. 44-45 • Wollheim, Peter. "Photography is not a language." *Vanguard* (September 1981), pp. 30-35 • Hedgepath, Ted. "Slight Variations in Photography & Language." *Artweek* (Aug. 15, 1981), pp. 11-12.

Todd Webb

Born: Detroit, 1905

Resides: Bath, Me.

Education: University of Toronto (studied mining engineering), 1923-1925; studied with Ansel Adams and Arthur Siegel.

Professional Experience: Began to photograph in 1939; photographer, U.S. Navy, 1942-1945; freelance photographer, New York, 1945-1947; contract photographer under direction of Roy Stryker, Public Service Department, Standard Oil of New Jersey, 1947-1949; worked as freelance photographer in Europe, 1949-1953, in New York, 1953-1961, and in Santa Fe, N.M., 1961-1971; contract photographer, United Nations and its agencies: UNICEF, World Health Organization, the World Bank, 1956-1960.

Recognition and Awards: John Simon Guggenheim Memorial Foundation Fellowship, 1955, 1956; National Endowment for the Arts Photography Fellowship, 1979.

Individual Exhibitions: 1946 — Museum of the City of New York. 1947 — Delgado Museum, New Orleans; Louisiana State University, Baton Rouge. 1950 — Museum of Art, Munich, West Germany; *Paris Architecture,* Paris Architectural Center, Wuppertal, West Germany. 1951 — *New York & Paris,* U.S. Embassy, Paris. 1954 — GEH, Rochester, N.Y. 1956 — *The Alert Eye of Todd Webb,* The Art Institute of Chicago (Sept. 20-Dec. 30; brochure). 1962 — Museum of Modern Art, Kalamazoo, Mich.; University of Indiana, Bloomington. 1965 — *Todd Webb Photographs: Early Western Trails and Some Ghost Towns,* Amon Carter Museum of Western Art, Fort Worth, Tex. (Nov. 25, 1965-Jan. 16, 1966; catalogue). 1966 — Texas A&M University, College Station; *Texas Homes of the 19th Century,* Amon Carter Museum of Western Art (book). 1967 — Museum of the Southwest, Midland, Tex.; University of South-

western Louisiana, Lafayette. 1968 — *USA Arts,* St. Restitut, Provence, France. 1971 — New Mexico Museum of Art, Santa Fe; Maison de la Tour, St. Restitut. 1974 — *Texas Public Buildings of the 19th Century,* Amon Carter Museum of Western Art (book). 1977 — *Todd Webb – A Major Retrospective,* Vitolo Rinhart Gallery, New York (Apr. 19-May 21); Westbrook College, Portland, Me. 1979 — Prakapas Gallery, New York (Sept. 4-29). 1980 — University of Southern Maine, Gorham (Oct. 28-Nov. 21; brochure). 1982 — Walker Museum, Bowdoin College, Brunswick, Me. (July-August).

Selected Group Exhibitions: 1948 — *In and Out of Focus: A Survey of Today's Photography,* MOMA, New York (April 6-July 11; catalogue: *Museum Bulletin;* traveled); *50 Photographs by 50 Photographers,* MOMA, New York (July 27-Sept. 28; traveled). 1952 — *Diogenes with a Camera II: Ansel Adams, Dorothea Lange, Tosh Matsumoto, Aaron Siskind, Todd Webb,* MOMA, New York (May 20-Sept. 1). 1955 — *The Family of Man.** 1958 — *Sixth Avenue* panorama as mural (4x24ft.), USIS Exhibit, Brussels World Fair, Belgium. 1962 — *Ideas in Images,* Worcester Art Museum, Mass. (Oct.17-Dec. 16; catalogue; traveled); *Laura Gilpin, Eliot Porter, and Todd Webb,* Museum of New Mexico, Santa Fe; *Les Grands Photographes de Notre Temps,* Hotel de Ville, Versailles, France. 1966 — *John Simon Guggenheim Memorial Foundation Fellows in Photography 1937-1965,* Philadelphia College of Art (Apr. 15-May 13; catalogue: *Camera*). 1967 — *Photography in the Twentieth Century.** 1977 — *Panoramic Photography,* Grey Art Gallery and Student Center, New York University Faculty of Arts and Sciences (Sept. 23-Nov.2; catalogue).

Books by the Artist: *Gold Strikes and Ghost Towns.* Doubleday & Co., Inc., Garden City, N.Y., 1961 • *The Gold Rush Trail and the Road to Oregon.* Doubleday & Co., Inc., 1963 • See also Pollack, *The Picture History of Photography,* and Coke, *Photography in New Mexico.*

Selected Articles, Essays, and Reviews (does not include commercial work for *Ladies' Home Journal, Collier's, Life, Look, Vogue, Harper's,* or *House Beautiful*): "Texas Victorian." *Art in America* (July 1969), pp. 96-99 • *Flash Art* (Summer 1980), p. 26.

Alice Wells

Born: Erie, Pa., 1929

Resides: Taos, N.M.

Education: Pennsylvania State University, 1949; attended workshops with Ansel Adams, 1961, and with Nathan Lyons, 1961-1962 and 1965-1966.

Other Names: Alisa Wells, Alice Andrews, Alice Wells Wittman.

Professional Experience: Worked for Eastman Kodak Company, Rochester, N.Y., 1959-1962; associate curator, GEH, Rochester, 1962-1969; assistant to director, VSW, Rochester, 1969-1972; faculty member, Penland School of Crafts, N.C., 1968-1972; workshop instructor, Center of the Eye, Aspen, Colo., summer 1971.

Recognition and Awards: Creative Artists Public Service Program, 1972.

Individual Exhibitions: 1967 — Aquinas Academy, Rochester, N.Y. (April). 1969 — Sir George Williams University, Montreal (prepared and circulated by the National Gallery of Canada from their collection). 1970 — *Found Moments Transformed,* VSW, Rochester, N.Y. (May 15-June 5; traveled; second version toured Italy under the auspices of *Popular Photography Italiana,* 1970-1972); Bucks County Community College, Newton, Pa.; Center of the Eye, Aspen, Colo.; SUNY at Albany. 1972 — Kenan Center, Lockport, N.Y.; Jefferson Community College, Watertown, N.Y.

Selected Group Exhibitions: 1963 — *Nathan Lyons / Alice Wells,* Institute of General Semantics, New York University; *Photography 63.** 1964 — *Photographs from the George Eastman House Collection 1900-1964.*** 1965 — *Six Photographers,* Krannert Art Museum, University of Illinois, Champaign (Feb. 26-Apr. 11; catalogue); *A Special View of Nature,* Florida State Museum, Gainesville (September; traveled). 1966 — *Contemporary Photographers II,* GEH, Rochester, N.Y. (traveled); *Contemporary Photography Since 1950,* GEH (traveled). 1967 — *Photography in the Twentieth Century.** 1968 — *Photography 1968**; *Contemporary Photographs**; *Photography USA,* DeCordova Museum, Lincoln, Mass. (catalogue). 1969 — *Recent Acquisitions 1969.*** 1970 — *The Photograph as Object 1843-1969.**** 1971 — *Figure in Landscape.*** 1972 — *Photography Invitational.** 1973 — *Fotografi Oggi Gli Americani,* Giugno-Luglio, Torino, Italy (catalogue); *Light and Lens**; *Combattimento Per un' Immagine.**** 1975 — *Women of Photography – An Historical Survey.** 1976 — *University of California, Los Angeles Collection of Contemporary American Photography.***

Books: *The Woman's Eye,* 1973. Edited by Anne Tucker. Alfred Knopf, New York • See also Life Library, *The Print* and *The Art of Photography,* and Gassan, *A Chronology of Photography.*

Selected Articles, Essays, and Reviews: Weaver, Mike. "New American Photography: The Authentic Vision." *FORM* (March 1968), pp. 15-22 • Zucker, Harvey. "Multiple Images." *Popular Photography* (June 1968), pp. 112-15, 130 • Fichter,

Robert. "Alice Andrews." *Creative Camera* (August 1969), pp. 282-85 • "A Selection of Photographs from The Pasadena Art Museum Permanent Collection." *San Francisco Camera,* vol. 1, no. 5 (1971) • Zannier, Itala. "L'Effecto Sabattier Usato Come Il Setaccio Dei Cercatori D'Oro." *Photografia Italiana* (December 1972), pp. 19-22 •

Minor White

Born: Minneapolis, July 9, 1908

Died: Cambridge, Mass., June 24, 1976

Education: University of Minnesota, B.S. in botany with English minor, 1933; studied with Alfred Stieglitz, Paul Strand, Harry Callahan, Ansel Adams, Edward Weston, and Edward Steichen, 1945; took graduate courses in art history and aesthetics in the Columbia University Extension Division (studied with Meyer Shapiro), 1945/1946; studied museum methods with Beaumont and Nancy Newhall, 1945.

Professional Experience: Worked briefly for a photofinisher and taught photography in the YMCA social/educational program, Portland, Ore., 1937-1938; "creative photographer" for the Works Progress Administration (WPA), 1938-1939; began to do publicity photographs for the Portland Civic Theatre, 1939; taught photography, then became director of the La Grande Art Center, Ore. (a small WPA center), 1940-1941; worked as photographer at MOMA, New York, 1945; photography faculty of California School of Fine Arts (now San Francisco Art Institute), 1946-1953; co-founder of *Aperture,* 1952, editor and production manager, 1952-1975 (credited as founding editor, 1975-1976); curator of exhibitions and editor of *Image,* GEH, Rochester, N.Y., 1953-1956; taught part-time at Rochester Institute of Technology, N.Y. 1954-1964; worked on a variety of commissioned projects, 1942 - death; taught numerous workshops around the U.S., 1956-death; was appointed visiting professor in the Department of Architecture at MIT, Cambridge, 1964, built up the program and established a permanent collection of photographs and directed exhibitions, 1968, promoted to tenured professorship, 1969, retired from faculty, 1974, but continued to teach part-time, appointed senior lecturer, 1975; exhibition designer; critic.

Recognition and Awards: Works Progress Administration grant to photograph the iron-front buildings of Portland, Ore., 1939; John Simon Guggenheim Memorial Foundation Fellowship, 1970; Fellow of MIT Council for the Arts, 1975-1976; Honorary Doctorate of Fine Arts, San Francisco Art Institute, 1976.

Individual Exhibitions: 1939-1941 — *Portland Iron-Front Buildings,* Ore. (WPA traveling exhibition); *Portland Waterfront,* Ore. (WPA traveling exhibition). 1942 — *Grande Ronde Valley Photographs,* Portland Art Museum; *First Sequence,* YMCA, Portland. 1948 — *Song Without Words,* San Francisco Museum of Art (traveled); *The Record Shop,* San Francisco. 1950 — *Intimations of Disaster,* The Photo League, New York; Portland Art Museum; San Francisco Museum of Art. 1952 — Raymond and Raymond Gallery, San Francisco; San Francisco Museum of Art (Dec. 4 - 21). 1954 — GEH, Rochester, N.Y.; Limelight Gallery, New York; Santa Barbara Museum of Art, Calif. 1955 — GEH; The Photographers Gallery, San Francisco; Village Camera Club, New York. 1957 — Limelight Gallery; San Francisco Museum of Art (with Dorothy Norman). 1959 — Gateway Gallery, San Francisco; GEH; Henry Ford Museum, Dearborn, Mich.; Image Study, Boston University; Limelight Gallery (with Paul Caponigro); *Sequence 13 / Return to the Bud,* Oregon Centennial Celebration, Portland. 1960 — The Art Institute of Chicago; Smithsonian Institution, Washington, D.C.; University of Buffalo, N.Y. 1961 — Carl Siembab Gallery, Boston. 1962 — Hetzel Union Gallery, Pennsylvania State University, University Park. 1964 — Humboldt State College, Arcata, Calif.; Ellsworth Museum, St. Lawrence University, Canton, N.Y.; Underground Gallery, New York; The Priceton Gallery, Chicago. 1965 — Gallery 216, New York; MIT Faculty Club, Cambridge; Reed College, Portland, Ore. 1966 — Lotte Jacobi Place, Hillsboro, N.J. 1967 — *It's All in the Mind,* Carl Siembab Gallery (Feb. 20 - Mar. 15). 1968 — Ringling Museum of Art, Sarasota, Fla. 1969 — The Friends of Photography, Carmel, Calif. (January - February); *Minor White: Allusions to Illusions,* Carl Siembab Gallery (Dec. 5-31). 1970 — Philadelphia Museum of Art (traveled). 1974 — Photography Gallery, Madison Art Center, Wis. (Apr. 3-28). 1975 — Cronin Gallery, Houston (Oct. 7 - Nov. 15); European tour (circulated by United States Information Agency).

Selected Group Exhibitions: A major monograph with an extensive bibliography exists for this photographer; therefore, group exhibitions and major articles, essays, and reviews previous to the publication of the monograph have been omitted. See White, Minor. *Mirrors, Messages, Manifestations.* Aperture, Millerton, N.Y., 1969, and Hall, James Baker, *Minor White: Rites and Passages,* Aperture, 1978. 1969 — *Recent Acquisitions 1969**; The Photograph as Object.*** 1972 — *Photog-*

raphy '72, Speed Museum, Louisville, Ky. (catalogue); *Octave of Prayer,* Hayden Gallery, MIT, Cambridge (catalogue). 1973 — *Through One's Eyes*; Combattimento per un' Immagine***; Photographer as Poet,* The Arts Club of Chicago (Jan. 10-Feb. 10); *Minor White / Robert Heinecken / Robert Cumming: Photograph as metaphor - Photograph as object - Photograph as document of concept.*** 1974 — *Language of Light**; Photography in America*; Celebrations,* Hayden Gallery, MIT (catalogue). 1976 — *The Photographer's Choice* (book); *American Photography: Past into Present**; Contemporary Trends.** 1977 — *The Great West: Real / Ideal*; Photographs: Sheldon Memorial Art Gallery Collections**; The Target Collection of American Photography**; Amerikanische Landschafts-Photographie*; The Collection of Sam Wagstaff,* Corcoran Gallery of Art, Washington, D.C. (Feb. 4-Mar. 26; book; traveled); *The Male Nude*; Quality of Presence*, Tusen och en bild.** 1979 — *Approaches to Photography*; Auto as Ikon*; Photography: Venice '79*; Photographie als Kunst 1879-1979/Kunst als Photographie 1949-1979***; Diverse Images.** 1980 — *Photography of the Fifties*; Aspects of the 70's: Photography*; Kalamazoo Collects Photography.** 1981 — *A Photographic Patron – The Carl Siembab Gallery,* Institute of Contemporary Art, Boston (Mar. 17-May 10; catalogue); *American Photographers and the National Parks*; American Landscapes,* MOMA, New York (July 9-Sept. 27; catalogue).

Monographs and Books by the Artist: *Zone System Manual.* Morgan & Morgan, Hastings-on-Hudson, N.Y., 1961. Rev. ed. 1968 • *Mirrors, Messages, Manifestations.* Aperture, Millerton, N.Y., 1969 • White, Minor; Zakia, Richard; and Lorenz, Peter. *The New Zone System Manual.* Morgan & Morgan, 1976 • *Minor White: Rites and Passages.* Text by James Baker Hall. Aperture, 1978.

Books Edited by the Artist (published by Aperture, Millerton, N.Y., and MIT Press, Cambridge) *Light,* 1968 • *Octave of Prayer: An Exhibition on a Theme,* 1972 • *Being Without Clothes,* 1972 • *Celebrations,* 1974.

Essays by the Artist: "Lyrical and Accurate." *The Camera Viewed — Writings on Twentieth-Century Photography – Volume II: Photography After World War II.* Edited by Peninah, R. Petruch. E. P. Dutton, Inc., New York, 1979, pp. 49-54 • "Found Photographs." *Photography: Essays and Images — Illustrated Readings in the History of Photography.* Edited by Beaumont Newhall. MOMA, New York, 1980, pp. 307-9 • "Silence of Seeing." *One Hundred Years of Photographic History: Essays*

in Honor of Beaumont Newhall. Edited by Van Deren Coke. University of New Mexico Press, Albuquerque, 1975, pp. 170-73.

Books: Danziger, James, and Barnaby, Conrad, III. *Interviews with Master Photographers.* Paddington Press, New York, 1977, pp. 14-35 • Adams, Robert. *Beauty in Photography – Essays in Defense of Traditional Books.* Aperture, Millerton, N.Y., 1981, pp. 91-98 • Whelan, Richard. *Double Take— A Comparative Look at Photographs.* Clarkson N. Potter, New York, 1981, p. 161 • See also Lyons, *Photographers on Photography;* Szarkowski, *Looking at Photographs;* Sullivan, *Nude: Photographs 1850 - 1980;* Coleman, *Light Readings;* Hill and Cooper, *Dialogue with Photography;* Witkin and London, *The Photograph Collector's Guide;* Goldberg, *Photography in Print: Writings from 1816 to the Present;* Jay, *Views on Nudes;* Life Library, *Art, Great Photographers, Great Themes, Photography Year 1975,* and *Photography Year 1977;* Coke, *Photography in New Mexico;* and Gassan, *A Chronology of Photography.*

John Wood

Born: Delhi, Calif., 1922
Resides: Alfred, N.Y.

Education: University of Colorado, B.S. in visual design; Institute of Design, Illinois Institute of Technology, Chicago, 1954 (studied photography under Harry Callahan and Art Sinsbaugh).

Professional Experience: Ran commercial photo studio in Concord, Mass., late 1940s; taught night school, Institute of Design, Illinois Institute of Technology, Chicago, 1954; joined staff of Alfred University, N.Y., 1955 (currently professor of design at the University's New York State College of Ceramics, teaching photo and printmaking); taught photography on an adjunct basis at the VSW, Rochester, N.Y., 1969-present.

Individual Exhibitions: 1953 — Avant Arts Gallery, Chicago. 1958 — Alfred University, N.Y. 1960 — Alfred University. 1962 — Alfred University. 1964 — Schuman Gallery, Rochester, N.Y. 1965 — SUNY at Brockport. 1966 — SUNY at Cortland; Edinboro College, Pa.; Kendall Gallery, Wellfleet, Mass. 1968 — Schuman Gallery. 1969 — MIT, Cambridge. 1971 — SUNY at Alfred.

1972 — *John Wood: Drawings, Photographs, Photo Collage,* VSW, Rochester, N.Y. (Jan. 21 - Feb. 22; traveled). 1976 — White Gallery, Portland State University, Ore. 1977 — VSW; Vision Gallery of Photography, Boston; Hockaday Center for the Arts, Kalispell, Mont. 1979 — Paul Cava Gallery, Philadelphia (October-November). 1981 — VSW (Apr. 25 - Aug. 14); Museum of Art, University of Oregon, Eugene (February-March). 1982 — Northlight Gallery, Arizona State University, Tempe (Jan. 17 - Feb. 14).

Selected Group Exhibitions: 1952 — La Jolla Art Museum, Calif. 1962 — *Monoprint Exhibition,* Philadelphia Art Alliance, Kansas City Art Institute, Mo. 1963 — (Organized by the American Federation of Arts; travelled to Iran, Turkey, Pakistan). 1964 — *Finger Lakes Exhibition,* Memorial Art Gallery, Rochester, N.Y. 1965 — *Finger Lakes Exhibition,* Memorial Art Gallery; print show, New York State Council on the Arts (traveled). 1966 — *Contemporary Photography Since 1950,* New York State Council on the Arts / GEH Rochester, N.Y. (traveled). 1967 — *The Persistence of Vision***; Photography in the Twentieth Century.** 1968 — *Five Photographers,* Sheldon Memorial Art Gallery, University of Nebraska, Lincoln (catalogue); *Contemporary Photographs.** 1969 — *Recent Acquisitions 1969.*** 1970 — *12 x 12,* Carr House Gallery, Rhode Island School of Design, Providence (March; catalogue). 1971 — *1971 Photography Invitational.** 1972 — *The Multiple Image***; Photographic Portraits.** 1974 — *Photography Unlimited.** 1975 — *The Photographer's Choice* (book); *12 Photographers,* New Organization for the Visual Arts (NOVA), Park Center, Cleveland (May 13 - June 6; catalogue). 1976 — *Contemporary American Photographs; Fichter, Walker, and Wood,* VSW, Rochester, N.Y. (traveled); *20 Photographers, Rochester, New York,* Centre Culturel Americain, Paris. 1977 — *The Target Collection of American Photography**; Photographs: Sheldon Memorial Art Gallery Collections**; The Extended Frame.**** 1978 — *The First Traveling Offset Rip-off Show,* VSW (traveled); Fosdick-Nelson Gallery, Alfred, N.Y. (two-man show). 1978 — *Spaces.**** 1979 — *Electroworks***; The Photographer's Hand,* IMP/GEH, Rochester, N.Y. (July 17 - Sept. 16;

traveled). 1980 — *Silver Interactions,* SVC/Fine Arts Gallery, University of South Florida, Tampa (May 30 - July 18; book); *The New Vision. Forty Years of Photography at the Institute of Design* (book); *Aspects of the 70's: Photography.** 1982 — *Paperworks: Art of Paper / Art on Paper,* Museum of Applied Arts, Belgrade, Yugoslavia (July 21 - Dec. 31); *The Markers,* Museum of Modern Art, San Francisco (May 29 - June 26; catalogue); *Photographer as Printmaker,* Arts Council of Great Britain (June 15 - Nov. 14).

Books: Wood, John. *A Ten-Page Note.* VSW, Rochester, N.Y. Reprinted in a larger edition, 1974 • Wood, John. "Portfolio of Offset Lithographs." VSW (1981) • See also Life Library, *The Print* and *Art.*

Selected Articles, Essays, and Reviews: *Statements,* no. 3 (1960) • White, Minor. "Review: The Persistence of Vision." *Aperture,* vol. 13, no. 4 (1968), pp. 59-60 • Sweetman, Alex. "Reading *The Bread Book* and *A Ten-Page Note:* The Experience Exceeds the Information." *Afterimage* (March 1974), pp. 10-11 • Scully, Julia, ed. "Photocollage: It's New Again . . .". *Modern Photography* (March 1975), pp. 114-19 • Hagen, Charles. "An Interview with John Wood." *Afterimage* (January 1977), pp. 8-15.